ALEXANDRA HARRIS

ROMANTIC MODERNS

English Writers, Artists and the Imagination
from Virginia Woolf to John Piper

With 79 illustrations, 48 in colour

Thames & Hudson

To Robert Harris
and in memory of Rosalie Harris
with love and thanks

Endpapers: Edward Bawden, *Tree and Cow* wallpaper design, 1927
Frontispiece: Edward McKnight Kauffer, *How Bravely Autumn Paints Upon the Sky*, 1938

First published in the United Kingdom in 2010 by Thames & Hudson Ltd,
181A High Holborn, London WC1V 7QX

Designed by Karolina Prymaka

British Library Cataloguing-in-Publication Data
A catalogue record for this book is available from the British Library

ISBN 978-0-500-25171-3

Printed and bound in China by C&C Offset Printing Co. Ltd

To find out about all our publications, please visit **www.thamesandhudson.com**.
There you can subscribe to our e-newsletter, browse or download our current catalogue,
and buy any titles that are in print.

CONTENTS

PROLOGUE:
In ENGLAND

Toller Fratrum is a small village in Dorset, close to where the River Hooke meets the Frome. Beside the farmhouse and a clutch of other stone buildings is the tiny church of St Basil. It was mostly rebuilt in the nineteenth century, but just to the left of the door as you enter, in the corner by the bell ropes and the unused heater, is a decorated font that reaches further back in time. Long-limbed figures with large moon faces, bulbously carved in deep relief, crowd together as if there were not quite room for them all. Wide eyes look out from the sandstone sides as they have been doing since the twelfth century – and as they were still doing in 1936, when the artist John Piper arrived.

He had been driving through England with his partner, Myfanwy Evans, photographing hundreds of churches and monuments. Standing in the draughty gloom of a remote nave, he would dampen the stone with a sponge so that the shapes were thrown into relief by his paraffin lamp. The light revealed some long-forgotten wonders. Crouching to enjoy the Toller Fratrum font, he thought about the primitive, expressive impulse in the art of his contemporaries. The Norman carvings seemed to him to have all the 'bigness and strangeness' of a portrait by Picasso.[1] He focused his camera on a figure who might be Christ – or Moses – and who supports the decorative rim of the font with raised hands. The figure's face and large arms look heroic, but beneath the little pleated skirt of his tunic, he has shaky-looking knees. At eight hundred years old, the image still felt close and alive.

Piper was thirty-two. After a false start as a lawyer to satisfy his father, he had been to the Royal College of Art and made an inspiring group of friends. He married one of them – Eileen Holding – but the marriage had broken down and now Piper was in love again. It was an exciting time. All the talk was about Paris and the latest abstract painting, and Piper was working hard on a series of geometric constructions. He was also looking at the art of 'England's early sculptors', and thinking of an odd story from the thirteenth-century chronicles of Peter Langtoft. It described a 'wander wit of Wiltshire' who went rambling off to Rome to study the antiquities

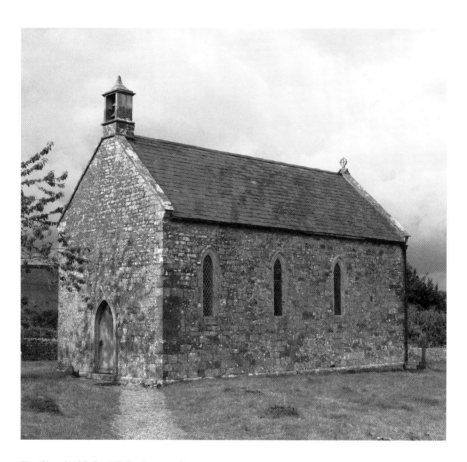

The Church of St Basil, Toller Fratrum, Dorset

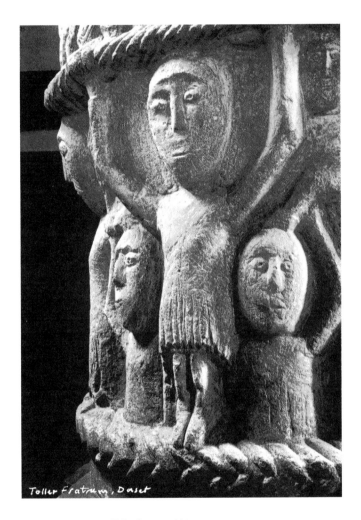

John Piper *The Font at Toller Fratrum*, 1936

without ever having visited Stonehenge. Appalled at his ignorance of his own country, the Roman antiquaries 'kicked him out of doors and bad him goe home and see Stonage'.[2] This comic parable appealed to Piper. All too often, he thought, we rush off to distant places without giving a thought to the astonishing things on our doorsteps. More than anything he wanted to 'goe home' and see not only prehistoric Stonehenge, but also the boldly striped lighthouse at Dungeness, the gardens at Stourhead, old stone barns in Oxfordshire, the lichen-patterned walls of Cornish chapels, the decorated interiors of pubs, the theatrical architecture of country houses.

These were Piper's personal enthusiasms, but in wanting to celebrate them he was doing something more than personal. Other people were showing new appreciation of such places, and by the late 1930s it looked to many observers as if a whole concerted project of national self-discovery was underway. Artists who had previously felt compelled to disguise themselves as avant-garde Frenchmen were now to be found on English beaches sheltering their watercolours from the drizzle. Anthologists (John Betjeman, Geoffrey Grigson, Herbert Read) collected up the verse of eighteenth-century parsons or packed vivid fragments of Romanticism into the tight compass of a paperback, while tourists paused in lay-bys to consult some of the newly written guidebooks. There were church murals, village plays, campaigns to save historic buildings. There were Paul Nash's megaliths, the erotic dramas of Graham Sutherland's landscapes, Vita Sackville-West's old roses at Sissinghurst, Edward Bawden's copper jelly moulds, Bill Brandt's photographs of literary Britain, Florence White's regional recipes. All these things – some large, some small – suggested the many forms that 'going home' might take.

When war threatened, and when finally it came, the imaginative claiming of England took on more urgency. This was the period of Virginia Woolf's cumulative, collaging novel *Between the Acts* (1941), T. S. Eliot's return to 'significant soil' in his poem sequence *Four Quartets* (1943), Evelyn Waugh's grand memorial *Brideshead Revisited* (1945), and Osbert Sitwell's expansively nostalgic autobiography *Left Hand, Right Hand!* (1945–50). Writers and painters were drawn to the crowded, detailed, old-fashioned and whimsical, gathering souvenirs from an old country that might not survive the fighting. There is a story to be told about this passionate, exuberant return to tradition. *Romantic Moderns* investigates one of the richest periods in the arts of this country, and it traces the extraordinary network of personal and cultural encounters from which a modern English renaissance grew.

Several kinds of powerful logic are discernible in this turn towards home. It seems partly to have been a response to the fiercely experimental ethos of high modernism. The revolutionary manifestos of the 1910s and 1920s declared new beginnings: the

artist's task was to free himself from the constraints of precedent and 'make it new'. He must rise above the accidents of personality and environment to seek universal myths and a common language of form. Architects of the International Style declared design to be transferable from one location to another, so they exchanged local stone for concrete and constructed levitating mezzanines that refused to be tethered to the ground. This form of liberty involved the abolition of roots. On all sides history and geography were jettisoned. The Futurists saw the past as an embarrassment to be bundled out of sight, and their call for a clean break with their predecessors took hold as one of the central manifestos of modernity. But it was not the most challenging, nor the most influential. By the 1930s artists were wondering how to reconnect with the headily abandoned past. The appeal of an international language of form began to feel limited: was it really right to resist the lure of eccentricity, locality, difference? Over the next few years the journey home would become, for many, a means of survival.

The desire to invoke tradition was not, of course, the only kind of response to crisis. Far from it. During a decade that began with the Great Depression and ended with air raids, artists and writers recorded unemployment, failing industry, and – when it came – the devastation of bombing. Some chose documentary as the most appropriate genre for the circumstances, demanding tough prose and straight facts, honouring the realities they found. Others wanted to create something absolute and untrammelled, in forms that might rise above contested national boundaries; if facts were divisive, best keep the canvas white. Deep below the activist surface ran the fear that none of this would be much use. Virginia Woolf reflected that to be in England in the late 1930s felt 'rather like sitting in a sick room, quite helpless'; it was, as Richard Overy has argued recently, a 'morbid age', nervily fixated on the imminent demise of civilization.[3] What role could the arts play at such a time?

The abstract paintings which epitomize one answer to the question exist side by side with the massed statistics of George Orwell's 1937 *Road to Wigan Pier*. And at the same time we find a different kind of documentary emerging, one that records versions of England and its history, whether it be in Edith Sitwell's lists of ornamental hermits or the roll-calls of village names and native tree species that E. M. Forster wrote into his pageants. The sense of imminent ending made many artists determined to include everything: to record what might be lost, and to enjoy as far as possible what the novelist Henry Green, surveying the goods in life's 'bargain basement', called the 'last look round'. 'We should be taking stock' Green warned.[4] A great many of his contemporaries were.

In 1940 Woolf started to draft a history of literature that explored the 'effect of country upon writers', linking finished works back to the circumstances of their

production: to floods, landscapes, interruptions, to 'the girl at the door', 'the wind and the rain'.[5] The following year, Piper wrote a patriotic book called *British Romantic Artists*. Linking up art with the geography of the nation, he described painters who are continually conscious of 'the changeable climate of our sea-washed country'.[6] His own work was clearly part of this tradition: you could write the weather forecast for the day in 1938 when he tore up scraps of painted paper and over-printed music scores to make *Dungeness*. Woolf's characters in *Between the Acts* know the forecast by heart. For them, inland, there is only a 'light but variable breeze'.[7] It was more than the climate that these two very different artists shared. As Woolf layered fragments of conversation, music, literature and folklore in her novel, Piper turned to paper collage and densely worked mixed media to give the sense of places that have accrued their meaning over time. His buildings and landscapes became intricate palimpsests. He might paint only a wall, as he did when he went to Muchelney Abbey in Somerset in 1941, but the wall is full of stories. It is an old wall in an old country, scarred and flaking, its tracery remoulded by the elements.

If we think of the canonical work of the 1930s it may not be old walls and weather that come first to mind. It was the age of Auden, and defined by him as that 'low dishonest decade' of 'clever hopes' and failed interventions; its literary culture was one of socialist politics, borderlands, ports and industrial ruins.[8] There was also, though, a culture fascinated by the decline of aristocracy and the symbolism of the country estate, interested in the future of village churches, and drawn to the Romantic tradition in the arts. A list of the historicist strands in 1930s culture makes the period sound like one of the pageants which appear in its literature: medievalism, Georgianism, baroque, rococo, Romanticism, Victorianism. Some of these movements involved little more than a weekend with the dressing-up box, but often they entailed sustained commitment to distinct aesthetic values, ways of living, and ways of looking at England.

Candida Lycett Green recalls that her father, John Betjeman, and his friend Piper were widely thought to have 'betrayed the modern movement with their liking of the provinces, of old churches and tea-shops'.[9] The charge is understandable. This was a time for taking sides, for issuing manifestos and keeping one's word. The battles for modern art and modern society were being fought in Paris and in Spain. What were Betjeman and Piper doing in Norfolk? It is not always clear whether conservatism of this kind was a retreat from contemporary affairs or a particular kind of locally oriented engagement. The question is a complex one and any answer is subjective. Was it a betrayal of the modern movement to be in love with old churches and tea-shops; was this a case of *giving up* and going home? Is Auden any less a 'modern' thinker because he wept with nostalgia while writing a devoted introduction to a selection of Betjeman's prose?[10] At any rate, the 'traitors' were not alone. And what can be read as a sign of retreat can also, perhaps, be read as an expression

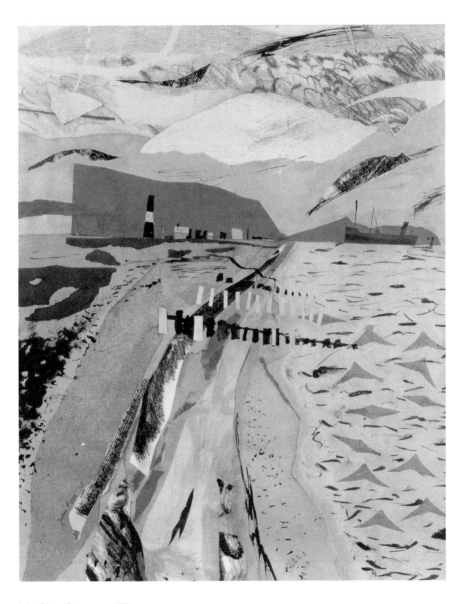

John Piper *Dungeness*, 1938

of responsibility – towards places, people and histories too valuable and too vulnerable to go missing from art.

Romantic Moderns is not a survey or a guidebook to the period. It leaves out a great deal that has been emphasized elsewhere, offering only a series of glimpses that might enrich the larger picture.[11] The 'Romantic' of my title is meant loosely and inclusively, as Piper uses it in *British Romantic Artists*. 'Romantic art deals with the particular' he says, and it is this particularity that I have wanted to explore.[12] Above all, this is a book about art and place. Its protagonists are always out looking at England and they invite us to follow in their tracks. They are pilgrims in their own country, going home to 'see Stonage'. The poet Edmund Blunden wrote an article about this in 1942, in a dark period of the war. He celebrated the 'strong desire to see something of our own country' that had been characteristic of the last few years. He noted the investigations into rural ways and village crafts, the revival of interest in Chaucer and in the author of *Piers Plowman*, and the 'fresh view' of native painting. Historians and artists, writers and readers, he said, had collectively gone in search of 'shrines which conceivably stand for the country we are now fighting for'. They were taking possession of the particular and local. And, like Chaucer, they were collecting stories along the way. Blunden gave his essay an appropriate title: 'On Pilgrimage in England'.[13]

1

ANCIENT
and MODERN

Photographs of the 'Abstract and Concrete' exhibition, which was the first showing in England of international abstract art, allow us to enter the world of the avant-garde as it was in February 1936. We are in Oxford. Outside, there is all the usual crush of bicycles, books, gargoyles and ancient stones. Inside at 41 St Giles, things are different. Exquisitely factured constructions by Naum Gabo occupy sober white plinths; wire mobiles by Alexander Calder are suspended expectantly in mid-air, casting slow-moving shadows around the walls. Piet Mondrian's grid compositions hold us in precarious equilibrium, distilling time and space down to the bare inter-section of lines. This may seem a strange starting point for an English pilgrimage, but it was from this silent, emptied-out space that the journey home began – or, at least, this is where it began for a distinctive group of experimental antiquarians, including John Piper, Myfanwy Evans and Nicolete Gray. They were excited and inspired by the whiteness, but they would become increasingly conscious of how much it seemed to be leaving out. With their wide interests and irrepressible love of the English landscape, these like-minded friends would go in search of a newly anglicised modern art.

The lure of abstraction in 1936, however, was extremely strong. The cata-logue for the Oxford exhibition was a special number of *Axis*, England's most adventurous art magazine. With its gleaming white pages and large reproductions, the magazine, edited by Myfanwy Evans, was in its second successful year. *Axis* provided a forum for the abstract work that was now the cause of much debate. Though Evans admired each painting for itself and 'not as an act of faith', she was sympathetic to the rapturous utopianism that lay behind the work of purist artists:

> There is in their whole attitude to painting and sculpture a passionate belief
> in the power for good of pure abstract work. Pure colours, brilliant contrasts
> or the delicate clarity of one pale line against another, the absence of human
> and earthly associations, all mean to them a positive step to perfection.[1]

These ideas of purity and abstinence dominated the language of European painting in the 1930s. In fact they were part of a whole modern fantasy of cleanliness.

Modernism asked whether the artist could engineer a tidier world. Could white paint restore our disorderly species to a state of primal clarity? The experiment got underway in revolutionary Russia, where the Suprematists painted white on white. Then, after the Great War, there was the corrosive dirt of the trenches to be washed away. By the 1920s the whiteness was entering people's homes. Le Corbusier issued strict instructions for purified living: 'Every citizen', he wrote, 'is required to replace his hangings, his damask, his wall-papers, his stencils, with a plain coat of white ripolin. His home is made clean.' This was not merely a case of bold interior decoration but an act of spiritual cleansing, as Le Corbusier explained: 'There are no more dirty, dark corners. Everything is shown as it is. Then comes *inner* cleanness'.[2]

There was little distinction between the living space and the work of art. Both must be emptied and purified. In Paris, Mondrian whitewashed his apartment in the hope of erasing tell-tale signs of his individuality. Again, this was no ordinary process of spring-cleaning: Mondrian pitted his whiteness against the outside world's colourful profusion by displaying in his hallway a single artificial tulip, whitewashed, in a vase. It was a serious joke, a showdown between the painter's urge to unify and nature's determination to fly unruly colours of its own.[3] Mondrian did allow some colour in his paintings, but only when contained by the grid system with which he kept his canvases in check. His grids promised a glimpse of a transcendent hidden order; the paraphernalia of daily life was rejected as unwanted distraction from the concentrated inner journey that Mondrian prescribed.

This philosophy crossed the Channel: in British art galleries the new orderliness reigned supreme. The Seven and Five Society (founded in 1919 by seven painters and five sculptors) decided in 1935 that everything in its annual exhibition should be abstract. Still lives and views through windows were no longer acceptable, and members who clung to figuration were unceremoniously asked to leave. Even the group's name was shorn of any suspicious literariness, and sleekly rebranded '7 & 5'. The most prominent young artists in Britain belonged to the 7 & 5. Ben Nicholson, the president, was now producing his white reliefs, carving geometric forms in wood and painting them over with a unifying coat of white. Barbara Hepworth was piercing through sculpted forms. John Piper was making taut constructions and collages of vertical shapes.

This art of purity was messy to make. When Eileen Holding took to constructivism, Piper bemoaned the 'awful consequences of sawings, chisellings, stacks of wood' all over their cottage in Betchworth. There was not much room for all this creative expansion, and for his part he tried to confine himself to 'a little perforated zinc and dainty pots of enamel'.[4] But in the silence of the gallery, with sawdust swept

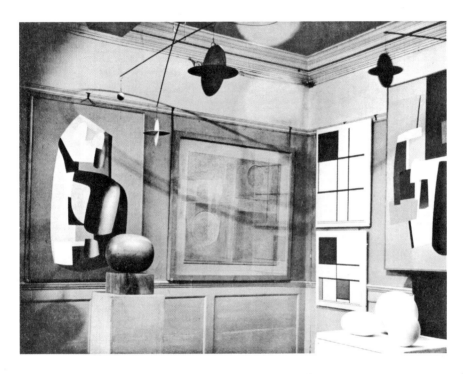

Installation photograph of the 'Abstract and Concrete' exhibition, Oxford, 1936

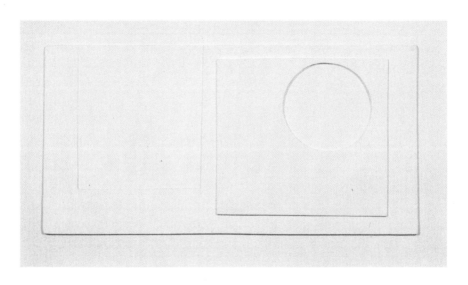

Ben Nicholson *1934 (White Relief, Circle & Square)*, 1934

away, these constructions functioned as antidotes to mess. They announced a newly weightless, untethered existence. In declining to represent anything, abstract art could claim freedom from everything. In this immaculate world there were no armies or class systems, no margins or centre. Its advocates championed an aesthetic liberty that stood for social liberty.

This was the climate in which Evans decided to launch *Axis*. The inspiration came largely from the Parisian painter Jean Hélion, one of the central figures in the Association Abstraction-Création. This was now the largest exhibiting group in Europe for abstract artists, and it published an annual journal of its work. When Hélion suggested that an English counterpart to *Abstraction-Création* might be possible, Evans responded not just with a magazine for English ideas, but with a publication that was truly international. Not having any formal art training, she wondered whether she was qualified; was an English degree (special subject: seventeenth century) and an addiction to galleries enough? With instructions from Piper about who to see, she went to visit French artists in their studios. She commissioned articles from Kandinsky, Léger, César Domela, and from Hélion himself, and published them alongside pieces by English critics like Herbert Read and H. S. Ede, the collector who had already accumulated much of the art that would find its permanent home at Kettle's Yard. The epicentre of all this activity was an unlikely place. In early 1935 Evans and Piper made their home together at Fawley Bottom, a remote, flint-walled farmhouse on the Oxfordshire–Buckinghamshire border. There was no heating, no running water, and no electricity. In the photographs everyone is wearing very thick jumpers. But there, on the kitchen table, avant-garde writing and images converged from all over Europe.[5]

The history of English abstraction, and of the English orientation towards France, was rooted in the work of the Bloomsbury critics Roger Fry and Clive Bell. The Post-Impressionist exhibitions of 1910 and 1912 had introduced modern French painting to England with extraordinary results. Gauguin's Tahitians and Matisse's dancing nudes caused a sensation: duchesses fainted in horror, artists were seized with delight. The charges of debauchery brought an atmosphere of illicit discovery to the arguments that Fry made steadily and confidently all through the hiatus, and which – had the offended parties only believed him – emptied the paintings of sexual provocation by detaching them completely from the human bodies they represented. Fry introduced a more platonic but no less sensual way of looking at these pictures. They were forms, he said (again and again), pure forms.

Fry's lexicon of purity and 'significant form' remained part of the language of the 1920s and 30s; it can still be heard in *Axis*. Ideas emanating from Bloomsbury were refined or rejected but impossible to ignore. Once you had read Roger Fry there was no way back. Here he is, explaining in the 1912 exhibition catalogue the absolute divide between art and 'ordinary life':

All art depends upon cutting off the practical responses to sensations of ordinary life, thereby setting free a pure and as it were disembodied functioning of the spirit; but in so far as the artist relies on the associated ideas of the objects which he represents, his work is not completely free and pure, since romantic associations imply at least an imagined practical activity. The disadvantage of such an art of associated ideas is that its effect really depends on what we bring with us: it adds no entirely new factor to our experience. Consequently, when the first shock of wonder or delight is exhausted the work produces an ever lessening reaction. Classic art, on the other hand, records a positive and disinterestedly passionate state of mind.[6]

It is an astonishing assertion of the extreme formalist position. To cross over into the world of aesthetic experience is to leave everything from life behind. Like a traveller stripped of his belongings as he crosses a border, Fry's ideal painters and viewers enter the new country as children, without practical anxieties and without the luggage of worldly experience. Much of the art on show at the 'Abstract and Concrete' exhibition in 1936 followed Fry in bidding goodbye to its 'earthly associations'.

The strong line of inheritance is not surprising. Fry worked tirelessly to publicize his ideals, and scores of young artists emerged with a sense that the painter must empty his mind of narratives and 'associated ideas'. They followed the lead of Bloomsbury by immersing themselves in the play of colours and shapes on the canvas, drawing attention to the act of pure painting. *Vision and Design* (1920), Fry's collection of his most radical essays, became, for many, the pattern-book of a new aesthetic; Ivon Hitchens, for example, recalled that Bell's *Art* became his 'Bible'.[7] The interest in France and in formalist thinking propounded by Fry and Bell took English artists in new directions, away from the sensual paint pots of Bloomsbury and into more austere, placeless realms. What remained constant was the idea of a fundamental split between art and life, insulating pictures from contamination by objects, places, people, pasts. This is why sounds from the street outside do not reach through into the exhibition room at 41 St Giles. The art inside creates its own world. Circles fly, squares float, curving planes embrace each other. The 'history of art in the thirties', as it was written by Myfanwy Evans in the mid-1960s, told the story of 'the gradual penetration of white, of black, of the primary colours, of sailing shapes'.[8]

There is, however, another 'history of art in the thirties', one in which spaces are increasingly filled, not with sailing shapes, but with objects of all descriptions, luring art away from abstraction. This other history is told in *Axis* too.[9] From its very first

issue, the magazine left room for dissent. Although articles regularly gave the impression of being manifestos, arranged in blocks of bold print noisy with imperatives, their contents were less decisive than their presentation. Evans used her first editorial to explain the doubts that led her to put wary inverted commas around the word 'abstract' in her title: *Axis: A Quarterly Review of Contemporary 'Abstract' Painting and Sculpture*. Abstraction was too vague a term, she thought, and too often used to excuse derivative art: 'It suggests certain limits rather than defines them'.[10] And she resisted all forms of categorization that might trap artists in stagnant, labelled boxes, decreeing certain kinds of behaviour.

Some of Evans's contributors had other serious doubts to raise. Paul Nash occupied a double spread in the first issue to explain why he was 'For, but Not With' the abstract painters, able to appreciate the 'immaculate monotony' of *Abstraction-Création*, but ultimately more satisfied by nature: by stones and leaves, trees and waves.[11] His was an influential voice. Nash was a respected father of modern English art, a man who had painted the devastated landscapes of the trenches, and whose post-war work, always haunted by death, had taken him in search of more affirmative places and strange, hidden harmonies between natural forms. He was always attentive to the shape of a sinewy tree or a humped burial mound, but the shapes alone were not enough. He wanted the place and the history of these things, and their human associations most of all.

Nash had been interested for some time in the national identity of modern art and regretful that it seemed so hard to be a modernist while still working in a native tradition. He posed the problem in 1932:

Whether it is possible to 'go modern' and still 'be British' is a question vexing quite a few people today [...] The battle lines have been drawn up: internationalism versus an indigenous culture; renovation versus conservatism; the industrial versus the pastoral; the functional versus the futile.[12]

Nash did not want his art to be severed by these battle lines and his work of the 1930s constitutes a series of brilliant peace-making interventions. When he wrote his contribution for the first issue of *Axis* in 1935, Nash was exploring the coastline of Dorset, where the cliffs were studded with fossils, and where the chalk paths winding across the grassy downland above looked like mysterious engravings on the land. His mind was full of ancient landscapes, but he was fascinated too by the formal experiments of his contemporaries. He considered the situation in his 1935 painting *Equivalents for the Megaliths*, which calculates the relationship between landscape and abstraction as if it were an infinitely complex mathematical equation. His painterly equivalents for the megaliths – based on the stones at Avebury – are

hefty geometric forms: a gridded screen, standing and lying cylinders, and a steel-grey girder that is and is not a lintel stone, all assembled in a cornfield. 'Equivalents' is a word that Fry often used to explain the goal of non-representational art, arguing that instead of mimicking the world the picture must be allowed to make its own, equivalent, reality. Nash's painting, which is at once mysterious and precise, broodingly ancient and clear-sightedly contemporary, makes use of abstraction to revitalize those strange shapes in the landscape.

Would abstraction stay pure, or would it go and plant itself in cornfields? Geoffrey Grigson, poet, critic and fierce controversialist, was characteristically decisive in his own contribution to *Axis*. If it kept to a rarefied course, abstraction would lead, he thought, not to all-encompassing Everywhere, but to nihilistic Nowhere. He warned against running off 'to nowhere through the dry spaces of infinity'.[13] Haunted by the political crises of Europe, Grigson was thinking intently about what was needed from an artist in the 1930s. He knew what he needed for himself, as he recalled in his memoir: 'I wanted comfort out of the arts and found myself writing that "Abstract art is not for the wanting in head and heart"'. In *Axis* he argued candidly that abstraction yielded nothing and was leading nowhere. He made the disturbing prediction that the logical extension of *Abstraction-Création* would be 'the suppression of art by ideal death'.[14]

Over the next few years a growing number of artists worried that they might be heading for this abstract oblivion. Ivon Hitchens was among them. A painter ten years older than Piper, and an original member of the Seven and Five Society, Hitchens struck his friends as a reserved, rather sombre man, wary of joining in too much and preferring to watch things from a contemplative distance. He was serious about abstraction, and serious about giving it up. In 1936 he was working on constructions like *Triangle to Beyond* and he contributed some sensitive line drawings to *Axis*.[15] Though his abstracts often started with a view or a pot of geraniums, he was interested in emptying his work of specifics so that it might gesture to infinity. Yet by 1938 he had embarked on a wholesale return to nature. Painting excursions from London took him to the South Downs, where damp earth, bracken and heather became bright sweeps of green, brown and purple on panoramic canvases, and the silver shoots of birch trees became rapid strokes of white, orchestrating foreground and distance. The following year he found that six acres of land were for sale on Lavington Common and by chance he was offered an old gypsy caravan at the same time. Two cart horses towed the caravan into his chosen position and Hitchens's new studio was established. Immersing himself in this Sussex countryside, and moving there permanently when a bomb hit his London studio in 1940, Hitchens conjured the smell, the light, the rising moisture of woodlands and heaths.

It was difficult to keep nature out. Even the people in Jean Hélion's paintings were no longer assortments of smooth plastic mouldings but wore hats and smoked

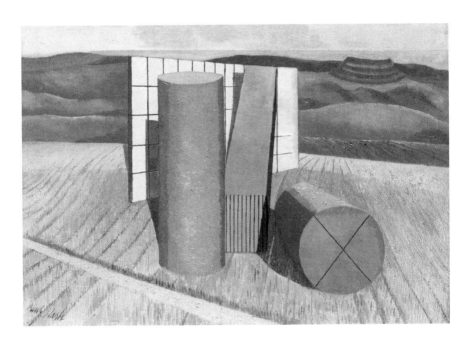

Paul Nash *Equivalents for the Megaliths*, 1935

Ivon Hitchens *Triangle to Beyond*, 1936

cigarettes. A fallen leaf in *Au cycliste* (1939) lies on the pavement with a particular self-consciousness, as if aware of itself as a dangerous incursion from the natural world, trespassing on a purist canvas. Hélion was ready for the trespass, as were other artists in France and across Europe. This was not only an English story, though in England it took a particular course.[16] Hélion, in Paris, feeling for sources of French identity, was beginning to think that 'the search for concentration, unification, has led to a diminution of the field of sight'. By the end of the decade he would become aware of 'an abstract system cracking at the seams and life budding mysteriously through it'.[17] Crowded with mixed metaphors, his language, like his painting, had arrived at bursting point, suggestive of a cracking egg or a budding plant, or a seamed bag no longer sealed.

The limitations of abstraction were becoming clear to Hélion, and they were certainly troubling Piper. In an article about him in *Axis 4*, the critic Hugh Gordon Porteus discussed abstract art 'as a game simply, or as a discipline', arguing that although Piper played the game masterfully, the mind 'hungers after other satisfactions before these ascetic productions'. This was not quite fair since Piper's abstracts are hardly ascetic. They have a witty, almost circus-like jollity; semi-circles and pinstripes consider each other, while dotted lines tease the eye into finding recessions and open doors. Still, Piper was, according to Porteus, being hampered rather than liberated by the abstemious creed to which he had subscribed. He achieved a certain 'magic' not because of, but in spite of, 'pure form'.[18]

Piper is so well-known today for his romantic vision of churches and country houses that it can be difficult to imagine him as a leader of the abstract movement. His abstraction, however, always fed his other interests. Though he persisted with his 'still-too-purified' forms all through 1936 and 1937, these paintings and constructions were certainly not free from 'associated ideas'.[19] They pointed outward to the simplified shapes of seaside architecture, and to the stratified layers of the land itself. Like Nash's efforts to cross the 'battle lines' of modern culture, Piper's work from now on would be all about making connections.

Landscape was not the antithesis but the ally of abstraction, especially when seen from a cockpit. This was the conciliatory message of Piper's contribution to *Axis 8* in late 1937, an article called 'Prehistory from the Air'. Piper had been studying the aerial photographs taken by his archaeologist friend O. G. S. Crawford, and marvelling at the new version of England they revealed. He had not seen it for himself, and in fact he would never go up in a plane. But as he looked at Crawford's pictures, Piper could see that they heralded a whole new kind of art. Big hills were now flat shapes. There was no vanishing point, and no horizon. Immediately grasping the significance of these new vantage points, Piper constructed a whole history of painting in

terms of the horizon line. The Renaissance painter recorded his view from one position, with a stable horizon before him; the rules of perspective were established and kept the world in order. But with the advent of aerial photography, Piper argued, there is no longer a right way up, a foreground and a distance. Gravity does not exert its homeward pull. There are no axes around which to organize things and the visible world is let loose to fill the field of vision.[20]

Piper juxtaposed three images to illustrate his point. The first was an engraving of the prehistoric mound at Silbury, the work of the eighteenth-century antiquary William Stukeley. The vantage point is firmly earthbound, and the hill rises large and solid in front of us. From the air Silbury is a different matter. Piper reproduces Crawford's photograph of the area, showing how all the bulkiness of the hill is lost. Next comes a painting by Joan Miró in which lines intersect with an orange disc on a blue ground. This is a long leap from Wiltshire into the world of a famously obscure Catalonian modernist. But with Piper the leap is easily made. He asks us to see that Miró's canvas, written over in its occult sign language, is analogous to a landscape seen from above, with its intersecting roadways, mounds and barrows. The European avant-garde, he was suggesting, could help the English see England in absorbing new ways.

This association between aerial vantage points and abstraction was not a new one. Horizons had begun to disappear in the late nineteenth century, as the critic Kirk Varnedoe has demonstrated. Caillebotte and Pissarro looked down from high windows onto Parisian streets and produced 'a "float" of shapes in the field of view'.[21] In the twentieth century, artists aimed higher than the top-floor windows. Picasso and Braque studied the world from all angles, so they were justified in calling each other Wilbur and Orville after the Wright Brothers, Cubists playing at taking flight. By 1915 Malevich was painting *Suprematist Composition: Aeroplane Flying* and (a decade before Piper) he reproduced aerial photographs in his 1927 book *The Non-Objective World*. For Gertrude Stein, Cubism was a form of flight and vice versa. She looked down from an aeroplane to see 'on the earth the mingling lines of Picasso, coming and going, developing and destroying themselves', busily denying their own solidity.[22] Back in England, it was not only Piper who had his eyes on the air. Asthmatically precluded from actually taking off, Paul Nash made his painting a substitute for learning to fly: 'Once the traditional picture plan was abandoned in favour of flying in space [...] I was airborne', he remembered, 'I could never be frightened by the laws of gravity again'.[23]

Piper's contribution to this high altitude history was to demonstrate that the earth from the air was not a rationalized system of relating shapes, but a complex network of field boundaries, green lanes and lost villages. As the historian Kitty Hauser explains in her brilliant study of photography and 'the archaeological imagination', the aerial view revealed the shadows of ancient settlements: secrets from

Ivon Hitchens *The Caravan, Greensleeves*, c. 1941

Jean Hélion *Au cycliste*, 1939

the past that could only be seen from the sky.[24] Piper looked at Ordnance Survey photographs as fine art: those of Wessex were, he thought, 'among the most beautiful photographs ever taken'.[25]

He cannot have viewed them with unalloyed pastoral pleasure. The aerial view was already the view of the bombing pilot, which is why, since 1930, Auden had been insistently and prophetically imagining Europe 'as the hawk sees it or the helmeted airman'.[26] In the spring of 1937 Luftwaffe planes flew over the Basque region, located the small town of Guernica, and dropped their catastrophic cargo. But aerial cartography, which would have such a large part to play in the logistics of war, also had a role in revealing the land that would be fought for. The camera's x-ray-like vision exposed the deposits of millennia scattered over the earth, all now risen to the surface and meeting the picture plane. Piper's fascination went into his collage *Archaeological Wiltshire* (1936–37), in which torn papers are built up to represent barrows, monoliths and plains. The process of collage becomes an archaeological dig in reverse as the geological strata are built up, glued together and inked over. Piper observes Silbury Hill as if from the air and the series of fields arrange themselves as if we were seeing a cross-section through the earth.

The May-to-December marriage of futurist flight with ancient archaeology was perfect subject-matter for *Axis* because its contributors were just as interested in their various antiquarian pursuits as in abstract art. It was also apt that the 'Abstract and Concrete' exhibition should have been organized by a medievalist. The woman who brought together examples of work by the foremost European constructivists was Nicolete Gray, a friend of Myfanwy Evans from the Oxford Arts Club, who had only recently completed her degree in medieval archaeology. She was the daughter of Laurence Binyon (remembered mostly as a war poet, but also the curator of Oriental art at the British Museum and an authority on early English watercolours), and she married her father's assistant at the museum, Basil Gray. Together they spent much of the mid-1930s writing a history of English printing. Nicolete published her own book in 1938. *XIXth-century Ornamented Types and Title Pages*, which is still widely used by students of lettering, was a work of typographical salvage, rescuing from oblivion the vernacular styles of Victorian pub signs and shop fronts as well as the more respectable bookish forms. It took courage to advocate such mixed tastes in the polarized art world of the 1930s. But Gray found ways to reconcile the values of abstraction with the decorative impulse of nineteenth-century design.

While Gray collected the exuberant fonts used by Victorian printers, John Piper and Myfanwy Evans were touring England in search of larger fonts in country churches, making their ground-breaking photographic survey of early sculpture: Rowlstone, Kilpeck, Codford St Peter, Toller Fratrum. Their response to modern art was coloured by the brilliant hues of medieval stained-glass windows and the bold

lines of early carvings. For a 1936 photograph Piper did some explicit bringing together. In a corner of his studio he arranged abstract canvases in among his water-colours of medieval glass, testing their companionship across seven centuries.

Piper did much of his exploring in the company of Geoffrey Grigson. When they came to know each other in 1935, Grigson's influential magazine *New Verse* had been running for three years and was an established outlet for 'Auden & Co.'. Grigson championed these contemporary poets for their commitment to physical, concrete *things*, and, as he stated in *Axis*, he was suspicious of abstraction. Like Nash, he came down firmly on the side of 'stones and leaves', filling his own poetry with the careful observation of the botanist and the topographer. In his first volume of verse he is magnetized by such 'oddments' as:

a white lupin planted

By a shed, a white horse
By a wood, the brown, the green
And off-white of the matt-surface

Of the downs.[27]

These are back-garden glimpses which are also icons; the white horse cannot help being connected with the monumental chalk horses of the Downs. There is an abstract picture in the orchestration of texture and colour (white against off-white), but also the domestic distinctness of the lupin and the shed. Realizing their shared interests, Piper and Grigson quickly became allies. Looking back on their friendship of the 1930s, Grigson described the growth and fading of a love affair. Having lost the brother with whom he explored the Cornish villages of his childhood, being with John Piper was like 'peacefully living again in a second family of two'. They shared a passion for guidebooks ('at least the Victorian ones by parsons and scholars and anti-quaries') and for 'singing hymns ancient and modern'.[28] Ancient and modern (but more modern than the Anglican hymnbook) is exactly what they were both trying to be in their writing, painting and tastes.

Piper and Grigson conducted a public discussion in *Axis*, under the heading 'England's Climate' and with a preface from William Blake:

Spirit, who lov'st Britannia's Isle
Round which the fiends of commerce smile...[29]

John Piper *Painting*, 1935

Silbury Hill, Avebury, Wiltshire. (Top) After Wm. Stukeley, 1723. (Bottom) Air photo (Crown copyright reserved). Opposite : Painting by JOAN MIRO

John Piper 'Prehistory from the Air', *Axis* 8, 1937

It was a strange epigraph to find in a cosmopolitan journal, envisaging as it does a self-contained island hedged around by enemies. For any reader who knew the source of the quotation it did more than herald a change of tack: it was a rallying cry for a new British art. Blake's poem 'Now Art has Lost its Mental Charms' imagines an angel speaking to the poet at birth and sending him to 'Renew the arts on Britain's shore' so that 'France shall fall down and adore'.[30] There was much to be done if French painters were going to fall down in admiration of the English. The first task was to determine how renewal might be achieved. 'Any Constable, any Blake, any Turner has something an abstract or a surrealist painting cannot have,' wrote Piper, 'the point is fullness, completeness.' He looked back through the English tradition for examples of art that contained something of 'life itself', arguing that a Shoreham barn painted by Samuel Palmer in the 1820s, 'fixes the whole passion of his age', and that 'Turner's medium, or Girtin's was a gay medium compared with ours'.[31]

The title 'England's Climate' gave a good indication of where Piper would go in search of 'life' and 'gaiety': he would take his painting out of doors, into the wind and rain. He took with him Thomas Girtin's medium – watercolour and paper – and he made a series of rough, energetic collages of English landscapes and coastlines. Already in 1933–34 he had been building cliffs out of newspaper and using doilies as curtains to frame harbour views. In 1936, with the simplicity of geometric construction in mind, Piper returned to the seaside. From Fawley Bottom he set off for the exposed shingle of Dungeness, Newhaven Harbour, the big flat beach at Seaford where the South Downs meet the sea, the lighthouses and shimmering grey stone of Portland Bill.

He found in these places a means of combining the clarity and form of his abstract paintings with his love of details and oddities. His English coast is structured by minimal, stark shapes, but there is also plenty to entertain the eye. Piper's use of mixed media – gouache and ink, blotting paper, scraps of over-printed manuscript – echoes the accumulation of shoreline detritus that so fascinated him. In *Breakwaters at Seaford* (1937) he tears and sticks his paper, leaving raw edges exposed and a sense of the January wind having snatched at the scraps, of 'England's climate' having played its part. With calligraphic sketchiness he inks in jetties and waves, and conjures a row of beach huts from a zig-zagging strip of paper. Paul Nash referred to the style admiringly as 'paper arabesque'.[32] The fleshy pinks and eggshell blues evoke the tinted grounds used by eighteenth-century watercolourists, and they recall a description given by Nash in 1934 of the 'bright delicacy' in colouring that has distinguished centuries of English artists: 'somewhat cold, but radiant and sharp in key'.[33]

While he sat on English beaches Piper paid homage to France, observing that the lettering on the side of a boat might catch the eye 'like "Le Journal" in a

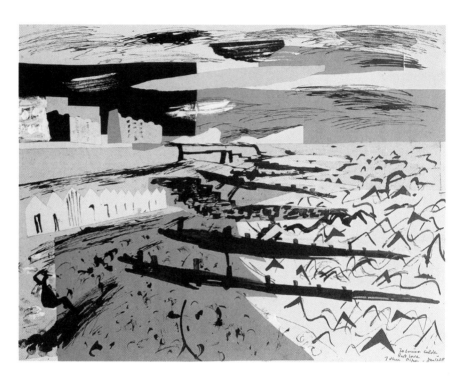

John Piper *Breakwaters at Seaford*, 1937

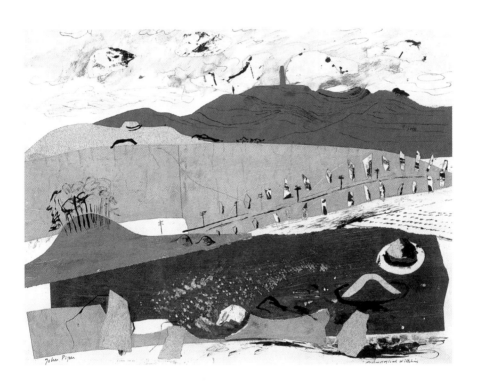

John Piper *Archaeological Wiltshire*, 1936–37

Picasso still-life'.[34] His collages owe much to the Cubist practice of *papier-collé*, and from the first his nautical scenes had been inspired by Braque. But the shared techniques underline their differences in approach. Where Braque and Picasso made their collages indoors, arranging wallpapers and veneers with infinite deliberation to signify tables, bottles, and guitars, Piper sat outside with a board on his knees, opening his work to nature and to chance. Confirming his cross-Channel loyalties, he contributed to the new French journal *XXe Siècle*, but his article was about the British coastline, suggesting what inspiration artists might find in the 'continuous line that girdles England'.[35]

It was in this coastal essay, called 'Abstraction on the Beach', that Piper expressed the controversial view he had been forming for some time. 'Abstraction is a luxury', he said simply, and in those few words he challenged the left-leaning politics of the whole abstract movement. As he tried to determine his position in relation to his contemporaries, he thought about the large, expressive faces in the early stone carvings he had been photographing. The men who carved those faces had not been so decadent as to make pure art:

> The early Christian sculptors, wall-painters and glass-painters
> had a sensible attitude towards abstraction. However hard one tries
> (many attempts have been made to make them toe the line with
> modern art) one cannot catch them out indulging in pure abstraction.
> Their abstraction, such as it is, is always subservient to an end –
> the Christian end, as it happened.[36]

Thinking of those sculptors who were servants to a larger cause than art itself, and whose work was intended to speak to ordinary people in ways that the new abstraction, it seemed, could not, Piper determined to renew the connection between art and life. If it was not a sacred art that was needed now, at least he might make art that found some sanctity in ordinary, local things. He looked around him, there on the beach, and described a Bartholomew Fair assortment of coastal ephemera: 'waterlogged sand shoes, banana skins, starfish, cuttle fish, dead seagulls, sides of boxes with THIS SIDE UP on them'. These bits and pieces offered a feast for the eye after a long spell of fasting. 'Pure abstraction is undernourished', he wrote, 'it should at least be allowed to feed on a bare beach with tins and broken bottles'.[37]

The new English art was to be allowed a far more varied diet than that. In an essay called 'Lost, A Valuable Object' (as if it were an advertisement placed in the columns of a local paper), Piper advocated a return to representation, to what he called with beguiling simplicity 'the tree in the field'. When he described some of the objects occupying his own imagination, however, they were fantastic agglomerations of ideas, including a 'beach engine' replete with poles and theatrical flats,

'symbolic of the machine-age but with tassels belonging to old-fashioned door-bells'.[38] A machine age with old-fashioned doorbells: it was an unusually elastic idea of modernity, but by the late 1930s it could claim a great deal of support.

2

CONCRETE
and CURLICUES

Not that everyone was thinking in terms of tassels, of course. The voice of purism was still much in evidence and the campaign for simple, rationalized living spaces was supported in England by the influential 1937 publication *Circle*, which brought together the country's major exponents of the constructivist point of view. Ben Nicholson, disapproving of Piper's eclecticism, became one of the editors, along with the architect Leslie Martin and the sculptor Naum Gabo. Contributors included Barbara Hepworth and Henry Moore. Like *Axis*, the title was purposefully geometric, and the perfect circle was a fitting symbol for the designs promoted inside. The tone was one of high seriousness; this art had a strong spiritual element and was close to a religion. Hélion remarked that there was 'something of the convent', about Ben Nicholson, and *Circle* was accordingly a book of ritualized silences, with a disciplined, contemplative approach.[1] Every page has an air of beginning again; it is a *tabula rasa* on which a better world might be built. And ideas about building were at the heart of the book, since the constructive approach was not just a way of painting but a way of living.

The constructivist philosophy was eloquently expressed in the Lawn Road Flats in Hampstead, London (also known as the Isokon Building), designed by Wells Coates in collaboration with the engineer Jack Pritchard. The building comprised a series of thirty-two efficient units, each just large enough for a single occupant or a couple. These were visionary statements of the potential for independence in the twentieth century: to live here you did not need (and could not have) a family or a mass of inherited furniture. The building was a vote of confidence in the unattached man and – radically – the single woman. But it was uncompromisingly censorious of those small, very human processes by which individuals carve out their space. Personal touches of interior decoration were not an option: all furniture and fittings were supplied, designed by Marcel Breuer and others as part of an integrated scheme. And because there were no odd ledges for the accumulation of knick-knacks, there was little danger of these pristine spaces being ornamented by their inhabitants.

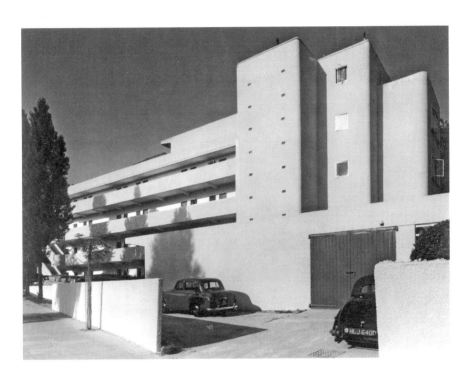

The Lawn Road Flats, Hampstead, designed by Wells Coates and built 1933–34

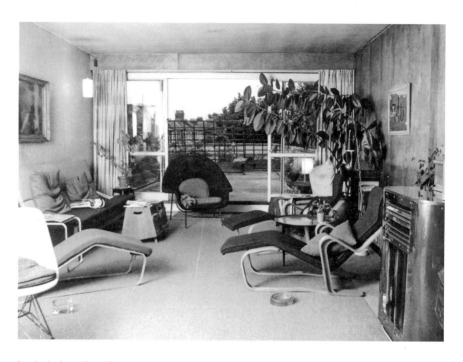

Inside the Lawn Road Flats, Hampstead, rooms not suited to clutter, c. 1950

Coates suggested that tenants might like to bring a vase, but anything more would be out of place.

The son of Methodist missionaries, Coates associated the spiritual life with freedom of movement and clarity of space. So the vow of abstinence he required from those moving to Lawn Road was also a version of that familiar cry of liberty issued by Le Corbusier and Myfanwy Evans. 'We get rid of our belongings', Coates wrote ecstatically in 1938, 'and make for a new, an exciting freedom'.[2] For a generation that had grown up in tightly furnished family rooms, these new spaces must indeed have felt revolutionary.

The Isokon lifestyle was not in fact very spartan at all (there was a glamorous in-house bar called the Isobar and a resident chef for when the cramped fitted kitchens did not appeal). But Coates's basic philosophy of communal living pared down to essentials was written into the design. And he had plenty of takers. The Lawn Road Flats became one of the headquarters of the British avant-garde, with Walter Gropius, László Moholy-Nagy and Marcel Breuer all renting apartments. Herbert Read christened this his 'nest of gentle artists', but the phrase was oddly inappropriate, perhaps ironic.[3] Nesting was not high on the agenda, and gentleness was not the most obvious characteristic of the art produced here. Wells Coates conceived modern man as an unfettered traveller, a universal citizen who knew no boundaries. His building purposely resembled an ocean-liner, as if it might leave its Hampstead moorings at any time and sail off to see the world. The 'cells' were also cabins, with folding wall-mounted tables and little sun-catching balconies. Agatha Christie, who lived at number 22 from 1940 to 1946, suggested that there ought to be a couple of funnels to complete the effect.[4] She liked the idea of an ocean-going apartment block. Perhaps, like the Nile steamer and the Orient Express, it struck her as a place of many secrets which pretended to have nothing to hide.

The Lawn Road Flats succeeded in banishing the decorated, possession-packed Victorian interior, and in doing so took their place in a distinguished line of clutter-free modern buildings. For Wells Coates, as for his minimal predecessors, the morality of modern man was at stake. Back in 1908 in Vienna, the most decorated city in Europe, the architect Adolf Loos had denounced twiddles and curlicues as the symptoms of moral degeneration. The bejewelled façades and trinkets, which proliferated in the capital of fin-de-siècle style, looked, to his eyes, extremely suspicious. Why cover things up unless there is something to be ashamed of? In a lecture called 'Ornament and Crime' Loos argued that the value placed on surface decoration was allowing a whole society to go rotten at the core. Decoration, he suggested, encouraged vices by concealing them; ornament was the beguiling accomplice of the century's many crimes.[5]

Among English critics it was Roger Fry who was most damning of the twiddles. He hated to see mass-produced decoration. Sitting in a railway station café one day in 1912 he surveyed the scene sadly and compiled a 'painful catalogue' of decorative horrors. He does his description with verve:

> On the walls, up to a height of four feet, is a covering of lincrusta walton stamped with a complicated pattern in two colours, with sham silver medallions. Above that a moulding but an inch wide, and yet creeping throughout its whole with a degenerate descendant of a Graeco-Roman carved guilloche pattern [...] Above this is a wallpaper in which an effect of eighteenth-century satin brocade is imitated by shaded staining of the paper. Each of the little refreshment tables has two cloths, one arranged symmetrically with the table, the other a highly ornate printed cotton arranged 'artistically' in a diagonal position.[6]

He continues with the pots and plants and the floral patterns stamped into the seats. It is all, he says, a 'futile display'. It gives no pleasure to the viewer, and it has cost the maker much 'horrible toil'. For Fry this interior summed up everything that could go wrong with aesthetics. It betrayed a culture of oppression, keeping up appearances by adding more and more ornament: an itchy, dissatisfied culture whose decorative efforts looked like 'eczematous eruptions' breaking out over the skin of England.[7]

This rhetoric of guilt and degeneration was a potent force behind the drive to modern cleanliness. In stripping back ornament, man was committing himself to a new openness, a new honesty, a new life of integrity. He would happily expose the material structures of his buildings because they would be so well-crafted; and in his own daily doings there would be nothing to hide in the shelter of fussy alcoves. The builders and furnishers would be happy in their work, because everything they did was purposeful and took its beauty from its usefulness.

But the censoring of ornament – by Loos, by Fry, by the Bauhaus, by Le Corbusier – was bound to provoke a reaction. Most agreed that automatized, industrially produced decoration had its limits, but there were strong arguments for fostering the decorative impulse as a form of expression. At first they came from young aesthetes and dilettantes who wished they were living in a more gilded age. As early as 1924 Sacheverell Sitwell, youngest of the eccentric sibling trio, published a landmark defence of ornament, inspired by his travels through Spain and Italy. *Southern Baroque Art* looked back to the art of the seventeenth and eighteenth centuries, replete with voluptuous façades and all manner of *trompe l'oeil*. Sitwell understood these elaborate visual illusions as a response to an illusory world. 'I know that the subjects of my choice are arraigned, in the earnest tones of the

learned, because they possessed an entirely scenic conception of life', he wrote. This was more a provocation than an apology: 'the camera should have taught us by now how elusive a quarry is realism'.[8] His argument was a strong one (we might now call it postmodern). We should not assume that a photograph tells the truth; nor should we assume that modern man in his open-plan house is in fact baring all. Perhaps, once you stripped away the decoration, you arrived not at a beautiful truth, but rather at another mask. Sitwell devoted himself to the art of façade, making tours of opera houses and stuccoed Venetian halls. He was confident in the hope that baroque would rise again – as a feast for the senses, and as an approach more honest than functionalism to a world in which everything, ultimately, is just another façade.

By the mid-1930s, at least two opposing camps in the ornamentation debate had clearly established themselves: those arguing for the clarifying influence of minimal design and the followers of Sitwell praising curlicues. The baroque took its name from the 'barocca' or flawed pearl, and the very point was its oddness and irregularity, its departure from an abstract idea of perfection. It invoked classical order only to increase the effect of its rebellion. But the English constructivists, working in a classical tradition, dreamt of making the pearl round again, and making their *Circle* whole. Piper's image of the machine age with old fashioned doorbells took inspiration from both sides. Could the modern home answer to the spirit of twentieth-century clarity without banishing the damask altogether? A number of original thinkers were weighing up the possibilities.

Among those developing a particular interest in old-fashioned fixtures and fittings was the young John Betjeman, whose steady stream of articles included surveys of engraved silverware and decorative craftsmanship.[9] He had left Oxford without a degree, done some half-hearted school-teaching and was very much in need of a new direction. He found it, gradually, by writing about architecture and topography. Between 1930 and 1935 he was assistant editor on the *Architectural Review*, a magazine which, like *Axis*, has a story to tell about the newly elastic approaches to modernism. In 1928 Hubert de Cronin Hastings, one of England's earliest converts to formalism, had taken over the editorship of a publication that still looked Edwardian, and made it a mouthpiece for modernist thinkers. This was where the English learned about the latest in European architectural thought. All through the 1930s, however, those large glossy pages with their Bauhaus-inspired designs were peppered with forays into subjects – architectural and miscellaneous – whose contemporary credentials were less immediately apparent.

Though he insisted that his office be decorated in William Morris wallpaper, Betjeman tried at first to be a modernist. He wrote a sympathetic defence of the High and Over House in Amersham, designed by Amyas Connell, one of the first

International Style buildings in Britain. The integrity of the purists seemed to him at least preferable to the faux accretions of jazz modern. He was scathing about 'period taste', copies and façades, and he drew attention to the well-planned interiors of Georgian buildings ('shorn of eccentricities') as a possible model for contemporary design.[10] But his tastes were quickly modified and Betjeman became more tolerant of eccentricities. As Timothy Mowl has put it, 1933 was Betjeman's 'year of facing both ways', admiring the austere perfection of Regency buildings while also investigating varieties of Victorian chandelier.[11] He spent much of his time finding ways to write about the English vernacular while still appearing enthusiastic about International Style. So he promoted C. F. A. Voysey, for example, the arch-inventor of the English suburban home with a period feel, as an under-appreciated pioneer assimilating Arts and Crafts motifs with bare functionalist design.[12] Betjeman has since become synonymous with an idiosyncratic brand of nostalgic conservatism, but to get there he went through a series of complicated negotiations which were not idiosyncratic but characteristic of an age. Betjeman's 'year of facing both ways' exemplified the divided allegiances of a whole Janus-faced decade, looking out on both curlicues and voids.

The *Architectural Review* continued to carry an enticingly mixed bag of ancient and modern, even after Betjeman's departure. His successor was J. M. Richards, who quickly became editor and remained so until 1971. Richards's allegiance to the modern movement and active commitment to left-wing politics was often antipathetic to Betjeman (who privately re christened him Marx), yet there was increasing catholicity even in Richards's approach. The *Architectural Review* in the late 1930s was an open forum where the latest modernist curves could be interleaved with antiquarian revaluations. Nicolete Gray, for example, considered the merits of Victorian chromo lithography, noting the witty combinations of the realistic and the conventional that made Victorian design akin to Surrealism, and reproducing a mid-nineteenth-century 'boudoir almanac'.[13] International Style buildings were intended to counter bad taste of this kind, but English modernists of the *Axis* group refused to see them as utopian worlds in white isolation. New buildings had to function alongside existing buildings; contemporary rooms might contain boudoir almanacs. Richards's own domestic arrangements seemed symbolic: he moved to a Georgian house in Chelsea (on account, he said, of needing more space to house the 60-volume maroon-bound edition of Walter Scott he had just purchased), and looked out from his window at two innovative buildings going up on the other side of the road – one designed by Walter Gropius and the other by Erich Mendelsohn.[14]

Richards moved among a circle of friends for whom architecture, interior design, typography, archaeology and painting were all overlapping parts of a democratically inclusive visual culture. In 1936 he married Peggy Angus, a painter and

designer with a quick temper, Communist convictions ('Red Angus') and a passion for simple country living. At the weekends there would often be visitors at Furlongs, Angus's flint-walled cottage under the South Downs. Eric Ravilious, the most English of watercolourists, might be found in the garden deep in conversation with the émigré constructivist László Moholy-Nagy. Or there might be Nicolete Gray discussing design with Serge Chermayeff, who, in company with Mendelsohn, had designed the white terraces and glassy expanses of the De La Warr Pavilion at Bexhill.[15] These are the kind of meetings that warn us against neat categorizations. If the manifestos of modernism called for programmatic reform, the revival of English art in the 1930s sprang more often from eclectic conversations on long walks and painting trips, or over dinner at Angus's kitchen table.

Some of the conversations took place at Chermayeff's nearby house Bentley Wood where (in the spirit of Drake on Plymouth Hoe) Ravilious remembered playing boule on the lawn one fine evening before the war.[16] Like Furlongs, and like the more famous Charleston (country epicentre of the Bloomsbury Group, just down the road at Firle), Bentley Wood was one of the cultural meeting places of the 1930s. Not everyone was pleased to find a radical architect like Chermayeff setting up home in this quiet country area, particularly when it became clear what sort of a house he wanted to build. The council authorities at first declined permission, understandably alarmed by his plans for a large, geometrical, flat-roofed structure which refused to 'nestle' inconspicuously in the landscape. Even here, however, in what seemed like a piece of modernist architecture at its most uncompromising, the details told another story. Chermayeff won the planners over by arguing that his was to be a timber-framed and weather-boarded house in keeping with the local vernacular. Most of his previous work had exploited the new technical possibilities of concrete, but now he was more interested in wood. His biographer Alan Powers reads the whole design of Bentley Wood as 'part of a romantic turn in modernism'.[17] The age of concrete, it seemed, was passing and a move back to local materials was at hand.

An advanced twentieth-century house might find a place in a very English landscape, and machine-age flats might yet be built with a very ancient door. The architect Berthold Lubetkin made this announcement in a literal fashion by installing draped caryatids, after casts from the Erectheion in Athens, to support the concrete entrance porch of Highpoint II, his 1938 apartment block in Highgate, London. Lubetkin, one of the most subtle and brilliant designers of the twentieth century, was never satisfied with plain functionalism. A witness to the Russian Revolution, he established his socialist principles early, and by the time he arrived in London in 1931 he was firm in his belief that everyone had a right to good design, and that architecture really could change lives. He wanted to use constructivist ideas to make clean, efficient, affordable spaces, but he also wanted to make imaginative

Eric Ravilious *Tea at Furlongs*, 1939

and personal homes. At Highgate he showed the world what he meant. Highpoint II rose grand and white into the sky; windows were configured as grids; the flats inside were efficient and uniform. And yet, on the way in, there was a virtuoso exercise in fake archaeology, partly a symbol of the classical principles underpinning the building, and partly Lubetkin's emphatic statement of his freedom to break the rules. The modern citizen would be welcomed home by a woman from fifth-century BC Greece, and if this joyous burst of figuration interrupted the building's abstract lines then that was a small price to pay.

Some of Lubetkin's stricter modernist contemporaries lamented such an act of treachery on the part of a man whose concrete Penguin Pool at London Zoo (1933–34) pointed its spiralling way into an arctically cool future, and whose design company Tecton represented the brightest hope for International Style in Britain. Lubetkin himself preferred not to be categorized, and defied all expectations by moving to Gloucestershire in 1939 to live in a remote sash-windowed cottage on a farm in Chipping Sodbury. In part this was the retreat of a disappointed man, whose architectural vision was interrupted by war. But it was also a principled decision to experience an older way of life while not losing sight of his urban vision.

While Lubetkin was sketching out plans for Highpoint, Oliver Hill was trying to design a suitable pavilion to represent Britain at the Paris World's Fair of 1937. Hill was a playful, allusive architect, a man of sudden enthusiasms, a lover of silly jokes, sunbathing and nudity. But here was a project to be taken seriously because it was his task to make a single architectural statement on behalf of the nation. The World Fairs were staged in tireless succession all through the 1920s and 1930s (Paris 1925, Chicago 1933, Paris 1937, New York 1939). Each contributing country erected a temporary structure showcasing its most notable people, products, landscapes, inventions. Some countries were in no doubt about the self-image to be presented: one of the most iconic images of nation-state showdown was that of the giant German and Russian pavilions in 1937 staring at each other across the Place du Trocadéro. What image did Britain present?

Hill's pavilion, as one approached it, was the epitome of elegant concrete constructivism. It had the glass and concrete curves of the cheerful seaside houses he had built at Frinton, but the lofty proportions of a sombre palace. Delicate *piloti*, which looked too thin to bear much weight, supported the roof over an airy atrium. Then there was the inside. The 'idea of England' promoted in a series of displays chosen by Hill in collaboration with Frank Pick – charismatic head of London Transport and chairman of the Council for Art and Industry – was one of fishing, tennis and weekend cottages. Dramatic photographs collaged on the walls took visitors far from Parisian urbanity into a country of sheep and cathedrals. Kingsley

Martin, editor of the *New Statesman*, noted acerbically that the building looked from the exterior like a 'white packing-case', but that, once inside, 'the first thing you saw was a cardboard Chamberlain fishing in rubber waders'.[18] Packing-case placelessness became home to soil types and fishing boots and Ravilious's model of a lawn tennis court. This was a pavilion with mixed messages, advertising internationalism on the outside and Englishness within.[19] To some visitors it seemed a welcome expression of open-mindedness; others regarded it as a woolly attempt to tick all the boxes. Either way, it was a high-profile barometer of the difficulties involved in the attempt to reconcile international modernism with the language of national tradition.

This was just what thinkers from the *Axis* and *Architectural Review* circles were already trying to do. And there were other intriguing projects going on at this time that suggested how constructivists and antiquarians could work side by side. John Betjeman was now in Oxford writing a large and tremendously indulgent book called *An Oxford University Chest*. And László Moholy-Nagy was taking the photographs to illustrate it. Moholy-Nagy's name suggests photography worshipful of machinery and bright electric light, yet here he was, training his lens on ivied arches and candlelit halls to complement Betjeman's fond architectural commentary and knowing anecdotes about undergraduate life. Ebullient and adaptable, Moholy-Nagy had already provided pictures for a book on the chaotic street markets of London, and another on old, upper-class Eton. He had also made a documentary film about lobsters in Littlehampton, seeing the potential for dramatic underwater shots of pugnacious claws, and imagining how the prehistoric shapes of the lobster shells might inspire new Bakelite products.[20] So perhaps no one was startled to see him standing in the rain in Oxford in 1937 on the look-out for passing dons.

University Chest (Betjeman made the most of the pun) was probably not Moholy-Nagy's first choice of work; he needed to earn some money. But he went at his task with imaginative sympathy, and expressed a part of himself which is rarely remembered. Betjeman later recalled his genius for capturing 'the beauty of crumbling stone, the crispness of carved eighteenth-century urns'.[21] Many of his photographs respond keenly to the surface detail of ancient buildings or the studious characters Betjeman liked to describe. Moholy-Nagy mixed up these hearty images of Oxford with more exploratory work. His dematerializing vision penetrates the gates of Trinity or the stonework of the Ashmolean in search of the linear structure behind the façade. And while Moholy-Nagy turned his eye on the Betjemanesque, Betjeman took a longer look than usual at machine aesthetics, devoting a significant section of the text to the Cowley motor plant. By the time *An Oxford University Chest* was published in all its old-school luxuriance in 1938, with marbled covers and much gothic type, Moholy-Nagy was director of the New Bauhaus in Chicago and

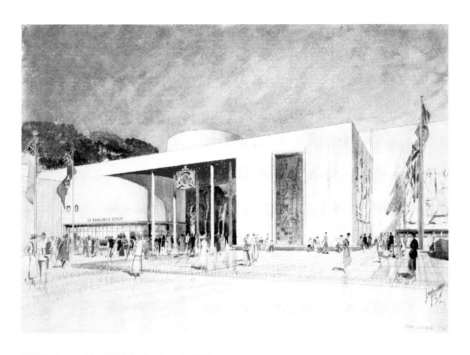

J. D. M. Harvey *The British Pavilion in Paris*, 1937

László Moholy-Nagy *In Broad Street*, in *An Oxford University Chest*, 1938

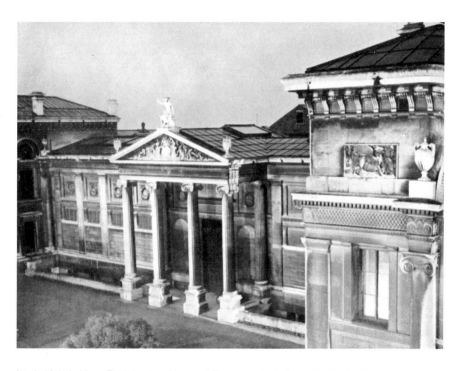

László Moholy-Nagy *The Ashmolean Museum & Taylorian*, in *An Oxford University Chest*, 1938

Betjeman was an icon of English conservatism. Their paths had diverged, but each had given the other a new way of looking.

Some of that same symbiosis was at work among the ancient and modern subjects of John Piper's book *Brighton Aquatints*. The binding was heavy, with leather corners and marbled paper, and inside were twelve hand-coloured prints of Brighton made using an aquatinting technique borrowed from Picturesque tourist prints of the eighteenth century. The book's introduction was by Lord Alfred Douglas, whose voice seemed to come from the 1890s. But look closely at the images and you can sense Piper's excitement in the marrying-up of tradition and modernity. In one print, aptly called 'Mixed Styles', he enjoys the architectural variety of a street in which Regency symmetries give way to Victorian flourishes, before reappearing, rationalized, in a large functionalist structure further down the road. A print showing Regency Square brims over with balustrades, lattices and bay windows, while the Metropole Hotel is accompanied by Gilpin-like observations on optimum viewing conditions: 'beneath dark clouds (a heavy shower just over)'.[22] *Brighton Aquatints* was published just before Christmas 1939. It was the most unlikely of war books, flaunting its thick creamy paper as if it knew paper rationing was only a few months away. It was a hefty anomaly, a collector's item for the gentleman's study in a different age. But it also had things to say about the present. It was a tribute to a flamboyant city that would be bombed more than fifty times over the next four years. And it was a showcase for an elastic kind of England, a bit seedy and very stylish, full of contrasts and odd pairings, and all the better for that.

There would not be many new buildings going up now – only the functional makeshift pill boxes and barracks and air raid shelters. But there was much thinking about what Britain might build for itself in the future, and about which aspects of its architectural inheritance most deserved to survive. Most plans for reconstruction involved high-rise urban developments with maximum economic efficiency, but other kinds of home did receive attention. The comfortable private paradises of sub-urbia gradually came to seem more appealing to the advanced architectural thinker, now that privacy and solidity were threatened. Even J. M. Richards, generally modernist and left-wing in his thinking, wanted to acknowledge their particular qualities. He had a long itinerant war, living in transit between Cairo, Jerusalem, Aleppo and Rhodes, and during this time on the move he wrote a book about English suburbia.

The Castles on the Ground (1946) was the first serious defence of suburban style. The exiled Richards allowed himself some romantic flights of rhetoric in praise of the neat gardens and neater hallways: 'Ewbank'd inside and Atco'd out, the English suburban residence and the garden which is an integral part of it stand trim

and lovingly cared-for in the mild sunshine. Everything is in its place'.[23] The man once called Marx was now admiring the proprietorial tidiness of ambitious suburban home-owners, whom he understood as the descendents of the country squire, proud of their territory. Richards felt keenly the scorning attitude of some of his colleagues who sensed this as another 'betrayal', but he made his point clearly: 'the modern movement', he wrote, 'cannot afford to be a closed minority art'.[24] He had come to the conclusion that by peering over clipped hedges and through stained-glass front doors, by giving a tradition, a narrative and some romance to the idea of suburbia, he was probably getting closer to supporting an art of the people than he could ever do by confining himself to more radical kinds of building. The book was illustrated by Piper, who was equally attracted to the fanciful possibilities of suburban housing, and equally convinced that all sorts of buildings can be good ones.

Just before the war Piper and Richards had worked on a series of *Architectural Review* articles that determinedly paid attention to everything in sight. Their rebellion from purism was to take the fabric of the built environment in its totality, discussing the merits of drain covers and shop fronts. They planned 'A Study of a Hundred Yards of a Suburban Road Examined Yard by Yard, Including the Pavement', and Piper went on to write a topographical survey of the road from London to Bath.[25] They were more interested in how things worked on the ground than in idealized architectural plans. These yard by yard examinations shared the ethnographic style of Mass-Observation, the social research organisation that represented the period's most ambitious attempt to look carefully at the way people live. What Richards and Piper were doing was, in a sense, the architectural counterpart to Mass-Observation's people-watching, which was in turn a variant on the bird-watching that one of its founders, Tom Harrison, had been doing for the Survey of Great Crested Grebes. And it was closely related in spirit to the prodigiously extensive work of the National Buildings Record (now the National Monuments Record) founded in 1940 as a visual index of architectural heritage from tombstones to cinemas. All these characteristic projects of the 1930s and '40s involved taking samples and analysing them minutely. They focused attention on 'trifles', looking seriously at the unsensational things which constitute the everyday life of the species.[26]

Mass-Observation declared itself a science, but Piper's surveys were never carried out with scientific detachment. They made fresh, sympathetic judgments about the qualities of ordinary places, and there was nothing clinical about the photographs taken by the Mass-Observation photographer Humphrey Spender to accompany 'Fully Licensed', Piper's article on Victorian pubs in all their over-decorated glory. It is an irresistible article, essential reading for pub-goers. Piper takes the sceptical modern gaze for a tour around a curlicue: 'It begins in the coils of a wig of wrought iron [...] it meets one of the palms and loses itself in fronds', it descends

the 'satisfying ogee' of a cast iron table leg and disappears 'twiddling' into the distance. 'Look out for the wonderful patterns engraved and frosted on bar doors, windows and mirrors', advises Piper, 'and regret that here again we have invented nothing so appropriate to take their place'.[27]

The curlicues of a Victorian pub represented a very different aesthetic philosophy to the concrete of the Lawn Road Flats, and it was not easy to reconcile the two. The inner cleanness demanded by Wells Coates and Le Corbusier would be jeopardized by these twiddlings, and Roger Fry would have been as disgusted with Piper's pub as he was with the Victorian station café. Piper, for his part, would go a long way for the pleasure of a well-ornamented railway station, and Betjeman would linger in it with fond delight.

This was a debate not only about style but also about ways of living, and it was closely linked with contemporary investigations into the morality of possessions. If twiddles were holding us back in the dark ages of sentiment and secrets, then so were *things* (which are of course essential to pub decor: murky photos, brasses, jugs). Lawn Road and many other modern living spaces required that possessions be left behind. Was it because they were dangerous and unhealthy? Or merely out of date? Serious investigation was needed if the twentieth century was to approach an understanding of the complex relationship between people and their belongings. Some of the most subtle analyses, which certainly influenced architectural thinking, came from the experts on human behaviour: novelists.

E. M. Forster had, for a long time, been considering the potentially damaging effects of possessions. In his 1910 novel *Howards End* he suggested that they had come to function as surrogates for the sense of spiritual ownership deriving from long familiarity with a particular place. Because we do not properly belong anywhere, we accumulate things to make us feel at home. Fetishized, dusted, carefully stored, our belongings do their best to fill the gap; but continuity from generation to generation is only ineffectually symbolized in the jealous guarding of family heirlooms. So Margaret Schlegel surveys the accumulated furnishings and bric-a-brac of her house at Wickham Place, wishing for a moment that it could all be sent 'toppling into the sea'. She knows that it must be packed and stored, since 'round every knob and cushion in the house sentiment gathered, a sentiment that was at times personal, but more often a faint piety to the dead'.[28] *Howards End* is a novel about inheritance, asking how and to whom things ought to be passed on. And as he explores these difficult questions, Forster raises the possibility that our attachment to material possessions might be a false allegiance.

The problem, really, as Forster diagnosed it, was the rootlessness of the middle classes. He observed sadly in 1939 that the middle class 'has never been able to build

John Piper *Mixed Styles: Regency–Victorian–Modern*, from *Brighton Aquatints*, 1939

itself an appropriate home, and when it asserts that an Englishman's home is his castle, it reveals the precise nature of its failure'.[29] A middle-class home is *not* a castle, and it has failed to establish any other, more realistic, identity. So Forster paused to reflect on the consoling maxim of a class left to imitate and dream: the castles are gone and we hanker after them. How would the modern architect approach this situation? Spurious castle-making was exactly what Wells Coates abolished when he designed rooms hostile to objects: his hygienically unencumbered apartment-dwellers would not be trying to reassemble the castle collections. But the modernists, it seemed, could not solve Forster's problem simply by getting rid of possessions. The possessions, as Forster had suggested, were a symptom not a cause, a symptom of having no fuller sense of belonging.

Virginia Woolf's Victorian houses are packed with strange items, inducing claustrophobia, and demanding that the sentimental ties they represent be honoured on a daily basis. Woolf couched her own modernist project in terms of an escape from clutter, opening windows in the crammed, airtight houses of the writers she provocatively called 'materialists'.[30] Objects remain troublesome, however, long after the ottoman and the whatnot have been cleared away. In her short story 'Solid Objects', John is held in thrall by odd pieces of glass and lumps of iron which, at first, promise clarity in a hazy world, but eventually take control of him entirely.[31] 'Solid Objects' is a comedy about collecting, telling the unlikely tale of a successful politi-cian who resigns his job to attend to the hoarded junk on his mantelpiece. It is also a tragic story, sinister and underplayed, about the danger of our need for relics, a need that can become an illness.

If Woolf documents a power struggle between objects and their owners, the struggle reaches its uncanny climax in the work of the Anglo-Irish writer Elizabeth Bowen. Her objects become overbearing and vindictive: they are watchful, they wear expressions and they do not give in to their owners. A wicker chair in *The Last September* (1929) discusses its occupant; a whole room in *Friends and Relations* (1931) is 'mortally disconcerted; the lamps staring'.[32] Inherited furniture, like the 'knowing' chairs and tables in *The Death of the Heart* (1938), is older and wiser than its owners, bearing sceptical witness to the goings-on around it. 'Furniture like we've got is too much for some that would rather not have a past' warns Matchett, the housekeeper, who polishes the sideboards deferentially because they know so much.[33] Bowen inherits this feeling partly from Ruskin, for whom the greatest glory of a building is in its power to bear witness: 'that deep sense of voicefulness, of stern watching, of mysterious sympathy, nay, even of approval or condemnation'.[34] She has Ruskin's sense of the present being answerable to the past. The housekeeper's deference is important and reveals some of Bowen's ambivalence about the nature of possessions. They are tyrants in her fiction, and perhaps her characters would be liberated without them, 'making for a new, an exciting freedom' as Wells Coates enthusiastically

declared. But those 'knowing' tables and chairs in *The Death of the Heart* have the weight of experience concealed within them. Only the most arrogant and reckless people in Bowen's fiction ignore these representatives from history.

Bowen's astute analyses of furnishing, and of the moral codes inscribed in buildings, sprang from her own experience of contrasting architectural surroundings. Having spent the first seven years of her life at Bowen's Court, the family big house in Ireland, accustomed to the huge sash windows and symmetrical austerity of what Virginia Woolf described as 'a great stone box', Bowen was suddenly uprooted and taken to the English seaside, where she spent the rest of her girlhood in the stuccoed south coast villas of Folkestone and Hythe.[35] 'I was surfeited with the classical when we sailed for England' she remembered, 'where release, to the point of delirium, awaited me'. She found herself in a 'paradise of balconies, ornate porches, verandahs festooned with Dorothy Perkins roses, bow windows protuberant as balloons'.[36] And she was ecstatic.

Bowen admires the ambition of houses without crannies, houses where entrances are made publicly through the front door and where there is nowhere to hide. At the same time she feels a strong temptation to creep in by the back door and feed on the decoration of English villas. She allows the children in her fiction to enjoy the profusion, but it is not for grown-ups to do the same. The boy in her 1945 story 'Ivy Gripped the Steps' can marvel at the variety of bric-a-brac, the 'manyness' of the vases in Mrs Nicholson's drawing-room, 'the bows, bays, balustrades, glazed-in balconies and French-type mansardes', but the adult narrator must see the ostentation and absurdity of all this. The ivy on the steps, cloaking a derelict house in wartime, is itself a symbol of Romanticism. The writer whose own home was determinedly bare ('not a creeper touches it' she says proudly of Bowen's Court) could be imaginatively held in the ivy's grip.[37]

Bowen spent much of her writing life imagining these architectural releases and containments as the causes (and symptoms) of her characters' various emotional ailments. Her fiction plays powerfully into contemporary debates about the merits of purity versus 'eczematous' excess. Plain buildings, 'evenly daylit, without shadow, curiousness or cranny', are in her view morally superior, encouraging an ideally impersonal attitude to life.[38] And yet it was in such a building that her father, and his father before him, went mad. It is as if the building had set too high a standard of rationalism, so that its inhabitants were doomed to fail its tests. Bowen harbours the suspicion that the sanest of houses are designed by those most intensely fearful of going mad. The square stone rooms of Bowen's Court (no nooks, no 'whimsical entrances and exits') embodied a philosophy remarkably similar to the open-plan living spaces designed by Coates and Le Corbusier.[39] International Style could be

understood as a kind of second Enlightenment, cleaning out dark corners, as Le Corbusier instructed, setting the scene for a well-regulated day-lit life. But as Bowen knew very well, people make houses to reflect not who they are but who they want to be, and they do not always live up to the ideas they set out in stone.

Who did the English want to be in the 1930s as they designed the spaces in which they would live and move during the twentieth century, and the buildings which would advertise England to the world? From all the rivalrous exchanges between modernists and traditionalists, ornamenters and ornament-strippers, floating mezzanines and rooted cottages, what emerged was a sense that modern architecture need not be at war with the past. After all, even Adolf Loos, grandfather of functionalism, had not intended people to live estranged from tradition. He argued that architecture should be simple, but that it should be responsive to personal adaptation. A home should have things in it; it must be the dwelling place of individuals. He remembered with fondness the house in which he grew up, where 'every piece of furniture, every thing, every object had a story to tell, a family history'.[40] The home he later chose for himself had a big inglenook and plenty of decorative bits and pieces.

Loos was an Anglophile, and his attitude was a very English one. It was not, in fact, very different from that of Piper and Betjeman, who both looked for ways to embrace modernism while hanging on tight to their histories. English commentators pointed out that even those buildings that announced themselves as supremely advanced were in fact firmly connected to Georgian tradition. No such thing as the really 'new': modernism as the English construed it was as old as the hills, or at least as old as the eighteenth century, and had a long, compelling story to tell.

3

A GEORGIAN REVIVAL

When in 1937 Serge Chermayeff appealed to his local council for permission to build his modern house at Framfield, he compared the linear, flat-roofed dwelling he proposed with the neo-Georgian council offices in which the appeal was being held.[1] What was so different? he asked. His design was consonant with the clean symmetries of the eighteenth century – and nobody was complaining about those. Similar tactics were much in use elsewhere in the 1930s. Certainly John Betjeman's way of getting to like modernist architecture was to assure himself that it was really a revival of eighteenth-century style. In many ways that is exactly what it was.[2]

Stand for a moment on the seafront at Morecambe and look at the white façade of the Midland Hotel, designed by Oliver Hill in 1933 and sparklingly restored and reopened in 2008. The smooth plaster frontage curves gently away like a Regency crescent. Long rows of boldly delineated windows range to either side of a central entrance. It is almost as sober and self-effacing and classical as the grand grey stone façade of Petworth House. But Oliver Hill was a specialist in modern varieties of eighteenth-century wit. He had already designed a series of acclaimed neo-Georgian townhouses whose elegant and 'amusing' details won the admiration of patrons, and he missed no opportunity to inject some holiday spirit into his seaside building at Morecambe. Two watchful seahorses by the sculptor Eric Gill guard the porch from a great height, and inside Eric Ravilious painted the circular walls of the dining room with festive murals, including a firework scene that recalled the eighteenth century as the age of pyrotechnic display. Taking their brushes to the white walls, Ravilious and his wife Tirzah conjured fizzing Catherine wheels and exploding rockets, using the faux-naïf graphic boldness of etchings from the 1740s when the Royal Fireworks lit up Green Park and the Thames.

'Why is it that the eighteenth-century so particularly delights us?' asked Lytton Strachey, who had been advocating Georgian taste since at least 1904: 'there hangs the picture before us, framed and glazed, distinct, simple, complete.'[3] It seemed to stand out as an 'enchanted island of delight and repose' in the troubled

sea of history.[4] This was a fantasy of course, but what fascinated Strachey was that, through a time of almost continuous war and political turmoil, polite society had managed to invent for itself an image of orderliness and leisure. It glazed the picture and smoothed the creases. Culture had been able to defy the messiness of the world, and it was that triumph of culture that Strachey admired above all. So his heroes were men like David Hume who rose above the small trappings of personality: 'No mortal being was ever so completely divested of the trammels of the personal and the particular, none ever practised with a more consummate success the divine art of impartiality'.[5]

Strachey's essays on the eighteenth-century essayists were themselves small masterpieces of eighteenth-century style. For elegant generalization, telling detail, and the alarming economy of a well-chosen image, they have few rivals. (Horace Walpole's writing, for example, is 'like lace': 'the material is of very little consequence, the embroidery is all that counts'.[6]) This inheritance was much noted and admired. 'Mr Strachey is the eighteenth century grown up' said Aldous Huxley, 'he is Voltaire at two hundred and thirty'.[7] Strachey himself felt the same. He decided not to write a life of Voltaire on the grounds that his subject would be too sympathetic; the necessary detachment might not, in this case, be possible.[8] So the Georgian literary revival began in Bloomsbury, and was conceived as a victory of modern taste over the perverse preferences of the Victorians. Part of the appeal was the combination of civility and raciness. Strachey's Georgians were erotic libertines and proud of it, and their sexual directness was expressed with Anglo-Saxon plainness. This was what Strachey loved in Alexander Pope, who may sometimes have conformed to rococo prettiness, but who displayed his true colours when he 'threw his wig into the corner of the room and used all the plainest words in the dictionary'. This Pope could teach the modernists a thing or two about freedom as Strachey pointedly observed: 'There are passages in *The Dunciad* which might agitate Mr James Joyce'.[9]

Virginia Woolf shared Strachey's enthusiasm, but her Georgians were fundamentally different from his. It was not plainness that attracted her so much as strangeness. She was less interested in the conventional 'prosaic edifice' of Walpole's mind than in the bizarre things ('knick-knacks and antiquaries, strawberry hills and decomposing royalties') that go on in its darker recesses.[10] Woolf celebrated this art of vagrancy, especially in her 1928 fantasia *Orlando*, which was, in part, a mischievous joke on proper Georgian taste. Her heroine gets bored by the company of Pope and Addison, and goes off for a spicier evening's talk by the fire with a prostitute. In Woolf's eighteenth-century England all is 'light, order and serenity', but only on the surface.[11] She was not for a moment persuaded that this was an 'age of reason' and so she revelled in its madness and its energy, leaving the drawing room and wandering the backstreets.

The Midland Hotel, Morecambe, seaside style by Oliver Hill

Eric and Tirzah Ravilious *Night*, at the Midland Hotel, Morecambe, 1933

Here again was the question of straight lines versus twiddles. Strachey commended Edward Gibbon for driving 'a straight, firm road' through the forests of history.[12] Woolf, on the other hand, was a connoisseur of forest detours, and sent Orlando off to camp with the gypsies or loiter with the ladies of the night. Theirs was a very eighteenth-century argument. Palladio had planned out Arcadia on the grid system, projecting in his façades an ideal of what human life might aspire to: the orderly, the communal, the upright. But English designers and writers had wrought havoc with those principles. Hogarth's 'line of beauty' was a serpentine counter to straightness, and it had subversive powers, as serpents do. Cunningly disguised by Hogarth in his 1753 *Analysis of Beauty* as yet another righteous rule to study in pattern books and follow to the letter, the line of beauty could go about its deviant business in the most respectable of ways.

These politics of style were intensely interesting to modern thinkers because their own aesthetic dilemmas were closely analogous. From Europe came ideals of rationalism: there was Mondrian offering grids and Le Corbusier offering white symmetries. The new International Style buildings, as we have seen, had little room for curlicues and personal knick-knacks. But just as Hogarth invented his errant line to counter Palladian straightness, the English in the 1930s invented a newly elastic kind of art. Woolf paid homage to the digressions so beloved of Tristram Shandy, and where Laurence Sterne's book ended by announcing itself a cock and bull story, Woolf concluded *Orlando* with a wild goose chase.[13]

Many of Woolf's literary contemporaries wondered what she was doing. Why was the architect of literary form, the writer who pushed furthest into the realms of silence, suddenly putting on pageants? For that is what *Orlando* is: a full-dress rehearsal of five hundred years of English life. Elizabeth Bowen admitted her disappointment. Looking back in 1960 she remembered how her generation had regarded the book as a 'setback' after Woolf's succession of 1920s masterpieces. Those previous novels had 'the chastity of the impersonal', whereas this – 'this *Orlando* – we did not care for the sound of it' – aroused suspicion even before it was published: 'the book was, we gathered, in the nature of a prank, or a private joke; worse still, its genesis was personal'. Bowen and her contemporaries had thought of Woolf as a disembodied genius. Like Fry's ideal formalist operating in an aesthetic world remote from all practical activities and daily concerns, Woolf could not be imagined as an idiosyncratic human being. 'We visualised her less as a woman at work than as a light widening as it brightened [...] Seldom can a living artist have been so – literally – idealized.'[14] In a triumph of modernist alchemy, the individual had been transmuted to an idea. But now here was *Orlando*. The idealizers stood back, betrayed.

Woolf was leading the way towards a new kind of art which involved the passionate recuperation of the personal and of the past. In *Orlando* she openly declared her love affair not only with Vita Sackville-West, but also (and this proved far more controversial) with the intimate details of landscape, the embroidered spectacle of changing fashions, and the eccentric, excessive history of the English country house. The 'chastity of the impersonal', as Bowen put it, would now be threatened with corruption from all directions. Modern art would be sent to bed with its predecessors.

The fantasia that Woolf orchestrated on paper was staged on a daily basis by Edith Sitwell, whose wardrobe consisted of brocades and taffetas and huge embroidered coats. Wanting to immerse herself in a more spectacular age, she ordered up piles of letters and memoirs from Mr Cox at the London Library and read her way back in time. Her 1932 book on Bath is a collage of history, guidebook, biography and fiction, and it includes a 'Bath Address-Book' at the end so that any fortunate reader finding himself there in the 1800s and wanting to visit Austen or William Beckford would know where to make his calls.[15]

Sitwell specializes in seductive images of abundance. In all her prose of the 1930s she cultivates what Victoria Glendinning calls her 'catalogue technique'.[16] Listing the furnishings of rooms, the ages of ancients, the fabric of dresses, she enrols herself in a struggle to shore up details against the diminishing effects of time. In her populous fantasies, ladies gather beneath the colonnades in mohairs (for satyr forests), grazets (for smooth lawns), flowered damask (for moonlight), 'bafts and dark baguzzees, chelloes and chintz, marmoodies, guinea-stuffs, njiccanees, quilts'.[17] The exotic language is a pleasure, but the gaiety of these scenes is always being undercut by theatrical nostalgia. These damask ladies are but the 'ghosts of a long summer day', and the present refuses to be kept at bay for long. The swaggering personalities of her eighteenth-century Bath are, by the end of the book, merely a 'light and glimmering dust, blown by a remembered wind'.[18]

The hoarded detail in Sitwell's books is part of her quest to make the past live again. These historical journeys were meant to be remedial, a means of imaginative survival in the hostile climate of the 1930s, 'this goose-weather', as she called it, depressed by her chilly, ascetic age.[19] It was in search of 'a medicine for our melancholy', that Sitwell conjured the anarchic processions of *The English Eccentrics* in 1933. She saw herself as a desperate scavenger, raiding the 'dust-heap' of history, and finding there enough relics to bring colourful characters 'flapping and bird-screaming' from another age.[20] *The English Eccentrics* is a sprawling book which refuses to be streamlined, a compendium of quacks, alchemists, travellers, and ornamental hermits (like the amphibious hermit Lord Rokeby who was rarely away from his bath and whose beard grew down to his knees). Sitwell's celebration of oddity and

excess was also her vigorous denunciation of functionalism. Her eighteenth century is emphatically not an age of rationalism, but of eccentricity.

When Sitwell wrote a biography of Pope in 1930 she imagined him not as an arbiter of classical taste but as a misfit in a world that insisted on sameness, an artist of gleeful perversity who delighted in cataloguing the absurdities of dunces. Sitwell was writing a passionate defence of an ill, odd, disfigured, ostracized poet whose work was a way of getting through the 'long disease' of life. Sitwell knew that she was championing an unfashionable figure; her portrait depends, in a way, on his having been failed by posterity. 'A large section of the public', she reflected, 'has not yet recovered from the cold, damp mossiness that has blighted the public taste for the last forty, fifty or even sixty years'.[21] That word 'mossiness' was her evocative antonym for the sharp-edged indoor world of Pope, a world of illusion rather than nature.

Sitwell's histories are bookish. They are made up of long quotations from other books, and the reader has the sense of a whole library being arrayed before him. She never treated her sources as authorities – they could be cut up and re-written – and her approach to quotation was creative. Reprimanded for misquoting Baudelaire, Sitwell declared archly that, fortunately, she had improved on the origi-nal.[22] She was disdainful of documentary accuracy and, unlike Piper observing every detail including the pavement, she was not bothered about seeing the version of Bath that survived in the twentieth century. Sacheverell Sitwell and his wife Georgia drove her over to look at the city but she only very grudgingly got out of the car.

Instead her imagination fed on the period accounts of others. 'As you know,' she wrote to Piper, 'I am not a movement-addict.'[23] So Sitwell sat still – in London, Paris and Derbyshire – and plundered the library books. But it was apt that she should befriend Piper when the two came to know each other in the 1940s because aesthetically they had much in common. Cutting, pasting, juxtaposing, Sitwell made the most impure of historical collages. In her letters to both John and Myfanwy Piper, Sitwell was always 'wildly excited'. She read *The Painter's Object*, Myfanwy's anthology of artists' essays, at Christmas 1943:

I am quite wild with excitement [...] I feel as if I had been having electrical treatment and oxygen [...] Even the fact that the whole household has just announced that they have got influenza again – and are crawling about on all fours groaning – cannot dampen my ardour.[24]

The anthology contained John Piper's 'Lost, A Valuable Object', with its call for a return to 'the tree in the field', and its bizarre, complicated 'beach object'. It appealed to Sitwell's baroque imagination, and she thanked Piper for an essay that 'explodes in one's mind'.[25]

The Pipers themselves, and friends like Betjeman and Grigson, were committed to a more mobile quest for their eighteenth-century inheritance. Their 'church crawls' were demonstrations of stamina – how many churches could be visited in a weekend? In cars and on bicycles, they set out on Picturesque tours around England. One of the most fruitful of these eighteenth-century excursions was to the Hafod Estate in Cardiganshire. John Betjeman owned a huge book of etchings after watercolours made there by John 'Warwick' Smith in 1797, showing an extensive landscape garden with 'foaming cataracts' and gothic arches.[26] All the famous Georgian tourists had been to admire it, and there was even a set of Derby porcelain embellished with Hafod scenes. And yet little was now heard of this formerly fêted spot. On a happy Welsh holiday in August 1939, in stolen days before the declaration of war, the Pipers set off to discover what had happened to it.[27]

What had happened was that Hafod had been abandoned: a great British landscape forgotten by the twentieth century. From 1783 until his death in 1816, Thomas Johnes had devoted himself to the creation of a Picturesque garden in the rocky, remote, inaccessible Ystwyth Valley. A cousin of Richard Payne Knight and a close friend of Uvedale Price, Johnes was an advanced student of scenery. Envisaging a garden with constant variety and startling vistas at every turn, he improved the already impressive offerings of nature by re-routing the river, making tunnels and bridges, and – best of all – blasting through a slate cliff so that an intrepid visitor, reaching the furthest point on the 'Gentleman's Walk' (not for faint-hearted females), could climb into the dark dripping mouth of a cave and emerge the other side into the deafening crash of a waterfall. This was a masterclass in the aesthetics of the beautiful and sublime.

Piper went equipped with a range of antiquarian guide books (including John Britton's 1815 *The Beauties of England and Wales* and Samuel Leigh's 1831 *Guide to Wales*), and, in the spirit of George Cumberland's modestly titled 1796 book *An Attempt to Describe Hafod*, he wrote his own 'Tour of Hafod' for the *Architectural Review*, illustrating it with a series of watercolours.[28] He saw the Lower Pirian Falls through the lens of Johnes and William Gilpin, but also of Picasso and Braque, borrowing the palette of Cubism's faded newspapers and wood-effect veneers. The zig-zagging rocks that slice the centre of his sheet constituted a geological Cubist collage. The combination of rigid, typographic linearity and subtle, hesitant draughtsmanship in, for example, Braque's *Glass, Bottle and Newspaper* (1914), became for Piper the gothic interplay between geometric rocks and encroaching nature where the planned views of the Picturesque gardeners gradually disappeared in the undergrowth.

Piper was thinking hard about the aesthetic connections between modernism and the Picturesque. In many ways the eighteenth-century scene-makers had opened

John Piper *Lower Pirian Falls, Hafod,* 1939

Georges Braque *Glass, Bottle and Newspaper*, 1914

the way for the explorations of the avant-garde, though the legacy was not often acknowledged. Gilpin's blocky paradigms of composition, arranging the landscape to fit the picture, were the work of a formalist prioritizing the play of shapes on a canvas. The picture was no servile reproduction of reality, but an end in itself. And above all the Picturesque admitted the artificiality of a stationary viewpoint. Its world was an infinite series of potential views, each one demolishing the last; stand and admire for a moment and all is composed, but move a fraction to the left or right and the prospect falls apart. Here was a powerful example for the Cubists, who examined the shards from which we try to piece together a table or a bottle, calculating the sum of possible perspectives. Here, too, was a model for the yoking of abstraction with landscape painting – that conciliatory project on which Piper was now embarked.

As he worked through these correspondences, Piper turned again and again to Christopher Hussey's 1927 study *The Picturesque*. For Hussey (who pays homage to Fry in his repeated use of those distinctive terms 'plasticity', 'form' and 'associated ideas'), the Picturesque theorists were forefathers of abstraction. In his version of the story, Richard Payne Knight campaigns for 'abstract, emotive qualities' rather than 'associative' ones and, had he paid more attention to form, 'could have anticipated Cézanne and Mr Clive Bell'.[29] Hussey's study presented Piper with the tempting idea that to look back to eighteenth-century guidebooks and landscape paintings need not entail a retreat from modernism. On the contrary it could be an investigation of its very roots.

Tourists of the Picturesque are great lovers of ruins: if there are none to hand then new ones can be built. Piper had plenty of ruins at Hafod and he was unstinting in his admiration of their 'decrepit glory'. Johnes's calculated vistas were now shaggily overgrown, and as for the house, which had once been a glittering onion-domed palace of Nash façades: 'Small trees grew in the campanile. And the sheep, sunning themselves on the ledges at the base, detach themselves as one approaches like large pieces of a fawn-grey masonry.'[30]

The mood of the Hafod explorations went into one of Grigson's poems:

My familiars visit the romantic caves,
The 1850 mansions, and the stuccoed lion,
Dive into the stump-speckled valley of Hafod,
Read Rogers on the robin, under the weed-
Surrounded urn.[31]

'My familiars', he writes pointedly. Not 'I'. By 1940 Grigson was distancing himself from his antiquarian friends and he was worried about Piper's work. The inclusion of houses, views and ancient walls seemed eminently defensible:

It wasn't, though enemies and scorners declared that it was, that he was deserting modernity for sentimentalities of the past. He was creating a theatre, a proscenium of English past and European present.[32]

But Grigson was starting to worry that this 'theatre' was staging only old plays: 'It was possible to suspect a preference, a reaction, a return, a rejection, an unwelcome kind of exclusion and coming clean, a Betjemanism in paint'. With crushing economy those last three words damned two old friends. Betjeman now seemed a traitor to the modern cause, 'betraying new poetry with old forms'.[33] And Grigson was not alone in being suspicious of Betjeman and Piper's Picturesque manoeuvres.

Reaction, return, rejection – the criticisms began to mount. They were painful, but Betjeman and Piper both felt convinced about the rightness of what they were doing. Nor was theirs the very insular approach they might have taken. Many of the eighteenth-century houses that so interested them were based on designs imported from the Continent and had stories to tell about a tradition of stylistic exchange. The Georgian revival was in important ways precisely the opposite of Little Englandism: it was an investigation of England's cultural relations with Europe and an effort to promote an audaciously international version of Englishness. The reason that so many classical houses and their estates were falling into ruin was that they had never been accepted as part of a national heritage. Hafod was a prime example, but there were hundreds more. The Victorian passion for crooked manors of the Olden-Time had a dire impact on the health of Georgian buildings, which were often regarded as foreigners parading their unsuitable stucco among the rolling hills. The change since then, in our sense of English cultural identity, is marked. Today we visit Lyme Park and Berrington and think of them as English arcadias, ideally placed in the pastoral landscape. But in the 1930s it took nerve, and a good deal of research, to rescue Georgian architecture, furniture, gardens and paintings from oblivion.

The first person to write about Palladian design was Margaret Jourdain, better known today as the partner of the novelist Ivy Compton-Burnett, though her own achievements were formidable. James Lees-Milne gave a striking description of her:

> Dressed in clothes subfusc she favoured large hats with rampageous feathers. At the end of a long gold chain she carried a Georgian spy-glass which she applied in a rather menacing manner to a small beady eye.[34]

Through that Georgian spy-glass, Jourdain examined every kind of eighteenth-century furniture.

Sharp-witted, determined and well-connected, Jourdain gained access to the country houses where major collections were hidden from public view. She wrote a study of early Georgian furniture as early as 1914, and there followed a prodigious number of publications on every aspect of interior decoration. She marched through chintzes and samplers, chairs and tables; she carried on past cabinet-makers in the age of Chippendale, Hepplewhite and Sheraton (1944), before arriving at a much-needed monograph on William Kent (1948). These were not interpretative works; the prose was strictly factual ('like a dry seed cake' said Dorothy Stroud, who had to type some of it up for *Country Life*), but the scope of Jourdain's primary research was unrivalled.[35]

In contemporary discussions of 'national character', it was often claimed that classicism and, even more so, the baroque, did not properly take hold in England.[36] But art historians set out to reconcile the English to their European inheritance, from the drama of late seventeenth-century baroque right through to the Regency. Sacheverell Sitwell's *Southern Baroque Art* (1924) remained a handbook for aesthetes in the 1930s. As John Steegman remarked in 1936, 'half Europe has stood enraptured in Salzburg or made long excursions to see a fountain or chapel, unstarred by Baedeker but underlined by Sitwell'.[37] When these newly trained eyes turned their attentions to England, it became clear that there was a whole neglected world of native baroque to be discovered. One had only to visit a house like Holkham, or Castle Howard, or Lord Burlington's Chiswick to see that the English had a flair for façade.

A quarter century after his first joyous excursions into the baroque, an older and a sadder Sitwell returned to the subject in wartime for a book called *British Architects and Craftsmen*. Published in 1945, it was a journey away from austerity into shell grottos and rococo churches, and into a world of orderliness where it seemed that nothing could go very wrong. He argued that William Kent's furniture at Houghton surpassed even that of the Italian Renaissance palaces; he described the beauty of Blenheim 'on a wet November evening', while the 'aloofness and self-effacement' of Whitehall seemed to him to be very much in the national character.[38] Alexander Pope had not thought much of the 'Venetian mania' that saw Palladian mansions rising from damp East Anglian fields, and he mocked the gullible men of fashion who 'Call the wind thro' long arcades to roar, / Proud to catch cold at a Venetian door'.[39] But there was something appropriately English in these marmoreal halls and draughty arcades, and Sitwell loved the way that a Palladian bridge copied verbatim from the Italian plans could be altogether different when translated to the damp English environment of Stowe or Prior Park.

His work was not always scholarly (as the more rigorous Nikolaus Pevsner pointed out in a very forgiving review that made light of Sitwell's myriad mistakes and misattributions). But this hardly mattered, because he was in search of a sensibil-

ity rather than facts.[40] A thoroughly eighteenth-century city like Bath could be read, he said, as the 'pattern of an age of order and of a spiritual state in which it was quite impossible for the horrors of our time to happen'.[41] Following suit, James Lees-Milne offered his 1947 study *The Age of Adam* as a 'last solace' for a society caught in a 'quagmire' but still able to drift back in imagination to the 'quickened elegance of eighteenth-century living'.[42]

Too often this turn to the elegant eighteenth century was motivated by a profound, ingrained snobbery, which made men like Sitwell and Lees-Milne regret the rise of democracy as the cause of falling aesthetic standards. Yet in the end they cared far more about matters of culture than about matters of class, and were ready to castigate anyone, particularly aristocrats, disrespectful of art. Lees-Milne explicitly set himself up as a scourge of upper-class philistinism, as he made clear when he told the story of his damascene conversion to architectural heritage. One summer evening during his time as an undergraduate, a party of friends had gathered at Rousham in Oxfordshire – a beautiful William Kent manor house, then being rented by the fabled alcoholic host Maurice Hastings. No one seemed to be in awe of the painted ceilings, rare gesso furniture and family portraits. On a drunken rampage, Hastings flourished a hunting crop at the pictures, cracking through the paint. Then he went out onto the terrace with a rifle and tried to shoot the genitals off the statues. 'I do not think that by then his aim can have been very accurate' reflected Lees-Milne in his autobiography: 'For all I remember he missed, and I sincerely hope that the manhood of Apollo, Pan and the Dying Gladiator remain unscathed to this day'.[43] The episode was grotesque and symbolic. Lees-Milne realized that evening how passionately he cared for 'architecture, and the continuity of history, of which it was the mouthpiece'.[44] He swore that he would devote himself to its preservation.

He had a major task on his hands. The Palladian columns of Nuthall Temple in Nottinghamshire went up in flames in 1929; Sutton Scarsdale Hall in Derbyshire was left open to the elements and eventually Osbert Sitwell bought it to make sure that the ruined shell, at least, would remain. In 1920 it had been proposed that no fewer than nineteen of Wren's city churches be demolished. The churches survived, but John Soane's Bank of England was demolished, along with the Adam brothers' Adelphi facing the Thames, and some of the great London residences: William Kent's Devonshire House in 1925 and in 1938 the rococo Norfolk House in St James's Square. Not until John Summerson's study *Georgian London*, begun in 1939 and published in 1945 (by which time Summerson had also amassed thousands of photographs of Georgian buildings as part of the National Buildings Record), would there be a proper record of what was lost, and what still stood.

In 1936, still in his twenties, Lees-Milne became secretary of the new Country Houses Committee of the National Trust. Until then the Trust had been primarily concerned with the preservation of countryside, but Lees-Milne oversaw

the first years of the new Country Houses Scheme, which allowed house owners to give their properties to the Trust without incurring huge taxation, and sometimes to continue to live in the houses without the financial burden resting solely on their shoulders.[45] During this same period *Country Life* was under the editorship of a devoted Georgian, Christopher Hussey, heir to the romantic Scotney Castle in Kent, author of a book on Petworth House, and of the book that influenced Piper, *The Picturesque*. Hussey campaigned in the magazine for the preservation of major eighteenth-century buildings, and inaugurated the weekly country house article 'Country Homes and Gardens Old and New'. Week after week through the late 1930s photographs and scholarly studies of eighteenth-century houses appeared in *Country Life*: Bretton Hall in Yorkshire, Stourhead, Devon's shell-encrusted A La Ronde.

One of the most hard-working Georgian activists was Douglas Goldring, author of many well-received, now-forgotten novels, a book about provincial tours on local bus routes (*Pot Luck in England*, 1936) and a great deal of pacifist propaganda. He was not rich; he did not own a Georgian mansion, he was not an aristocrat, and he did not want to be an aristocrat. He had called his autobiography *Odd Man Out* (1935) and he found himself again an odd man out when he tried to start a pressure group to save Georgian heritage. The aesthetically enlightened Mayfair set pledged its support but Goldring was often left to do the hard graft alone. He complained bitterly that he was treated as a lowly servant by the young peers who professed to care for England's buildings.[46]

Goldring managed to get the Georgian Group up and running in 1937, with Lord Derwent acting as Chairman and the travel writer Robert Byron as deputy. One of Goldring's friends warned him to watch out ('your Georgian Group will develop into an informal club of rich dilettanti who have taken up Georgian architecture as a fashionable hobby') but Goldring did not need much warning.[47] He took his leave as soon as he could, and the group was the lesser for it. Yet despite the dilettantish element, the group attracted many of the serious architectural thinkers of the 1930s, including John Betjeman, John Summerson, Nikolaus Pevsner, Osbert Sitwell, Margaret Jourdain, James Lees-Milne. There was the architect Albert Richardson, who lived by candlelight at Ampthill in Bedfordshire and might be spotted going to dinner in a sedan chair, but who was also a progressive figure in the drive to shape modernist building from the legacy of Soane. There was Clough Williams-Ellis, who was now well underway with the building of Portmeirion, his Italianate village on the Welsh coast, while keeping an admiring eye on Marxist planning policy in Russia from the vantage point of a huge baroque desk in George Romney's former studio. Though some of these people would happily have turned back the clock to the eighteenth century (Albert Richardson tried his best), most looked for a balance between conservation and development. J. M. Richards, expert

Cecil Beaton *On the Bridge at Wilsford*, 1927

in both Georgian heritage and European modernism, was struck by how often the 'modernists' did more to keep the past productively alive than those, like Reginald Blomfield, enemy of the new, who noisily attested their traditionalism.[48]

As the effort to safeguard eighteenth-century heritage got underway, so too did the vogue for conjuring up faux-Georgian paradises as suitable habitats for twentieth-century living. Bloomsbury, again, was early on the scene. Duncan Grant and Vanessa Bell designed interiors for Dorothy and Gerald Wellesley at their Sussex home, Penns-in-the-Rocks, dappling their pastel paints to imitate marble alcoves graced by cherubs and male nudes. But the experts in the distinctive art of Georgian re-creation were Cecil Beaton and his circle, young aesthetes who fashioned themselves both as silver-suited futurists and as eighteenth-century squires. People of extremes, they flaunted both their modernity and their archaism, and the two could not always be told apart.

Imagining themselves as the nymphs and swains of Arcady, the Bright Young People arranged themselves on the rustic bridge in Stephen Tennant's park at Wilsford, clasping ribbons, nosegays and baskets in mournful innocence. Beaton photographed them there in 1927, and over the next fifteen years he recorded them again and again, reclining with a lute under the trees or picnicking on a hillside in Eden. These photographs constitute a modern version of the Wallace Collection, in which prominent figures of the *beau monde* appear as banditti in pastiches of Zoffany and Watteau. Like his rococo predecessors, Beaton insists on the capacity of art to make the world ideally picturesque. That is its divine purpose, to be achieved with great pains. Like paintings, Beaton's pictures are artfully staged and composed: his subjects are not about to move off and on. Eternity stretches before them in the sylvan glades.

Beaton's aesthetics of leisure were principled. He was using the medium of the instant click, but his photography was never a high-speed snapshot art. Christopher Isherwood, in deference to the documentary movement, declared himself to be a camera 'recording, not thinking'.[49] Beaton was dismayed by this appropriation of photography for instant reportage, and elevated it instead to the status of old-master painting. He stood by the individualism of the artist, thinking not recording, a virtuoso not a machine.

Since Beaton's milieu composed their lives as pictures, they had a constant need of suitable background scenery. Best of all were the landscape gardens at Stowe, where a succession of eighteenth-century gardeners had sought to out-do ancient Rome with their avenues and temples, vistas, grottos and shrines. The house had been turned into a school in 1923 (the design overseen by Clough Williams-Ellis), but you could still go up the drive and under the triumphal arch which rears

square out of the parkland. You could admire the Temple of the Worthies, and walk over the Palladian bridge, with the mist coming up off the lake in the morning, or the sun on the yellow arches in the evening. When the young artist Rex Whistler visited in 1926, he was immediately inspired to start painting eighteenth-century panoramas, and he had a big new project in which he could use them.

Whistler was commissioned to paint a series of murals for the Tate Gallery Restaurant, and he set about creating the subterranean wonderland still enjoyed by diners at Tate Britain today. A continuous landscape unfolds as a frieze going right around the room. Here are colonnaded palaces and terraces, urns and statues, serpentine lakes, and mountains ethereal in the distance. Unicorns leap and maidens sigh. All is enveloped in a blue-green haze that takes us back into the stylized eighteenth-century world of François Boucher – except that many of the landmarks are recognizably English. The arch from Stowe makes an appearance and so do many of the garden features from Wilton, which was of special significance to Whistler because it was home to his closest companion, the novelist and country writer Edith Olivier.

It was Olivier, a woman much older than the Bright Young Things who became her friends, but the central figure in their circle nonetheless, who dreamt up and wrote down a story to accompany Whistler's Tate murals. It was called *In Pursuit of Rare Meats* and it described the quest of a royal party proceeding through the country of Epicurania in search of delicacies to enrich their diet. Stowe becomes the exotic land of Woste; Stephen Tennant presides as the Crown Prince Etienne. They pass through well-composed scenery where 'wild forests and rushing streams blend with the more cultivated beauty of lawn and garden'.[50] Cantaloupes, caviar and mushrooms are found along the way, with a unicorn and a cupid to provide suitable incidents. Most of the party travel by carriage, but Rex Whistler cuts a more up-to-date figure on his bicycle.

It was appropriate that the mural should depict an elaborate tour. Looking at England was an art, and local tourism could be refined to an act of genius, as Edith Olivier made clear when she described the various sight-seeing styles of her friends. She liked Rex Whistler's talent for finding side-roads which 'meander nowhere in particular', apparently existing solely for the picaresque pleasure of the motorist. She praised Sacheverell Sitwell as similarly 'magnetic', and Zita James as 'scholarly and accomplished' in her touring, having always to hand a library of antiquarian guidebooks.[51] Like Kipling's narrator in 'They', motoring down secret lanes, these tourists are taken deep into the past, at speed, by modern engines.[52] The past they are most pleased to discover, however, is not creaking and lichen-covered, harbouring spirits, but grandly classical and stuccoed.

Motoring through Wiltshire in 1930, Edith Olivier and Rex Whistler (on holiday after finishing his Tate murals) took Cecil Beaton to see a house that Stephen

The Palladian bridge at Stowe, Buckinghamshire

Cecil Beaton *Under the Ilex Trees, with his Sisters Nancy and Baba*, 1935

Tomlin had glimpsed from a distance on Cranborne Chase. The story, as Beaton told it, has the feel of entering a sentimentally idealized landscape painting:

> With intense excitement we got out of the motor. Below, stretching to the distant sea, lay an extraordinary sylvan carpet. There were hills wooded with a variety of beautiful trees. Among a cluster of ilex trees a coil of smoke arose.[53]

The party descended into the valley and found Ashcombe, a small, decaying manor dating from the 1740s. Past the Gibbs archway they went, towards the large windows of the garden front and the five-bay orangery. 'None of us uttered a word as we came under the vaulted ceiling and stood before a small compact house of lilac-coloured brick. We inhaled sensuously the strange, haunting – and rather haunted – atmosphere of the place'.[54] Beaton negotiated the lease of Ashcombe in 1931 and started work on the creation of a Georgian arcadia.

The house and its surrounding countryside became for him 'a complete escape to the realms of fantasy', a contained world where weekends could be spent in costume with friends, posing in period tableaux and arranging enormous floral displays to stand among the rococo furniture and ormolu mirrors. Rex Whistler and Edith Olivier were habitués; David Cecil, Henry Lamb and Augustus John all lived in the area and visited. Ashcombe was a theatre in which identities were as changeable as interior decor, a place of carnivalesque pageantry where retiring to bed meant a trip to the circus. Much of the furniture was made-over junk done up with a passion for fakes and veneers. Beaton's photography makes icons of his subjects, and his interiors practise the same cosmetic art. The purpose of swags and cartouches is to cover up origins and make a drama of superiority since furniture, like people, can be dressed up and made to appear aristocratic. Here there was no need for genuine ancestry: history could be invented rather than inherited, and it was less troublesome that way. These expedient inventions allowed for social mobility, bolstering the aristocracy of wit and beauty that enabled middle-class Beaton to emerge triumphant as lord of the manor.

Beaton claimed Ashcombe as his own through elaborate rites of belonging. He became obsessed by, and went in tireless pursuit of, a painting made soon after the gardens were laid out. He staged photographs of himself standing nonchalantly beneath the ilex trees as squires had posed before him for the painters of their day. In the spirit of *Orlando*, and Edith Sitwell's half-imagined, misquoted accounts of Bath, this was a modern pageant rather than any earnest reconstruction. In Cecil Beaton's company there was no searching for authentic olde England: the Wiltshire hedgerows looked to him like the bluish, cotton-wool shrubberies of Fragonard. He employed an Austrian architect to renovate the house, and banned all traces of oak.[55]

Ashcombe's spirit of costume drama and invented aristocracy was revived in the twenty-first century: Madonna chose it as the house in which to establish herself as tweeded and Barboured Wiltshire gentry. *Vogue* photographed her there in 2005, and the set-designer Shona Heath re-created some of Beaton's gilt and pastel furnishings.[56] Mostly, however, minimalism had overtaken the baroque: a small fragment of the circus mural survived, floating wanly amid cream walls in a spare bedroom, where once there had been a bed shaped like a carousel and a series of merry-go-round murals riding dizzily around the walls.

Beaton, Whistler and their friends spent the 1930s bringing European baroque and rococo to remote corners of Britain. The Cornish fishing village Clovelly became, in Whistler's hands, a *toile-de-jouy* fabric with cherub-edged capriccios and fountains of Neptune, and at Port Lympne in Kent, Philip Sassoon's dining room became a *trompe l'oeil* Regency tent. Lord Anglesey's house at Plas Newydd was made into a dreamy haven when Whistler launched on his interior design schemes there in 1936. Sitting at the table in the dining room, one could look out in one direction across the Menai Straits to Snowdonia, and in the other direction across a sunny Mediterranean port to ethereal mountains beyond. Which was reality? Italy and Wales were fused in the same imaginary panorama. On the one side King Neptune has just climbed out of the sea and come padding across the marble floor leaving wet footprints; on the other, perhaps a guest has come in dripping from the damp garden, ready for his dinner.

To the designers of modern Georgianism, the Arts and Crafts version of England looked dubious. Its insularity was constraining; its earnestness was conceited. They concurred with Evelyn Waugh's much-quoted tirade (in his 1930 travel book *Labels*) against the persistent location of 'real' England in a Tudor fantasy. Waugh was fed up with the clichés of oldeness:

> arts and crafts, and the preservation of rural England, and the preservation of ancient monuments, and the transplantation of Tudor cottages, and the collection of pewter and old oak, and the reformed public house, and Ye Olde Inne and the Kynde Dragone and Ye Cheshire Cheese.[57]

Partly this was a protest against the homogenized styling of suburbia, where Tudorbethan reigned. It was also a protest against the tastes of the older generation. Just as Whistler transplanted Plas Newydd to Italy and Beaton banned oak beams in favour of ormolu, Stephen Tennant wrought a thorough transformation at Wilsford. The house had been built in the early 1900s with well-made fittings and vernacular furniture, but when Tennant inherited it on the death of his parents he rapidly

Rex Whistler *Clovelly Chintz*, 1932

Rex Whistler Mural in the dining room at Plas Newydd, 1936–37

redecorated. Practical home-spun surroundings were not for him, so he designed a rococo palace filled with rocaille tables, exotic plants and an alarming collection of reptiles.

The artifice was at its height at Faringdon House in Oxfordshire, the home of the industriously eccentric composer Lord Berners. Here again there was no old-worldliness, no organicism, even 'herbaceous borders were held in contempt'.[58] Berners disposed of his mother's oak dressers and replaced them with glass and gold. His furniture was intended to catch the eye rather than stand solidly in the background: a leaning cabinet cunningly designed by Salvador Dalí made a spectacle of its own apparently imminent collapse. Lest Berners's flock of white pigeons should look too natural, he dyed them yellow and pink and turquoise, and advised local farmers that they should colour their cattle likewise. The local farmers, it seems, declined. Nancy Mitford imagined Berners as the whimsical Lord Merlin in *The Pursuit of Love* (1945) and pointed out that, while Lord Merlin's house was full of Kauffman ceilings and Sheraton furniture, his 'taste was by no means confined to antiques': there were the Cocteau plays, the Dada spectacles, and 'it was sometimes difficult to know where jokes ended and culture began. I think he was not always perfectly certain himself'.[59] Culture was itself a joke to be played seriously.

These elite games depended partly on their status as a minority activity. As the historian Peter Mandler has pointed out,

> what made the Georgian style so acceptable in polite society was its clear opposition to the old meanings and identities widespread in the world at large, as the Arts and Crafts aesthetic trickled down to the masses. By embracing the Georgian, the younger generation could simultaneously reject the feeble, romantic aestheticism of their elders, and the mean, fussy Englishness of bourgeois suburbia.[60]

But it should not only be read as a matter of snobbishly rejecting others and establishing a closed circle of high-taste initiates. This would be to underestimate the work of people like Piper, Betjeman and J. M. Richards in raising public awareness of eighteenth-century heritage while also paying serious attention to the architectural ingenuities of the suburbs. For them, Georgianism was not a sign of superiority but rather a great enthusiasm that they wanted to share – on television and radio, in guidebooks, posters and lectures.

The same is true, and more so, of Eric Ravilious and Edward Bawden. They offer a different version of Georgianism, one which is not at all grand or aristocratic, though their subject matter may overlap with that of their more imposing contemporaries. A mural designed by Bawden in 1938 features a pillared house in parkland with an elaborate cupola-ed greenhouse. Bawden's friend Douglas Percy Bliss

Edward Bawden Design for a mural at the International Building Society Club, Park Lane, 1938

observed rather sceptically that there are 'hints of Rex Whistler' here and 'a feeling that a Sitwell brother might soon appear'.[61] But when Bawden takes over this distinctive imagery the façades are never so immaculate. Cacti sprout in odd directions, giant plants grow out of roofs and the vantage point is not that of the aristocrat, but that of the gardener, whose trowels and spades dominate the foreground. It is not the leisurely vistas that interest Bawden: there is work to be done, and the really interesting things are those that require attention in the potting shed. This is Beaton's England seen from below stairs with a crisp, practical aesthetic of its own. It is an early expression of the middle class's growing imaginative investment in Georgian heritage – a phenomenon that would escalate during the 1940s and 1950s, and cause overcrowding at National Trust properties in the twenty-first century. This was the beginning of the democratization of the country house, where now we obediently admire the state rooms but are happiest poking about in the well-ordered greenhouses and drinking tea in the stable block or the kitchens.

Ravilious (whose favourite reading included Sterne, Boswell, Johnson and Gilbert White) painted with the cool, clear precision of the early watercolourists he loved. But unlike Francis Towne or Thomas Girtin he was rarely lured by the sublime. He would return from painting trips in Wales not with images of mountains but with studies of geese and little grey-walled dissenting chapels. Between them Bawden and Ravilious developed a witty neo-Georgian style that was joyous and accessible, suited not only to wealthy drawing rooms but to London Underground posters and affordable tea-cups. The dining set that Ravilious designed for the small furniture company Dunbar Hay is the elegant Regency remade for the modern home. And the table might be laid with one of the dinner services he designed for Wedgwood, drawing inspiration from the Georgian pottery he loved to collect, and particularly from the neo-classical motifs of 1790s Queen's Ware. Ravilious returned to his beloved fireworks when he designed a Wedgwood mug for the coronation of George VI in 1937. He loved the showiness of grand occasions like this, but also the domesticity of fireworks in back gardens, each family enjoying its private carnival contained within fences. He was inaugurating a new Georgian age and injecting into it some of the wit, style and confidence of the last one.

4

VICTORIANA

The arrival of the nineteenth century is announced, in Woolf's *Orlando*, by the onset of a large black cloud. Orlando has grown used to wide sunlit Georgian streets. But now the whole atmosphere is changing. The air becomes damp, and the damp creeps into the houses. Decay is everywhere, and so are *things*. Each addition to the Victorian home leads inexorably to the next, and Woolf's sentences hurtle on at mounting speed to keep pace with the accumulation:

> a drawing-room [led] to glass cases and glass cases to artificial flowers, and artificial flowers to mantelpieces, and mantelpieces to pianofortes, and piano-fortes to drawing-room ballads, and drawing-room ballads (skipping a stage or two) to innumerable little dogs, mats, and china ornaments.[1]

Amid the mayhem, Orlando is exasperated. 'The spirit of the nineteenth-century was antipathetic to her in the extreme.'[2] Woolf's comical picture of Victorian life says a good deal about why so many people of her generation wanted to break free from domestic clutter. It had haunted their childhoods in the 1880s and 1890s; it was symbolic of complicated family ties, household duties, and innumerable small rituals of gentility. It was difficult but not impossible to escape, and the determined exit from the parlour became one of modernism's great works. Woolf and her siblings, the children of Sir Leslie Stephen, abandoned the black lacquer furniture and heavy velvet curtains of Kensington to establish themselves in high-ceilinged, pleasingly symmetrical Bloomsbury rooms (Fitzroy Square was built in the 1790s; Tavistock and Gordon Squares in the 1820s). Here, friends could gather at any time of day and the walls could be painted with bright murals. Roger Fry's Omega Workshops stocked the kind of decorated furniture you might want to install in a modern drawing room: nudes around the fireplace, fish and flowers on the carpet.

From this state of freedom, Roger Fry performed the experiment of looking at some Victorian furniture to see how he would respond. Taking two quintessential

pieces, the ottoman and the whatnot, he considered the cyclical workings of taste. He observed that items once prized as the accoutrements of any self-respecting parlour were likely to become, a few years later, objects of disgust. They might then be forgotten for a period, before at last reappearing as sources of joy, emanating a 'generalized historical fancy'. If 'distance lends enchantment to the view' as the nineteenth-century maxim had it, then it appeared to Fry that whatnots and inlaid marble tables from the 1850s were just reaching the correct distance for enchantment. He saw that this period could present a 'charming' face to posterity ('we imagine the Victorians forever playing croquet without ever losing their tempers'), but the whatnot could not charm him for long. Born in 1866, brought up in a disciplined Quaker family, and drilled in the 'rigid scheme of Victorian domes-ticity', Fry knew the social world that had produced and guarded these artefacts. To someone who had known them in their heyday, they evoked 'the boredoms, the snobberies, the cruel repressions, the mean calculations and rapacious speculations of the mid-nineteenth-century'. And apart from the associations, there was the sheer ugliness of it all: 'a kind of bastard baroque, passing at times for a flimsy caricature of rococo'.[3] This was what he and many like him had worked so hard to leave behind.

For the next generation, however, Victoriana held no terrors. Evelyn Waugh, John Betjeman, John Piper, Kenneth Clark, Edward Bawden and many others, all born in the first few years of the twentieth century, were in a position to be gradually, warily enchanted. When Bawden painted a tribute to the illustrator Richard Doyle, the cherubic imps and insects in the undergrowth of Victorian fairyland became cheerful modern grasshoppers. J. M. Richards recalled that Bawden was among the first to take pleasure in 'Victorian ornaments – wax fruits in glass cases and the like'.[4] At his home in Great Bardfield, copper jelly moulds, Staffordshire pottery, and other items of Victoriana were lovingly arranged on the shelves. Edward and Charlotte Bawden lost no opportunity for extravagant interior decoration. Peggy Angus went there to visit, and her biographer reports on what she found:

> One room had printed bird cages full of birds, and another was like a church
> with brass rubbings fitted into architectural shapes. The lavatory walls
> were papered with pages from risqué novels and the *pièce de résistance* was
> a screen in the bedroom Peggy was given, papered with old love letters
> containing gossip and scandal.[5]

In their streamlined times, with Le Corbusier insisting loudly on the home as a machine for living in, the oppressor was not proliferation but sober uniformity. Caricatures of rococo and bastard baroque might be called on to provide welcome relief (and the once-hidden love letters could now be put on show). Lytton Strachey, whose identity rested on his Georgiansim, jokingly predicted that perhaps by the

year 2000 people would be able to look approvingly on 'the baroque enchantments of the age of Victoria'.[6] He did not expect such a thing to happen within his lifetime, but the new appreciation was already beginning.

The younger writers who began in the late 1920s to think seriously about Victorian aesthetics tended, like Orlando, to look at nineteenth-century design with a mixture of horror and amazement. Kenneth Clark was only twenty-five when he wrote *The Gothic Revival: An Essay in the History of Taste* (1928). The subject was proposed by his friend Charles Bell, an authority on English art at the Ashmolean Museum, but the newly married Clark – youthful, clever, up-to-date, just back from an inspiring period at Bernard Berenson's Villa I Tatti in Florence – was unenthused by wet afternoons in the Bodleian researching architects like Pugin and Gilbert Scott. At first, the only viable approach seemed to be 'to write a sort of satire'.[7]

Clark began with a straightforward explanation as to why this important architectural phenomenon had thus far escaped the attention of scholars: 'the real reason why the Gothic Revival has been neglected is that it produced so little on which our eyes can rest without pain'.[8] It was from a sceptical distance and with an eyebrow half-raised that Clark conducted his detailed survey of these buildings, and asked why they were once so popular. He lamented the nineteenth-century insistence on architectural moralizing, which he saw as a poor excuse for the lack of aesthetic standards. When it came to the Albert Memorial, he fully endorsed the irreverent description given by Lytton Strachey in his 1921 biography *Queen Victoria*. Both men looked to this massive edifice, built in deep mourning and high seriousness, for 'good entertainment value'.[9] But as work on the book progressed, Clark found that he was 'gradually, albeit inadequately converted'. He was starting to admire the work of G. E. Street and William Butterfield, and he was immersing himself in Ruskin. His book was itself more a Gothic construction with odd protuberances than a cleanly proportioned Georgian villa. Clark apologized for (while cheerfully drawing attention to) the digressions in his narrative – some of which are 'inexcusable', but simply 'seemed interesting'. After all, 'there is no nourishment, we are told, in chemically pure food'.[10]

Evelyn Waugh's first book, *Rossetti*, published in 1928, the year of Clark's *Gothic Revival*, announced that he too was one of the new Victorianists. Like Clark, Waugh had chosen a profoundly unfashionable kind of art – which was no doubt part of the appeal. 'For twenty years [Rossetti's] painting has ceased to command any authoritative admiration', Waugh explained, and he had his own reservations about the 'turgid and perverse genius' of his subject.[11] But he wrote an energetic, empathetic study, negotiating between Rossetti's failures and his 'fitful moments' of brilliance, catching his breath at the 'exquisite beauty' of the *Beata Beatrix*.[12]

Reviewers noted that Waugh's tone was far more respectful than that often employed in discussion of Victorian figures. 'The tradition of modern biography',

Edward Bawden *Homage to Dicky Doyle*, 1931

Paul Nash *Bollard and Bedhead*, 1935

Roy Campbell observed, 'is to search for incompatibilities: to adopt a tone of indulgent irony towards one's subject'. He was referring to the biographical trend which had grown up in the wake of Lytton Strachey's *Eminent Victorians* (1918), and he was stern about the slick, easy condescension that had become fashionable among Strachey's imitators. Evelyn Waugh, however, had taken a different stance: '[he] has succeeded in not patronizing his subject, though he makes no attempt to whitewash him'.[13] This sense of getting free from irony was exactly what Clark felt in his *Gothic Revival*. He later recalled that, by the time he reached the latter half of the book, he had 'escaped from the infection of Stracheyan irony'.[14] It was a kind of modernist uniform being shaken off.

If Waugh did not patronize Rossetti, this was largely because he identified with him. According to Waugh's biographer, Martin Stannard, 'the resemblances between Waugh's portrait of Rossetti and Waugh himself were extraordinary to the point of being prophetic'.[15] Both felt themselves out of kilter with their times; both came to rely on the sedative chloral; both were prey to fleeting, consuming passions. But there was also much in the book that went beyond the personal. Waugh's biography was an extended defence of detail and sentiment in an age of significant form.

It is indicative of Roger Fry's continuing dominance over English aesthetics a full fifteen years after the apotheosis of Post-Impressionism that a young man writing the life of a Victorian painter in 1928 should begin, and end, by quoting him. Waugh contrasted Fry's view that 'real artists' begin by painting 'an old pair of boots or something of that kind', with Rossetti's memory of his own first subject matter: the fantastic images he saw rising from the flames while lying on the hearth rug at home.[16] The point was that for Rossetti the subject mattered, and was the inspiration. It could not be just any old object, any old pair of boots. Waugh returned to Fry in his conclusion, and called for some deviations from 'purity'. 'Pure painting, according to reputable standards, should concern itself solely with beauty and not with anecdote'. But Waugh was impatient with this propriety. He wanted the 'impure thrill' of Bosch, or Martineau – or of Rossetti, who might bring some imaginative relief to an 'era of competent stultification'.[17]

Waugh's campaign for impure painting won enthusiastic backing during the 1930s. Kenneth Clark reflected that, since the English are a literary people, 'we should not complain when our painting reflects this side of our character', and the new generation of critics did not complain.[18] Sacheverell Sitwell went in determined search of literariness, aiming to define a particularly English genre and dignify it with a history. The result was his substantial *Narrative Pictures*, which appeared in 1937, and paid attention to the Victorian love of 'detail for detail's sake'. Sitwell warned his contemporaries not to mock such works as Arthur Hughes's *April Love* (1855–56), and he declared it high time to 'lift the curtain' on the genius of Richard Dadd.[19] The hallucinogenic undergrowth, the tyrannous imps and insects of Dadd's

Victorian fairyland, were unleashed again for a modern audience. The royal family, too, was recast as Victorian fairies. When Cecil Beaton photographed Queen Elizabeth in 1939, he adopted the style of the glossiest and most sentimental of nineteenth-century court painters, and a favourite of Queen Victoria, Franz Xavier Winterhalter. Glittering with fairy diamonds and girlishly arrayed in lace, Elizabeth smiles serenely out from a cloud of frothing foliage, playing – with royal seriousness – her part in a Victorian costume drama.

The heightened detail and sheer strangeness that modern eyes perceived as characteristic of nineteenth-century art made it a ripe hunting-ground for Surrealists. When Herbert Read edited *Surrealism*, a landmark book published in 1936 to coincide with the opening in London of the 'International Surrealist Exhibition', he claimed an English lineage for the Surrealist movement, and gave Victorian art a major role in its development. Whatever claims to innovation André Breton might make, the English, said Read, had got there first. Lewis Carroll and Edward Lear were accomplished Surrealists, attuned to the perverse wisdom of nonsense. There were many painters 'to be rescued from the dustbin of the nineteenth century', Samuel Palmer and John Martin among them, but 'the most serious task is a reconsideration of the Pre-Raphaelites', whose painting has 'all the ingredients' of the surreal.[20]

The nineteenth-century passion for collections, catalogues and odd juxtapositions (a passion much encouraged by the monarch herself), was appropriated in the 1930s as a Surrealist phenomenon.[21] When Paul Nash, England's acknowledged master of the objet trouvé, went to live in the Dorset town of Swanage in 1934, he was delighted to find ornate Victorian bedposts and door-knockers in peculiar places around the town. Their history was suitably strange. In the 1870s, the entrepreneurial George Burt had brought a haul of architectural salvage from London to Swanage with the intention of enhancing the town. He embellished the streets with bollards and street lamps, and erected part of the Mercer's Hall from Cheapside as a new frontage for Swanage Town Hall. Surplus bits of fancy ironwork were left in fields to await suitable employment, and there they waited until 1935, when Nash photographed a bedhead propped against a London bollard in the chalky tufted grass of a Purbeck cliff and declared Swanage to be 'a Surrealist dream'.[22] As Kitty Hauser suggests, the use of this kind of recognizable English landscape was 'a way of tempering and naturalizing' such 'imported movements' as Surrealism.[23] With some nineteenth-century ironwork added to the mix, Surrealism started to look less like an import than a home-grown phenomenon, native to any English antique shop.

Nash's ode to surreal Swanage first appeared in the *Architectural Review*, which was itself one of the best barometers for the rise of interest in nineteenth-century style. It was there, under a range of pseudonyms, that Betjeman made his

way through the Victorian architects, thanking God for William Morris and for 'the old ways and the old country'.[24] And it was as the *Review*'s roaming apologist for the Gothic Revival that Betjeman was given a walk-on part in Evelyn Waugh's 1934 novel *A Handful of Dust*. Hetton Abbey, the neo-Gothic manor at the centre of the novel, is 'devoid of interest' according to the guide books; the gloomy great hall, the tapestried bedrooms, and medieval tomb in the fireplace are all profoundly out of fashion. But, thinking of Clark's books and Betjeman's articles, Waugh notes that some pioneers are beginning to appreciate it again: 'Already it was referred to as "amusing", and a very civil young man had asked permission to photograph it for an architectural review'.[25]

Betjeman himself, with his poems of rural churchyards and bicycles on the Banbury Road, was becoming an icon. He was treated as a mascot (Geoffrey Grigson wrote that he would 'open a subscription any day to buy Betjeman for the nation') but he was treated seriously too.[26] John Lehmann chased his poems for *New Writing* while T. S. Eliot printed several in the *Criterion* and offered to publish the 1937 collection *Continual Dew* at Faber. As it happened, Betjeman had already promised the book to John Murray, who indulged the poet's extravagant tastes in book production and commissioned from Edward McKnight Kauffer a whimsically surreal jacket design involving a severed hand and falling dew. Inside, following a dripping tap on the title page, the poems were surrounded by rustic idylls drawn in the florid Victorian manner of Miles Birkett Foster. It was a long way from Faber house style. Bevis Hillier points out that, had *Continual Dew* been published by Eliot, it would have been a chaste volume with 'no decorations, dripping taps, dendriform lettering, leaf-sprouting hands or prayer-book paper' (the title's source in the Book of Common Prayer made this last feature particularly appropriate).[27] Betjeman made a spirited affirmation that he was quite content not to be one of Eliot's 'Thirties poets'. Consoling himself with his prayer-book paper, he mused that it would be 'infinitely more horrible to appear uniform with Stephen Spender and MacNeice'.[28]

The lifting of the curtain on previously unfashionable painters and obsolete tastes was recorded by Evelyn Waugh in his fiction. Back in 1928, the year of his *Rossetti*, when the reappraisal of narrative pictures was only just beginning, Waugh's novel *Decline and Fall* described the architectural dilemmas of the society hostess Margot Beste-Chetwynde. Margot is unfortunate enough to live in an unspoilt Tudor mansion with no modern credentials at all, and she therefore employs a dour constructivist architect to pull it down and provide her with something truly contemporary. What Otto Friedrich Silenus designs for her is a 'creation of ferro-concrete and aluminium', intended to look as much like a factory as possible since factories are the only kinds of building that can be beautiful. Domestic architecture,

according to Silenus, is doomed to failure from the start, since the needs of human beings are bound to get in the way of formal perfection.[29]

By 1939, however, Margot's tastes have changed. In the novel Waugh was writing at the outbreak of war, and which he published in 1943 as *Work Suspended*, Margot has abandoned her concrete palace and is to be found taking tea in the studio of the elderly Mr Plant, a figurative painter with a vigorous dislike of Clive Bell. After a lifetime's obscurity, Plant is suddenly – by dint of his very out-datedness – all the rage. He is a survivor from a previous era, living in one of the last bohemian studios in St John's Wood, now flanked on all sides by modern flats. Ensconced in this nineteenth-century haven, he can laugh at 'that poor booby called Cézanne', continue work on his 'large canvas, crowded with human drama in the manner of Frith', and enjoy his new-found popularity.[30]

Victorian curios (waxed fruits, eternalized flowers, Staffordshire dogs, Prince Consort figurines) appealed to the decadent imagination of the Bright Young People, who chose as mascots these relics of the nineteenth-century home. Cecil Beaton staged a portrait of himself surrounded by significant props and placed in prime position (where a Renaissance duke might perhaps have placed a globe or scroll) a bouquet of eternal flowers under a high glass dome. In answer, the Surrealist photographer Angus McBean made his celebrity subjects themselves into ornaments. In 1940 he cut out the face of the comic actress Beatrice Lillie and pasted it under a dome. Could she be as eternal as the wax flowers whose place she took? These were faddish affectations but they were not without meaning. For people who caricatured their own transitoriness – rented houses, fast cars, fast relationships in several senses of the word – the Victorian ornaments spoke powerfully of lost permanence. They were adopted as jokes, but also as tokens of mourning. McBean was accused of insensitivity in his portrait of Lillie and was sternly told that disembodied heads and broken glass were not very funny in wartime. But perhaps this was precisely the sad, sinister implication that he had intended as he photographed the shattered and no longer protective dome.[31]

The dome was broken, and Victorian railings – miles of them, defining British streets, marking out values of possession and privacy – were now disappearing. In 1942, watching miserably as wrought iron railings were torn down for scrap metal, Waugh wrote a letter of complaint to the *Times*. 'The railings which adorned the houses of all classes were symbols of independence and privacy' he argued, 'in an age which rated liberty above equality'.[32] He was careful to emphasize 'all classes', knowing that he would be accused of elitism. His point was that a little privacy dignified the lives of those who could not afford much space, and gave them more freedom than could be achieved in the open-plan apartment blocks idealized by modern socialists. It was a controversial letter to write when the wartime rhetoric of community was at its height. The *Times* ran an editorial considering Waugh's

DORSET

RIME Intrinsica, Fontmell Magna, Sturminster
Newton and Melbury Bubb
Whist upon whist upon whist upon whist drive, in
Institute, Legion and Social Club.
Horny hands that hold the aces which this morning
held the plough
While Tranter Reuben, T. S. Eliot, H. G. Wells and
Edith Sitwell lie in Mellstock Churchyard now.

Lord's Day bells from Bingham's Melcombe, Iwerne
Minster, Shroton, Plush,
Down the grass between the beeches, mellow in the
evening hush.

Page layout from John Betjeman's *Continual Dew*, 1937

Cecil Beaton *Self-Portrait*, 1935

claims. It remained unconvinced that nineteenth-century design was yet more than a minority interest though the title of the article suggested otherwise. 'Taste in Transition' it was called.[33]

It was easy in the 1940s to read Victorian taste as a kind of status symbol, but it was linked to something much wider and more deeply felt than this. What Waugh helped to articulate was the intense, desperate conservatism of wartime. Writing about railings he was dealing with the most potent of symbols. With walls torn down and families thrown together, with constant interruptions and rubble blowing in through shattered windows, privacy had become a luxury to be yearned for. Solidity and comfort, those things which the modernists were perhaps too ready to scorn, had become precious memories. It was not so common now to dream of 'sailing shapes' as Myfanwy Evans had done in the 1930s. Jean Hélion, the master of abstraction, came to this painful realization during the two years he spent as a prisoner of war, and was forced to revise his aesthetics in the face of these bleak times. As an elderly man he would remember sadly that in prison 'you don't dream about angles or surfaces and so on. You dream about women, bread, smokes and trees'.[34]

If *Axis* had caught the spirit of experiment in the 1930s, it was a new journal, *Horizon*, edited by Cyril Connolly and Stephen Spender, which came closest to the heavier and more nostalgic mood of the 1940s. The covers for both were designed by John Piper and the typographical difference between them is eloquent. The typeface for *Axis* had been bold sans-serif, thick black ink on glossy white pages, with a simple coloured disc bearing the issue number. Now, in contrast to that minimal geometry, here was *Horizon* with its brown scrolls on laid paper and its title set in Elephant Bold Italic. The title itself had been the subject of some debate. When Grigson expressed his doubts about 'Horizon' (it suggested 'flatness'), Connolly wrote to Spender that 'if a metaphor is flat, nothing is more positively sickening in a title than the adjective "new"'.[35] The days of Grigson's *New Verse* were over, and newness was not so enticing now.

Connolly received complaints about his chosen cover, but he was firm in its defence. It was not 'old-fashioned, but out-of-fashion' he insisted stoutly, and deliberately so:

> the editors believe that the fashionable cover, a functional applied-abstract design which incorporates photography and heavy sans-serif, is as out of date as a rubber topped chromium table in a neon lit cafeteria.[36]

The truly contemporary table, he implied, is crafted solidly from wood, and he quoted with satisfaction the correspondent who likened Piper's cover to 'the dowdy outside of an old-fashioned restaurant where you know you will eat well'.[37] Connolly's sturdy tables and familiar restaurants were images of steadiness in a world that

was no longer knowable and which had no certain future. 'Civilization is on the operating table and we sit in the waiting room', he wrote in his first *Horizon* editorial; would Europe as he knew it, and loved it, survive? He conceived his waiting room task as one of remembrance and encouragement; he must make the present bearable by recalling a time when civilization was in good health. This is why Connolly, and a great many others of his generation, turned away from the idea of avant-gardism and looked backwards instead, in search of fullness and luxuriance. 'The moment we live in is archaistic, conservative and irresponsible,' he said, convinced that the effort to be modern was itself a thing of the past.[38]

There was nothing insular about *Horizon*: part of its aim was to keep up a sense of European exchange. Connolly was thinking sadly of his beloved France, while Spender was thinking of his friends from a happier Germany. Both men used the magazine to remember these pre-war cultures alongside English subjects that would have looked heretical in *Axis*. There was much enthusiasm for the nineteenth century. In the June 1940 issue Robin Ironside turned back to the symbolist painting of Edward Burne-Jones and Gustave Moreau. Grigson found another outlet for his continuing work on Samuel Palmer, whose life he was writing as a tragic story of English Romanticism tainted by commercial pressure.[39] Neo-Romanticism featured large. Peter Watson, the financial force behind *Horizon*, was a serious art collector and, as well as Picassos and Klees, he was committed to buying the best work by the new British Romantics. Many of his paintings were reproduced in the magazine, most notably Graham Sutherland's *Association of Oaks* (1940) in issue three. It was appropriately interleaved with 'Kilvert's Country', an evocative account by William Plomer of the Welsh landscape he had been exploring while editing the diary of the Victorian clergyman Francis Kilvert.

Tastes change in wartime. Connolly clearly felt that his readership would be receptive to the sensibility of Burne-Jones, or Francis Kilvert, or John Betjeman. But it took a long time for Victoriana to be recognized as part of a national heritage, with buildings worth saving and artists worthy of public celebration. The scholarly reappraisal got underway with John Steegman's penetrating study of Victorian taste in 1950 and Pevsner's *High Victorian Design* in 1951, marking the centenary of the Great Exhibition at Crystal Palace.[40] But it still seemed to Betjeman that a love of Victorian architecture was generally regarded as a dilettantish affectation. Perhaps it was because Victoriana appeared so sturdy and familiar that it was in danger of being neglected. The Victorian Society, which campaigned for the preservation of buildings from the period, was founded only in 1958, more than twenty years later than the Georgian Group.

Not until the late twentieth century did Victorian painting acquire widespread admiration and high market values. Christopher Wood, one of the first art dealers to specialize in nineteenth-century painting, recalled that for many

Angus McBean *Beatrice Lillie 'Surrealised'*, 1940

decades the Victorians were conspicuously absent from art-history syllabi and auction rooms. Well into the 1960s, he said, it appeared that 'English art stopped dead with Turner and Constable'.[41] Yet there were always pioneers willing to stand up for the out-of-fashion. What looked to Roger Fry like the products of repression and conformity became, for some of the next generation, symbols of much-needed aesthetic release.

5

From PURITY
to a PAGEANT

'Feelings about life and art have changed.' This was Kenneth Clark's observation as he looked back on three years, 1936–39, in which aesthetic values seemed to have shifted perhaps more dramatically than in any other short spell in English history. If the change could be measured anywhere, it was in the period's attitudes to Roger Fry, and it was in the preface to a posthumous edition of Fry's *Last Lectures* (1939) that Clark made his striking, summative comment.[1] For the generation of artists who established themselves in the changeable climate of the late 1930s, Roger Fry became in memory a great symbolic figure, a touchstone for a whole system of beliefs. For his friend and biographer Virginia Woolf, Fry was an aesthetic guide and a necessary antagonist whose work helped her to crystallize her own changing sense of her art.

When Fry died in September 1934 it was not at all clear where English art was heading. The 'glorious aesthetic day' of Fry and Clive Bell was now 'in twilight' as Frank Swinnerton put it, and their teachings were subject to intense scrutiny.[2] To many it seemed that Fry had severely damaged English painting. Benedict Nicolson (son of Harold Nicolson and Vita Sackville-West) thought Fry had carried out a complete 'demolition', leaving English art in 'ruins'. He lamented that 'no place was left for a national style in the greenhouses of Bloomsbury where frail, exotic flowers from the Rue du Bac were planted'.[3] And John Piper was among those artists who felt acutely the pressure to become 'mental expatriates', pressure which turned him against 'that whole line of Bloomsbury-hedonist country'.[4] English art was at a crossroads. Even Clive Bell was forced to ask 'what next?' Confronting the problem in a 1935 article for the *Studio*, he anticipated that the 'next phase in English painting' must be the 'exploitation of the national heritage by artists whose sensibility has been tempered by the discipline of Cézanne and the abstract painters'.[5] Here was the chief advocate of European neo-classicism announcing that the time had come to revisit a native inheritance and to revitalize it with lessons learnt abroad.

It was in this 'twilight' time that Virginia Woolf worked on a biography of Fry. Reading and rereading his essays, she was confronted by the delights, but also

the problems, of a formalist approach to art. Fry had cleaned up after the Victorians, tidying all excesses of emotion and messy entanglements between art and life. But could a painting really function apart from its context, in an autonomous aesthetic world purified of external reference?

Woolf was writing, often very painfully, about a beloved friend. She was writing about someone whose work she admired more and more (a fact that she particularly wanted to convey to her sister Vanessa Bell, Fry's long-term confidante – 'I realize that he's the only great critic that ever lived').[6] Yet she also needed to question Fry and weigh his aesthetics against her own. She tested her response to pictures against his, standing in front of Cézannes and trying to see what he saw. 'I'm now seeing in chairs, pictures, tapestries a remote world of inexplicable significance,' she told her sister. She was contrasting the 'severity' of this world, 'its bareness from impurity', with the world of literature: 'all books are now rank with the slimy seaweed of politics; mouldy and mildewed'.[7] In the autumn of 1938, just after the Munich crisis, the mould was growing thick. The appeal of purity was clear, but Fry's belief that aesthetic feeling could somehow be detached from the experience of living was fundamentally at variance with Woolf's sense that the processes of creation and reception are structured by their contexts, and by interruptions from the world beyond the frame.[8]

She had already written into her fiction the desperation of characters who probe for the formal design underlying a chaotic world. At a concert in *The Waves* (1931), Rhoda longs to get beyond metaphor and associations to something irreducible:

> "Like" and "like" and "like" – but what is the thing that lies beneath the semblance of the thing? [...] There is a square; there is an oblong. The players take the square and place it upon the oblong. They place it very accurately; they make a perfect dwelling-place. Very little is left outside. The structure is now visible; what is inchoate is here stated; we are not so various or so mean; we have made oblongs and stood them upon squares.[9]

But this way of seeing cannot be sustained. Already the players are human again, dabbing their foreheads. Rhoda's search is doomed, and it is dangerous: Woolf imagines the formalist as a visionary who does not survive.

The way she chose to structure her book on Fry said a good deal, implicitly, about her attitude to formalism. Instead of aspiring to harmonized wholes, she pulled together 'scattered and incongruous fragments', letting the ellipses between them play a part in her portrait.[10] 'How can one make a life out of Six Cardboard boxes full of tailor's bills [*sic*], love letters and old picture postcards?' she asked Vita Sackville-West in desperation, but she made these spoils of a full life symbolic of Fry's relentless activity.[11] She put the reader in the position of biographer, surrounded by

newspaper cuttings 'mixed up with passports, with hotel bills, with sketches and poems and innumerable notes'.[12] There is a list of Fry's favourite things, and an anthology of his letters – on mysticism, religion, Rilke, painting. Far from despatching the Victorian 'Life and Letters' format with Stracheyesque efficiency, there is a twinge of nostalgia for those stout volumes. Each time she breaks into her narrative to reprint a complete letter, meticulously including the address, the date and the signature, she pays tribute to the traditional format that was giving her more scope for a method of additive compilation than any Post-Impressionist ideal of an immune and self-contained whole.[13]

As Arthur Waley pointed out in his review, the biography was 'avowedly an account rather of Roger Fry's personality than of his art or opinions'.[14] Woolf is evasive on the subject of Fry's criticism. His books, she says in an admiring but non-committal summing-up, are 'very rich and profound'. Her respect for his energy in expounding theories is accompanied by some wry dismissiveness about the theories themselves. His ideas about literature become vaguely preposterous in her hands. Shakespeare and Shelley were importers of 'impure associations'. 'Cézanne and Picasso had shown the way; writers should fling representation to the winds and follow suit'. Woolf gives full rein to the irony of her position as a novelist rehearsing Fry's opinions on the English as 'incurably literary'. Since 'literary' was, for Fry, a word of censure, Woolf runs through its attendant vices: a liking for the associations of things, not the things in themselves, and an 'impure taste' for the gothic extravagances of the village churchyard, 'its owls, its epitaphs and its ivy'. All this went along with a dislike of England itself, which had 'no meaning in the lines of the landscape' and was, all in all, 'smug, pretty and small'.[15] *Between the Acts* (1941), the novel she was now writing, was going to celebrate every one of the things Fry dismissed.

'Impure associations' are the very stuff of her biography. She describes Fry painting, but what fascinates her is not the private world of painter and canvas, but the 'tentacle' that Fry sends out to communicate with the world at large, a tentacle which attaches itself 'to whatever is going on in his neighbourhood'. His books, too, send out feelers. When she reads them Woolf is aware not only of the theories on the page, but also of the background hum of 'eating and drinking and love-making', physical and alive 'on the other side of the page'.[16]

Woolf did accept a division between the areas of Fry's existence: 'there was the hurried and distracted life; but there was also the still life'. These were the 'two rhythms', quite different, that structured his days. There was the muddle in his rooms, the frying pans mixed with palettes, but there in the midst of it all was the still-life arrangement protected by a placard: DO NOT TOUCH.

The floor was strewn with papers. There were the pots he was making, there were samples of stuffs and designs for the Omega. But on the table,

protected by its placard, was the still life – those symbols of detachment, those tokens of a spiritual reality immune from destruction, the immortal apples, the eternal eggs.[17]

Woolf locates her discussion of the 'two rhythms' at the end of her chapter on the years 1914–18 and makes it bear – at least in part – the burden of explaining how Fry survived the upheavals of the war. Writing at a time when another war seemed inevitable, Woolf was considering Fry's use of 'detachment' as a means of survival. For some years now she had been attracted to the idea of 'immunity' as a possible way of managing the anxieties of her own life. As a ploy for self-preservation, she prescribed existence apart from 'rubs, shocks, suffering'. But this method of self-preservation overlapped dangerously with an idea of shutting out the voices altogether. Through 1939 and 1940 she was acutely aware of how 'purity', 'anonymity' and 'immunity' could take hold of the imagination and change their shapes; she knew that she needed to be capable of both immunity and involvement. But what of her art? Was detachment, as Fry argued, 'the supreme necessity of the artist'?[18]

The younger thinkers who surrounded her now thought otherwise. Stephen Spender argued in *The Destructive Element* (1935) that the subject mattered, that writers had a responsibility to address social and political issues in their work. He was pleased, for example, to find that T. S. Eliot (whose influential essay 'Tradition and the Individual Talent' had looked to Spender like an art for art's sake manifesto 'brought up to date by Bloomsbury and called "significant form"') was now training his critical eye on the social environment of writers, mixing up art and morality.[19] Surprisingly, but significantly, Woolf agreed to write an article for the socialist *Daily Worker* in 1936. In it she described how the artist's studio was now 'besieged with voices'. Far from being a 'cloistered spot' where the artist could contemplate his apples in peace, it was now crowded with people urging the artist to promote their agenda, or help their cause.[20]

The call for involvement and commitment was a familiar one. Myfanwy Evans prefaced her anthology *The Painter's Object* (1937) with an imagined transcript of those besieging voices: 'have you seen *The Worker* – do you realise – can you imagine – don't you see you're bound to be implicated – it's a matter of principle'.[21] The voices were troubling Eric Ravilious in his sleep. One night in June 1936 he had a dream in which the socialist publisher Victor Gollancz commissioned him to illustrate the latest volume of aristocratic escapades from P. G. Wodehouse. Marrying up Blandings with the Left Book Club, it was, as Ravilious put it, 'a little in the Surrealist fashion', but symbolic of the confused appropriations of culture for left and right.[22]

Artists and critics of all persuasions were asking how Fry's doctrines of detachment should be regarded in the climate of political unrest that dominated

Roger Fry *Still Life: Jug and Eggs*, 1911

the late 1930s. Julian Bell applied himself to the problem. As a young poet committed to action, but also as a son of Bloomsbury, he negotiated uneasily between two increasingly distinct value-systems. In an open letter to Cecil Day-Lewis, whom he chose as a representative of the socialist poets, he tried to reconcile liberal and revolutionary ideologies, suggesting what they might learn from each other. 'The left enthusiasts', wrote Bell, are busy attacking the 'survivors of liberalism', yet in his view these survivors – among them John Maynard Keynes, E. M. Forster, H. G. Wells – 'represent a higher, more mature, more dignified and assured culture than the "left"'.[23] The Auden circle was not producing the rational, public poetry that Bell envisaged for the classical revival. The private jokes of Auden and Christopher Isherwood's *The Dog Beneath the Skin* (1935) hardly constituted a proletarian literature, and Bell pointed out that Molière, by contrast, 'read his plays to his cook'.[24] Roger Fry, as Bell knew, had tried to introduce a democracy of sensibility in which one's maid could appreciate Matisse.[25] Perhaps formalism was more socially engaged than it appeared.

In another open letter Bell paid tribute to Fry's aesthetics. He praised Fry's 'rich classicism', and claimed him as the father of the group who now stood for an Augustan public culture in which belief was expressed through action.[26] His way of looking at pictures had been 'abiological', subjecting 'human emotion to the inhuman relations of form and the demands of the *matière*, even to the point where Christ crucified becomes "this important mass"'.[27] Christ as form, no more and no less. Julian Bell shares Fry's capacity for making these astonishing claims sound indisputable.

Others of Bell's generation were less sure about the value of an 'abiological' attitude, and their thoughts crystallized in response to Woolf's biography. Among the prosecutors was Benedict Nicolson, whose ultimate respect for Fry's criticism is evinced by his work on a book of his selected writings (never realized) and the serious reassessments of Fry that he conducted in a series of articles for the *Burlington Magazine*. Fry was a role model, and for that reason Nicolson questioned – very candidly – the man who emerged from Woolf's *Life*. In an uneasy series of letters to Woolf, he addressed the problem of Fry's formalism, arguing that the painterly qualities he isolated 'cannot be abstracted from all the other ideas, associations, feelings, desires which go towards the painting of a picture, the composing of an opera, the writing of a poem'.[28] Woolf was, in a sense, Fry's representative, and she argued on his behalf, vehemently defending him from Nicolson's criticism. But it was Fry's active life of teaching and lecturing that she used to refute Nicolson's charge of elitism. It was – notably – not his theory of art that she defended.

Similar reservations to those expressed in Nicolson's letters had already been aired more publicly by both Herbert Read and Kenneth Clark, who had rapidly become the most influential figures in the English art establishment. Read, who

fashioned himself as a public ambassador for culture, admired Woolf's biography but described Fry retreating into a 'private world of his own sensibility'.[29] Clark's response was more complex and more divided. He had regarded Fry as one of his closest friends and had taken on the task of editing the Slade Lectures, which Fry left incomplete at the time of his death. The volume, eventually published as *Last Lectures*, is a crucial indicator of Fry's changing reputation in the years after his death. It contains both an introduction by Clark, written early in 1936, and a preface added later, in April 1939. The introduction is full of admiration ('In so far as taste can be changed by one man, it was changed by Roger Fry'), but it also probes at Fry's limitations.[30] 'Purity is a dangerous word to apply to such a complex and vital matter as art', Clark observes, and he goes so far as to suggest that Fry's response to Greek sculpture might constitute the *'reductio ad absurdum* of the pure aesthetic response'.[31]

It was an outspoken introduction, which served to alienate Clark from the Fry family. More telling still was the preface added three years later. As his friend's editor, he wanted to present a version of Fry's work that had value and relevance in 1939; he wanted to show how a 'doctrine of detachment can survive in a world of violence'. Yet he did not rewrite the introduction to address this new problem; possibly he was not at all sure how it might be addressed. 'It may be many years', he warned, 'before Roger Fry's sense of values is once more widely acceptable'. Looking back over the work of a friend and mentor, wanting to make it viable in the present climate, but feeling it to be incongruous in a world on the brink of war, Clark felt compelled to make a grave charge: 'To be a pure painter', he wrote, 'seems almost immoral'.[32]

The art Clark now advocated was very different. It was full of emotion and detail. Its subject was the British landscape and its lineage was Romantic. Recalling in his autobiography Fry's horror of Turner and his indifference to Samuel Palmer, Clark wondered how he would have responded to the group of English artists, including Sutherland and Piper, who were clearly positioning themselves in that tradition. Their work, Clark thought, 'would surely have distressed him'.[33] It seemed to Clark increasingly important that art should be allowed to claim national allegiance and artists be encouraged to acknowledge their Englishness. He even tried to rescue Duncan Grant from Fry's Francophile influence and establish him as a descendent of the old English masters. In a 1934 catalogue preface he admired Grant not as a Post-Impressionist but as a painter in the native tradition: 'Hogarth is remembered for the Shrimp-Girls rather than for his compositions in the Grand Manner,' he observed, 'and Duncan Grant, though he owes so much to French art, cannot help being as English as Hogarth and Gainsborough'.[34] From this point on, Grant found in Clark a patron who was perhaps more suited to advocating his place in the British school than Fry had ever been. Fry himself admitted as early as 1924 that the modern

Duncan Grant *A Sussex Farm*, 1936

movement's emphasis on 'complete and solidly realized constructions' may have 'hampered rather than helped [Grant's] expression'.[35]

In an extensive series of landscape paintings through the late 1930s, Grant rendered in easy, luxuriant brushstrokes the farms and downland around Charleston. Familiar Sussex barns with their half-hip gables were framed by trees in the manner of nineteenth-century vignettes. One of the paintings chosen to represent British art at the New York World's Fair in 1939 was Grant's *Green Tree and Dark Pool*, depicting a corner of England with a spreading tree and a rickety fence. Twenty years earlier Grant's designs for the Omega had been influenced by primitive art; now as he settled down to design a tea set for Wedgwood – just as Whistler, Sutherland and Ravilious were doing – Grant chose the most primly domestic of motifs, the English rose, and gave it rococo flair. In 1912 the great decorative project had been the murals for the Borough Polytechnic, with their radical distortions, urban themes and public setting. The project that would occupy the Bloomsbury artists during the war years was the decoration of Berwick Church in Sussex. The return to local tradition could not have been more clearly marked.

But it is in Virginia Woolf's last novel, *Between the Acts*, that we find the richest and most self-aware expression of this turn towards an impure, inclusive, and very English eye. In April 1938 she recorded in her diary ideas for a novel that would be 'composed of many different things', 'all life, all art, all waifs and strays'. She was immersed in Fry's ideas about the necessary detachment of art from life, but she knew that she wanted in her own writing a way of including fragments from every kind of experience. She started to list the things that might get in: 'people passing – & perpetual variety and change from intensity to prose. & facts – & notes; &'.[36] These jottings anticipated an additive, inquisitive book with a magpie eye for shiny nuggets of cultural treasure: fragments of poems, snippets of conversation, catalogues of local names.

Between the Acts begins in the 'big room' of an English house on a summer evening in June 1939, and it ends on the following evening with the family back where they started, in the room at Pointz Hall, talking among themselves and listening to the faint night sounds drifting in from the darkening garden beyond. In the interim there is the day of the pageant. The stage is set, the sandwiches are prepared, tea is laid out in the barn. The family convenes for lunch, while village people and local gentry gather outside for the performance. The play itself takes all afternoon, presenting scenes from English history broken by long intervals in which the audience gathers and disperses. People gossip and mingle, bound together by a common place and inheritance, but they also split off from each other, divided by personal, incommunicable fears and desires. It is a book about a continuous English way of life that now threatens to break apart, and it asks how it might be possible to hold the pieces together.

This is a novel passionately concerned with the English language. Woolf had tried, in 1937, to imagine what 'pure' language might be, and the germ of the linguistic play in *Between the Acts* is to be found in a talk she gave for the BBC that April. The title assigned her was 'Craftsmanship', but she spent the first few minutes substituting something more suitable: 'A Ramble Round Words, perhaps'. Rambling was a favourite metaphor for thinking and writing (one which, like the idea of the common reader, recalled Samuel Johnson). It suggested a leisurely excursion without a distinct goal, and with time to take in the view. It was a principled opposition to the stern linear progress Lytton Strachey so admired in Edward Gibbon, whose readers 'were not invited to stop and wander, or camp out, or make friends with the natives', and it opposed, too, the straight lines and rigid grids that had come to define modern design.[37] Woolf had already been 'Rambling Round Evelyn' (1925), and within the year she would be planning her 'rambling capricious' novel of village life.[38] Rambling round words in spring 1937, she wryly observed that even if one were to start a 'Society for Pure English', words would soon show their resentment 'by starting another for impure English'.[39]

Woolf makes the very idea of 'pure English' sound like a reductive nonsense, but she was not making anything up. The Society for Pure English had been founded by Robert Bridges and others in 1913 and was still producing its 'Tracts' on language usage in the 1930s. The great and the good of English letters had joined up: Thomas Hardy and Edith Wharton in the early days, Forster later on, and, characteristically, Roger Fry, who advocated the purity of language as keenly as the purity of pictures. Woolf was a notable absence from the register, and by 1937 when the Society had run out of steam she clearly felt justified in joking about its aspirations to keep a living language under control.

Her own idea of language was quite different. She imagined 'Mother English' as a loose woman, whose words kept eloping and mating together unsuitably, royal words with commoners.[40] In *Between the Acts* Mother English is unstoppable. Every word engenders another, leaving everyone irredeemably sidetracked. As Lucy the cook stands stoutly in the kitchen making sandwiches, her mind is scuttling crablike through long-distance sequences of thought. Her imagination 'skip[s] sidelong, from yeast to alcohol; so to fermentation; so to inebriation; so to Bacchus,' and leaves her lying 'under purple lamps in a vineyard in Italy'.[41] The 'orts, scraps, and fragments' of *Between the Acts* are borrowed from the greasy plate of Cressida's errant love, and they retain their air of promiscuity.[42] Poems, nursery rhymes and music hall songs associate, like words, high with low, just as in Piper's account of English architecture, refined Georgian crescents consort with elaborate stucco villas across the way. Woolf allows no work of literature to remain detached. Even Giles the cricketing stockbroker is not immune from these contagious words. He quotes *Lear* to the tune of an Elizabethan dance, and moves by way of William Cowper's 'stricken

Virginia Woolf at Knole, Kent, where Vita Sackville-West grew up, 1928

deer' into gothic remembrance of 'a churchyard haunter at whom the owl hoots and the ivy mocks'.[43] Here is the English imagination that had so frustrated Fry with 'its owls, its epitaphs and its ivy', as Woolf put it in her biography.[44] This was 'impure taste' at its most licentious.

Miss La Trobe, the director of the pageant in *Between the Acts*, despairs that her own work of art, the pageant, should likewise be so interrupted and impure. There she is, out in the open, with cows mooing and the audience fidgeting, and a cast of village actors who can't remember their lines. How can she be expected to produce anything coherent? 'O to write a play without an audience', she sighs, '*the* play'.[45] She wishes she had a back-cloth to hang between the trees – something that might seal in the illusion and keep the audience focused. But her dream of a pure, intact work of art must remain only an idea. The play cannot remain immune from its surroundings. What Miss La Trobe discovers, however, is that the unscripted interruptions have much to contribute. When a shower of rain comes down, when the cows bellow, when the sun plays on the English landscape and catches a church spire in the distance – this is when the play has its fullest impact and when the audience feels united.

In her description of the 'two rhythms' in Fry's life, Woolf had contrasted the mess of his studio (frying pans, palettes and all), with the still life on the table, symbolizing 'detachment', 'immune from destruction'.[46] The two rhythms are in close proximity, but Fry does not allow one to invade the other. In *Between the Acts*, however, Woolf makes room for both the work of art and the debris around it. The points at which the pageant begins and ends are uncertain ('was that the end?'). The audience lingers on during those absurd transitional moments between 'art' and 'life', when the child still dressed as England stands sucking a peppermint drop, and the Age of Reason hobnobs 'with the foreparts of the donkey'. Bartholomew 'respect[s] the conventions' by not going backstage, among the brambles, but Woolf trespasses freely on the dressing-room collage of paper swords, cardboard crowns and strewn dishcloths attended by butterflies.[47] In the published text the pageant script is italicized, typographically roped off, so as to approximate Miss La Trobe's desired back-cloth. But in the manuscript novel that Virginia Woolf left when she died, there were no italics. The script spilled over into the framework narrative, becoming, at points, indistinguishable from it. Fry's 'two rhythms' could not be kept separate.

Miss La Trobe's desire for a play 'without an audience' recalls Auden's statement, in the 1935 programme for the Group Theatre, that 'ideally there would be no spectators'.[48] For Auden this was not because the ideal play would be detached, but because, on the contrary, it would be so fully integrated with a community that every member of the audience would feel 'like an understudy'. Miss La Trobe veers between longing for an hermetic ivory tower, and joy in the inclusiveness of her

pageant. She has found roles for shopkeepers and children, even the village idiot and, like Piper on the beach, she risks outdoor performance rather than clinging to the controlled conditions of the barn.

Between the Acts has often been read as a novel of disintegration in which art fails and language fails and a rich past gives way to a meaner present. It might be compared with The Waste Land (1922) as a work of modernist fragmentation lamenting the alienation of a community from the traditions that were once its life-blood. It is all these things, but it is a joyous book as well. The house is meant as a stable centre. The first draft of the novel opens with an old oil-lamp giving out a firm, familiar light, 'Not a wandering light like the car's; but steady'.[49] It is a version of the lamp Woolf imagined at the centre of The Waves, around which the moths would gather and disperse. Like The Waves, this is a novel about what holds us together. Fragments fall apart, but they are also reassembled in the compulsively associative imaginations of Woolf's characters. As she is followed through the garden by William, Isa yokes together a memory of Swinburne's 'Itylus' (prompted by Bart's quotation 'oh sister swallow') with the 'Fly, away' of Keats's 'Ode to a Nightingale', which in turn attaches itself to 'La Belle Dame Sans Merci'.[50] Literature is here conceived not as a series of authoritative texts, but as a remembered store of phrases and ideas, altered by each owner and still evolving. Mere orts and fragments they may be, but they are personal possessions.

Woolf, too, is taking possession. In Between the Acts a few square miles of England are claimed with a vividness that comes from Woolf's long, deep acquaintance with the Sussex landscape. She delights in the naming of fields and villages, and in the rehearsal of local knowledge. For all its sadness, this novel is also Woolf's intense celebration of her countryside. In the empty barn a butterfly suns itself sensuously; 'whiffs of sweetness and richness veined the air'.[51] Outside forces – war, aerodromes, rural development – wait humming in the wings, ready to encroach, but it is not yet too late to record the last of England. On this single day all the past seems to have risen to the surface and to be consciously felt in the present. Each character feels a weight of history behind him. Lucy Swithin's imagination reaches back to a time when England was joined to the Continent and mammoths walked in Piccadilly. Sitting with his feet on his trusty dog, old Bartholomew takes up the pose of a medieval tomb effigy. The house itself contains a Norman arch, which might, on the other hand, be Saxon. The facts of history are much less important to Woolf in this book than the potent shapes that they take on in people's minds.

What now serves as a larder at Pointz Hall was once the chapel. Old sanctities have broken down, but new ones have grown up: inherited sayings and snatches of folklore are repeated and pondered with reverence. The chapel-turned-larder is a symbol of decline, but it is also an index of how life has been adapted and replenished. The house, like the landscape, is archaeological, harbouring layer upon layer

of human experience. Nothing is pristine: there is an unfinished wing, a muddled library and the chapel has got mixed up with the larder – but it is these imperfections that give the novel its great energy. The house, its history, its landscape, and its inhabitants are, like the pageant, 'a mellay; a medley'.[52] This is the kind of novel Woolf elected as a potent counter to the inhumanities of war, and an aesthetic that she envisaged from the very first, when she wrote in her diary about her desire to include 'all life, all art, all waifs and strays'. Woolf wrote that, for Fry, 'all that echoed and reverberated was abhorrent'; but insistently in her own last book 'none speaks with a single voice. None with a voice free from the old vibrations.'[53] She filled her writing with the mismatched and various. She listened for the echoes and recorded the spoils of a long English past. While she was writing Fry's biography, Woolf considered the possibility that art could only survive though periods of instability if it remained apart and contained, but in *Between the Acts* Fry's 'abiological attitude' seems to have been left very far behind.

A BREAK
for REFRESHMENTS

The kettle is boiling, the table is laid. But this is not quite a 'break' because 1930s thinkers did not go off-duty at mealtimes. Their debates about style, about inheritance, about plainness and excess were concerned not only with the design of the world around us, but also with what we choose to take into our bodies. In the kitchen, as much as in the studio or writing room, the dominance of continental style was reassessed. If Piper felt a 'mental expatriate' when he started out on his painting career in an art world ruled from Paris, English cooks and hostesses had every reason to feel the same as they prepared their menus.[1] In order to command proper respect a meal needed to be presented as French. Confidence in native cooking had sunk to an all-time low at the turn of the twentieth century, as Virginia Woolf knew when she served up the triumphant Boeuf en Daube at the great pre-war dinner party in *To the Lighthouse* (1927). Mrs Ramsay says that the recipe is a French one passed down by her grandmother, and the news comes as no surprise to her guests:

> Of course it was French. What passes for cookery in England is an abomination (they agreed). It is putting cabbages in water. It is roasting meat till it is like leather. It is cutting off the delicious skins of vegetables.[2]

These opinions were still commonly expressed in the mid-1920s when Woolf was writing her novel. But over the next two decades there would be imaginative attempts to revive a sense of excitement about English cookery, both its ancient rural roots, and its long history of adapting ideas from all over the world.

Food is bound up with ideas of inheritance. Recipes are passed on through generations, proudly kept in the family as a sign of continuity. Cooking tends to be about subtle adaptation rather than precocious displays of originality. The attempt to reawaken good cookery in England in the 1930s was motivated largely by this reassuring idea of domestic lineage. Food writers from Florence White to Ambrose

Heath appealed to their readers' warm sense of the remembered farmhouse kitchen. It was probably not remembered at all: few people really had a store of culinary wisdom passed down through centuries. Tradition had gone missing, and the new cookbooks helped to fill the gap. Rich rustic stews established themselves as antidotes to busy urban lives. This kind of food explicitly resisted the anti-domestic modernity of the streamlined kitchens designed by Le Corbusier or Wells Coates – tiny spaces with fold-down tables, more suited to the opening of tins than to prolonged stewings. But the fantasy of the farmhouse and the rival cult of efficiency overlapped and influenced each other in complex ways.

The European avant-garde had long since been articulating purist theories about the benefits of simple living and simple eating. Adolf Loos's prescriptions about the danger of ornamented buildings, for example, proved equally applicable to teatime snacks. Unimpressed by the extravagant displays in the windows of Viennese bakeries, Loos argued that gingerbread tastes better when it comes as a plain biscuit than when it comes, frivolously iced, in the shape of a man:

> I prefer undecorated gingerbread. Modern people will understand.
> Ornament supporters think that this urge for simplicity is self-denial.
> But un-ornamented food tastes better, and decorations used to make
> food appear more appetizing are not for me.[3]

Plainness was perhaps more urgently needed in the larder than anywhere else since food becomes part of the body and provides fuel for the mind. The truly modern citizen, Loos wrote, could be distinguished by his diet: 'the vegetables he likes are simply cooked in water and served with a knob of butter'.[4] The key was to hone one's appreciation of the simplest things.

Few envisaged that minimalism could be taken to such extremes as those reached when the Futurists turned their attentions away from war-making ('the world's only hygiene') and towards the more peaceable arts of the kitchen.[5] Filippo Tommaso Marinetti, founder of Futurism, published a manifesto on Futurist cooking in 1930 and followed it up with a Futurist restaurant (opened in Turin in 1931) and a Futurist cookbook (1932).[6] All these were full of showy, violent, sexualized performances, stimulating the senses in macabre ways. But the idea at the centre was really a minimalist one. Marinetti argued that eating must cease to be a relaxed, time-consuming, weight-gaining indulgence. If the Italians were to be a heroically efficient race it was no good sitting about drowsing over a bottle of Chianti and a big plate of pasta. Pasta, in fact, was the greatest miscreant of all, tending to make the eater slow and pessimistic and consigning him to 'nostalgic inactivity'. Pasta, said Marinetti, must be abolished for the good of Italy; its heaviness was holding the nation back. Thinking more generally about the modern diet, Marinetti called for the 'abolition

of volume and weight in the conception and evaluation of food'. In his weightless kitchen, tiny tablets of nutrition were arranged geometrically on plates (bicarbonate of soda, peeled bananas and cod liver oil all equidistant from one another) in anticipation of the day when 'food pills' would be available. Such cooking was a form of abstract art: a cubic centimetre of celery might balance a cubic centimetre of peas.[7] This constituted a kind of algebraic equation, so it was fitting that Marinetti abandoned 'recipes' in favour of 'formulae'. His formulae ensured that each part of the body was awakened and each of the senses stimulated in calculated ways. Futurist diners ate with their hands so as to encourage more immediate apprehension of the raw material of food. The etiquette and ornament of the well-dressed nineteenth century was at last, according to Marinetti, at an end.

The change had been anticipated by the most famous chef of the extravagant fin-de-siècle. Georges Auguste Escoffier, who cooked at the Savoy and whose distinctive brand of French food became de rigueur in fashionable English households, foretold the twentieth century's obsession with sparse nutritional mathematics. As early as 1907 he observed that 'much of the paraphernalia and frills have vanished or will vanish'. This ever-busier society would 'take simplicity to its limits', lusting after efficiency: 'We will strip [dishes] of most of their nonessential ingredients. In a word, cooking, without ceasing to be an art, will become scientific and will be elaborate in formulas.'[8] It was an accurate premonition. This stripping to essentials would also be the policy of constructivists and other advocates of the rationalized lifestyle. Since constructivism took a holistic approach, integrating painting with architecture, planning the future of transport, zoos and relationships, the digestive tract could not have escaped its attentions. Abstract artists expressed their preference for pared-down food. Jean Hélion, for one, was committed to culinary simplicity, and when asked about his interest in everyday beauty he stressed his liking for cabbage.[9]

How did these modern revolutions play themselves out in English kitchens? A strong vein of food morality was already firmly established in the Arts and Crafts tradition of cottage living. 'Good cooking is a moral agent' wrote Joseph Conrad in an introduction to his wife's *A Handbook of Cookery for a Small House* (1923). Jessie Conrad was still holding the sentiment dear in 1936 when she republished the introduction in *Home Cookery*.[10] Good cooking in the Conrad household meant simple cooking ('not the more or less skilful concoction of idle feasts') and was conducive to bodily efficiency. Easily digestible food encouraged 'the serenity of mind, the graciousness of thought'.[11] The Conrads' no-nonsense kitchen craftsmanship was part of a puritan tradition in English domestic life, and it was also in keeping with modern thinking from Europe, where Loos made a point of shunning *wiener schnitzel* in favour of roast beef and cabbage.[12]

Cabbage was contentious. It had long carried an ascetic reputation. An English gardener's book from 1699 lamented that cabbage affords 'but a gross and melancholy juice'; Tristram Shandy in 1756 refused to train his narrative to the dull, orderly lines that he associated with cabbage (he would not go on 'coolly, critically, and canonically, planting his cabbages one by one, in straight lines, and stoical distances'); and the nineteenth century disguised its cabbage with various sauces.[13] So by the twentieth century any purist approach to the hated vegetable was, in its way, quite radical. The fashionable hostess Alice Martineau took a bold step in calling her second cookbook *Cantaloup to Cabbage* (1929) and instructed readers how to boil cabbage to the best effect. But she was not sure anyone would want to eat it in this primal state, so she hastily added a coda: '[the boiled cabbage] can be pressed into a mould before turning out, and eaten with brown sauce, or tomato sauce round it, when it will be pronounced "good"'.[14] This was a brave step towards being one of Loos's modern citizens, but more comfortable with the decorative mould and a goodly quantity of sauce.

Simplicity has to be done well. The ingredients need to be fresh and the cooking needs to be done to perfection. Loos may have admired the English for their unfussy meals of roast beef and cabbage, but in practice if the beef is cooked to leather (as Mrs Ramsay's guests observe) the result is unappealing. Too often in England the tradition of simplicity got mixed up with just not caring. E. M. Forster summed up the situation while being tormented by a choice of 'porridge or prunes' on a train. The porridge would fill him up; the prunes would clear him out. The whole thing was joylessly efficient and Forster felt very despondent about English attitudes to eating: 'they eschew pleasure and consider delicacy immoral'.[15] Woolf could be savage about functional food and she was never more scathing than about the miserable dinner at a Cambridge college she described in *A Room of One's Own* (1929). The prune makes another appearance here, exuding (in one of Woolf's venomous sub-clauses) 'a fluid such as might run in misers' veins who have denied themselves wine and warmth for eighty years'.[16] Good cooking, such as would encourage good thinking, needed to be more of a feast than this.

Woolf found some more satisfying ways to get back to basics. She is often discussed in terms of ethereality, but she is a passionate food writer. Even her most abstract novel, *The Waves*, is set largely in restaurants, amid crumbs and greasy knives and the very physical paraphernalia of eating. She has no time for finicky dinners served in a succession of small courses with exotic names and little taste. In a deleted section of *The Years* (1937) Eleanor goes with high hopes to a cheerful-looking London restaurant but finds the food distinctly cheerless: 'white fish with pink blobs on it', then Poulet Marengo, and so on through five courses. 'Why not have one dish and that a good one? That's what we want; then why don't we have it?'[17]

Asparagus.

Sea Kale.

Salad.

Artichokes.

Spinach & Eggs.

Salad in Jelly.

Stuffed Tomatoes.

Baked Potatoes.

Russian Salad.

Brussels Sprouts.

Cauliflowers.

Spanish-Onions.

Vegetable-Fritters.

Potato—Croquettes.

VEGETABLES.

Illustration from Mrs Beeton's *Every Day Cookery and Housekeeping Book*, 1890

In her own kitchen Woolf enjoyed being able to have what she wanted. In her diaries and letters she makes delighted notes about the bread she is baking, or the trout she has lined up for dinner. 'I have only one passion in my life – cooking', she writes in 1929, having just taken veal cutlets and a cake out of her newly acquired stove.[18] 'It's a quarter to 7. at which hour I light my oven', she tells Ethel Smyth in a letter one evening in 1931 and, flirtatiously, boastfully, just for pleasure, she writes out what will go in it: 'my chicken brew; and a divine blood red soup, made of beet-root, onions, carrots, and I think a dash of some spirit'.[19] Cooking is an event because she is not used to doing it. She associates cooking with freedom, because it means that she can be independent of the servants with whom she had such a vexed, awkward, intimate relationship. And this was probably the biggest influence of all on modern food: the departure of the kitchen staff. It threw householders into panic, and some-times into ecstasy. All ways round it marked a new phase in the history of English food. And it was simple, satisfying recipes that were needed.

Bloomsbury turned to Europe for inspiration – not so much to the grand dishes of Escoffier et al., but to the rural peasant traditions that were still going strong. The turn to the regional cooking of France, Spain and Italy is important in the story of English food because it opened the way to a new appreciation of regional cooking at home. This was a different brand of simplicity to that promoted by the purists, but it was equally a statement of the modern culinary spirit. It was even endorsed by Picasso. He was advised to adopt a minimal diet and his doctor particu-larly recommended spinach. But Picasso himself had meatier tastes. His paintings were greedy beings, feeding on mythologies and carnivorously consuming bodies, so it followed that the spinach, for all its modernist credentials, was not the most appro-priate food for him to eat. Instead he rejoiced in the robust cassoulets of his native Catalonia, and after the war he would paint the kind of dishes from which he thought such food should be eaten: big rough earthenware plates with fish flapping about in the bottom and faces chatting away around the rim. Picasso was willing to define himself by his voracious appetite, and was not entirely joking when he explained the failure of his marriage to Olga Khokhlova in terms of their incompatible diets: 'Olga loves tea, cakes, and caviar', he said, 'And me? I love Catalan sausages and beans'.[20]

Among the English exponents of regional food was Roger Fry, who was devoted to traditional Provençal cookery. In London, his dirty saucepans were aban-doned under chairs and mixed up with tubes of paint. But in France he took more care and sometimes carried around with him a huge Provençal cooking pot. Fry, Woolf, Vanessa Bell and their friends all sent joyous letters from France recording long lunches, long dinners, fresh seafood, rich stews, ripe cheeses and excellent wine. This was conversation food, shared from a big pot and intended to inspire the kind of reflective talk for which Marinetti had no time. 'Much of our French culture began with gastronomic experience,' remembered Vanessa Bell's daughter Angelica

Garnett: the food set the tone for a way of life.[21] Bean stews, impromptu gatherings, no more gongs: here was a rebellion against orderly ranks of dressed-up dishes like those in Mrs Beeton's *Book of Household Management* (1861). Looking with an untrained eye at the illustrations in that Victorian gospel, it is easy to mistake a Chartreuse of Partridges for an iced cream cake. And that is part of the point. Garnished on all sides, topped with turnip rings, each crowned with a sprout, all traces of partridge are carefully concealed. The modern partridge, by contrast, would be fleshily revealed.

The earthy Mediterranean fare favoured by Picasso and Roger Fry became the envy of many English cooks. Cassoulets were the fashion, and their informality gave them a risqué appeal. In the pages of *Vogue* Marcel Boulestin evangelized about *cuisine bourgeoise*, and from 1937, when he made the first ever cookery programme for television, Boulestin showed the more privileged television-owning households exactly how to produce warm, enticing family meals. Ambrose Heath's 1932 *Good Food* revealed the influence of Boulestin in self-consciously 'peasant' dishes. And he paid homage to Bloomsbury by giving a recipe for Boeuf en Daube.[22] This was a surprising thing to find in a book aimed at the newly cook-less middle class. When Woolf described the monumental dish in *To the Lighthouse* it seemed to belong to a lost world, a world in which the cook could devote three days to the preparation of one dish, and in which the family could gather for long enough to perform the magic rite of eating it in the hour of its perfection. There is deep nostalgia in Woolf's sensual description of the 'exquisite scent of olives and oil and juice', and the 'confusion of savoury brown and yellow meats' she sees as she looks imaginatively into the depths of the pot.[23] But Heath showed that with a little alteration (a good effect could be achieved in three hours rather than three days) those big juicy meals borrowed from Provence could make excellent modern dinners.

The vernacular was on the rise and this prompted an obvious question: if French regional cooking is this good, did anything comparable ever exist in England? Affirmative answers were emerging. The most dedicated English food historian was Florence White, daughter of a long line of Sussex innkeepers, who founded in 1928 the English Folk Cookery Association. White toured hundreds of remote kitchens, talking to cooks and to those who, as children, had eaten things no longer made. She collected recipes from manor houses, farms and cottages, and made public appeals for regional or family specialities. When she published *Good Things in England* in 1932 it was the culmination of a major social history project. Here were methods for raising a piecrust in Warwickshire; here was the recipe for Gossip Bowl, a potent mixture of crab apples and white wine that might even harbour a Shakespearean fairy ('And sometimes lurk I in a gossip bowl', sang Puck, 'In very likeness of a roasted crab').[24] White devoted part of the book to a regional survey, county by county: a kind of kitchen tour around England.

Her work was part of a much larger folk revival movement, but White was always careful to distinguish herself from the more insular folk enthusiasts. She had lived in Paris for many years and was well-practised in the arts of French cookery. She was not suggesting that English cooking should lose contact with Europe, but she did want the English to feel sure they had something worth sharing. White's insistence on the excellence of all things English can sound rather defensive ('Stew' is just as good a word as 'ragoût' she says, and casserole-cooking 'is only a fashionable word for our own hot-pots').[25] But her patriotism was motivated by a basic belief that international exchange would thrive better if local knowledge was strongly developed. 'There is no reason why the famous French cuisine and our fine traditional English cookery should be bitter rivals', she wrote, and many agreed.[26] White could feel a growing interest in the possibility of recovering native cookery. Local recipe books for individual counties were being issued by Women's Institutes (Cornwall 1929; Worcestershire 1936).[27] And another good sign was the increasing availability in the big stores of traditional raw ingredients. The husked wheat necessary for frumenty, for example (and White's book gave a frumenty variant from almost every county in England) could now be purchased from Army & Navy.

The turn to old England did not have to mean stodginess. Hilda Leyel was a specialist in traditional plant lore and proprietor of the Culpeper stores (named after the seventeenth-century herbalist Nicholas Culpeper). She made the seventeenth-century diarist John Evelyn the hero of her 1925 book *Green Salads and Fruit Salads*. It was a new idea to write exclusively about vegetables, but Leyel did it with an eye on the past. Salads were generally considered a continental imposter on the British table, and better suited to warmer climates. Leyel showed this to be quite wrong. Taking her readers back to Evelyn's burgeoning salad gardens, she listed dozens of herbs that had been staple and delicious ingredients around 1700, but which were now unknown or untrusted. With Florence White, she set the tone for a series of books which would open new possibilities for English cookery. They answered, on the one hand, to the spirit of modern experiment and, on the other, to the rich, marginalized traditions of English food.

It would be wrong to make the recuperation of English cooking sound clear-cut. If Englishness was increasingly in vogue, so were many other things. A selection of cookbooks from 1931–32 gives a sense of the range. There was the *Futurist Cookbook* with its formulae, and Ambrose Heath's meaty stews for when time was less pressing. Then there was White's *Good Things* with its tour through regional English kitchens. Quite different again was Ruth Lowinsky's *Lovely Food* (1931), which catered to the cosmopolitan tastes of the Bright Young Things and their disciples. This was aimed at wealthy households where servants still remained, and where guests expected to marvel at the ingenious things it was possible to do with food. So Lowinsky's key word is not 'satisfying', or even 'tasty', but – that all-

important word of the party-going generation – 'amusing'. Her ambitious golden rule is that 'food must above all things be varied, surprising and original'.[28]

Lowinsky prized originality because she conceived the meal as a work of art – a subtle arrangement of people and delicacies, perfectly judged in accordance with the mood of the occasion and the time of day. Food for picnics, food for people who do not like each other, food for a supper after Covent Garden: each presented a new aesthetic challenge. The post-opera menu pointed up the fine balance Lowinsky created between food and feeling since the meal needed to be conceived in response to the emotional demands of the opera. No supper, she warned, could be eaten with satisfaction after both *Tannhäuser* and *Manon*. The dinner, in her world, was the triumphant completion of the operatic artwork, usurping Wagner or Massenet in a perfectly orchestrated final act.

Lowinsky emphasized the table entertainments that would accompany the food ('cards, paper games, murders etc') and her book carried illustrations of eye-catching centrepieces designed by her husband, the Surrealist painter Thomas Lowinsky. These, too, were wittily conceived, parodying the current preoccupations of the avant-garde. Guests might be treated to a little constructivism, or a taste of the primitive: chromium structures spiralling into the air with flowers slotted in at the top or perhaps an African carving flanked by cacti. Sometimes the decorations alluded to the vernacular while displaying their ironic distance from it, as in the centrepiece which involved a Staffordshire cottage surrounded by white roses. Allusions to culinary history were many and various, and some of the dishes were as richly decorated as anything illustrated by Mrs Beeton. Victorian food had become, in this company, a matter of fond amusement, elements of which might be incorporated in the newly light and elegant fare. As Edward Bawden knew when he arranged his collection of nineteenth-century copper jelly moulds at Great Bardfield, kitchen cast-offs offered much that was appealing to the modern eye.

Cecil Beaton's ideal diet was characteristically artful, transforming food into either a joke or a jewel. He gave Alice B. Toklas a recipe for iced apples which, typically, undoes the solidity of the apple and reinvents it as a translucent apparition.[29] Such food was well-suited to the high-speed connoisseur: Beaton's ethereal iced apples would not weigh you down as you moved off rapidly into the future. And food was often sidelined altogether, fitted in – if there was time – between drinks, a kind of incidental sequel to the extended cocktail hour. So the most characteristic culinary art of the 1930s elite is the art of the hors d'oeuvre. The London stores catered to sophisticated tastes in nibbles. According to a stock list wonderfully illustrated by Bawden, Fortnum's could offer eleven varieties of olive and a fantasia of savouries including peach-fed ham and reindeer tongue.[30] These miniature meals were something more abstract than food. They were the idea rather than the actuality of eating: a brief sensation, a toying with appetite, a culinary make-believe.

Edward Bawden Publicity material for Fortnum and Mason, 1937

The war put an end to these games of refinement. By 1940 almost every tempting ingredient was difficult to get hold of. It took the greatest exertions of skill and resourcefulness to get any kind of varied diet, and many people found themselves too tense and anxious to enjoy their food. In wartime literature, it is often the comforting basics, particularly butter, that become the objects of fantasy. When Vita Sackville-West sent the Woolfs a pound of butter, Virginia responded with a long, brilliant rhapsody of a letter:

> You've forgotten what butter tastes like. So I'll tell you – it's something between dew and honey [...] Please congratulate the cows from me, and the dairy maid, and I would like to suggest that the calf should be known in future (if its a man) as Leonard if a woman as Virginia.[31]

That was in November 1940, after almost a year of rationing. It would be another fourteen years before butter was freely available. Extravagant food fantasies got into Evelyn Waugh's *Brideshead Revisited*, written during 1944. The novel was a huge feast, a mirage of satiety conjured in desperate circumstances. As Waugh explained later,

> It was a bleak period of present privation and threatening disaster – the period of soya beans and Basic English – and in consequence the book is infused with a kind of gluttony, for food and wine, for the splendours of the recent past, and for rhetorical and ornamental language.[32]

So Charles and Sebastian swirl venerable wines in glasses warmed by candlelight. Cream and hot butter mingle at dinnertime, 'separating each glaucous bead of caviar from its fellow, capping it with white and gold'.[33]

Cookery writers tried, in more practical ways, to fill the empty table. Constance Spry, especially, refused to capitulate to the soya beans. She was a friend of Ruth Lowinsky, and she discerned something unexpected about *Lovely Food*: that the recipes were in fact very economical. Though the recipe for Gigot d'Agneau Polonaise 'may need to be modified in the matter of a glass of champagne and the juice of a lemon, it is still good', and resourceful, too, since it makes good use of local produce. Spry told her readers that in England they had 'better ingredients than almost any other country'; she drew keenly on French and American recipes but always with an eye to the qualities of English regional farming and the possibilities of the kitchen garden.[34] In these years of digging for victory, a range of other books turned attention to food grown close to home. With the help of the 1943 King Penguin guide to edible fungi, for example, one might supplement rations and

home-grown vegetables with delicacies from the forest floor. Care needed to be taken (there were a number of wartime deaths from mushroom poisoning), but there was much to be gained.

For all the promise of local produce, culinary patriotism was not always easy to rouse. John Hampson's *The English at Table* (1946) was a difficult book to write because the tradition of English food seemed uncertain, partly subsumed by imitation French cooking, and now threatened by standardized processed meals. Hampson was interested in working-class culture (he had had a surprise success in 1931 with his novel *Saturday Night at the Greyhound*), so he was looking particularly for the survival of regional habits of eating. Hampson worried that the modern kitchen was in danger of becoming a mere 'cubby-hole' for the opening of tins.[35] And what had happened, he asked, to the store of English kitchen wisdom passed down from the Middle Ages, from John Evelyn and Hannah Glasse? Many of today's food writers see the war years as a decisive break marking the end of good English cooking.[36] After rationing and austerity, it would be Elizabeth David's Mediterranean dishes in the 1950s and 1960s that set the tone. David's books were sexy, rebellious, and so iconoclastic that Christmas dinner as she imagined it might consist of an omelette and cold ham and a nice bottle of wine. Even the Neo-Romantic artist John Minton, a follower of Samuel Palmer and William Blake, was now drawing sunny fishing ports to illustrate David's warmly intoxicating books. English pies, it seemed, might never be tasted again.

But they were; and this short sketch of modern English food needs a post-war coda because the 1930s project of national revival, cut short by wartime shortage, came into its own several decades later – and in a style unmistakably reminiscent of Piper, Betjeman, Grigson and the interwar antiquarians. The idea was kept alive in the interim by Dorothy Hartley, who conceived her 1954 *Food in England* as an old English kitchen 'where one might come in any time and talk with the cook'. Hartley's traditional recipes came with a whole way of living attached, embedded as they were among centuries of local wisdom about how to lay particular kinds of fires, or whitewash a house, or even build a privy. The old ways seemed to Hartley to be also the most modern. The medieval cook, confronted with cabbages, would simply 'shred them and put butter thereto'. This, and other simple, practical methods, convinced Hartley that 'our modern conservative cooking is as old as the hills'.[37]

In the late 1960s Elizabeth David began to read hundreds of old English cookbooks, and she embarked on a series called 'English Cooking Ancient and Modern'. It did not reach the encyclopaedic proportions she planned, but the volumes she completed are celebrations of an English tradition which is not stolid and insular but flavoured with the spices of the world. *Spices, Salt and Aromatics in the English Kitchen*, which builds on the interwar work of Hilda Leyel, is a glimpse of England's love affair with the ingredients of the Arabian Nights. And then, in the

1970s, Jane Grigson did for English food what her husband Geoffrey had done in the 1940s for English poetry. Very much in the spirit of his antiquarian anthologies, she gathered recipes from country kitchens and offered them to the common reader as an English inheritance. Her 1974 *English Food* was immediately recognized as a classic. Like Piper and Betjeman, she was recovering a whole English climate that had long been in need of a public advocate:

> There's much to be said, and more than is usually said nowadays, for a
> national cookery that has invented Queen of Puddings, Summer Pudding,
> syllabubs, gooseberry fool, Bakewell Pudding and that sweet concoction
> we now insist on calling crème brulee as if it were French and not the Burnt
> Cream of the English cooks of the eighteenth century.[38]

Where Florence White had recorded every frumenty recipe, paying witness to a dying rural art, Jane Grigson was more concerned with what might successfully be made in the modern kitchen. She selected carefully and made helpful adjustments, so that even a cook more used to opening jars could get a sensual, evocative taste of the past from John Evelyn's Tarte of Herbs or a Devonshire Squab Pie. Grigson used as her epigraph Parson Woodeforde's description of a hurried meal, an eighteenth-century notion of fast food. It was an image so far removed from modern England as to be nicely comical, but at the same time it was movingly familiar, as if an older relative had invited us, rather belatedly, for dinner:

> 29 February 1788: We gave the company for dinner some fish and oyster
> sauce, a nice piece of boiled beef, a fine neck of pork roasted and apple sauce,
> some hashed turkey, mutton steaks, salad, etc., a wild duck roasted, fried
> rabbits, a plum pudding and some tartlets. Dessert, some olives, nuts,
> almonds and raisins and apples. The whole company were pleased with
> their dinner, etc. Considering we had not above three hours' notice of their
> coming we did very well in that short time. All of us were rather hurried
> on the occasion.[39]

6

The CANON REVISED

In 1941, while he was working on his biography of Samuel Palmer, Geoffrey Grigson noted with amazement the unstudied, unappreciated state of English art in general. Centuries of painting – and what had become of it all? 'We have still only the beginnings of an art history'.[1] He was not alone in feeling himself to be starting almost from scratch. Early twentieth-century historians of English painting had at least one major predecessor, of course, in the giant form of John Ruskin. But Ruskin's Turner was not theirs, and nor was his adulation of the Pre-Raphaelites. Beyond these favoured subjects, Ruskin's prodigious energies had often been directed towards the art of the Continent. Piper worked hard to reclaim Ruskin's insights for England. In his article on 'Pleasing Decay', for example, he quoted a long passage from *Modern Painters* on Calais churches and advised the reader to consider English ones in their place. Ruskin is 'generally right', he said, 'allowing for a few Ruskinian prejudices – that things abroad are automatically better and truer and righter than things in England'.[2] Allowances, it seemed, always had to be made. But as contemporary painters increasingly looked to the example of English predecessors, and as the balance of power in the cultural establishment moved towards figures like Kenneth Clark and Herbert Read, both attentive to the distinct qualities of the native school, the names of English artists were starting to acquire new resonance.

In the formalist and internationalist view of Roger Fry, it was a mistake to get too bound up in the promotion of national culture. Fry argued in 1934 that, although patriotic feeling might have its uses, it should be 'rigorously excluded' from the practice of art history.[3] He was writing in his *Reflections on British Painting*, a book which grew out of a pair of lectures given earlier that year, timed to coincide with the Royal Academy's 'Exhibition of British Art *c.* 1000–1860'. The newspapers that spring were buzzing with interest in the exhibition and excitement about how impressive the British display had turned out to be. Fry was less convinced. Huge audiences gathered at the Queen's Hall to hear his lectures (there was seating for

two thousand and no space to spare). What he suggested to them, and what he published in the resulting book, was calculatedly provocative:

> We know when we think of names like Giotto, Raphael, Titian, Rembrandt, Velasquez, that we are speaking of a class of artists to which no English painter can possibly be supposed to belong [...] I have to admit sadly that British art is not altogether worthy of [British] civilization.[4]

Fry scoured British paintings for a sense of form and design, but he found very little. This was a grave shortcoming since, according to Fry,

> the power to see and feel plastic form is almost a measure of an artist's power to free himself from the interests of ordinary life and attain an attitude of detachment in which the spiritual significance of formal relations becomes apparent.[5]

English artists were doomed to fail Fry's test. He was not impressed by the 'roly-poly handwriting of Rowlandson', or by Hogarth's satires, lacking in 'focus' and obscuring the 'truth that art has its own specific function, that it conveys experiences which are *sui generis*'.[6] There were many points on which Fry's view had changed since the audacious essays of *Vision and Design* (1920); his low opinion of British art was not one of them. He had acknowledged the role of representation as well as form, but he was not going to read pictures like books. He was unwilling to immerse himself in the strewn, incriminating artefacts, the buttons, wigs and teacups, of Hogarth's *Marriage à la Mode*.

No writing on English art for at least the next decade could afford to ignore Fry's *Reflections*. But ideas were changing fast, and increasingly critics located the value of painting as much in its evocation of place as in its orchestration of forms. In the catalogue to the Royal Academy show, the curator W. G. Constable emphasized the capacity of English painters to respond to their surroundings. Their art, he wrote, is an answer to 'the physical and emotional call of a particular place, person or social group'; it is a 'humanised concomitant to the affairs of everyday life'.[7] Paul Nash was abroad at the time of the exhibition, but that year he too published an attempt 'to discover the essential spirit' of the English genius. What Nash emphasized most insistently was the connection with the land. The *genius loci*, he wrote, is almost the 'conception' of English art, and it was therefore fitting that when Nash wrote about his own work he described himself not as a modern master silently absorbed in his studio, but as an ancient huntsman 'hunting far afield over the wild country to get my living out of the land as much as my ancestors ever had done'.[8]

In the search for distinctly English forms of art, critics alighted upon the phenomenon of the landscape watercolour. Adrian Bury, an energetic advocate of early English drawings, responded to the watercolours on show at the 1934 exhibition as family heirlooms:

> In two small rooms is concentrated the essence of an achievement wholly and exquisitely English. It is as national as the language itself, as much part of England as her contours and climate.[9]

These raptures were typical of interwar writing about watercolours: even the most scholarly critics were moved to uncritical exclamations of delight. They agreed that in England, in the late eighteenth and early nineteenth centuries, the landscape watercolour experienced a golden age. If the medium could be exported, the subject matter to which it was so ideally suited could not: the damp fields and windy skies of the Romantic watercolourists were geographically specific. To J. B. Priestley on his *English Journey*, retiring from Birmingham's drearier sights to investigate the water-colours in the City Art Gallery, even the painters' names – Cox, Varley, Bonington – sound like English apples and towns.[10] The lyrical, small-scale watercolour deposed history painting as the genre of national self-definition. The tree in the field acquired the status of epic, 'as national as the language itself'. It was the cosiest of epics, easily domesticated. By 1945, the critic H. J. Paris was misty-eyed over this national possession: 'we love watercolours as things made by the Englishman at home' he enthused, 'as delightful things, personal things, like the taste of good food or wine, or the softness of silk, or the smooth damp sweetness of England after tea'.[11]

The cataloguing work of Laurence Binyon at the British Museum and Martin Hardie at the Victoria and Albert Museum had made it possible to study the development of individual painters, and to construct accounts of the watercolour school as a whole. Binyon himself brought together the findings of this new research in his landmark survey *English Water-Colours* (1933), which, for the first time, pre-sented the development of watercolour painting as a coherent story with a strong, appealing trajectory. He celebrated the convergence in the work of Girtin and Turner of two earlier traditions: the coolly objective recording techniques of early topographers like Paul Sandby and Thomas Hearne, fusing with the airy fantasies of John Robert Cozens. It was a kind of biography, the life-story of a technique, and it portrayed the watercolour as a perfect English character, combining practicality with Romanticism, starting out as military draughtsmanship and maturing into visionary art.

Binyon made his watercolours very English (even when their subjects were foreign, as very often they were), and he gave them modernist credentials too. He chose as his frontispiece *The Source of the Arveiron* (1781), the most nearly abstract of

Francis Towne *The Source of the Arveiron*, 1781

all Francis Towne's compositions. Great bulks of unfathomable rock rise monumentally above crystalline facets of glacial water, ice blues glitter in white sunlight. 'Form and colour appeal to [Towne] for their own sake,' Binyon tells us, 'almost as they might to an artist of our own day'.[12] The traffic between past and present moved in both directions. The bare, bright watercolours of Eric Ravilious have the voice of Binyon behind them, championing the modernity of Towne.[13] Binyon's watercolour tradition could even usurp Fry's Post-Impressionist canon to dominate the family tree of modernism. It is not without a hint of triumph that Binyon concludes his story with a tribute to John Sell Cotman: 'There was no need to invoke Cézanne', he writes, 'for Cotman was there to show the way'.[14]

The story of Cotman's reputation might in fact be read as a miniature history of aesthetics in the early twentieth century. Today he is one of the best-loved of English artists, admired for the ochre washes of his landscapes and churches, the sudden flashes of colour, the bold clean harmony he finds in a wall or a bridge. But it was not always so. He died in obscurity in 1842 and was largely ignored by the Victorians. It was not until 1922 that a dedicated exhibition was mounted at the Tate Gallery, and the following year the pioneering collector A. P. Oppé published a book in which he observed the 'emotional value' in Cotman's 'colour, line and massing'.[15] For the young students at the Royal College of Art in the 1920s, who would make regular trips down a fabled staircase from the College to the V & A just next door, Cotman was an inspiration. Ravilious, in particular, learned from his thin, glassy planes of muted colour. He visited Oppé's collection, and he went on admiring pilgrimages in search of Cotman's painting spots. J. M. Richards remembered a happy winter excursion in 1935 while he was staying with Eric and Tirzah Ravilious at the Midland in Morecambe. Oliver Hill's modernist building had not proved watertight, and Ravilious was repainting his damaged murals in the empty, closed hotel. The three of them took a day off for an excursion to Greta Bridge, which Cotman had painted in 1807. There, in the winter rain, they all paid tribute to him a hundred and thirty years later.[16]

In a 1937 article about Englishness, Nash described Cotman's 'truly architectural use of watercolour'.[17] Architectural? This was not the obvious way to write about a medium whose essential quality is transparency, and which tends towards insubstantiality rather than solid construction. But Cotman, it seemed, had been reborn as a modernist, and was described in the language that Roger Fry had developed for the advocacy of Post-Impressionism. Given Cotman's painterly architecture it was appropriate that his biographer should have been Sydney Kitson, a Leeds architect who developed a serious case of 'Cotmania' when he first saw the illustrations in Oppé's book. The authoritative biography he published in 1937 told the story of Cotman's youthful apotheosis, valuing most highly the early work in which Cotman uses flat, minimal washes and feels for the abstract interplay of forms.

Kitson delights in the pared-down drawings of 1805–6: Cotman had 'entered upon his kingdom'; he was an inspired artist translating an ordinary scene into 'something new for all time'.[18]

More tributes followed to mark the 1942 centenary of Cotman's death and everyone agreed that there had been 'an extraordinary change in the valuation of his achievement'.[19] He was now clearly established as a proto-modernist, with Martin Hardie referring to his 'significant form' and 'geometrical variations'.[20] But more attention was also being paid to his achievement as a great Romantic. He no longer had to be moulded as a European classicist (our answer to Cézanne) in order to fit contemporary taste. He could be welcomed as an Englishman and an antiquary. His art could be appreciated in all its impurity, its associated ideas, 'its owls, its epitaphs and its ivy'.[21] In a series of articles during the war John Piper did just that.

Piper's Cotman is very different from that of Oppé or Binyon. He is more interested in the rough, romantic texture of an old wall than in its solidity. Most of all he is a painter interested in communicating personal emotion, and in finding a 'simple, public method of expression'.[22] In 1934 Roger Fry had noted this personal vein in Cotman, and denounced it as 'sentimental vulgarity'. But he had been speaking in a different, pre-war world.[23] The experience of war had, in Piper's view, made more relevant than ever the vision of England delineated by Cotman. In a wartime climate characterized by both rapid destruction and appeals to the permanence of some essential Englishness, Piper observed that it was now more respectable than ever 'to recognise in Cotman a distant kindred spirit'. Cotman's sentimentality may have 'damned him in the aesthetic view of the nineteen-twenties, but it does not damn him for us'.[24] The viewer might now look at one of Cotman's desecrated chapels and find there a legible symbol of the death and decay visited on wartime Britain, and among the ruins some vestige of hope: some intimation that 'a phoenix would rise'.[25]

In much of this writing about British art the language was emotional and purposely fostered a sense of familiarity. The work of Nikolaus Pevsner, however, was just the opposite, which is perhaps why it carried such authority. Pevsner had been lecturing on the nature of Englishness since the early 1930s. His talks in Göttingen about 'Das Englische in der englischen Kunst' contained the beginnings of a life's work and, when he was forced by the Nazis to give up his academic work in Germany, Pevsner came to England and taught the English about their own traditions.[26] After extricating himself from an internment camp in Liverpool in 1939, Pevsner spent his war in London, fire-watching on the roof of Birkbeck College by night, and by day elaborating the characteristics of England's heritage in the

lecture hall beneath. The lectures were just as much his war work as the fire-watching: they aimed at the definition of an enduring English vision. In these wartime talks at Birkbeck, Pevsner was sketching out the arguments that would eventually form the basis of his 1955 Reith Lectures, published to wide acclaim as *The Englishness of English Art*.[27] So a book which belongs in some ways to a post-war world and to the second wave of aesthetic formalism also arises from a moment of urgent patriotism as each night Pevsner watched London under attack.

His method was determinedly scientific. He wanted to make a thorough and objective study of English art, from the smallest watercolour to the greatest cathedral window, describing accurately what he saw, and employing the rationalism of a foreigner evaluating a heritage not his own. Pevsner looked at England and English art with very different eyes to Piper, Betjeman, and Grigson, those native historians with whom his project might be compared. (The differences are palpable when you put a Shell Guide next to Pevsner's *Buildings of England*.[28]) But, like them, he made bridges across from the lessons of abstract contemplation to the embrace of antiquarian heritage. He developed a method of pairing apparently polarized works and locating their common denominator – which must, he reasoned, be inherent in the national genius. When Pevsner put Constable's steady, observant truth to nature alongside Turner's wildly free-wheeling 'fantasmagoria', he claimed that 'both are concerned with an atmospheric view of the world, not with the firm physical objects in it'. This mode of analysis extended to architecture: 'perpendicular is downright and direct. Decorated perverse, capricious, wilful, illogical and unpredictable'. Yet (with a little ingenuity) both could be held within a coherent corpus of Englishness because 'both styles are anti-corporeal or disembodied'.[29]

Pevsner had Fry very much in mind. As he explicitly stated, these 'reflections on English art were written in the hope of being able to get a good deal further than Roger Fry and to obtain more valid results by analysing a wider range of works of art'. So where Fry had looked only at painting, Pevsner took into consideration illuminated manuscripts, architecture and the decorative arts. And in another patriotic manoeuvre, Pevsner intimated that the 'spirit of the age' is not always to be embraced, and that the English had done well in avoiding the spirit of modernity. 'Art in her leaders is violent today,' he writes, 'it breaks up more than it yet re-assembles'. It is a good thing then that England has not been in the vanguard, for she 'dislikes violence and believes in evolution', standing by the positive characteristics of conservatism – 'faith in continuity and a dislike of breaks'.[30] No revolutions on the canvas: no revolutions on the ground.

It all made a difference. Writing his 1942 article 'On Pilgrimage in England' and surveying recent cultural discoveries, Edmund Blunden announced theatrically that the last few years had seen 'the unveiling of the great British school'. He listed the names that had come to signal the 'triumph of our home painting' –

John Sell Cotman *A Sarcophagus in a Pleasure-Ground*, c. 1806

'Rowlandson, Cotman, George Stubbs, Francis Towne, Turner of Oxford (the other we had always with us), Samuel Palmer' – and concluded with satisfaction that they are 'magical'.[31]

With the visual arts becoming more integral to English life, it was fitting that the National Gallery should become a meeting place for Londoners in wartime. Like the dome of St Paul's, which remained miraculously intact night after night through the Blitz (rising serene above chaos in Herbert Mason's much-publicized 1940 photograph), the Gallery was a symbol of survival. Large crowds came to hear the daily lunchtime concerts organized by the pianist Myra Hess, who secured the services of musicians like Benjamin Britten and Michael Tippett, and ensured that sandwiches were laid on by a formidable canteen committee. Her own performances became legendary. While playing a quieter variation of Schubert's *Impromptu in B-Flat Major* one lunchtime, Hess heard a flying bomb approaching. She handled the situation with gusto by playing a 'tremendous crescendo to cover the noise'. Her audience did not notice, or pretended not to notice, that anything untoward was going on.[32]

The gallery walls had been stripped of their Constables and Cromes, and the collections evacuated to abandoned mines in Wales. They were not entirely safe there, threatened as they were by occasional rock falls and unstable humidity, but it was hoped that they would escape the bombing. Many of the large rooms at the Gallery were left echoing sadly, their purpose suspended. There were well-attended exhibitions of work by the official war artists, however, and each month a single painting from the permanent collection was brought out of store and put on display. These pictures became symbols of a whole heritage temporarily in packing cases but alive all the same. The editor of the *Burlington Magazine* (the Finnish scholar Tancred Borenius) described the 'beehive-like' activity around these pictures as dozens of visitors focused their attentions on a single work. He set down for posterity the list of paintings shown, feeling that this 'anthology' was a significant indication of the 'artistic orientation of the time'.[33] The choices were not eccentric. Few would quibble with Titian's *Noli Me Tangere*, or with the intimate tranquillity of a Pieter de Hooch courtyard; Tintoretto's *Saint George and the Dragon* was obviously apt. The choice of English pictures is telling, however. From the Gallery's collection of Turners it was not a scene of sublimity that was selected in the summer of 1942, but *A Frosty Morning: Sunrise* with its quiet horses and rustic figures, soon to begin their daily work. Humanity is not a sideshow to nature's spectacles as is so often the case with Turner. Here the rising sun has potential not only to create aesthetic effects, but to warm the pinched country people. Nearly six hundred people each day came to see this landscape of subtle optimism in which airborne Turner comes down to earth.

This work of cultural discovery might seem marginal to the story of England at war, but it was very much a part of the Home Front effort in a campaign that was being fought explicitly in terms of heritage. When British forces bombed the Old Town of Lübeck in 1942, the reprisal came in the form of the Baedeker Raids – on ancient cities like Exeter, Bath, York and Norwich. German propagandists claimed that they would work their way through the Baedeker tourist guides, targeting not centres of commercial or military strength, but repositories of national tradition. Culture was under attack and had to be mobilized.

The wartime flourishing of public interest in the arts has been much remarked upon. Paul Fussell documents the avid demand for books (especially long ones, especially Trollope), both at home and in the forces. Marvelling at the huge numbers of people who turned up to see exhibitions of war art, Brian Foss describes a 'renaissance' in public demand for the arts.[34] The establishment of CEMA (Council for the Encouragement of Music and the Arts) marked the beginning of state arts funding, giving support to thousands of organizations from touring players to colliery music groups. And then there was the genial voice emanating from the wireless.

The radio had become a standard household item by 1939 and the BBC commanded unprecedented authority as a cultural arbiter. Under John Reith in the 1930s the Corporation had aimed to raise public taste and although the wartime Forces Programme did more to supply light entertainment, there was not much sign of standards being lowered. The philosophical discussion programme *The Brains Trust* was the improbable broadcasting success of the 1940s, with around 10 million listeners tuning in each week.[35] Radio was the new medium of the public intellectual, who might address his or her audience on art, literature, politics or ethics, providing an education while also fostering an atmosphere of intimate conversation. The voice on the radio was authoritative, but it also aimed to be the voice of the man next door. Perhaps there was a regional accent (like J. B. Priestley's broad Yorkshire); almost certainly the presenter addressed you as a friend sitting just the other side of the fire.

The measured, familial tone of the radio talks was also the tone of English propaganda. Less shouting; more rational conversation. Hilda Matheson, who had pioneered radio 'talks' in the 1920s, brought all she knew about intelligent broadcasting to bear on her new tasks at the Ministry of Information. One of her big successes (though she died, partly from over work, before it came to fruition) was 'Britain in Pictures', a series of short books published by Collins with plenty of illustrations, each offering an enjoyable account of a British institution or custom. Over eighty titles were issued during the war, from *British Merchant Adventurers* to *English Inns*, accumulating to form an anatomy of the nation. They exemplified the form of self-reflexive anthropology that flourished in wartime Britain, bearing witness to

Lady Gator's Canteen Committee outside the National Gallery, London

the fugitive details of a culture under threat. So wild flowers and table manners were crucial to the group portrait, and the private voice counted for most in this public keeping of accounts. When the chief editor of Collins saw the bright volumes displayed in a seafront bookshop, they struck him as the 'defiant cockades that a nation of shopkeepers might justifiably flaunt in the faces of their book-burning foes'.[36]

'Britain Blows her Trumpet!' read the advertisements, but although there were some small trumpet flourishes there was little pomp and circumstance. Moderation, balance, proportion, compromise: these were the watchwords of the series. Vita Sackville-West was proud to write that 'England is not an exciting country' in terms of landscape and climate, and 'this moderation reflects itself in our temperament'.[37] This was the rhetoric of calm in the face of the storm. The books gave an impression of four-square stability, in keeping with all this slow, sane observation, though often they were written on the move, in the most unstable conditions. Graham Greene wrote *British Dramatists* on a boat to Africa, typing his manuscript on borrowed typewriters in remote ports; Elizabeth Bowen wrote her *English Novelists* while to-ing and fro-ing on official duties between England and Ireland.

Bowen's contribution to the series is a brisk, incisive piece of literary criticism, but it wears its learning lightly. Bowen addresses herself to the common reader in an armchair, with the great writers by his side. 'England's past in art, as well as in history, has helped to build up her heroic To-day,' she writes, 'it is natural to want our writers beside us as we face this new phase of human experience.' The novelists seem especially close because, 'while in painter or poet we expect the sublime (or timeless), in the novelist we expect the familiar, the day-to-day'.[38] Bowen sketched the history of the novel as a self-portrait of the English, from the rational, orderly surface to the 'shadowy, deep underneath'. Dickens, for example, has 'zest and humour' but also a 'nervous, or dusky' side. In *The English Poets* David Cecil imagined English poetry as more like a landscape with a wind blowing though it: the central line of development is represented by the 'fresh gale, racy with the smell of earth' that blows through the pages of Chaucer, and the poetry of Blake which affects the reader like the 'rush of the wind in the tree-tops'. Milton, by contrast, 'all marble and precious stones', exemplifies the 'un-English type'.[39]

In their 'Britain in Pictures' volumes, both Bowen and Cecil promoted literature as the expression of a whole people, and Graham Greene's *British Dramatists* insisted on drama as a communal art. Greene likes to think of drama's raucous, demotic beginnings. The play moved from the church out into the churchyard, he writes, 'where the feet of the mob trampled over the graves'. There in the open air the plays 'grew, like a church, anonymously'. But the puritans put an end to this, and 'the drama will not really interest us again until the audience has once more become popular'. Greene's enthusiasm is firmly focused on the popular, outdoor side of English life that dominates 'Britain in Pictures'. What he waits for, although he is

not clear whether it has yet arrived, is the point at which 'the line curves and returns to the market where we started'.[40]

The 'Britain in Pictures' emphasis on a common heritage, vitally rooted in everyday life, was very much in tune with contemporary ideas in literary criticism. All through the interwar years literary histories had been haunted by visions of ideal societies producing immediately expressive art. Mostly they took their lead from T. S. Eliot, who in 1921 had made his seminal diagnosis of modern literary culture. There had been, he said, 'a dissociation of sensibility', a fatal break between language and experience. For the metaphysical poets of the sixteenth century, he argued, a thought was an experience, something organic and felt. By the mid-nineteenth century a change had occurred, not just in poetry (though it was apparent in poetry) but in the 'mind of England'. Browning and Tennyson, unlike their Renaissance counterparts, 'do not feel their thought as immediately as the odour of a rose'.[41] Eliot's theory initiated a whole series of accounts charting, each with slightly different inflection, the estrangement of literature from ordinary experience, and lamenting the worship of the abstract over the local. F. R. Leavis, ten years younger than Eliot, profoundly affected by his experience of war and, by 1930, just emerging as an influential force in the Cambridge English faculty, constructed a major critical enterprise around the founding idea of an 'organic community' slowly deadened by the industrial revolution. Seizing on Eliot's theory of dissociation, and on his own concepts of a rural society integrated by common physical work and the vitality of the spoken word, Leavis set out to rewrite the history of English literature.

In *Revaluation*, published in 1936, he constantly evokes the rural and local, the down to earth in the most literal sense. He takes Shakespeare and Donne to be the presiding geniuses; Donne's use of the speaking voice, 'the sinew and living nerve of English', is the benchmark by which his successors are measured.[42] Leavis enjoys Jonson's 'rooted and racy' English; Wordsworth's chief characteristic, in Leavis's view, is his 'firm hold upon the world of common perception'. Even Keats, who by the 1930s had come to be seen as an exquisite precursor of Victorian aestheticism, is remade as a poet of that 'concrete vigour' which is a 'native English strength'.[43] This was a powerful attempt to define a coherent English canon. And although Leavis's milieu and discipline was very different from that of the *Axis* group, he makes a related call for a reconnection with *things*: stones and leaves, trees and waves.

There were some high-profile casualties of Leavis's canon-making, and the greatest casualty of all was Milton. The Leavisite creed of indigenous, vernacular immediacy turned England's epic poet out onto the building site: 'a good deal of *Paradise Lost*' wrote Leavis 'strikes one as being almost as mechanical as bricklaying'.

Milton, he argued, focused 'rather upon words than upon perceptions, sensations or things', resulting in literature that is fundamentally estranged from daily life.[44] Here was a 'dissociated' sensibility if ever there was one and Leavis agreed with Eliot that Milton had a 'dazzling disregard of the soul'.[45]

Milton's position in literary history was the subject of fierce dispute. The interwar battle for his reputation became a battle for the character of the English canon as a whole. How could Latinity, epic, indoor learnedness, be the keystones of a tradition increasingly identified with the 'rooted and racy', the immediate, the common-sense, the out-of-doors? 'Milton's dislodgement, in the past decade, after two centuries of predominance,' wrote Leavis in *Revaluation*, 'was effected with remarkably little fuss.' It was effected at just the time when formalism in the visual arts was being challenged, a time when the appeal of associated ideas, long derided by Fry as impostors in the world of the picture, were bubbling up among pure abstractions. The notion of 'architecture' in art, so important for Fry, yields for Leavis only a whiff of 'inertly orthodox generalities'.[46] And so, against the architecture, the abstractions, the *dissociations* (as he saw it) of the Miltonic tradition, Leavis championed the 'local life' of vernacular literature.

Leavis's dramatic revision of the canon shaped the period's other projects of revaluation. The potent imagery of lost wholeness appealed to Auden, who had a strong taste for oral culture and ballad-forms. In the mid-1930s he worked on an anthology called *The Poet's Tongue* which bears many Leavisite hallmarks in its attentiveness to the needs of students and in its idea of a whole community's engagement with poetry. The book was a collaboration between Auden and John Garrett, the charismatic headmaster of Raynes Park County School for Boys. Garrett liked to make connections between the life of his school and the most advanced of literary activities: he roped in Auden to write the school song, and badgered T. S. Eliot into awarding the prizes on Speech Day. Committed to this spirit of integration, *The Poet's Tongue* was a landmark anthology which promoted the idea of a common poetic language that could be understood by children and adults alike. The editors were trying to bridge the gap between highbrow and low, a gap which they thought should never have opened. Leavis had venerated the demotic, varied, integrated culture of the 'organic community' and bitterly lamented its demise; Auden and Garrett state similarly their commitment to the local. 'Universal art can only be the product of a community united in sympathy, sense of worth, and aspiration'.[47]

The quest to record the art of such communities was one of the most distinctive and energetically pursued activities of cultural historians between the wars. Oral culture, in the period of its decline, had never before been held in such esteem by the literate; all over England written records of it were being made. The anthropologist and country writer H. J. Massingham, for example, collected a 'jest-book or florilegium of tales of the humour of the hills and the Vale of Evesham', and Edith

Olivier, always an attentive observer of Wiltshire life, recorded the Quidhampton Mummers' play, asking each of the actors to recall the part that had been passed down to him from his ancestors.[48] Florence White's search for ancient inherited recipes was part of this same eclectic movement.[49] This was the sort of thing that Evelyn Waugh moaned about in *Labels* ('Ye Olde Inne and the Kynde Dragone'); it was the cult of authenticity that drove Sitwell to façades and Beaton towards his skin-deep veneers.[50] But these different calls to the past interacted and played off each other, and all went in search of English traditions which might offer a model for future renewal.

Remembering the organic community was itself a communal effort. Writers, artists, farmers, social historians, musicians – all came to a shared recognition that it was the duty of their generation to bear witness to the dying arts of the countryside. Certainly musicians had been passionately involved in this project since the turn of the century. Ralph Vaughan Williams had a moment of revelation in 1903 when he heard a folk song called 'Bushes and Briars' sung by a Norfolk shepherd and felt a profound sense of recognition. That same year Cecil Sharp collected his first folk song and over the next three decades, just as it died out almost completely from the fields and villages, folk music acquired the status of a national cult.

Vaughan Williams revised the canon of English music so as to reflect its ancient, rural roots. Early on, he replaced the nineteenth-century establishment voice of *Hymns Ancient and Modern* with the traditional folk carolling of his *English Hymnal*. Then his 1925 *Songs of Praise* and the 1928 *Oxford Book of Carols* became popular national treasuries of folk poetry and music. The sense of familiarity that he first experienced when hearing the Norfolk shepherd was enduringly important to Vaughan Williams, whose highest praise for a work was to say that it was as if he had known it all his life. This was the intended effect of the work he composed to represent British music at the New York World's Fair in 1939. It was based on five surviving variants of the folk song 'Dives and Lazarus' and the listener, he hoped, would feel himself sheltered from a world of violence, safe for a short moment (and it is purposely a short piece) in the company of cellos and harps, part of an ancient land.[51]

The English Musical Renaissance, as it was known at the time, had begun with Edward Elgar and Frederick Delius, and came of age between the wars as a movement both historicizing and contemporary. Compositions emerged that defined both the past and the present of English culture: Peter Warlock's *Corpus Christi Carol*, Vaughan Williams's robust *Five Tudor Portraits*, Ernest Moeran's *Symphony in G Minor*, with its alternately fluid and disjunctive reworkings of East Anglian songs, Michael Tippett's early madrigals, John Ireland's visions of the Sussex Downs.[52] Not everyone agreed that the folk movement had a fruitful effect on English music. Britten, for one, thought it falsely nostalgic, and 'not genuinely of the

people'.[53] He was certainly right in the last point: folk song had not played much part in musical life for centuries. The point of the revival was to close over the gap, asserting by sheer force of will that the vital rhythms of English music had been continuous across the ages.

Where the folk revival was potentially limiting, the closely related return to Renaissance court music offered both patriotic appeal and more scope for complex experiment. Britten turned to the 'discordant harmonies' of Purcell, taking inspiration from his fusion of the familiar and the strange. Extensive scholarship on sixteenth- and seventeenth-century music, pioneered by Arnold Dolmetsch and gathering momentum all through the 1920s and 1930s, opened new possibilities for composition. Just as medieval stained glass suggested to John Piper ways of understanding the abstractions of Léger, early music offered English composers new perspectives on the modern. It is characteristic of this generation that Peter Warlock, whose 1926 book *The English Ayre* recovered a whole corpus of early songs, was also the first Englishman to write a substantial appreciation of Arnold Schoenberg.[54]

In 1938, while Vaughan Williams was setting 'Dives and Lazarus', Piper was considering the work of the early sculptors, and Woolf was collecting folklore and rhymes for *Between the Acts*, Auden published his *Oxford Book of Light Verse*. In it he traced the survival across the centuries of the socially integrated poet – from the earliest anonymous balladeer to John Betjeman. It is a playful collection, mischievously planting *Don Juan* in among ballads and ditties, nursery rhymes and riddles. It is also Auden's brilliant correction of the wayward obscurity and conspiratorial secrecy that characterized his own early poetry. The light verse forms he was now using, and which he collected in this anthology, represented the antithesis of the codes and signs and cultish diagrams that made his early poems so forbidding to the uninitiated reader. Auden the occultist was making a sustained attempt to promote the social function of poetry. He was arguing that, although one of the legacies of Romanticism was a notion of the poet as inspired outsider, a seer doomed to be misunderstood, there was an older and equally valuable tradition of the poet as insider, able to speak with, and on behalf of, the people around him. This is why Auden was so admiring of Betjeman, and why – only partly tongue-in-cheek – he wondered whether he had in fact given birth to the bicycling balladeer who was an extension and completion of himself: 'I can never make up my mind whether Mr Betjeman was born after the flesh or whether he was magically begotten by myself in a punt on the Cherwell one summer evening in 1926'.[55] It was as if from the same Oxford beginnings these two poets had come to embody two branches of literary culture and now fantasized about reuniting.

Auden prefaced *Light Verse* with an abbreviated history of literature. He looked back to a medieval society 'united in its religious faith and its view of the universe', a society in which the poet was at one with his contemporaries and making poetry in their language. 'Till the Elizabethans, all poetry was light', he argued: light in the sense of expressing the 'experiences of the poet as an ordinary human being'. But Auden then traced poetry's retreat into highbrow introspection: 'As the old social community broke up, artists were driven to the examination of their own feelings and to the company of other artists'.[56] The detached writer may have gained in objectivity, but he was divided from his audience and struggled to communicate. It was the story of Auden's own writing – and to compensate he enrolled himself in the 1930s effort to recover the art of the group.

Auden selected verse that was intended to be spoken or sung, or that took for its subject-matter the 'everyday social life of its period'. He looked for verse that was 'simple, clear and gay' – adjectives used by Piper and Grigson in *Axis* to describe the kind of English painting to which they hoped to return. Like Leavis and Eliot, he demoted Milton and his descendents while promoting the 'speaking voice' of the anonymous balladeer, allying himself with Wordsworth's advocacy of natural speech in the *Lyrical Ballads*. The integrated group poet can also be an eccentric individual, so the socialist exercise of celebrating the poetry of the people expands to include the aristocratic Byron, and the deeply conservative Betjeman, with his middle-class, Anglican-antiquarian tribute to Westgate-on-Sea. Auden was not suggesting that what he chose was the 'greatest' literature. But it was clear to him that the verse which best communicates with the English is often the most thoroughly engaged with convention, tradition and familiar provincial life: verse with recognizable sentiments, poetry close to home.[57]

Auden's *Light Verse* was one of hundreds of anthologies that appeared in the late 1930s and during the war, and which saw their task as an urgent saving up of England's heritage. They were storehouses and hold-alls, containers in which to put personal treasures. And the anthology infected other genres with its elasticity. It lent its acquisitive aesthetic to the novel, to cinema, to painting and architecture, all of which stretched their limits to see how much of the past they might hold.

Anthologies and novels are closely related: they are cumulative literary forms which resent containment. Stevie Smith made this point emphatically. Her two novels of the 1930s, *Novel on Yellow Paper* (1936) and *Over the Frontier* (1938), are narrated by a compulsive anthologist called Pompey Casmillus, who spends a good deal of her time pruning and grafting quotations, and misremembering verses. Because she regards her narrative as a capacious anthology, gathering up disparate observations and re-telling long stories, she is happy to devote a central portion of

Novel on Yellow Paper to a parlour game in which the reader must guess the source of literary extracts and cultural snippets. The difficulty with anthologies is finding a place to stop, but Pompey has firm tactics for the problem of endings: 'I shall know when to stop, and I shall stop. And whatever I write then will be Volume Two'.[58]

Wartime encyclopaedists, aware that there may not be time for Volume Two, squeezed their belongings into tighter containers. The literature of 1939 and 1940 is full of references to bags, pockets and boxes. In a wartime essay on Coleridge, Virginia Woolf described his long sentences 'pocketed with parentheses', imagining the brackets as handy places in which to put extra bits and pieces.[59] Henry Green called his autobiography *Pack My Bag*, adopting the last words of the philosopher F. H. Bradley. If Green was going to die he wanted first to have packed his bag with remembered oddments: 'Everything must go down that one can remember, all one's toolbox, one's packet of Wrigley's'.[60]

In this spirit of collecting, Geoffrey Grigson made his anthology *The Romantics* (1942). If only everything *could* go down: Grigson fantasized in his preface about an all-inclusive quest, a 'vast following out of *The Road to Xanadu*'. He was thinking of John Livingston Lowes's fanatically detailed study of Coleridge's sources, an epic attempt to reconstitute the mental card index of the poet. Grigson wanted to immerse himself in the Romantic imagination, retracing the road 'inch by inch':

> reading the philosophers, the mystics, the theologians the travellers,
> the plant-physiologists, the chemists, the antiquaries, the anatomists, the
> speculators, the transactions of all the societies, the buildings, the gardens,
> the curved mahogany doors and the ivory door plates; the auriculas
> and the pinks [...] and piecing together the chryselephantine image
> of the Romantics.[61]

Grigson's anthology is the next best thing. Once inside his strange museum we find a list of 'reasons why the Druids were fond of foxgloves' presented by the antiquary William Stukeley, and we are told to 'compare the contents of Stukeley's head' to the exhibits in 'Glass Case no VI' in Don Saltero's 'Coffee-House of Rareities', which includes an owl moth, pods of tamarinds and an alligator's egg.[62] In the same way that Livingston Lowes had sorted through the contents of Coleridge's head, Grigson imagines the mind as a kind of anthology, and the anthology – or museum case – as a map of the mind. Each item is unique and not just an example of a tendency. As Grigson said much later, 'a poem isn't a Member of Parliament and can "represent" only itself'.[63] Half the electorate must therefore come too. There are extracts from diaries and reference works, and notes made by painters: 'the colours in a Reynolds or a Gainsborough dress [...] the gleaming ivy on the ruined arch of a

Gothick Abbey [...] The crash of the tower at Fonthill', the crash William Beckford was sorry to miss – because he would have enjoyed the sheer exhilaration.[64]

Even Grigson's endnotes are miniature essays full of miscellaneous objects. He recalls that one poem was found in a 'Regency picture, framed with seaweed'; Coleridge's poem 'The Aeolian Harp' is the prompt for a full history of aeolian harp production. Coleridge's own harp, notes Grigson, was made by the farmer's boy Robert Bloomfield, and Coleridge kept it clamped in the window of his cottage at Clevedon. A generalized religious verse by Christopher Smart prompts in Grigson the most specific of recollections, of an 'eighteenth-century altar-cloth in the Chancel of Cliffe Pypard church in Wiltshire'.[65] It is appropriate that the book should be dedicated to that other itinerant antiquarian John Piper, and that the dedication is followed by a record of the places they have been together: 'Bupton, Clevancy, Hafod, Fawley & Snowhill'.

Small humane details and familiar-sounding places came crowding into the many anthologies intended for a readership far from home in wartime. Compiling a selection for troops in 1939, Herbert Read was, like Henry Green, thinking about luggage. He produced a little book in a durable, wrap-around binding, conveniently sized to fit (like Penguins) into a soldier's pocket – or his bag. The book was called *The Knapsack*: it was easily portable, and it was in itself a kind of bag, packed with a soldier's mental survival kit. Read wanted to include something for every mood. So he put into the knapsack a great range of things, from Spinoza's philosophy to Edward Lear's nonsense rhymes. There is a series of biographical pieces, such as Hazlitt's inviting sketch of Cobbett ('we feel delighted, rub our hands and draw our chair to the fire', writes Hazlitt, 'we sit down at the table with the writer [...] to a course of rich viands, flesh, fish and wild-fowl').[66] There are accounts of war ancient and modern, but there is also 'The Jumblies' and some suitably 'earthy' lyrics. Among a group of nature pieces there is Proust's swelling description of the hawthorn bushes along Swann's Way, and rapid daily notations from Gilbert White's diary, which takes the soldier through a whole 'English Year', from the humming of bees in July, to the retirement of Mrs Stokes's tortoise on 25th November. Aesthetic proliferation was an appealing distraction from austerity, and in the conservative mood of wartime such details were stored up with greed.

Herbert Read's *Knapsack* was designed to be part of a soldier's equipment, and another popular anthology, Field-Marshall Wavell's collection *Other Men's Flowers* (1944), also established itself firmly on the front lines. Wavell drew on the oral tradition to promote poetry as a living force, taking memory as his organizing principle. In a period of six months away from the Front in 1941, between operations in the Middle East and his departure for Burma, Wavell wrote down the poems that he knew by heart. He did so as part of an exchange of views with his son, who shared his love of poetry but whose tastes were different. So, as his son recalled,

'it began as an idea for a family conversation but we gradually prevailed upon him to let the world join in'.[67]

Since learning to recite Scott as a boy, Wavell had been building and furnishing this store of memory, and now, he wrote, 'here is the finished house'. This was not only poetry as armour, but poetry as a portable home. However personal his selection, Wavell envisaged literature as a public force, and in this sense his anthology shares Auden's conception of light verse as part of the spoken life of a community. Great poetry, to Wavell, was that which lent itself to recitation. He noted with admiration the 'gusto' with which Churchill declaimed verse and used it as a rallying force. T. S. Eliot by contrast had shirked his duty to communicate to men by 'wrapping his great talent in the napkin of obscurity'.[68]

Wavell's taste for 'old favourites', for poetry with rhythm and gusto, won him enormous popularity. In a preface to the 1947 edition of his book, Wavell recounted the story of one particular copy during wartime. A soldier had been reading it carefully during the period leading up to the D-Day landings. As he read each poem he annotated it with the date, and sometimes with the circumstances, and he added his comments. He read the last of the poems on the crossing to Normandy, where he died shortly afterwards. The book was saved, and later sent to Wavell by a friend.[69] Wavell's 'finished house' of remembered words had now been extended by other minds, other lives. He had started a conversation that would go on.

7

The WEATHER FORECAST

It can be intensely moving to find notes in the margins of a book, or a train ticket from some forgotten trip tucked between the pages. You remember, or imagine, the place in which it was read – the mood, the time of day – and these things become part of the book itself. The soldier's notes in Wavell's anthology were an extreme instance, a last memory trace, but that deep responsiveness to the environment of reading and writing runs through much of the art of the 1930s and 1940s. This art has an acute sense of place and (since its processes are more important than its inertly finished products) it likes to betray something, too, of the place in which it is made. Often artists and writers choose to work in places where the weather can get in: they leave open windows in the studio, or they leave the studio behind and opt instead for a draughty church or a windy beach, or a caravan on hummocky common land.

The twentieth century threatened to alienate people from their weather. The modern house was efficiently insulated and there was no need to get wet when you left it because the motor car would take you where you wanted to go. And perhaps there was not much good weather left anyway: the Victorians had used it all up in their long, moist, mossy century. This, at least, is what Stevie Smith suspects. Wry and wise, always attentive to the unpredictable emotional micro-climates of her much-loved London suburb Palmer's Green, Smith is an acutely weather-conscious writer. She is often nostalgic about the Victorian damp she remembered from her childhood. Her weather-watching narrator Pompey in *Novel on Yellow Paper* imagines nineteenth-century England to have been soaked with rain, and she hears a constant dripping in the background of its literature. 'How richly compostly loamishly sad were those Victorian days', she broods, before launching into a wallowy fantasia on Tennyson's mournful 'Tithonus':

> How I love those damp Victorian troubles. The woods decay, the woods decay and fall, The vapours weep their burthen to the ground, Man comes and tills the field and lies beneath, And after many a summer dies the swan. Yes,

always someone dies, someone weeps, in tune with the laurels dripping, and the tap dripping, and the spout dripping into the water-butt, and the dim gas flickering greenly in the damp conservatory.[1]

The dripping and weeping are one and the same: weather and emotion go together. Smith has a sense that, in improving our plumbing and stopping up drips, we may also have stopped up some vital flow of feeling. Part of the artistic project of the 1930s is therefore to recover the leakages.

In a radio broadcast about the poet Thomas Hood, Smith spoke of the 'complicated feelings that come to those who walk alone in the damp'. She was acutely sensitive to those feelings and her fiction celebrates the poetics of moisture.[2] Pompey is the kind of person who, when she opens a book or looks at a picture, is entering a landscape and letting the climate seep into her. Hence her extrapolation from 'Tithonus' to a whole weeping, vaporous world, starting in the conservatory and gathering momentum until the drip has become a flood, gushing along through overflowing dykes between 'sodden fields'.[3]

The watery images generate each other because water is, for Pompey, a source of imaginative energy. 'A heat wave and all the fixed hard colours take it out of you', she explains, 'but these days of murk and mess and a high wind, if I can have that too, puts it back into you again'.[4] Smith's narratives are founded on this feeling for mess, and for one thing being blown or washed into another. Commas and full stops are used grudgingly because they puncture language and fix it hard, like the landscape in a heat wave. Far better to let one clause run into the next, fertile and fluid. The printed word, which is fixed on the page, aspires to be as smudgily mutable as a raindrop, and English grammar unlearns its clean manners in the effort to be murky.

Smith writes desolate poetry about when the tears and the streams refuse to come. 'Happy the man of simple span / Whose cry waits on his pain', she says, but there is no such relief for those whose sadness outlives or eludes the stock of tears: 'The clouds hang down in heavy frown / But still it does not rain'. Her places suffer likewise. She mourns for Brickenden in Hertfordshire, which is damp enough but appears to have no proper stream:

Hadst thou thy stream,
O wood of Brickenden,
This had been
Paradise.

Paradise must have a river running through it, a life-source and 'translucent drain'. The poet turns diviner, beating the bounds of a wood that mocks her with its

'profligate viridity' and 'pashy ground', before settling at sunset to write 'the tragedy of unwatered country'.[5]

Smith is a passionate advocate of close relations between art and place. She writes explicitly about the question – a very urgent question in the art of the 1930s – of whether art should work towards placeless universality or openly declare its origins. In *Over the Frontier* (1938) she has Pompey give an opinionated speech about locality. Pompey is convinced that 'inspiration feeds upon the matter at hand'. Surveying Spanish and Dutch varieties of painting, she concludes that the greatest art is saturated in national characteristics:

> There can be no good art that is international. Art to be vigorous and *gesund* must use the material at hand. *Numen inest.* Oh the folly and weakness of foreign travel in search of inspiration.[6]

She quotes an aphoristic couplet from the home-loving poet William Cowper: 'How much a dunce that has been sent to roam, Excels a dunce that has been kept at home'.[7] It is as if she is punningly agreeing with Piper's parable about the humiliations of the 'wander wit' who went to Rome without having seen Stonehenge. The dunce at home must possess at least some native intelligence, and as for the artist at home, he is the supreme creator.[8]

Smith herself had roamed extensively: she was a European thinker, whose writing is seasoned with foreign words and classical reference. It was typical of her to espouse locality in a sentence that mixes up English, German and Latin. But she was proud to live in the same house all her life, and intent on translating the world into her own English idiom. Home is the point she comes back to, and from which all of her writing grows.

Because the English climate is unstable and unpredictable it is a symbol of Romantic changeability. Roger Fry found this extremely irritating. He complained about the 'ugly black English weather', and he sought instead the strong light of southern France for his painting. The artist he most admired, Cézanne, had moved away from the misty uncertainties of the Impressionists and painted Provence as something crystalline and eternal. The artist's role, as Cézanne and Fry conceive it, is to see *through* the incidentals of atmosphere, reaching for the unchanging structures beneath. When Fry tried to paint England there was so much weather that it got in the way of any such penetrating vision: 'all the trees have collected gloomy inky shadows round them and I want clear-cut shapes and colours', he protested. 'No one ought to try to be an artist in England.'[9] But the English eye saw the inky shadows as the dark source from which art might emerge.

The film-makers Michael Powell and Emeric Pressburger, who worked together as 'The Archers', made dark skies the subject of some comic and patriotic

rejoicing, suggesting that bad weather is not only life-giving but life-saving. Their 1946 film *A Matter of Life and Death* begins with a thick black fog rolling in over the South Coast – a fog so thick and black that when a Lancaster Bomber pilot jumps from his burning plane into the clouds the messenger sent from Heaven to escort him to the land of the dead loses sight of him completely. This turns out to be fortunate for the pilot, Peter Carter, who is, appropriately, also a major contemporary poet. Having fallen several thousand feet to certain death, he wakes up on the beach, alive. The exact weather conditions and timing (2 May 1945, ten past four in the morning) are crucial. Death has been caught out, rained off. 'I missed you because of your ridiculous English climate', says the (French) messenger from the other world. By the time Peter has settled into being alive again, the obliging fog has passed, the sun has come out, and England has become a land of glorious Technicolor, as opposed to the dull black-and-white of the efficient, orderly Heaven he has so narrowly escaped. In a film about an individual cunningly flouting the system, fog becomes the benevolent force that confounds rationalism and champions the idiosyncratic. The dead are filed away in Heaven, neatly grouped by era and category; by contrast the fog permits mistakes and obscurities. It is no less than a symbol of imaginative freedom. The weather in Heaven seems always to be the same; far better the surprises of life, and of England.[10]

No painterly medium could be more suited to a moist climate than one based on water. The ruralist Thomas Hennell evoked the wateriness of both climate and painting in an essay 'In Praise of Water-Colour' (1943). He had a punishing technique of painting when it was about to rain, when the 'atmosphere is limpid'. But one must be quick to capture it, he warns: 'now is the moment', soon the clouds will disperse or condense,

> and now comes the rain [...] the jealous god Jupiter Pluvius and his minions soon wash the drawing into shapelessness, rip it off the board and flap it in the mud.[11]

Like Paul Nash's description of the landscape painter as an ancient hunter roaming 'far afield over the wild country', this is the testament of an outdoor artist.[12] With his drawing board stuffed down the back of his jersey to protect it from the rain, Hennell cut an eccentric figure as he cycled along on his painting trips, distinguished by 'a peculiar flat silhouette'.[13] His conception of art could not be further removed from the controlled studio environments so beloved by the Post-Impressionists, who counted still-life as the 'purest' kind of art and carefully positioned the placard: do not touch. For Hennell the moment was all, and he was ready to seize it, his delicate

Thomas Hennell *Lime and Frost*, 1942

paintings energized by the possibility of their imminent and soggy return to nature. Eric Ravilious shared Hennell's hardiness. 'I sit like a rock in any wind' he told Tirzah in a letter home from Wales in winter 1938. And a month later the wind was still blowing: 'the paper won't stay on the board and washes are a bit difficult to handle and my hat blows off'.[14] This was all part of the process.

John Piper, too, liked to work outside whenever he could, and loved the odd blots and splashes that arrived unexpectedly in his paintings. Blots, after all, are potent things. The early Romantic painter Alexander Cozens developed a 'blot technique' that made the artist an imaginative interpreter of accidental splodges; the psychoanalyst Hermann Rorschach, in 1921, asked his patients to become artists in this vein, interpreting the inkblots he gave them. Piper's splashes do not require that we transform them into anything – they are happily themselves. But they confirm the allegiance between art and the world beyond the painting. And, like the sand found in a half-read book, they are the souvenirs of a time and place, nature's signature added next to that of the artist.

Piper's buildings and landscapes are stagey actors, so he gives them dramatic weather for a backdrop. Though he recommended in *Brighton Aquatints* that the Metropole be seen just after a rain shower, in his lithograph the rain is still lashing down, driving almost horizontally across the seafront façades. 'You seem to have very bad luck with your weather Mr Piper', said George VI on looking at Piper's thunderous drawings of Windsor in 1943, and realizing that Piper filled his skies with rain clouds even when the sun was shining.[15] There were plenty of jokes about Piper's weather, but it had a firm philosophy and a long tradition of English art behind it. Those clouds have blown in from the paitings of Constable and Turner. Appreciating and reconciling their polarized visions, Piper pays tribute to both. Henry Fuseli is said to have called for his greatcoat and umbrella when he looked at paintings by Constable.[16] Piper liked to quote this anecdote and his pictures have the same effect, though sometimes you feel an umbrella would be a flimsy defence – as it would be against a painting by Turner. Like an asteroid burning up as it enters the atmosphere, any object in Turner's paintings is an incidental plaything of the weather, dissolved by rain or set on fire by sunlight and doomed to be solid no longer.[17]

The young Ruskin devoted a long section of *Modern Painters* to the 'truth of skies', sensuously evoking Turner's 'breaking, mingling, melting hues' and embarking on his own career as a devoted recorder of clouds.[18] When Ruskin looks at one of Turner's skies he is plunging into an 'infinite and immeasurable depth', entering upon a whole world of vaporous sensation. Ruskin complained that his busy contemporaries did not devote enough time or attention to the sky, but those with time for contemplation have always projected their fantasies on the clouds. In the venerable tradition of Hamlet (whose clouds are camels, weasels and whales), Stevie Smith,

The Archers, Thomas Hennell and John Piper watch the theatre of the changing sky and find in it the sources of their art.

Piper's best writing about this is in his 'Britain in Pictures' book, *British Romantic Artists* (1942), which is a history of art's relationship with England's geography. It is a description of Piper's own artistic genealogy, and it is a persuasive argument against the view of art as a kind of free-floating signifier, unbounded by nationality. 'Romantic art deals with the particular' he writes, and his book is therefore a history of particularity.[19] This is the rich tradition that he pits against abstraction, and he invokes the weather (particular weather) as its central symbol and shaping force. Piper opens with a diagnosis of the effects of weather on the English eye:

> As a race we have always been conscious of the soft atmosphere and the changeable climate of our sea-washed country, where the air is never quite free from mist, where the light of the sun is more often pale and pearly than it is fiery. [...] This atmosphere has sunk into our souls. It has affected our art as it affects our life. But it has not resulted in congenital softness of vision.[20]

As proof of that last statement, he discusses paintings not in terms of 'softness' but in terms of their sharp observation and distinctness of detail. Sometimes this involves inventive misreadings, which tell us as much about Piper's own aesthetics as about the painters in question. His Picturesque tourists are more interested in the texture of mud and the tracks of cart wheels than in abstract questions of composition. Moving into the nineteenth century, Piper recasts Turner as a painter interested in the particularity of a hill town or a rock formation, claiming him (as Ruskin had also claimed him) as a painter of detail rather than dissolution.

Because Piper's Romantic artists are responsive to the conditions of specific times and places, they attend to what is happening in the immediate vicinity rather than imagining what is going on in the distance. William Henry Hunt, who obsessively painted birds' nests, is recognized by Piper as a 'half-submerged genius'.[21] Such painters are fundamentally myopic, and (like Woolf contrasting the short-sightedness of Mrs Ramsay with the classical, unbending long-sightedness of her husband) Piper makes myopia a romantically creative gift. Accordingly, he concludes his book not with an image of sublimity, but with an ordinary, well-loved corner of England. He reproduces Paul Nash's watercolour of the Pipers' Oxfordshire garden at Fawley Bottom, drawn on the spot, in a familiar place, giving the texture of the flint wall and the shape of the garden gate. It is a good but minor painting, and a surprising choice as the picture on which to end a book. But Piper was making a point. 'Nash has often identified the romantic with the remote – of time and place', reads the text next to the picture, but of course the image itself has nothing to do with

remoteness.[22] This is Piper subtly correcting Nash for a faulty conception of Romanticism. In an exchange of letters between the two artists, the correction was made explicit. When Nash wrote saying that he was puzzled by the choice, Piper replied that, in his opinion, 'dreams are *not* as romantic as bits of real experience'. 'Your view from my window deals with a bit of particularity that I know very well', he insisted, justifying it as 'a bit of vision worthy of English Romantic Art at its best'.[23] It was a manifesto for local art, for a return to the tree in the field. The choice of that simple watercolour, with its flint wall and garden gate, summed up everything Piper was saying in *British Romantic Artists* about the greatness of art that grows out of familiar places, sensuously responding to the weather and the land.

Virginia Woolf, wary of patriotic effusions, declined to write for 'Britain in Pictures' or contribute to a related anthology proposed by Hilda Matheson and Dorothy Wellesley in 1940. She turned them down 'rather tartly' on 12th July, the day Leonard gave away the Monk's House saucepans to be made into aeroplanes. Like Piper and other 'Britain in Pictures' authors, however, she was thinking about the relationship between the arts, landscape and England's climate. That autumn, she began to write a history of literature, a 'Common History book'.[24]

It was never finished, but Woolf made extensive notes about its possible shape and contents, completed a full draft of the first chapter 'Anon' (which covers a long chronological stretch from the first songs to the late sixteenth century), and wrestled with different openings for a second chapter on the growth of private reading. The notes and drafts give a palpable sense of the kind of book Woolf wanted to write. This history would be shaped by views from windows and stretches of country. It would work 'the other way round' from most critical studies, following the trail backwards from a poem to the environment in which it was written. There was to be no academic staleness, 'no text book', just the 'genuine scent – the idea of the moment'. Woolf talked with Duncan Grant and Vanessa Bell about the possibility of 'a book explaining lit. from our common standpoint, to painters'; and with this audience in mind she avoided any hint of arid literary specialization. The texts she discusses prompt not scholarly footnotes, but backgrounds, panoramas, situations, 'the thing seen: the framework'.[25]

Ideas for 'Reading at Random' (or 'Turning the Page' as Woolf later referred to it) first started to form while she was out blackberrying, and the imagery of footpaths, hedgerows, Sussex in September, found its way into the book as she started to write. Her sense of literature taking its rhythm from topographical bumps and byways is very close in spirit to that of her younger contemporaries. Like Piper, Grigson and Betjeman, Woolf was looking out at an old country, and reading the stories it had to tell. Anon, Woolf's representative figure for any number of early

anonymous poets, inhabits the downland of *Between the Acts*. There is still visible 'the green scar not yet healed along which he came when he made his journeys'.[26]

All her life Woolf had wanted to make great writing available to ordinary, unspecialized readers, and often she counted herself as one of them, a 'common reader'. Now she was more urgently concerned than ever: could literature do anything to help people in wartime? What if common readers felt estranged from the tradition that was being trumpeted at them, and for which they were meant to be fighting? These anxieties had shown themselves at Pointz Hall. At the centre of the house, at 'the heart of the home', is the library, the physical repository of the reader's canon. But although literary heritage is gathered here ('Keats and Shelley; Yeats and Donne'), it fails to impart its knowledge. Isa goes to the books as a person with toothache to a chemist's shop, but none of them offers a cure. 'Books are the mirrors of the soul' as a visitor to Pointz Hall once said, but now 'There they were, reflecting. What?'.[27] Packed tightly inside this expression of doubt is an abridged history of art since Shakespeare. It once held the mirror up to nature, confidently reflecting the world, and then the role of art was romantically interiorized to make books the mirror of the soul. But now both nature and the soul are ghost-like, making no reflection. The books at Pointz Hall seem to have lost their solidity and purpose. This was something that Woolf felt in her own reading. In a sad wartime diary entry she noted that 'even the "tradition" has become transparent'.[28] How could it be made real again, she wondered; how could the library be reinstated at the 'heart of the home'?

'Reading at Random' may have started out as a book explaining literature to painters, but it became a book about a shared inheritance, aimed at Isa, as much as Vanessa Bell, and at thousands of other common readers in wartime casting about in the chemist's shop. Woolf tried to restore the physicality of the 'tradition' by linking books back to the solid, daily world from which they grew. She imagined writers walking along the same paths as their readers, worried about the same things, looking out on the same view. Woolf knew that these ordinary connections between writer and reader could be too easily forgotten.

With all this in mind, and as a summing-up of all her own intense feelings about reading and landscape, Woolf conceived her book as a passionate exercise in literary geography. She mapped the pathways of the English village: 'roads, often flooded, often deep in mud, led from the cottage to the Manor, from the Manor to the church in the middle'.[29] They signalled the connectedness of a society in which the poet could wander from the small houses to the big. In this world there was no division between the artist and the audience, indeed the 'audience was itself the singer', remembering and adapting the words of Anon who never thought to give his name. Here, the work of art could no more be roped off from its surroundings than can the pageant in *Between the Acts*, and Woolf's determinedly 'impure' critical method is to

Paul Nash *Spring at Fawley Bottom*, 1938

keep half an eye always on what the audience is doing. The Renaissance play, she argues, 'was a common product, written by one hand, but so moulded in transition that the author had no sense of property in it'.[30] And Woolf's book itself resists all sense of artistic immunity. She decided to write it 'rather from memory'.[31] Instead of referring to authoritative texts and getting the detail exactly right, she would prioritize the shape that books had taken in her mind – where, like all memories, they had doubtless been metamorphosed in unaccountable ways by time and environment.

Woolf was used to tuning the rhythms of her prose to the tramp of her footsteps as she walked across the Downs, and in her critical work she makes vivid use of topographical metaphors to capture the varied sensibilities of other writers. So she compares Montaigne ranging over the world with Bacon keeping to 'a narrow path between hedges'.[32] Perhaps she took her cue from Hazlitt, who contrasted Coleridge's propensity to compose while 'breaking through the straggling branches of a copse wood' with Wordsworth's preference for strolling up and down a 'straight gravel walk'.[33] All these Romantic geographers, whichever kind of pace and path they choose, are making themselves part of their landscape, and their landscape part of their art.

This is what Woolf was writing about in *Between the Acts* when she had the sudden shower come down in the middle of the pageant, and the constant sense, all through the novel, of the sky in the background lightening or clouding over, the breeze picking up or easing off. All her life Woolf had been writing the weather into her books. The familiar refrain 'would it be fine?' had haunted *To the Lighthouse*. The progress through epochs is marked in *Orlando* by changes in climate; the winds in *The Years* come blowing into the lives of the Pargiters, yoking them together with unknown people crossing the same blustery streets. In *Between the Acts* the weather brings a community together: it is what these people share, in this village, on this day. So the trivial conversations about rain have a richness to them, which is about the desire to belong to a place and time. Professional weather forecasting had only just begun, which is why Woolf plays with the distinctive new terminology for England's climate: the newspaper predicts 'a light but variable breeze'.[34] By the time she came to revise the novel, however, these references to meteorology were references to a pre-war world. In September 1939 public forecasts were officially stopped because the information might assist potential invaders. But of course the weather itself carried on as before.

T. S. Eliot remarked of Yeats in 1940 that 'in becoming more Irish, not in subject-matter but in expression, he became at the same time universal'. It sounded paradoxical but was not: Eliot's point was that you had to know somewhere very well in order to communicate powerfully with people in other places. He found in

some of Yeats's earlier work a sense of 'the Western seas descried though the back window of a house in Kensington'; far better for Yeats to look out on the world from Ireland.[35] Vaughan Williams had a similar philosophy about music. In his 1932 lectures on national music he advised young composers to learn the 'secret' of their own land before trying to communicate to the world: 'If the roots of your art are firmly planted in your own soil and that soil has anything individual to give you, you may still gain the whole world and not lose your own souls.' The word 'parochial' was not, for him, a derogatory term: 'It is better to be vitally parochial than to be an emasculate cosmopolitan. The great names in music were at first local and the greatest of all, Johann Sebastian Bach, remained a local musician all his life.'[36]

Committed to this local vision of art, Herbert Read designed his anthology *The English Vision* (first published in 1933 and then reissued in 1939 with a preface suggesting its significance for a nation at war) as an organic growth, starting with little plots of ground and growing into something universal. 'The book proceeds on a genetic plan,' he explains in the preface, beginning with 'the soil, the physical climate and the actual landscape', before moving on to the English as a race, and considering their religion, art and literature. Read's 'genetic' plan is embodied in an excerpt from William Blake's *Jerusalem*, which imagines divine creation in terms of the *London A-Z*, among 'fields from Islington to Marybone, / To Primrose Hill and Saint John's Wood'. The poet of the local-universal, the poet whose visions occur on garden paths, is the chief spokesman for Read's England.[37]

These were the 'genetics' of Read's own life as he told it in his two-part memoir *Annals of Innocence and Experience* (1940). Tracing all his mature perceptions back to his years of rural boyhood in Yorkshire, he tried to recover what he saw with the 'innocent eye'. Travelling in memory from the vale to the church, to the kitchen and the blacksmith's shop, he rewrote the familiar landmarks of home as 'magic shrines' at which the pilgrim might find some kind of salvation. All life, he said, was now 'an echo of those first sensations', and English literature, as he saw it, had a similar biography, doomed to exile but taking its strength from the memory of early roots.[38]

Read's focus on literature stemming 'from the land' was profoundly nostalgic, but it was forward-looking too, in that Read advocated, and confidently anticipated, a return 'to the land'. True, he had written at length on the relationship between art and industry, but he claimed that the industrial phase was transient, that modern society had to concentrate on stoically getting 'through to the other side of it' in order to reach a new age of mechanized agriculture. While Read fashioned himself as an urban intellectual, he never stopped reminding his readers that he was 'by birth and tradition a peasant' and that there was nothing surprising in his being both at once.[39]

These refrains of the period's literary criticism (vigour, land, local knowledge) turned all sorts of long-standing literary dilemmas into debates about

organicism. There was, for example, the case of Shakespeare's rustics. Where John Dover Wilson had suggested that the Gloucestershire scenes in *Henry IV* burlesque rustic ways for the entertainment of an urban audience, E. M. W. Tillyard now argued that 'from first to last Shakespeare was loyal to country life'. In Tillyard's Elizabethan world picture, with its orderly organicism valuing each detail as 'part of nature's plan', literature belonged as much to Stratford-upon-Avon as to London.[40] It was worth a visit to Shakespeare's birthplace, then, to try to understand the landscapes that were in his blood. Humphrey Jennings's short propaganda film *Words for Battle* (1941) took the viewer to some other sacred literary spots.[41] While the voice of Laurence Olivier delivers extracts from great literature, the camera rests on Milton's tomb, on the blue plaque marking the place of Blake's birth, and on Kipling's gravestone in Poet's Corner. The film pays homage at these shrines – both to great men, and to the particular places in which they lived and died. Jennings was taking his audience on a kind of literary pilgrimage, a grand tour around England.

The process of reading had become, by common consensus, also a process of literary pilgrimage. If the war put an end to the prolific cross-country ramblings and trampings of the 1930s, 'excursions' in book form could still be taken. In 1944 Sheila Shannon and W. J. Turner launched a series of illustrated anthologies called 'New Excursions into English Poetry'. They were the idea of the émigré Austrian publisher Walter Neurath (later the co-founder of Thames & Hudson), whose company Adprint was also producing 'Britain in Pictures'. Myfanwy Piper went down to the coast, contributing to the series a volume called *Sea Poems* (1944). It is a literary collection akin to her husband's beach collages of wind-blown paper scraps. Myfanwy selects some familiar visions of the island nation: Hardy's 'Beeny Cliff', Kipling's 'Sussex'. Like John Piper linking the British air ('never quite free from mist') with the peculiarities of British painting, Myfanwy writes that Tennyson's poetry is 'saturated with the sea as one's hair and skin are saturated with salt after staying near it'.[42] He is a poet of the sea, which shapes his vision even when he is writing about something else entirely. Edith Sitwell appreciatively described the collection as 'wandering from one air to another like the airs of the sea' as if wind and rain blew through the pages.[43]

Linking poetry to places and climates, to the mist on a hill or the salt in the air, the 'New Excursions' writers scoured Britain to see what had grown from the land. Another volume in the series was especially keen to cover ground. *English, Scottish and Welsh Landscape Verse 1700 – c. 1860*, with lithographs by John Piper, was edited by John Betjeman and his friend Geoffrey Taylor (poetry editor of the Irish periodical *The Bell*). The chosen extracts describe not landscape in general but places in particular. So Tennyson appeals to Betjeman and Taylor as a local poet, 'a sardonic Lincolnshire humorist'.[44] Almost every poem in *Landscape Verse* is labelled with a county. This emphatic marking of poetic territory means that Coleridge's

'Frost at Midnight', for example, becomes a poem about Somerset. Coleridge's meditation on the creative rites of fatherhood might address common human experience, but this anthology insists that the poet observes from a single vantage point on one cold night. The outside gets inside, literature is rooted to the spot, and the most universal of poems has its genesis in a specific place.

The elusive relationship between literature and place became the enduring subject of the period's most compulsive literary pilgrim. Bill Brandt was associated with the documentary movement, but he was susceptible to fantasy and Romantic antiquarianism. Brandt was brought up in Germany and then worked in the Paris studio of Man Ray. When he arrived in England in 1931 he started taking photographs of slums, and crowds on the beach. But Man Ray's studio had been a place of staged fantasies and this theatrical vein was always there in Brandt's art. His charwomen were posed; the holidaying workers on the beach were his friends playing a part. He aligned himself, ostensibly, with Mass-Observation (left wing, realist, suspicious of fiction), but Brandt was no journalistic reporter. He was, increasingly, a poet of place. It may have made him another traitor to the modern movement but it was no surprise when, partly under the influence of John Piper, Brandt moved away from the contemporary urban scenes he photographed in the 1930s and into the ancient landscape.

He produced a series of image-sequences for *Lilliput* during the 1940s, all of them cultural journeys through England. There was 'The Brontë Country' and 'The Hardy Country', a set of poets' birthplaces, and a tour of grand, decaying English gardens. Many of these photographs would be assembled in 1951 as *Literary Britain*, Brandt's defining tribute to the yoking of topography and creative energy. Brandt arranged each double-page spread as a pairing of quotation and image. The fields and houses on the right, some of them very ordinary, are sanctified by the words on the left. So while literary critics investigated the effect of landscape on writers, Brandt put the process into reverse by testing the effect of writers on country. He photographed a stone path glimmering dimly through a misty expanse of the Malvern Hills. As soon as we associate this path with William Langland, the place begins to look haunted; visions of Piers Plowman start to appear.[45] Brandt dissects the process by which literature, having grown from the land, goes on to remake the landscape in its image.

Brandt is not quite a nature-worshipper. His landscapes are carefully rigged scenes rather than found objects. Like Piper painting black skies on sunny days, he jettisons naturalism in favour of effect. More painstaking even than Beaton in his crafting of composition, Brandt would travel around with hefty props and lighting, arousing distrust in those who thought that photographers have a duty to tell the

Bill Brandt *Top Withens*, 1945

truth.[46] The most time-consuming of his preparations was the necessity of waiting for the right weather to coincide with his mental image. Reclaiming the pathetic fallacy, he ensured that each writer got the weather he deserved.

Usually it was wintry weather that he needed. Chaucer had specified April as the month for pilgrimages, envisaging fresh growth and springful showers. Brandt made his own pilgrimages in more punishing conditions, photographing England in dense fog and winter rain. *Literary Britain* is a catalogue of English weather: D. H. Lawrence's Eastwood terrace is slushy with half-thawed snow, menacing clouds hang suspended above Horace Walpole's Strawberry Hill, and an ecstatically illuminated mist fills Anthony Trollope's cathedral. Brandt paid many visits to the Brontë Country before taking his iconic photograph of Top Withens, the farmhouse thought to be the location for *Wuthering Heights,* in 1945:

> I went to the West Riding in summer, but there were tourists and it seemed quite the wrong time of year. I liked it better misty, rainy, and lonely in November. But I was not satisfied until I saw it again in February. I took the picture just after a hailstorm when a high wind was blowing over the moors.[47]

The wind was tearing at the long grasses; the light was bright and low. But even in these long-awaited conditions Brandt was not content. He did not just 'take the picture'; he made a collage of pictures. Not satisfied with the sky, he replaced it with the sky from a different photograph, brilliantly over-exposing both negatives so that the moorland earth became impenetrably black, pitted with the spectral white of the settled hailstones.[48]

Literary Britain is the book in which Brandt lays claim to his adopted country. It is not the work of a detached observer documenting life in a foreign land; it is Brandt's fulsome enrolment in a meteorological tradition. It allies him with the Romantic writers whose footsteps he followed and photographed, and it is in dialogue, too, with the great reclaiming of the English landscape that was the work of his contemporaries. Woolf's Anon walks along paths 'deep in mud' and Thomas Hennell's drawings get perilously close to puddles. John Piper's story of art is also a story of dampness. When these artists and historians open a book or look at a picture, they are walking across country, assessing the climate, or testing the effect that soil-type might have on the texture of language and paint. Brandt's *Literary Britain* affirmed that language has, in its turn, changed the texture of the land.

The most passionate of all the period's meteorological art was the work of a man who had exiled himself from England, and who felt drawn back to his native country by the poetry of place. Benjamin Britten left for America in 1939 and embarked on a

mobile expatriate life. He was in Escondido, California, when in 1941 he read an article in *The Listener* about George Crabbe. It was by E. M. Forster and it evoked the intense relationship between Crabbe and his native Suffolk. What magnetized Forster was Crabbe's sense of particularity, the particularity of the true topographer. He admitted that Crabbe's long poem, 'The Borough', was 'not great poetry by any means', but:

> it convinces me that Crabbe and Peter Grimes and myself do stop beside an opening sluice, and that we are looking at an actual tideway, and not at some vague, vast imaginary waterfall, which crashes from nowhere to nowhere.[49]

Britten wanted to be there by the sluice as well, somewhere rather than nowhere. He was living in a town whose name meant 'hidden' and he was now thinking of a town which, to him at least, meant 'home'. He bought a copy of Crabbe's work in San Diego and by the start of 1942 he was trying to get a passage back to England. He had already sketched out the opera that would become *Peter Grimes*.

There is an irony in the fact that it was Crabbe who lured Britten home. 'The Borough' was no love letter to Aldeburgh: Crabbe loathed the place and left as soon as he could. But there is a profound sympathy in the connection between Crabbe and Britten. Crabbe was haunted by this town he rejected and all his writing returns to it. 'Even when he is writing of other things', Forster pointed out, 'there steals again and again into his verse the sea, the estuary, the flat Suffolk coast, and local mean-nesses and an odour of brine and dirt'.[50] Britten is similarly magnetized and repelled, and similarly haunted by this stretch of coast.

His struggle with a home that is both alluring and treacherous is played out in the agonies of Peter Grimes, the violent, visionary fisherman who fantasizes about domesticity. Grimes dreams of building 'some kindlier home' where life is lived neatly and productively:

> Fruit in the garden, children by the shore,
> A whitened doorstep, and a women's care.[51]

In his isolated hut on the cliffs he pays homage to the housekeeperly rituals cherished by the respectable community. Grimes keeps his hut clean and orderly, in purposeful defiance of the chaotic passions that rule him. Britten and his librettist Montagu Slater take care to specify in the stage directions that the apprentice's clothes should be 'neatly stacked' on Grimes's shelf.[52] And yet Grimes embodies the spirit of disor-der and disruption. He imagines order and then tears it apart, unable to confine his imagination to the well-tended orchard and the seemly front door. His voice refuses to join politely with the merry rounds sung by the townspeople in the inn, so he

demonically gathers up their small motifs and tosses them about like flotsam on a wave of sound. He is in league with the storm against which they barricade their houses, and the townspeople barricade themselves against Grimes too.

Britten conceives this brutish fisherman as a solitary, suffering artist who yearns for peace but whose role it is to be always exposed at the dangerous limits. 'What is home?' Grimes asks, his voice protracting and caressing the word as if it were the name of a lover. He then moves on from this abstract question to a question which is more devastating because it is more particular: 'Where is my home?' The tragedy is that he is already standing in the place that should be home. If not here, then where? 'What harbour shelters peace?'[53] He insists that he is 'native, rooted here':

> By familiar fields,
> Marsh and sand,
> Ordinary streets,
> Prevailing wind.[54]

It is these quiet, unspectacular things that he loves, as Piper loves the painting of a familiar garden. But Grimes is not ordinary enough for these ordinary streets; the conventional, impressionable society of the Borough has made of him a scapegoat that must be driven out. He is ejected from the sheltering harbour (which is not peaceful but monstrous) into the wild weather on the beach, which acceptingly embraces him. The fog which comically saves the life of Peter Carter in *A Matter of Life and Death* now becomes the accomplice of Peter Grimes in his madness. Because it is itself chaotic, bad weather licenses madness. Lear could not have raged on the heath in sunshine. Fog, in all its indeterminacy, makes the familiar world a ghostly place, and encourages hallucination. Grimes becomes the voice of the fog, just as Britten's score for the opera's four sea interludes becomes the voice of the sea itself. 'If wind and water could write music', observed Yehudi Menuhin, 'it would sound like Ben's'.[55]

Britten respects the homely conventions of tidiness and sanity; so does Grimes. But both produce their greatest art while stumbling through the fog. The artist not only records the weather but is part of it, and must die if society is to keep the elements at bay. While Grimes drowns himself offstage, far out at sea, the Borough makes itself spick and span for a new day. 'Cleaners open the front door of the inn and begin to scrub the step [...] The Nieces emerge and begin to polish the brasses outside the Boar'.[56] There is something savage in this conspicuous carrying-out of the respectability rites Grimes could not manage. Britten asks whether the restoration of order that traditionally completes a tragedy has, in this case, been achieved at too high a price. The wild weather has been banished and the damage repaired, but has something of immense value been lost?

When Bill Brandt took a series of photographs of Aldeburgh in 1948, published in *Lilliput* as 'Peter Grimes Country', he captured the atmosphere of quiet after the storm. A still pool of water on the shingle reflects a still, grey sky; the burdened, silhouetted figure of a fisherman moves across the wide beach; the rough form of a timber hut juts out over a calm, apparently innocent sea. These images of quietude are Brandt's elegy for Peter Grimes, who was the personification of the storm we feel has recently died away, and who has paid the price of this ensuing calm. Brandt photographed what Grimes dreamed of: a harbour sheltering peace.

A later inhabitant of Aldeburgh would conceive of a windier tribute. In 1980 the architect H. T. Cadbury-Brown put forward a proposal for a Britten memorial that would take the form of a rough wooden column erected on the beach, drilled with holes so that it became an instrument for the wind. When a storm blew at a particular force, the wood would produce the two notes used by the crowd in Britten's opera when they insistently call out 'Peter Grimes!'. It would have been an inspired tribute to the composer, and to an opera that is both about art's Dionysian collusion with the elements, and its orderly efforts to resist them.[57] This proposal was never taken up, but a different memorial was erected on Aldeburgh beach. Maggi Hambling's *Scallop* is a steel ear listening to the sea, and it is also a giant version of the shell that echoes with sound and which we press fancifully to our ears as children. Hambling called it 'a conversation with the sea', though the line from *Peter Grimes* she punched into the rim of the shell evoked something more insistent and disturbing than a conversation: 'I hear those voices that will not be drowned'.[58] The scallop shell is the badge traditionally worn by pilgrims, and it is an apt emblem for a composer whose career was shaped by the pilgrimage he made back to his native coast, and whose work is still inspiring pilgrims.

The story of Britten's nostalgia from abroad and his return to the country of Crabbe have become part of the opera itself. Britten recounted it in his introduction to the Sadler's Wells programme in 1945, remembering how Forster's article on Crabbe 'evoked a longing for the realities of that grim and exciting sea-coast around Aldeburgh'.[59] Britten wanted his audience to understand the opera as a homecoming, and a manifesto, too, for the reconciliation of art and place. In subsequent years he kept returning to the subject of a national culture growing up from particular places and enriched by its association with the landscape. When the people of Lowestoft made him a Freeman of the town in 1951 he accepted the honour with gratitude and spoke of his deep attachment to the place:

> I am firmly rooted in this glorious country and I proved this to myself when I
> once tried to live somewhere else [...] Roots are especially valuable nowadays,
> when so much that we love is disappearing or being threatened, when there is
> so little to cling to.[60]

H.T. Cadbury Brown *Proposal for a Memorial to Benjamin Britten*, c. 1980

Britten, who had struggled so hard with his sense of belonging, and who had written about a man cast out from his native place, would never be complacent about the meaning of 'home'. And his work represented a modern reconciliation with the earth. Back in 1910 Matisse had painted his mural *La Musique*, and in it he imagined the musician as a universal being. His singers, crouching on an anonymous, eternal green bank, are not individuals but archetypes. Their naked bodies, unmarked by the world, are clean vessels from which primal sounds might emanate. By the 1940s, Britten had rejected this conception of music and replaced Matisse's platonic abstraction with metaphors of rootedness and growth. There is no weather in Matisse's painting; the singers must be inspired by the gods. Grimes, by contrast, is inspired quite literally by the raging breath of the wind.

8

VILLAGE
Life

If a Domesday Book had been compiled in the late 1930s, recording the inhabitants of villages and outlying farms, it would include most of the major figures of English art and letters: the Woolfs in Rodmell, the Pipers at Fawley Bottom Farmhouse, the Betjemans under the white horse at Uffington, Gerald Lord Berners in nearby Faringdon, E. M. Forster in Abinger, Stanley Spencer in Cookham, Vita Sackville-West in Kent, Edith Olivier in Wilton, Cecil Beaton at Ashcombe, Evelyn Waugh at Stinchcombe in Gloucestershire, Edward Bawden in Great Bardfield, Eric and Tirzah Ravilious in nearby Castle Hedingham. Each had a deep feel for what English village life had been and might still be – and each explored these possibilities in art. It seems counter-intuitive to describe English villages as centres for the avant-garde. We are used to the idea of progressive thinking emerging from the crucible of the great modern cities – from subway stations, bars, street corners, crowds. Measured against these the village hall does not seem a promising place to go for modern experience, but it certainly cannot be left out of the account.

In the 1930s rural England seemed caught on the cusp. In some areas, and in some respects, not much had changed since the Middle Ages; elsewhere there was little left of the old ways, though they might remain in living memory. Sitting outside the brightly lit shops an elderly inhabitant would often be able to describe the harvest festivals that once went on in that same street. These were the years when people started to buy cars as a matter of course (though still with much excitement), the village bus ran regularly into town, here and there electric lights came on in the houses, central heating was installed, weekenders arrived, commuters set off on Monday morning not for the fields but for the office. Much of this provided welcome improvement to rural living conditions, but there was worry and sadness too about what was being lost. The calls for a reversal of the urbanizing process – and for a revival of the traditional rural community – were loud and influential. Many of those calls came from artists who saw potential for a reinvigorated local culture based in, or at least based on, the English village.

'Stag' artist's proof. Gertrude Hermes, 1932.

Gertrude Hermes *Stag*, 1932 – one of a set of six engravings for Gilbert White's *Selbourne*

Writing his volume on villages for the 'Britain in Pictures' series in 1941, Edmund Blunden suggested that after all modernity's urban experiments, it might be the humble village that offered the best model for the future of English life. It would not be as it had always been, but this was no bad thing: 'the days of the great houses in our country have passed [...] and yet it is reasonable to expect that the village will flourish anew.' Blunden proposed that it might even have a providential role to play as the 'salvation and fulfilment of England'.[1] The campaign for village renewal already had momentum behind it. Country books had a high profile between the wars, much higher than today. Books like *English Fabric: A Study of Village Life* by the Dorset writer F. J. Harvey Darton or *England is a Village* by C. Henry Warren were written, read and discussed with attentiveness. The *Times Literary Supplement* would typically devote several pages each week to rural writing.

The countryside dominated the airwaves too. John Betjeman's talks on topographical curiosities and appealing village customs (May Day festivals, hobby horse parades) proved so popular that they were upgraded from the Regional Service to the National Service. It was a symbolic promotion: Betjeman's determinedly local programmes designed for West Country listeners and made in the Bristol studio were not to be local any longer. The wireless may have heralded an age of communication but it was also good at re-antiquating England. As one historian points out, the radio hosted an 'orderly and regular procession of festivities, rituals and celebrations – major and minor, civil and sacred', so that the medieval cycle of feast days had rarely been so keenly followed.[2] The rural calendar, long absent from the lives of urban people, was now punctiliously observed and a new kind of oral community was forming around the radio, with a character that was unmistakably pastoral.

Among the many signs of growing interest in village heritage was the popularity of that great village writer from the eighteenth century, Gilbert White. The 1930s saw a surge of enthusiasm for his work, and for Selborne, the Hampshire village he loved and recorded. This is a phenomenon worth pausing over because the various responses to White give a sense of the ruralist debates that were going on, and of how they intersected with changing ideas about aesthetics. White's journals appeared in 1931, edited by Walter Johnson, and his work was tirelessly reissued over the next decade.[3] Gertrude Hermes produced beautiful woodcuts like prehistoric fossils for a proposed Gregynog Press volume.[4] Her *Stag*, for example, is exquisite in its textural detail: the fur on the flank is tangible. But it also has an iconic, heraldic quality. This stag stops apprehensively for a moment and catches our eye before leaping away. Yet he seems also to be permanent, representing Selborne for all time.

Then there was a 1935 edition which presented *Selborne* 'rather as a literary masterpiece than as a scientific treatise' and emphasized White's 'miniature poetry'.[5] Further editions appeared in 1936 and 1937; John Piper gave a copy to Myfanwy as one of his first courtship presents; reviewers unanimously hailed the 'discoverer of

England'.[6] Part of the appeal was that, although White lived through revolutionary times, he was never distracted from the continuity of life in his parish, and was able to write at length about nightjars on the day the French stormed the Bastille. His writings were testament to nature's endurance through political catastrophe.

The prolific country-writer H. J. Massingham, tireless in his proselytizing for rustic revival, collaborated with Eric Ravilious in 1938 on an illustrated selection of the writings, and claimed White as the man to have opened Englishmen's eyes to their countryside. Massingham saw the particularity of White's *Selborne* as an example to men 'who have lost the art of distinguishing one place from another'. White's village unit was discrete and contained, whereas now, in an age of cars and rail links, the individuality of the local was being lost in a homogenous mass. Had he lived in the 1930s White would have seen 'the apartness, the self-sufficiency' of his village 'burst like a bubble on Oakhanger Pond'. Massingham argued that some of the old concentration and coherence had to be regained, and he promoted White as a 'national figure' at a time of crisis, one whose writings were 'fruitful in example for the salvation of England'. At a time of war and social decay, help might be found in the richness of understanding derived from careful and unrushed observation. Here, said Massingham, was the 'supreme voice of the English parish'.[7]

The accompanying engravings are small masterpieces of selection and humour. Ravilious had loved White's *Selborne* since his student days. He reread it with delight in 1936 ('every minute I can spare') and relished the poetry inherent in White's record of nature's calendar. '"There are bustards on the wide downs near Brightelstone"' he wrote to Helen Binyon, 'isn't that a beautiful statement?'[8] He went to Selborne and walked through the sunken pathways and across the hangers. Ravilious looked closely, too, at the tiny intricate woodcuts Thomas Bewick had made at that same time in the late eighteenth century, full of life and practicality, yet also Romantic in their vision of infinite detail. Bewick, as much as White, appealed to the English eye of the 1930s. Blunden used Bewick tailpieces (along with a view of Selborne) to help him evoke the spirit of the English village in his 'Britain in Pictures' book, and Bewick is the very first artist cited by Piper in his *British Romantic Artists*. 'The particularisation of Bewick about a bird's wing' is for Piper the epitome of English Romanticism. Bewick's genius is to capture a detail that 'for a moment seems to contain the whole world'.[9]

Ravilious gets the world into his Selborne engravings, but not quite in Bewick's way. He gives the sense of each detail picked out as if seen through White's sharply focused field-glasses, but his birds are often more stylized motifs than essays in natural history. Ravilious was attracted to the silhouette portraits that were so popular in Georgian England, and he translates the style of the paper-cut profile into his engravings of birds so that we identify a thrush or a swallow from its distinctive outline against the sky. Ravilious seizes on moments of comical strangeness,

like White's examination of a stinking dead moose. Elsewhere, an owl flies over the entrance to a lane, or White leans on his spade, dressed in his frock-coat, to watch the slow manoeuvres of Timothy his tortoise.

White evoked for Ravilious an orderly, domestic world of eighteenth-century civility, where the rhythms of indoor and outdoor life were productively connected. The frontispiece he designed for the first volume of *Selborne* showed White and his correspondent seated at an elegant drawing room table that seemed to have migrated out into the open, surrounded by fields and birds. For the second volume he engraved a view down a church aisle towards the pulpit, but where the altar should be we have instead a view out into the open country, a lane winding away through the trees, and a little greenhouse (Ravilious's favourite subject) echoing on a small scale the shape of the church itself.

This sense of the writer's desk being linked to the natural world appealed to Virginia Woolf when she joined in the Selborne renaissance by rereading White in 1937, and again in 1939 when she contributed an essay on him to the *New Statesman and Nation*. She found in White's prose the sense of a door having been left open, 'through which we hear distant sounds, a dog barking, cart-wheels creaking'.[10] Here was a technique that had affinities with her own desire to be detached but also receptive, including 'the girl at the door, the wind and the rain'; it was the open door through which Anon might come, bringing with him the country and its weather.[11] And she found in White's prose something of that mixture of the particular and universal that Piper found in the woodcuts of Bewick. She noted that White's 'observation of the insect in the grass is minute' but he then raises his eyes to the horizon in a 'moment of abstraction'. She was unwilling to confine White to the eighteenth century: 'he escapes from Selborne, from his own age,' she observed, 'and comes winging his way to us in the dusk along the hedgerows'.[12]

Why had White become such a contemporary figure, winging his way like a clear-sighted owl into the dark twentieth century? He was loved, of course, for his timeless qualities, but he was also being used as someone relevant to the present time, precisely because the world he knew was disappearing. As transport links improved, an ever-increasing number of people wanted to live in the newly accesible countryside. They needed houses, roads, shops, jobs – and other modern amenities that were difficult to reconcile with the ancient, slowly evolved patterns of village life. The suburbs of towns and cities extended so far that they swallowed outlying villages in their paths; in the space of a few years remote hamlets could find themselves in the commuter belt of a large town. Elsewhere, villages grew from the centre outwards: the post-office, church and single street of houses might now be surrounded by a major housing development. And as ribbon development flourished along rural roads, unchecked until the Restriction of Ribbon Development Act of 1935, the enlarged village thrust its tentacles deep into the landscape. Clough

Williams-Ellis published his 1928 book on the planning problem under the vivid title *England and the Octopus.*[13]

Could the old ethos of familiarity and coherence survive these transformations? Government rhetoric in the 1930s insisted that the English were all still bound together by rural values; the rites of the village green were in the Englishman's bloodstream, and nothing could erase them. The currency of these ideas had much to do with the personality of Stanley Baldwin, prime minister for most of the 1920s and leader of the Conservative majority in the National Government of the 1930s. From Worcestershire himself, brought up in the Severn Valley, Baldwin liked to give swelling panegyrics on the ancestral countryside. He wanted 'the tinkle of the hammer on the anvil in the country smithy' to ring in the ears of the modern Englishman, and he called on instinctual, atavistic powers of connection:

> The wild anemones in the woods in April, the last load at night of hay being drawn down a lane as twilight comes on, when you can scarcely distinguish the figures of the horses as they take it home to the farm, and above all, most subtle, most penetrating and most moving, the smell of wood smoke coming up in the autumn evening, or the smell of the scotch fires: that wood smoke that our ancestors, tens of thousands of years ago, must have caught on the air when they were coming home from a day's forage.[14]

Slow, expansive, appealing to sights, smells, sounds, primitive conceptions of home in the wilderness, Baldwin's speeches legitimized a culture of country nostalgia almost as Queen Victoria had sponsored a culture of mourning. And Baldwin's country feeling, too, was a form of mourning. He talked about country memories rather than about the survival of village life in the present. The conjured village of the mind's eye was a substitute for real experience, aimed at a largely urban and suburban audience buying into the dream of roses around the door, taking pleasure from the evocative souvenirs of a different time.

All this was understandable: Baldwin saw the future as an urban one and was harnessing what he could of the country's lasting emotive power. In January 1931 he spoke of 'the love of country things' which exists 'traditionally and subconsciously' in the hearts even of those whose families have worked in the city for generations. 'The country' he said, 'represents the eternal values and eternal traditions from which we must never allow ourselves to be separated'.[15] The problem, however, was that people did feel themselves very painfully separated from their country inheritance. If the dream of the 1930s was to recapture a sense of belonging to particular stretches of country, the nightmare was to find these places irrevocably changed.

It happened all too often, as George Orwell knew when he described the violation of a once-familiar landscape in his 1939 novel *Coming Up for Air.* It is a book about

the loss of home – not literal homes so much, but the places to which we feel imaginatively connected and which, at some level, we claim as our own. Orwell's George Bowling is an unheroic hero who lives in a suburban street and sells insurance for a living. He looks like a contented man, with home and job and wife, but he is consumed by a sense that his life lacks meaning because it has no vital connection either to a past or to a place. So Bowling makes a journey home to Lower Binfield, the village of his youth. He feels like a traitor for doing so; he is playing truant from the expectations of the twentieth century and it must all be done in secret, like an assignation.

What he finds is a real place turned into bad fiction, a collection of pseudo-picturesque tea-shops and new housing developments, adding up to a good-sized manufacturing town.

> The Mill Farm had vanished, the cow-pond where I caught my first fish had been drained and filled up and built over, so that I couldn't even say exactly where it used to stand. It was all houses, houses, little red cubes of houses all alike, with privet hedges and asphalt paths leading up to the front door.[16]

Bowling feels his own story of disappointment to be so inevitable as to be almost redundant. 'You know the kind I mean', he says repeatedly because he is retelling what everybody knows: coming up for air is impossible. There is no air; all England is submerged. Orwell, in mourning for Bowling's lost inheritance, gives a eulogy for the remembered village and the country pleasures of the small boy learning to fish. This is his own remembrance, too, of his boyhood in Oxfordshire, first in Henley and then in the village of Shiplake (next to Binfield) where he went bird watching and fishing. Exploring the sense of premature nostalgia that came to many who expected to die early in the approaching war, Orwell at the age of thirty-six looked back and listed with reverence the kinds of fish in the pond. He recalled the ecstasy of 'the still summer evening, the faint splash of the weir'.[17]

For the working people of the suburbs, however, there was no way back in reality. The tinkling of the anvils was a memory, no more than that. Orwell is outraged by this national fraud. 'The dustbin that we're in reaches up to the stratosphere' thinks Bowling. Lower Binfield prosaically bears out its name.[18] Looking down from the stratosphere, the situation appeared just as bad. In Evelyn Waugh's *Vile Bodies* (1930), Ginger's view from an aeroplane window reminds him of some words he once learnt from a blue poetry book: '"*This sceptre'd isle, this earth of majesty, this something or other Eden*"? D'you know what I mean?' But what unfolds beneath him is not very Edenic:

> arterial roads dotted with little cars; factories, some of them working, others empty and decaying; a disused canal; some distant hills sown with bungalows; wireless masts and overhead power cables.[19]

Guileless Ginger doesn't notice the discrepancy, but Waugh does. He presents a rural England that is becoming a waste land, and which is in the hands of people who do not even notice what is happening. Graham Greene rewrote Waugh's scene from the ground for those not privileged enough to fly. In *Brighton Rock* his characters have to make do with a bus ride out to the cliffs near Peacehaven, which is as close as they get to a sceptr'd isle.

> 'It's lovely,' Rose said, 'being out here – in the country with you'. Little tarred bungalows with tin roofs paraded backwards, gardens scratched in the chalk, dry flower-beds like Saxon emblems carved on the downs.[20]

For these people, above and below, the country is a place where the houses are slightly further apart and have gardens. What Bowling has lost, they never saw. The dry flower-beds are a brave but pathetic modern echo of the massive Saxon emblems carved expansively in the hills by a race which possessed its landscape. The detached tone is telling: Waugh and Greene view the suburban landscape with sad irony because what has happened looks to them too mean to be worthy of tragedy.

George Orwell, Evelyn Waugh, Graham Greene: these are very different kinds of writers with very different political vantage points. But related images of the violated landscape recur across their work. They look out on the ruined land of English conservatism, or the deserted village of English socialism, or the lost inheritance of working men, or the lost beauty of the eighteenth-century estates. The fight against rural development sometimes got imaginatively tangled with the fight against Fascism, producing a bizarre fusion of the two most pressing forces that seemed to threaten the liberty of individual and community life. The association was made explicitly in *The Aerodrome* by the young novelist Rex Warner. Published in 1941, the novel is a parable in which war breaks out between a generic English village and the society of a nearby aerodrome, where tradition is condemned as a form of servility, and the word 'locality' is censored because it sticks in 'the mud of the past'.[21] Attracted by the prospect of 'ease and efficiency', the novel's hero Roy defects from the village to the aerodrome and rises quickly within its ranks. But his work as a pilot is a literal severance from the land, and he longs for 'the meadows whose soil [he] had not touched for so long'.[22] He finds himself caught between the forces of mechanical progress and country rootedness.

The village in Warner's novel is requisitioned and absorbed by its rival in an allegory of rural England subsumed by Fascism. The Rector and Squire are confronted and killed by the Flight-Lieutenant and the Air Vice-Marshal. Only very narrowly, via a series of outlandishly improbable twists, the aerodrome is defeated. But 'tradition' and 'locality' have come close to extinction, and what is so striking about the book is that the threat does not come from a foreign enemy invading

Eric Ravilious Illustration from *The Writings of Gilbert White of Selborne*, 1938

from without. It is inside, within the walls. The aerodrome is just next door to the village. It is a monster that has found its way, insidiously, into the back garden. It stands for Fascism, but it stands also for the dangerous 'ease and efficiency' with which the modern was supplanting the old. *The Aerodrome* is a book about the war with Hitler, but it is also about the battle that England was having with itself.

Warner's symbolism is crude, and his association of the aerodrome with Fascism must have seemed particularly ill-judged in a novel published just after the Battle of Britain. But the subtlety of the book comes in its diagnosis of the mixed flaws and virtues of the village. Warner situates it on the front line against a place-less, tradition-less future, yet he sees it as a weak and imperfect force, paralysed by indecision and rankling secrets. With its adultery and incest, it is just as bad as the idyllic but murderous village communities (Fenchurch St Paul; St Mary Mead) which play host to the period's crime fiction. Warner suggests that the concept of the village had to be imaginatively renewed if it was to survive at all.

Warner designated the village as the defender of civilization; Blunden proposed it as the 'salvation' of England. In the paintings of Stanley Spencer this salvation was already underway because Christ had arrived in Cookham. Spencer is England's village visionary, a painter who saw the Second Coming played out in his native Berkshire town, and whose ecstatic intensity of observation allowed him to trans-figure every ordinary corner of Cookham into a pulsing, vital, sacred land. Spencer sees the world with that sharp focus which comes from long years spent attentively watching the life of one place. For him, the fundamental point about the village is that it is small. Every part of it is familiar, and because it is familiar the tiny changes stand out. The early flowering of a plant, the occasion of the fête or the swan-upping: these events become momentous in the calendar. Taught by the Romantics, Spencer's observations are distilled to a penetrating intensity.

Spencer loved Cookham all his life, but he worshipped it in changing ways. In 1912 his work had hung in Grafton Street among the Matisses at the 'Second Post-Impressionist Exhibition'. He had been interested in formal containment; he had simplified his shapes and schematized his colours, and he responded to Fry's advo-cacy of early Italian murals. *John Donne Arriving in Heaven* (1911), the painting he gave to Fry and Bell for their exhibition, was a ceremonial orchestration of abstract, priestly figures occupying the canvas like monolithic standing stones. But Spencer's imagination was too full of nature's compelling detail for abstraction to take hold, and too much in thrall to the particular surroundings of Cookham. In the 1930s, when he returned there after a decade's absence, every brick and flower in the village seemed uniquely fascinating. He wanted to paint it all with the worshipful attentive-ness of the Pre-Raphaelite, recording each fallen leaf and blade of grass. No detail

could be surrendered in the interests of formal design; to do so would be an act of desecration. So he paints every petal in the straggly clump of Michaelmas daisies on the edge of a field, the neatly weeded ornamental gardens on terraced streets, and the view from his window over gates and sheds. Standing before these domestic scenes he felt, he said, like Moses before the burning bush, compelled to take off his shoes in reverence.[23]

In 1937 Spencer painted *A Village in Heaven*, an appropriate subject since the heaven he imagined was a series of villages. The village in his picture is Cookham, of course, with its flint walls, village green, and war memorial. But something has happened to the inhabitants. They are bursting with sexual energy, embracing each other and gripping onto straggling tree roots, drawn together in a great orgasmic communion. A disciple directs proceedings, heralding in what is nearly a triumphant moment of cohesion, but which stops just short, somewhere between absurdity and transcendence. Spencer's dealer rechristened the painting *The Village Fête* to detract attention from the emphasis on free love, but more accurately it foretold the fate of the village in Spencer's ideal world of intimacy and uninhibited expression. Each button and daisy is credited with the expressiveness of a face; dour chintz wrappers are mesmeric. Everything is holy and everything is connected.

That connectedness is profoundly important for Spencer: his is fundamentally a social vision. When city-dwellers think of the countryside it is often as a place of quietude and escape. The hectoring noise of the metropolis is left far behind, along with the constant social demands. Writing her *Novel on Yellow Paper* in a London office, Stevie Smith's Pompey dreams of being out in the open, away from the crowds, lying on an 'ivory haystack' under a chestnut tree.[24] That haystack is her artist's fantasy of the ivory tower, an immune, protected place where her imagination will be free to roam, uninterrupted by the aggravating distractions of daily life. But most of the period's rural art and literature is characterized by a suspicion of the ivory tower and a longing for something quite different – an ideal community. Spencer's village fantasies are about vitality and cohesion. His village people live out their lives in alert, sexually charged intimacy, compelled to be part of the group. And this is the modern quest that exceeds in its urgency even the quest for space and peace. The longing for community is the most powerful motivating force behind the rediscovery of the village.

To some, and especially to F. R. Leavis's expanding circle in Cambridge, it seemed that the longing was in vain. In 1930 Leavis published the first of his many fierce denunciations of the mass culture which he thought had killed the old village. He was outraged by the vacuity of machine-age leisure which left men and women lying back idly in the dark of the cinema. The literary life of a previously 'informed and cultivated' public was now reduced to newspaper snippets and advertising jingles.[25] It was all bits of this and that; nothing was properly joined up. Predictably,

he thought the rot was emanating from America; the resourceful singers of local folk songs were now twiddling the radio knobs. Imported from elsewhere, the jazz rhythms and film scenarios had nothing to do with practical life in England – which meant that entertainment was now fatally removed from daily work. Not that daily work was satisfactory, now that the conveyor belt had come. 'The organic community has gone', announced Leavis and his colleague Denys Thompson in their 1933 book *Culture and Environment*.[26] This was the founding statement of the circle that formed around Leavis's literary journal *Scrutiny*. His modern England was an alienated, isolating society now condemned to cell-like flats but remembering a past in which it was organically whole. His story was a revision of Genesis, recording our time in Eden and our fall from grace.

In his efforts to convey the scale of the catastrophe, Leavis drew on the writing of George Sturt, a Surrey wheelwright who became a prolific recorder of village life. Sturt's accounts of a moribund way of life, published in a succession of books including *Change in the Village* (1912) and *The Old Wheelwright's Shop* (1923), were all issued under the pseudonym George Bourne. Like Spencer, who was named 'Cookham' by his art school contemporaries, Sturt became the embodiment of his village, The Bourne. Sturt claimed that rural life had changed so dramatically that only 'an afterglow from the old civilisation' now remained.[27] Leavis studied that afterglow for clues about what once had been. Using Sturt's first-hand testimony for evidence, he evoked the integrated life of the organic community, describing a society in which country people were taken 'closer and ever closer into England' by work which united them with both fellow man and nature.[28] According to Leavis they were profoundly satisfied by physical labour, seeing their work through from beginning to end, dealing in wholes rather than in bits and parts. Their leisure time was spent in conversation, passing on the wisdom of centuries.

The whole warm, fulfilling picture was profoundly idealized. Leavis did not dwell on the quotidian hardships and boredoms of village life. He paid little attention to Sturt's balanced conclusion that, though we may regret the changes, the old system had never been perfect and had 'gone on long enough'.[29] Whatever the truth about this rural past, Leavis was far more interested in the promotion of a myth that might benefit the future by sending his contemporaries back in search of core values. The damage to the old society was done, but Leavis spent his life trying to lessen the disaster. His substitute for the irrecoverable community was literature. It had to be literature that attracted 'levels of response', appealing to common readers and intellectuals alike and allowing productive exchange between the two.[30] It had to be read closely and preferably read aloud – in a way that might momentarily recapture the cultural cohesion of the old organic group.

With his mythology of rootedness and organicism, Leavis shared in that consuming modern fantasy of 'beginning again'. The back-to-the-village movement in

Stanley Spencer *A Village in Heaven*, 1937

Stanley Spencer *A Village in Heaven*, 1937 (detail)

England might appear to be provincial, indeed it sponsored provincialism, but it was part of a project undertaken all over Europe. It belonged to that same protracted endeavour which saw Gauguin sailing to Tahiti in search of an ideal primitive life, and the German expressionist Max Pechstein leaving his top hat behind in his smart Berlin apartment in favour of a life spent carving totems in Palau. It was this same quest – for a simpler, healthier, more expressive, more coherent way of living – that led the English to the wheelwright's shop. If native culture was to be reborn, it would find its inspiration here.

The veneration of village culture crossed freely between art forms. While the English Musical Renaissance centred on the Queen's Hall in London, it always insisted on its rural sources. For the composer John Ireland, inspiration came from the downland and wild brooks around West Chiltington in Sussex, where he would eventually settle in an old windmill, close to Arnold Bax who moved into the White Horse Inn at Storrington. Ireland's pupil Ernest Moeran drew likewise on strong regional sympathies, bringing Celtic influences into dialogue with folk tunes (like the elegiac 'The Shooting of His Dear', which haunts his only symphony) heard on the Norfolk Broads.

The visual arts, too, could be 'rooted'. Leavis campaigned for the union of high and low culture represented by traditional crafts and, most explicitly, by the Studio Pottery movement which flourished during the interwar years. Potters like Bernard Leach and Michael Cardew were able to transform a village craft into a high art, and the transformation worked vice versa too, as high art renewed its relationship with the village. Leavis enthusiastically collected the work of Michael Cardew, whose small acts of alchemy conjured beauty from clay, reclassifying the humble pot as sculpture. Like human beings, these pots were moulded from earth and aspired to heaven, but they nevertheless kept a foot on the ground. Cardew revered the 'foot' of a pot as the most vital, highly charged part of the object. It remained unglazed, as a point of physical connection with the earth from which the pot was made.

As the Studio Pottery movement indicates, the history of art between the wars is inseparable from the growth of interest in local crafts. To H. J. Massingham it seemed that the abstract movement was a symptom of alienation from the practical life of the soil, another sorry outcome of the Enlightenment. But the English abstract painters were fascinated by craft, never departing for long into purely intellectual realms. Ben Nicholson's white reliefs represent the furthest point in the English journey towards purity, but they also pay homage to the craftsmanly ethos. They hung in the 7 & 5 exhibition next to Mondrian's dematerializing grids, but they were chiselled and planed as satisfying physical objects. Study them closely and one finds that the circles are not quite perfect and the surfaces are not at all smooth.

These are hand-crafted pictures that recall the artist's origins in the village work-shop. Nicholson consciously defined himself in a practical domestic tradition. He used the top of an old kitchen table as his palette, mixing colours on it and scrubbing it clean. He even told Herbert Read that working on a painting was like 'scrubbing the top of a really well-used kitchen table': homely and physical.[31]

Even the 'greenhouses of Bloomsbury' with their exotic foreign flowers (as Benedict Nicolson put it scathingly) looked, from another angle, more like potting sheds where practical work was as important as pure painting. When Thomas Hennell wrote his 'Britain in Pictures' volume *British Craftsmen*, he included Fry and the Omega Workshops along with the thatchers and blacksmiths.[32] The classification was a little incongruous since most of the Omega's decorated screens went to furnish the houses of princesses and bohemians rather than the humble rooms of cottagers, and much of the Omega's furniture was in fact not hand-crafted at all, but bought-in and painted over. Nevertheless, Fry went to Poole to learn pottery and the plates he subsequently made for the Omega, with their handmade feel and generous rim for condiments, demonstrate what he was trying to do. His commitment to applied art qualified him for inclusion in Hennell's story of British craft.

Hennell himself was devoted to recording a more practical rural heritage, touring farms with his sketchpad, attentively drawing every design of rick finial and variety of plough, using pencil and lightly applied watercolour to make faint, delicate images full of air and movement. Attracted to ordinary, ramshackle, working places, he painted farms that would never be mentioned in guidebooks. 'He loved everything about the country', wrote Arnold Palmer, 'from the tin-roof of an insecure lean-to above the farmer's maltreated car to the precise skill of the smith or the thatcher'.[33] Hennell sympathized with the arguments of *Culture and Environment* and worked hard in the cause of rural remembrance. In 1939 he provided illustrations for *Country Relics*, a study by Massingham of the obsolete craft tools that he had been rescuing from abandoned farms and storing up in his shed as a museum of rural skill. Recorded in Massingham's words and Hennell's pictures was a world of lathes, sickles, scythes, fromards, leggetts and harrows. Hennell wanted his own painterly practice to recall the organic community. According to his close friend Edward Bawden, he treated his painting as a form of craft, going at his canvases 'like a carpenter'.[34] It was a potent image of the modern artist having left his ivory tower.

Nineteen-thirties culture pastorally reconvened the lost personalities of the village. In Bernard Leach we find the artist as potter, in Hennell the artist as carpenter. In T. S. Eliot we find the poet as farmer, or at least as a champion of agriculture. The extent of Eliot's interest in farming is not always acknowledged, but it was a significant part of his intellectual life. While many other writers settled for rural elegies,

Eliot campaigned for rural resurrection. As a publisher at Faber he built up a distinguished list of writers whose work dealt with specialized subjects such as husbandry and soil improvement, but who were also making public appeals for help in their attempts to curb the relentless decline of British farming. Eliot wanted a wider audience for these ideas, so he used the editorial pages in his journal, the *Criterion*, to comment provocatively on rural matters. Conceiving culture and agriculture as mutually dependent, he understood the degradation of one to be disastrous for the other. The urbanization of the ruling and literary classes was a kind of standardization that signalled the degeneracy of a whole society. Farming must be renewed if English culture was to stand a chance:

> To have the right frame of mind it is not enough that we should read
> Wordsworth, tramp the countryside with a book of British Birds and a
> cake of chocolate in a ruck-sack, or even own a country estate: it is necessary
> that the greater part of the population, of all classes (so long as we have
> classes) should be settled in the country and dependent upon it.[35]

He had done his research and was absolutely serious. England's most prominent poet was advocating a vast, co-ordinated return to the soil.

Eliot was corresponding regularly with the Hampshire farmer Viscount Lymington, a radically right-wing agriculturist who had become a friend. Lymington led a group called the English Array (using the word in its archaic sense to mean a battle formation), which rallied a kind of medieval militia in the cause of the soil, and condoned Hitler's analogous fight for the pure soil of Germany. Eliot admitted to Lymington that he had very little practical knowledge of agricultural work, but he emphasized his long-standing concern about the decline of English farming.[36] What he got from Lymington in return was a rush of blood-and-soil rhetoric, hymning the rootedness of the racial 'family'. Dangerous politics were at work in the fields. Lymington was out to revive what he called 'Merry England', though it was a dubious kind of merriness that the anti-Semitic and eugenically-minded aristocrat conceived.[37]

There was keen interest, from a number of different camps, in the renewal of merriness. The Kindred of the Kibbo Kift, a youth movement formed in opposition to the increasingly militaristic Scouts, wore handmade Saxon hoods and adopted ancient dialect names as they assembled for ceremonial camping and hiking activities. Robin Hood modified his views on the distribution of wealth and became a domesticated Little Englander championed by Georgian poets. J. C. Squire's 1928 play *Robin Hood*, for example, made the outlaw a pillar of the establishment.[38] The English Folk Dance Society brought medieval rites to the modern village green. But none of this could guarantee the health of the countryside. You could dress up in

antique costumes but it would not bring the community back to life. The Dorset farmer Rolf Gardiner, a friend of both Eliot and Lymington, led the way in rejecting what he saw as a stale museumizing tendency in which decommissioned culture was neatly tagged and displayed to the bemused delight of onlookers.[39] Gardiner wanted folk culture to evolve, not to be embalmed as the strange relic of an urban nation. With this end in view, he had established a model farm on Cranborne Chase, calling it (as if it were a medieval fertility rite, and this was not far off the mark) the Springhead Ring. There was a ceremonial inauguration in September 1933, after which, each summer right through the war, Gardiner ran a harvest camp, recruiting volunteers to join in a highly ritualized programme in which farm work was combined with dancing, singing and hiking, each camp ending with the symbolic lighting of a beacon on the Downs.[40]

Gardiner's explicitly Germanic styling of himself sent rumours through the surrounding country about Nazi affiliations, though Patrick Wright's investigations reveal Gardiner's disgust at the fascist corruption of older German ideals. The Springhead Ring won many admirers. When Massingham first visited in 1939, following an introduction from the novelist Adrian Bell, Springhead evoked for him 'the early Christian pilgrims whose lights shone out through the Dark Ages at Iona'.[41] These were indeed the Dark Ages: with the coming of war and the need for British self-sufficiency, the work of the Dorset farmers started to look less medieval and more urgently contemporary. When Gardiner convened his Kinship in Husbandry in April 1941, he was joined by high-profile figures like Edmund Blunden and Arthur Bryant, and was able to command real influence over government agricultural policy.

The Kinship members wanted to lead the way, not only in farming, but also in the arts, the two being naturally related. Concerned that the 'capacity to act Shakespeare in a barn' (or a pageant on the lawn) was not enough to 're-create the village as a living entity', Lymington argued that a new form of drama must grow naturally from the life of the soil.[42] The exchange of ideas among these radical farmers had a decisive influence on Eliot. By 1941 he was lamenting in his letters to Lymington that metropolitan tastes should exercise such a dominant influence on rural life.[43] Eliot suggested that the tired, dissociated, over-civilized Westerner in search of a more vital culture could look at the traditions grown out of, and fast dying back into, his native soil. Visiting the village of his own ancestors, East Coker, in 1937, and writing his poem of the same name in the early months of 1940, Eliot had already been articulating his own complicated and divided search for those soil-bound roots.

Approaching East Coker along a green sunken lane in summer heat, the speaker in Eliot's poem looks into an 'open field' and finds that visions start to rise:

If you do not come too close, if you do not come too close,
On a summer midnight, you can hear the music
Of the weak pipe and the little drum
And see them dancing around the bonfire [44]

The sultry village with its genteel sleepy dahlias comes alive in the poet's mind as part of a primitive rural fantasy. The dance is a sacred rite of the kind that modernists repeatedly invoke. It is rhythm and energy and unity. Matisse painted it. So did Derain. But the figures in Matisse's *La Danse* float and skip through their eternal circlings on a bright originary hill top. Like the singers in the companion painting *La Musique*, they are representative beings, belonging everywhere and nowhere, creatures of the sky as much as the earth. Britten, in *Peter Grimes*, revised Matisse's theory about the origins of song; Eliot, in East Coker, revises Matisse's choreography. His dancers are embedded in the ground,

Lifting heavy feet in clumsy shoes,
Earth feet, loam feet, lifted in country mirth
Mirth of those long since under earth
Nourishing the corn.[45]

This muddiness proved controversial. Leavis felt that Eliot, while pretending to celebrate the peasantry, could not help but sneer. He attacked the 'reductivism' of a passage which summed up rustic life with a blunt appraisal of the natural cycle: 'Eating and drinking. Dung and death'.[46] Eliot's picture of the organic community disappointed Leavis. It appeared to be a caricature, wilfully ignoring all the civilized oral culture and social integration that Leavis valued so highly. And it opened up a distinction between literary and organic culture by describing the dance in a collage of different voices. There are the rough Saxon monosyllables, but these are set against the voice of Eliot's eminent and educated ancestor, a moral philosopher in the sixteenth century, Sir Thomas Elyot. For a moment Eliot sees the dance through the Tudor scholar's eyes and articulated in his voice: 'The association of man and woman / In daunsinge, signifying matrimonie – / A dignified and commodious sacrament'.[47]

That fragment of stately diction aroused Leavis's suspicions, but there is little evidence that Eliot intended to be reductive. The connection with the earth, the 'dung and death', was for him the very sign of civilization. By introducing death to the world of Leavis's lively peasants, Eliot was commending the realism and wholeness of the rural life cycle. And perhaps Leavis was right to be wary because, in this matter of rural revival, Eliot was now closer to the views of Lymington and Gardiner than to Leavis's own. Eliot did not want to distance himself from those dancers, but to join them, as he made clear in the patterning of his language. In 'East

Coker' he imagined the long-dead villagers 'nourishing the corn'. In 'Dry Salvages', the next part of his poem sequence *Four Quartets*, he used the image again as he envisaged his own burial in the earth:

We, content at the last
If our temporal reversion nourish
(Not too far from the yew-tree)
The life of significant soil.[48]

While Leavis discovered the village ethos at second hand and Eliot relied on the reports of agriculturalists, there was another writer of the countryside whose voice sounded truly knowledgeable and immediate to those who read her during the war. Flora Thompson was a woman of sixty-three when she finished *Lark Rise*, published just before war broke out in 1939. She had not written much for years, although she had kept up a magazine nature column all through the 1920s while living in Liphook, close to Selborne, and following the cycle of the Hampshire year in the tradition of Gilbert White. Now she was in Dartmouth with a husband who disapproved of her literary aspirations; but the expression of her particular vision at just this moment, in *Lark Rise* and the two sequels written during the war, brought her a devoted following who regarded her as a kind of national storyteller. Richard Mabey has remarked that one of Thompson's distinctive skills was to make 'even the most minutely detailed anecdote work as an allegory'.[49] This was precisely what made her work feel archetypal before it was even finished. The point of *Lark Rise* was its density of observation, but it was also the outline of a lost Eden and lost childhood. Thompson managed it without over-freighting her material, keeping a lightness of touch. Her story of leaving the hamlet for the town, and the town for the city, still has the effect of making readers think she is telling *their* story.

Thompson grew up in the 1880s as the daughter of a disappointed, impoverished builder's labourer in the Oxfordshire hamlet of Juniper Hill. As a young woman she left behind these rural origins, becoming part of the social transition her writings describe, but she pledged to record the hamlet as it had been in her youth. She mixed personal memory with meticulous research, so that her writing was partly autobiography with all the intimacy of a family memoir and, at the same time, partly an anthropological study of a remote tribe. Impatient with nostalgia, Thompson wanted to get things right and tell them how they were. She allowed herself moments of lyricism (harvest fields ripple gold, songs sung for the last time echo on) and she was moved by the local poetry of the hamlet; recording its rhymes and tales as part of England's literature, she elevated the stories of the fields to

Vaughan Williams rehearsing for E. M. Forster's pageant *England's Pleasant Land*, 1938

the status of 'a rustic *Decameron*'.[50] But in hamlet life all luxuries were worked for, and so Thompson's prose toils on between its moments of vision, observing domestic rituals and the labours of the months.

Massingham prescribed *Lark Rise to Candleford* (the collective name for the trilogy) as required reading for ruralists. Writing an introduction for the book in 1945, he argued that Thompson pointed the way forward to a new agricultural age. *Lark Rise* showed, he thought, that it was not too late for 'the restoration of the peasantry' to re-people the land.[51] This was a radical agenda, but there was no such clear-cut message to be found in Thompson's text. The extreme poverty of the hamlet is never far from the surface of her account, and she insists that change is gradual, a matter of adaptation and compromise rather than revolution heralded theatrically from above.

Lark Rise has come to stand for quaintness, marketed with Helen Allingham's sunny cottage gardens on the cover, or flooded with golden light for television serialization on a Sunday evening.[52] But there is no sepia tinge to Thompson's thinking, and no sentimental love of crooked cottages. Clear-sighted, forward-thinking, she stays clear of the angry tirades against development voiced by so many of her contemporaries. She knew the old life was a hard one and would have agreed with Sturt when he said decisively 'I would not go back'.[53] She wanted to bear witness and to pay tribute. Those who lived in the hamlet 'deserve to be remembered', said Thompson, 'for they knew the now lost secret of being happy on little'.[54]

The rural writing of the 1930s goes in search of the 'lost secrets' of country life and asks what might productively be saved from the old community. It had not, after all, been left very far behind. In 1939 a quarter of English villages were still without piped water, and the vast majority had no electricity.[55] Flora Thompson's hamlet life seemed both very distant and surprisingly close at a time when cinemas sprouted up next to country inns in some areas, while in others there were still no modern amenities at all. Virginia Woolf was constantly interested in the sense of transition she felt at Rodmell. Writing her history of literature, she observed that 'by shutting out a chimney or a factory we can still see what Anon saw'.[56] So she could. There is a photograph of Rodmell in 1937 in which the road is flanked with ricks.[57] It was taken on the occasion of the last smock funeral in the village, with mourners in their traditional dress walking alongside the farm wagon which bears the coffin. It was 'the last', but it had survived this long and seemed so integral to village life that Woolf embedded it in an early draft of *Between the Acts*. Old Bartholomew Oliver imagines his own funeral as a traditional village occasion:

the farm cart, decorated with moss and chrysanthemums, or with primroses

and palms according to the time of year, bore him, through ranks of villagers, some wearing smocks, to the family grave.[58]

This glimpse of old England was cut from the final text, but the novel remains poised between ancient rites and intimations of change. Woolf describes a village that seems at times untouchable in its longevity. The old families of the area are here, the Dyces of Denton, the Wickhams of Owlswick. But these indigenous country people are well aware that they have been joined by 'new-comers, the Manresas, bringing the old houses up to date, adding bathrooms' (as the Woolfs had done); even the 'gentleman farmer' Mr Haines, who fashions himself as a yeoman, goes off home in his car to the 'red villa in the cornfields'.[59]

The pageant at Pointz Hall is an attempt to bring these disparate people together in celebration of their shared place. Cohesion alternates with fragmentation: the audience listens together for a moment and then divides. The last tune of the pageant, played as people depart, goes on repeating these rhythms in the background: 'The gramophone gurgled *Unity – Dispersity*'.[60] The gramophone, and the novel itself, ask whether it is possible to reinstate the path by which Anon walked between village and manor, 'that track between the houses in the village [that] has been grown over'.[61] The effort is at least temporarily successful: by the end of the day, the 'pilgrims had bruised a lane on the grass'. Near the close of *Between the Acts* Miss La Trobe walks to the pub with the next production already forming in her mind. She sits in the smoke listening to the voices around her and it is from the crude conversation of the men in 'earth-coloured jackets' that the 'wonderful words' of her new play begin to take shape. This is how Woolf imagines the creative process in her last novel: no visions on the lawn as in *To the Lighthouse*, or long stories told at restaurant tables as in *The Waves*. Miss La Trobe is not ideally integrated with the community; her neighbours are suspicious of her and in turn she is bored, sometimes disgusted, by them. But her art binds them together and the villagers who surround her (but do not welcome her) have a vital part in its making. 'Words of one syllable sank down into the mud. She drowsed; she nodded. The mud became fertile'.[62]

The pageant represents an oral, communal art, not the dream of one romantically inspired individual. Miss La Trobe accordingly refuses to take a bow at the end: she does not want the play to have an author and would rather it were the creation of 'Anon'. Not that the medieval Anon would have put on a pageant like this. Jed Esty has traced the development of pageant-plays and shown that they were really a late-nineteenth-century invention bound up with the pomp and circumstance of empire.[63] With the indefatigable dramatist Louis Napoleon Parker as master of ceremonies, an Edwardian pageant might involve thousands of actors parading through British history and much bravura singing of imperial anthems. It was the kind of thing Woolf most distrusted, hence her attacks in *Three Guineas*

(1938) on self-satisfied processions: 'The outsiders will dispense with pageantry', she said.[64] Perhaps this is why she stages a pageant in her novel while making it into something very different. It *is* too ambitious and long (Woolf wryly shows the audience getting bored). But it feels more like a medieval village play than one of Parker's bombast epics. Esty is convincing in his suggestion that Woolf is purposely reclaiming tradition 'from an imperial Britishness that had appropriated the national past'.[65]

As she did so, many other kinds of dramatic tradition were reclaimed. All over England local acting groups and troubadour companies were being formed, reviving local arts. The British Drama League had an arm devoted to Village Drama. The Woolfs went to Pulborough to see Angelica Bell's group, the London Village Players, perform the raucous village comedy *Gammer Gurton's Needle* (which, so Mrs Swithin tells us, was also performed one year at Pointz Hall), and similar events were repeated across the country. The critic Una Ellis-Fermor reckoned in 1937 that the growth of the amateur movement had been 'one of the most important dramatic developments of th[e] century'.[66]

And Woolf was certainly not alone in using a revised species of pageant to explore connection and disintegration within the village community. On three rainy days in July 1938, in the grounds of Milton Court, an Elizabethan manor house near Dorking, E. M. Forster staged a pageant called *England's Pleasant Land*. As with Forster's earlier pageant, *Abinger Harvest*, the music was provided by a fellow Surrey villager, Vaughan Williams. It was on a grand scale, played by a military band, and included pieces like 'The March of the Old Order', which Vaughan Williams was writing for his Fifth Symphony. The pageant was about a land whose pleasantness kept coming under threat, and which was now more severely tested than ever. The setting was also the subject: Forster dramatized the relationship between the gentry at Milton Court and the villagers who had lived for centuries on the lands around it. The gentry and the villagers work symbiotically until, up at the manor, Squire George is persuaded to enclose his lands. It was a decision being taken all over England in the eighteenth century and for Forster it signified the malign victory of greedy commercialism. In his pageant, the fatal act of enclosure precipitates an eighteenth-century Fall, bringing the gentry into conflict with villagers deprived of their common land. In the following scene, Forster's 'recorder' stands alone on stage, reading from Oliver Goldsmith's poem 'The Deserted Village'.[67] This marks the end of ideal community, as Forster conceived it. The society reconvened after the enclosures would never achieve the same vitality.

Goldsmith's deserted village was gradually repopulated, however, and the theme of *England's Pleasant Land* was the endurance of country life in the face of such disasters. The enclosure acts, the modern developers, and another world war, were woven into the same cycle of threat and survival. Forster specified that the same actor who played the Norman knight must also be the squire of the enclosures,

and subsequently the squire whose death in the nineteenth century besets his heirs with death duties. 'Their costumes may alter', he wrote, 'but their characters will not change'.[68] Staged in aid of the Dorking and Leith Hill District Preservation Society, the pageant was raising funds to help these characters and their landscape survive the latest in a long series of dangerous transformations. Domesday would, with strenuous efforts, be averted.

After the war, the village was again talked of as part of England's future. *Life in an English Village*, a King Penguin book from 1949, is a good register of the new attitudes had emerged from the debates of the 1930s and 1940s. There is a long introductory essay by the enterprising publisher Noel Carrington (brother of the artist Dora Carrington, and responsible for some of the best popular books of the period), followed by a series of sixteen colour lithographs by Edward Bawden. Carrington's main point in the essay is that, in order to continue, the village must change. The mounting nostalgia that had made a false religion of the old ways had threatened to bring the village to a grinding and obediently tumbledown halt. 'How do we come to take it as natural that a typical village should look much as it looked a hundred years ago?' asked Carrington.[69] He pointed out that this immunity from time was not really very natural at all. Even in those glowingly bucolic places like Dedham or Burford (he imagined watching them 'on a film in which the years became minutes'), the village as it now appeared was the result of adaptation: buildings being pulled down, new and more appropriate buildings going up. Now that changes were again beginning to happen in the right spirit (among them, 'dance, drama and the arts are coming back into village life') Carrington thought the enjoyments of the village had 'come back for good'. 'A silent revolution' had been going on.[70]

Bawden's lithographs are not quaint or crooked. They are full of people doing things: pouring pints, queuing in shops, sweeping the church, repairing machinery, mending shoes, cutting meat, going to school. This is not a village seen from the outside as a tourist, hoping that people will get out of the way of the photograph. These pictures are all of working interiors. For most of his life Bawden lived in Great Bardfield, and found all that he needed there. J. M. Richards admired his ability 'to find inexhaustible subjects to paint simply by looking in a new direction down his own village street'.[71] These busy lithographs for *Life in an English Village* were Bawden's tribute to that familiar street and its inexhaustibility.

9

PARISH NEWS

For Eliot the important concept was not so much the 'village' as the 'parish', a community of Christians held together by a common belief. Only the church, he thought, could give rural societies the purpose and coherence they needed. His vision took on detail and solidity, it became a whole philosophy, and in 1939 he published a book devoted to it: *The Idea of a Christian Society*. Eliot's 'community of Christians' would cultivate a 'common culture' and form, collectively, the 'conscience of the nation'. It would be structured according to the allegiances of the parish system, each parish being largely self-contained, with its interests focused in a particular place, and, crucially, 'attached to the soil'.[1] This model social unit could not have been more different to the temporary living arrangements designed by Wells Coates. Eliot's ideas were about being tied to a place and to a group, firmly rooted down and attached to the past. His parishes have 'a kind of unity which may be designed, but which also has to grow through generations'.[2] *The Idea of a Christian Society* was Eliot's personal dream of unity in a divided, distracted society. Its insistence on faith made it unsympathetic reading for many, but with the village adopting new prominence on the modern map, and the church remaining physically – if not spiritually – at its centre, there was much that proved compelling in Eliot's argument that the church should once again form the hub of the nation's cultural life.

John Betjeman, teaching listeners 'How to Look at a Church' in a radio broadcast of 1938, winningly translated the technicalities of the guidebook (Early English, Perp., Dec.) and tried to make churches feel as warm and familiar as 'a house that has been lived in for generations'. He wanted people to feel they belonged there. Churches, he said with feeling, are not backwaters 'but strongholds'.[3] He knew that they could be instrumental in reviving rural communities, even where faith was lacking. They had for centuries been the focal point of village culture. This was where English music had flourished; it was also the village art gallery with a permanent collection of extraordinary richness, from wall paintings and ceiling bosses to stained-glass windows and memorial sculpture. As Graham Greene pointed out in his

history of English drama, the church was also the oldest theatre, where rituals acted at the altar spilled over into the entertainments of the market square.[4] If regional culture was flagging, it was perhaps because churches had lost their sense of identity.

Among the most influential campaigners for the alliance of church and art was George Bell, Dean of Canterbury from 1925 to 1929, and subsequently Bishop of Chichester. He wanted to restore the centrality of the church in community life (as proof of which he immediately gave instructions that Canterbury Cathedral be kept open for longer hours and that women be allowed in without hats). He had an influential circle of friends, including T. S. Eliot, Charles Williams, Dorothy L. Sayers and Laurence Binyon, all of whom gathered frequently to discuss new ways of broadening support for local religious art. Much of their thinking centred on drama since plays have such potential to bring together a community. There was already a growing interest in amateur touring companies and village players, and church sponsorship gave new impetus to the movement. Bell founded the Religious Drama Society in 1930, and the Chichester Diocesan Players emerged later as an active group, taking their plays and pageants around Sussex villages.[5]

Plays outside were one thing; a play inside a cathedral was another. The Anglican Church had never allowed one; not since the Middle Ages had there been any widespread practice of performance within churches. But George Bell pushed hard to persuade the diocese that a play in Canterbury Cathedral might attract a wider audience and give the space a new imaginative life. The idea was controversial, but at Whitsun 1928 a nativity was staged in the nave. *The Coming of Christ* was written by John Masefield with music by Gustav Holst and, as a sign that it was the product of the community, not simply imposed from elsewhere, most of the actors were Canterbury people. They played out in local terms the most universal of stories. Following the tradition of Blake at Felpham and Spencer at Cookham, they imagined the arrival of God in their midst. Six thousand people turned out to see this Canterbury nativity. The acoustics in the nave were so bad that only a few of those six thousand caught the words, but the atmosphere was so exciting that the event was deemed a triumph. Bell's rapture was still audible in a sermon he gave twenty-five years later remembering that first Whitsun play: 'the colour, the movement, the acting, the singing, the bells, the procession, the stir, the wonder, the awe, the concord and the worship within the Cathedral!'[6]

Even after his move to Chichester, George Bell remained an energetic force behind the festival. The Canterbury play became an annual rite (though the stage emigrated to the Chapter House where the acoustics were slightly better). There was Laurence Binyon's *The Young King* in 1934, Charles Williams's *Thomas Cranmer of Canterbury* in 1936, and Dorothy Sayers's *The Zeal of Thy House* in 1937. The play that Bell commissioned for 1935 roused particular interest because it was to be written by T. S. Eliot.

E. Martin Browne, who had produced Eliot's pageant play *The Rock* the year before, and who would collaborate with him on all his subsequent plays, remembered a weary, taciturn Eliot coming to stay with him in Rottingdean while trying to finish the Canterbury commission. That weekend, to relieve the gloom, they immersed themselves in local drama, going to Eastbourne to see a play involving choral speaking of the psalms, and then on the Sunday Martin Browne and his wife, the actress Henzie Raeburn, staged 'a triple bill' in the village church, including the Annunciation from the Lincoln Cycle of mystery plays. It was an exciting time for drama and Eliot could feel it; the atmosphere of the revival went into his writing. He needed a title for his play and it was Henzie who suggested *Murder in the Cathedral*. It sounded like a detective story – a sequel to Agatha Christie's *Murder at the Vicarage?* It was bound to draw the crowds.[7]

And so it did. The murder was in the Chapter House rather than the Cathedral, but the proximity of the action to the actual site of Becket's martyrdom gave it all the magnetic drama of being 'on the spot'. Eliot's script exploits this to the full. 'Here let us stand, close by the Cathedral' is the opening line, delivered by a chorus of Canterbury women ('small folk drawn into the pattern of fate'). From this point onward the word 'here' returns insistently, reminding us that the drama is inherent in where we are.[8] The space is made intimate and electric, defined by intimations of what lies beyond:

PRIESTS: Is the window-bar made fast, is the door under lock and bolt?
TEMPTERS: Is it rain that taps at the window, is it wind that pokes at the door?[9]

As an 'Interlude' between scenes Thomas à Becket delivers a sermon from the pulpit, so that the action of the play becomes indistinguishable from the normal life of the Cathedral, religious ritual and theatre becoming one.

In the tradition of the Canterbury plays, many of the actors were from local amateur companies, though Becket was played by Robert Speaight and the 'Women of Canterbury' came from an acting school in London. What these women represented, however, was the ordinary population ('the scrubbers and sweepers') of the city, called upon to bear witness. And this is at the heart of Eliot's play, this bearing witness to what happened in this place. It is drama for the 'morbid age', a drama of watching, waiting, fearing.[10] But there is redemption in the honouring of this site. At the close, after the killing, the Chorus consecrates the stage as 'holy ground':

The blood of Thy martyrs and saints
Shall enrich the earth, shall create the holy places.
For wherever a saint has dwelt, wherever a martyr has given his
 blood for the blood of Christ,

There is holy ground, and the sanctity shall not depart from it
Though armies trample over it, though sightseers come with
 guidebooks looking over it.[11]

It was ungenerous of Eliot to yoke the sightseers with the armies, as marauders blundering through. It was part of his instinctive, snobbish recoil from tourist crowds, but he must have known that the relationship between sightseers and pilgrims is a close one. Though they may look unpromising and uncomprehending, casual visitors who come to see the tracery often leave feeling that they have seen more than architecture. Eliot makes a careful distinction between merely 'looking over' and actively bearing witness; his own play, which was an improvement on guidebooks as a way of narrating religious history, made sure that the audience felt it was doing more than just looking. Having said its distinctive mass over the holy ground of Canterbury, the play transferred to London. As the cathedral had become a theatre, theatres now became cathedrals. The insistence of 'here' did not seem to the London audiences any less physical or immediate, though their task of witnessing was, in important ways, an imaginative one.

Bishop Bell's commissions were receiving national acclaim, and he pressed on. The results of another of his projects can still be seen at Berwick Church under the South Downs. Light streams in through the large clear windows, revealing bright paintings on every wall: annunciation, nativity, resurrection, Christ in glory. There is a long tradition of church painting in the area. Medieval artists decorated the walls at Hardham, Clayton and Keymer, using expressively stylized figures and earth-ground colours to narrate the stories of the Bible. But the paintings at Berwick are not from the Middle Ages. They were commissioned by Bishop Bell as part of his campaign to revive church murals, and painted during the first years of war. They are the work of Duncan Grant and Vanessa Bell, painters whose names had, in Roger Fry's lifetime, been synonymous with Post-Impressionism. By 1940 these innovators of high modernism were designing Christian pastorals for the walls of a village church.

 'You'll never guess what we are up to', Vanessa Bell wrote to Jane Bussy in 1941, full of surprise and excitement:

It starts by the curious fact that Duncan is in touch with a bishop. [...] We have got as far as doing sketches, which have met with approval on the whole, though D.'s Christ was thought a bit attractive and my Virgin a bit frivolous. Still that is easily changed, and on the whole we accept every suggestion and read our Bibles diligently.[12]

Vanessa Bell *Nativity* at Berwick Church, East Sussex, 1941–42

Duncan Grant *Christ in Glory* at Berwick Church, East Sussex, 1941–42

In the end it did not all go so smoothly. The scheme met with objections; a delegation of parishioners felt strongly enough to take the matter to the Chancellor's Court, arguing that Grant and Bell's murals had nothing to do with a living tradition, being merely brash defacements of a beautiful building. The court hearing that took place in October 1941 in the little flint schoolhouse at Berwick was a test-case for the efforts of modern artists to integrate themselves into local communities, and it proved a hard one.

The murals were eventually approved, with the support of Kenneth Clark and Frederick Etchells, who were called in as expert witnesses. Clark's interest in the scheme is no surprise, since he was the financial and organizational force behind so many of the period's cultural projects, and had been promoting the Englishness of Duncan Grant since the mid-1930s. The story of how Frederick Etchells came to be involved is a more intriguing and revealing one. In 1913 he had seceded from the Omega Workshops to launch a Vorticist riposte to Bloomsbury. His distorted, angular figure paintings and black interiors for the Rebel Arts Centre in 1914 had been intended as virile challenges to the 'pleasant tea-party' of Fitzroy Square.[13] From painting he turned to architecture, bringing modern European theory to England when he translated Le Corbusier's *Vers une architecture* (*Towards a New Architecture*) in 1927. He was a radical figure, but his enthusiasm for the international avant-garde was mixed up with his growing commitment to ancient English buildings. He moved out of London to restore a Georgian house in rural Oxfordshire, and posed as the eighteenth-century architect Batty Langley in a series of faked letters for John Betjeman's *Ghastly Good Taste* (1933).[14] Etchells became a mentor for Betjeman, who frequently reported on their pleasant church-crawls and, indeed, their tea-parties.[15] Both men understood the possibilities of the modernist revolution, but they also saw the need to combine its lessons with sustained faith in the buildings of the past.

The painting at Berwick went ahead. Grant and Bell did not paint directly on the walls, but prepared huge panels at Charleston, only a few minutes from the church. By late 1941 Charleston was 'all a-dither with Christianity'.[16] Just as the resurgence of the pageant genre included local people in a communal artistic venture (in *Between the Acts* Woolf had the carpenter's daughter play young England, the tobacconist play Queen Elizabeth), the painting of the Berwick murals involved family, friends and neighbours. Local shepherds posed at the birth of Jesus carrying their Pyecombe crooks (made in a nearby village and famed as the best crooks in the trade); the children worshipping at the crib were those of the Charleston gardener and housekeeper, all in their school uniforms. Populated by costumed angels and shepherds, the barn which was used as a studio must have resembled a painting by Stanley Spencer, with impromptu *sacre conversazioni* taking place in the back garden.

As if narrating the home-coming of modernism, the murals fuse continental influence with native models. The fresco cycles of the Italian Trecento had been amongst the precursors claimed by Post-Impressionism, their formal organization and purposeful distortion cited as paradigms of expressiveness. In one of Duncan Grant's four chancel screen roundels, depicting the labours of the months in medieval tradition, a man hands a woman a basket of apples just picked from the tree, as English a scene as could be, except that the woman places the basket on her head, as did the Italianate figures of Grant's much earlier *Lemon Gatherers* (1910). The monumental figures of Giotto and Fra Angelico, who had inspired many of Vanessa Bell's earlier paintings, now merged with recognizable village faces set amid local Sussex scenery. Her *Annunciation* might be in Italy, but her *Nativity* is in England, set in the barn at Tilton and taking as its backdrop the downland scenery of Firle Beacon, which dominates the view from the church.

The murals are responsive not only to place but also to time. The gospel stories they depicted were two millennia old, but they were retold for the extraordinary times in which they were painted. Grant's panel for the chancel arch, the culmination of the mural cycle, shows Christ in glory, seated high up in the heavens attended by angels. Kneeling on the ground below, with downland scenery rising around them, are five recognizable figures. On the right is the rector of Berwick, and next to him Bishop Bell, taking his rightful place as patron – as donors in the Renaissance had knelt in the wings of the paintings they sponsored. On the left are a local soldier, a sailor, and an airman, representing the troops who had gone to war from this small place. The panel was both a religious picture and a war painting, and within a year of its installation at the church it had become a war memorial as well. Douglas Hemming, the soldier Grant painted, was killed near Caen in 1944 at the age of twenty-six and buried in Normandy. That year, too, the Berwick Church windows were blown out by a bomb, though the paintings remained intact and became objects of remembrance.

As George Bell worked towards the reinvigoration of church art in Sussex, another clergyman was emerging as an influential patron of the arts. Walter Hussey was the vicar of the good-sized late nineteenth-century parish church of St Matthew in Northampton. He saw that it was in just such places as this that art could reach an audience, and reach back into a tradition. To celebrate fifty years since the consecration of of St Matthew's in 1893, Hussey commissioned music from Benjamin Britten, who responded with the ecstatic cantata *Rejoice in the Lamb*, and he asked Henry Moore if he would make a sculpture. Moore was uncertain. It was a difficult commission for an agnostic; it was difficult for any modern sculptor: 'The great tradition of religious art seems to have got lost completely in the present day', Moore wrote

sadly to Hussey. In a long series of mother-and-child sketches during 1943, Moore felt his way back into that lost tradition. Eventually he carved in Hornton Stone an exquisite Madonna and Child, which was placed against the wall in the North Transept in 1944. In its boldness and conscious naïveté, and in such details as the decorative neckline of the Madonna's dress, the sculpture recalls the tomb effigies that Moore had admired in local parish churches all his life. There are many other debts (to the generous embrace of Masaccio's Madonna in the National Gallery, to Jacob Epstein's hieratic primitivism, and to the weighty equilibrium of Matisse's 'back' sculptures), but this is an English sculpture for an English church, monumental while also movingly intimate. 'I have tried to give a sense of complete easiness and repose,' Moore wrote, 'as though the Madonna could stay in that position for ever (as being in stone, she will have to do).'[17] This was a sculpture designed to belong in one place.

There would be more art in Northampton after the war: poetry by W. H. Auden, and Graham Sutherland's agonizing *Crucifixion* (1946). Later, Bishop Bell appointed Hussey as Dean of Chichester, ensuring a continued investment in art in the city. The beginnings of all this, however, were in that particular turn to the local that marked English art in the late 1930s and early 1940s. Perhaps most significantly of all, it was the time of T. S. Eliot's *Four Quartets*. The poems were issued separately between 1935 and 1942, but at the end of October 1944 the sequence appeared in Britain as an integrated whole, taking as its subject matter the English village and the idea of home.[18]

The *Four Quartets* began in Canterbury. Some of the lines that Eliot excised from *Murder in the Cathedral*, partly because they seemed too abstract for the stage, stayed with him and became the foundation for 'Burnt Norton': 'Time present and time past / Are both perhaps present in time future'.[19] So the poem took its first impetus from the rhythms of language as it might have been spoken by a choral group in the large, echoing space of the Chapter House, with an audience listening and bearing witness. When Eliot returned to 'Burnt Norton' in 1940 and decided that it might be integrated into a whole sequence of poems, those origins in the drama were still in his mind. His work was full of echoing sounds, it was concerned with acts of careful speech and careful listening, and – perhaps most importantly – it was written for a public. Eliot wanted people to hear these poems. At this time when everyone he knew was deciding what they could contribute to the war effort, he wanted very much to feel useful, and to feel that poetry could be useful. He had been broadcasting regularly on radio for over a decade, and shared with John Reith the conviction that radio was an almost revolutionary medium that could make literary culture public property. Now, more than ever, that potential seemed important. Robert Speaight read each of the wartime *Quartets* for the BBC as they came out, and Eliot himself read the whole sequence both for radio and for gramophone

Henry Moore *Madonna and Child* at St Matthew's, Northampton, 1943–44

recordings. Though there was much in the poems that was interior and secretive, there was also a shared public imagery of national survival.

'History is now and England': that is the voice of a rousing speechmaker and it was meant to be. These were substantial words to set against 'dust in the air suspended' in the ruins of the Blitz.[20] At Canterbury Eliot had wanted the chorus spoken by 'scrubbers and sweepers'; now, as he said in a lecture tellingly entitled 'The Social Function of Poetry', he wanted 'a common language of the people'.[21] In this common language and in a common cause he would 'fight to recover what has been lost / And found and lost again and again'.[22] *Four Quartets*, then, were to be Eliot's poems of 'recovery': recovering lost places and unheard voices. He therefore turned himself into an antiquarian explorer, visiting houses and churches, taking photographs, reading the inscriptions on gravestones, and listening by roadsides for sounds from the past.

The defining sense of place that had characterized *Murder in the Cathedral* is again the structuring principle for *Four Quartets*. The poet wanders in manor gardens, he follows deep lanes, he finds the Pentecostal fire between ditches and hedgerows. The weather and the seasons that Woolf was writing into her history of literature constitute for Eliot a holy language of 'autumn heat', 'vibrant air', 'Midwinter spring'.[23] Eliot's orchestration of the four elements and the four seasons (which imitate and offset each other so that frost becomes May blossom), elevates 'England's climate' to a cosmic scheme. Each of the four poems bears the name of a place. Burnt Norton is a house in Gloucestershire, East Coker is the Cotswold village in which Eliot's ancestors lived for generations before sailing to the New World. Eliot retraced their journey by setting his next poem, 'Dry Salvages', on the coast of Massachusetts. And then he brought the sequence firmly back to England to find its culmination in Little Gidding, a Cambridgeshire village with a strong Anglican history reaching back to the seventeenth century. The chapel at Little Gidding is an out-of-the-way place to get to ('leave the rough road / And turn behind the pig-sty') but it is the goal of Eliot's pilgrimage no less than Becket's shrine had been. Again there is the insistence on the word 'here': here 'where prayer has been valid'.[24] It is the continuity of worship that makes the chapel sacred, the accumulation over time of prayers offered up in one place. Little Gidding and East Coker are the kinds of parish communities Eliot described in *The Idea of a Christian Society*, in which he insisted that unity must 'grow through generations'.[25]

Eliot's work of recovery, which brought him into physical proximity with his Anglican forebears and with his own Elyot ancestors, was also about closeness to a literary inheritance. In *The Waste Land* (1922) he had walked among the sickly fragments and half-interred bodies of a poetic tradition, but here the dead have become talkative ghosts, not so much hauntings as blessings. Like the ghost children in the garden of Rudyard Kipling's story 'They', these are lost family. The 'familiar

compound ghost' we meet in 'Little Gidding' (the ghost of Yeats and Dante and Dante's master before him) is a familiar in all senses of the word. And yet what seems to be very close in these poems is also elusive. The ghosts fade 'on the blowing of the horn'; the roadside visions vanish.[26] And the lines of inheritance are not finally drawn with any certainty. Eliot makes his journeys home to ancestral ground and 'significant soil', but he is always the visitor, approaching from elsewhere. When he arrives, the gardens are deserted and the landscapes are not fully understood. He is left as an exile turning over clues.

This is partly why the echoes of Kipling keep coming back. In 1940 and 1941, Eliot was rereading Kipling and compiling an anthology of his poetry (which the war was bringing back to prominence).[27] Here was another literary exile who had sought out an English home and taken possession of it in his writing. When Eliot wrote his introduction to the anthology, he found that he was also writing about himself. Digging into the Sussex landscape and summoning the former inhabitants of Pook's Hill, Kipling was 'reclaiming a lost inheritance' – as Eliot was doing when he summoned the dancers of East Coker.[28] And what Eliot called the 'contemporaneity of the past' in Kipling's landscape was precisely what he wanted to evoke in his own *Four Quartets*.

As Eliot worked on 'Little Gidding' in 1941, Piper painted Muchelney Abbey on the Somerset Levels, where only the Abbots' House and the foundations survive from what was once a large Benedictine monastery. Piper chose a single wall, brought it almost flat up against the picture plane, and studied its texture. He painted layer after layer, scratching and rubbing through from one stratum to the next, plunging one corner into deep shadow and picking out another in sharp bright white. He jotted in the lines of the tracery, bruised and obscured in some places and in others revealing clear decorative shapes. Ruskin called it 'voicefulness', this articulate quality in ancient buildings that Piper evokes without attempting to translate it. It might also be called the 'contemporaneity of the past'.

It was Piper's love of churches that led him to Christian faith (he was confirmed with Myfanwy in 1940); Eliot's faith led him to English churches, and to the villages around them.[29] But both men were also able to use Christian places as symbols of permanence that would speak beyond the religious community. Their churches are palimpsests, accruing traces of individual and communal lives. These are places which draw their identity from strange artefacts in niches and half-legible inscriptions, all embedded – like Eliot's lyric 'moments' ('The moment in the arbour where the rain beat / The moment in the draughty church at smokefall') – within the fabric of something larger.[30]

Eliot's poetry and Piper's paintings were fused in the imaginations of some of their contemporaries. Stephen Spender remembered the 'feeling of incandescent faith' that lit up the art of wartime. Piper and Eliot, and other artists who helped to

define the 'religious mood of the war', were linked, said Spender, in their commitment to the 'idea of the sacred'. It was an idea that went beyond the church to a wider vision of the country, an idea that 'England itself was sacred'.[31]

10

VARIATIONS
on a VIEW

One thousand five hundred topographical watercolours were made for the Recording Britain project between 1939 and 1945. Most are now at the Victoria and Albert Museum, though some are on loan to regional galleries because the subject matter is of local interest. Barns, high streets, bits of unremarkable country road, that's what they show. Was there really time to produce all these during the war? There is something so English in the fact that watercolour views were made in the same quantities as military armaments – and something American, too, because there was American money (from the Pilgrim Trust) behind this major operation.[1] The old country was to be recorded on a giant scale, but it mattered that there should be nothing giant about the vision of England projected. The drawings were to be small in scale, depicting small-scale things, and they were to be done in water-colour because it evoked a tradition reaching back to Paul Sandby and encompassing generations of amateurs who had gone about looking at England.

It was a good way of keeping artists employed away from the front line, but it was not a spurious task that they were being asked to perform. In 1939 it felt extremely urgent that the effort at recording should be made. The idea was to paint corners of Britain that seemed vulnerable, not only to the effects of war, but to 'the sinister hands of improvers and despoilers'.[2] For the most part this meant areas of rural England where agriculture was now being overtaken by industry and subur-ban development. Southern areas were the priority because the bombs looked set to obliterate them first, but artists were soon commissioned to paint in almost every county. Barbara Jones sought out old merry-go-round horses and inn signs, Walter Bayes went to Braintree on market day, Kenneth Rowntree brought his distinctive, witty, four-square style to church pews in Whitby and a lone farmhouse in Derbyshire where there is a smart red door but only tumbledown walls to mark the edges of fields. Thomas Hennell painted a road through the Cuxom Valley, which was about to be subsumed by Rochester. John Piper joined up early, and as he recorded stone barns and churches he thought of John Sell Cotman, who had engraved the

antiquities of Norfolk at a time in the early nineteenth century when they hung like fruits 'ready to drop'. Piper read Sydney Kitson's biography; he went (again) to see the Cotman drawings in Michael Sadler's collection and filled sketchbooks with rapid copies; he wrote to Eric Ravilious about the merits of Cassel's 'Earth' and 'Roman Ochre' pigments.[3] They were Cotman's colours, and they were the colours of Recording Britain, which presented an umbery-ochre nation that might not for very much longer be painted in this mellow palette.

The pictures were a form of wartime propaganda, of course, meant to give 'a sense of the continuity of the English town and village'.[4] When he visited an exhibition of them in 1941 Herbert Read remarked in patriotic spirit that they show 'exactly what we are fighting for': 'a landscape whose features have been moulded in liberty, whose every winding lane is an expression of our national character'.[5] But they also documented the abandoned buildings and overgrown gardens that composed a rural England already left behind. This is the insistent doubleness of country art in wartime: it presents the land as a symbol of both timelessness and change. 'Field by field and tree by tree our countryside dwindles', wrote Arnold Palmer, the administrator of Recording Britain, 'and like a spendthrift heir we begin, too late, to keep accounts'.[6] The country might at least be saved up and passed on in words and in pictures. 'We should be taking stock', said Henry Green, referring to life in general, but the urge to take stock of the landscape was one of the strongest imperatives of all.[7] Recording Britain, and not only in topographical watercolours, had been one of the great preoccupations of the 1930s, and there were many ways in which it could be done.

The motor car and Green Line bus networks made rural England more accessible than ever. It could now be seen quickly, in a weekend, and every weekend offered the chance to see a different part. In preparation you might read one of the celebrity English explorers. H. V. Morton's *In Search of England*, a travel journal of such appeal that by 1934 it came of age with its twenty-first edition, took the tourist in pursuit of 'unspoilt' villages and quintessentially English views. Morton was adept at pilgrimages (he was present at the opening of Tutankhamun's tomb and then wrote a book following Jesus through the Holy Land) so there is a sense of pursuit in his quest for 'authentic' places. He is pleased when things are 'true to type' – cities, for example, which shelter beneath their cathedrals 'like dear old ladies under an umbrella'.[8] This cosily anthropomorphized England is almost always friendly to the roaming motorist. Even the industrial towns that Morton expects to hate (he eyes the fog of Liverpool from a distance and gives it a wide berth) turn out to be better than he thought, as long as he concentrates on their medieval customs. Morton's inns and dark beers and eccentric roadside encounters became a middle-class cult; his bullnose Morris 'Maud' was among the best-known cars of the 1930s.

When J. B. Priestley set out on his *English Journey* in 1933, he wanted to record what he saw, not only what he wanted to see. Looking out from his chauffeur-driven Daimler he must have cut the figure of a visiting dignitary, more genteel even than Morton, but when he got out of the car to talk to people and explore the backstreets he got closer than Morton to the truth of things. Priestley was a Yorkshire man from Bradford and determined never to forget it, so he did his best to get the measure of the North. His was a form of investigative journalism that prompted Bill Brandt and George Orwell to go and see the industrial towns for themselves. And though he did not hide his horror at what he saw there, he made a brave promise that he would rather take a holiday in West Bromwich than in Florence. At heart he was a pastoralist, always imagining what the coal cities looked like before the steam age, and taking comfort from promising glimpses of the countryside beyond their smoky limits. Priestley was a descendent of Daniel Defoe on his *Tour through the Whole Island* (1724–26) and, more particularly, of William Cobbett on his *Rural Rides* in the 1820s, combining picaresque incident with a mission of social reform. Priestley's famous conclusion, reached as he arrived home from his adventures to his familiar fireplace, was that there were at least three Englands: the old cottage England, the industrial nineteenth-century England, and a new, electrified, Americanized England. He worried about their alienation from each other. He was bothered about Bolton and, at the other end of the scale, he was bothered about the reclusive aristocrat he found building a model town Uncle Toby-like in the garden of his Cotswold manor. The efficient, standardized new economic systems, urged Priestley, 'must somehow be stretched to fit him in, manor house, museum, hotchpotch, toy village and all'.[9] The idea of England, a nation easily caricatured and reduced to permutations of national characteristics, would have to be more elastic, and Priestley encouraged this stretchiness by inspiring his readers and listeners to really go out and look at their country, not only the 'beauty spots', but every bit of it.

This was the age of English journeys: the huge influence of Morton and Priestley was rivalled by yet another explorer, S. P. B. Mais, who wrote so many books that reputedly he made even Churchill feel tired. Like Priestley he was an indefatigable broadcaster who saw the potential of radio to communicate with millions while still sounding intimate. And like Priestley he knew that while urban housing and working conditions certainly needed to be investigated, most of the workers who listened to him wanted to get out of their daily grind and into open country. The best he could do was to be a companionable guide. For his talks on 'This Unknown Island' Mais cast himself as an amateur 'equipped with just the ordinary man's interest in legends and customs', and set off to seek out hidden places (though being an ordinary working man, he would not be able to get away until the weekend).[10] When his talks were published in book form, they came

accompanied with hand-drawn antique-looking maps which made Bradford and Keighley look about the same as Haworth, indicated by a church in the middle and a friendly scattering of houses. Audience participation in his radio programmes was much encouraged. Mais cultivated active communities of listeners, who might write in to contribute a wassail song from Yorkshire or direct him to an unlogged beauty. As much as Mass-Observation, this was a kind of social anthropology and it proved extremely popular. For the first time the general public was writing its group history – and compiling a common guidebook to map its 'unknown' paths.

There were distinct varieties of tourism that were not to be confused. Morton's England of villages seen from the car was not the England of the workers who went rambling or hiking and who wanted expanses of wildness. The village-visitors preferred, on the whole, to feel private and self-determining, enjoying the superior satisfaction of finding places others had yet to find. Rambling, by contrast, was a group activity, involving the singing of folk songs and a firm investment in a communal claiming of the land. Determined not to take a picturesque or sentimental view of the countryside, ramblers wanted wide views, free from signs of private ownership, the more elemental the better, and Morton was not to be found in their pockets.[11] What cut across these schools of touring was a fascination with local history, particularly of the prehistoric kind. Rulers were set down on Ordnance Survey maps as the hunting of ley-lines became a standard pastime – and a very modern one, having been conceived in 1925 by the self-taught archaeologist Alfred Watkins who introduced England to the mysterious, compelling geometries of *The Old Straight Track*.[12] On a July evening in 1932, sixteen thousand people boarded specially scheduled Southern Railway trains in London and headed south. Mais led a moonlit walk over the Downs and everyone convened to watch the sunrise from the Iron Age hill fort of Chanctonbury Ring.[13] It was a version of Romanticism, but with safety in numbers. In *Howards End* Leonard Bast had to walk alone through the night on his self-awakening journey, but this organized primitivism of the 1930s was a more social experience. Partly an archaeology seminar and partly a pagan rite, it was a reconnection with other people as well as with the land.

Country walks were now journeys through ancient history. Tracing *The Genius of England* in 1937, H. J. Massingham invited the casual walker to decipher the prehistoric downland code, 'the turfscript of these abandoned downs'.[14] Anyone, he was saying, could interpret the long-evolved language of the land. It would be another twenty years before this readerly approach became an organized scholarly process. The study of local history grew up in response to W. G. Hoskins's observation in 1955 that 'the English landscape itself, to those who know how to read it aright, is the richest historical record we possess'.[15] But already in the 1930s, history was becoming local. It was as if the nation had taken a leaf from Langtoft's chronicle and gone out to 'see Stonage'.

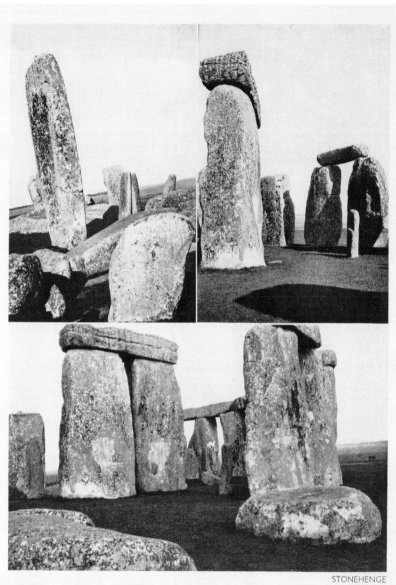

STONEHENGE

Carola Giedion-Welcker and Walter Gropius *Stonehenge* in *Circle*, 1937

Stonehenge, in fact, is a good example of how a particular landmark in the English countryside could inspire different kinds of appreciation. It was particularly potent because it signified strength and endurance, while at the same time being vulnerable and seeming to stand for a vulnerable England. Like so many areas, Salisbury Plain faced the prospect of development. The stone circle itself was under government protection, but the area surrounding it was still in private hands by the late 1920s and liable to be built on at any moment. A Stonehenge Cafe had already sprung up to take advantage of the tourist trade (it is visible in photographs from 1927), and commentators anxiously surmised that other buildings would follow. A major appeal was launched, backed by both Stanley Baldwin and Ramsay MacDonald, to buy the surrounding area and place it in the safe-keeping of the National Trust. The rhetoric of the appeal was stirring:

> The solitude of Stonehenge should be restored and precautions taken to ensure that our posterity will see it against the sky in the lonely majesty before which our ancestors have stood in awe throughout all our recorded history.[16]

Money came in fast; modernity in the form of cafés and car parks was, for the moment, fended off. But Stonehenge was nonetheless a modern icon. For centuries the ancient stones had been at the forefront of modern art. The structures and proportions favoured by the Neoliths had been borrowed by architects like John Nash in the eighteenth century to give gravitas to his classical façades in Bath. The columns and pediments derived from Rome of course, but they derived from early England too.[17] And then the stones became Romantic: for Turner they glistened like a golden city in shafts of sunlight; Constable saw them touched by a rainbow from a tumultuous sky, as if still making the covenant with the gods first established thousands of years before. Between the wars, Stonehenge continued its protean career.

Paul Nash found equivalents for the megaliths, replacing standing stones with geometric forms and thereby declaring that they could be read as abstract art. Measuring Salisbury Plain against a Miró painting, Piper suggested similar affinities. Advanced architectural thinkers admired the same formal properties in the stones that had appealed to the builders at Bath. Among the pictures of purist villas and abstract constructions in *Circle* (1937) a series of Stonehenge photographs appeared. Two were by the German writer Carola Giedion-Welcker, a specialist on contemporary sculpture, and a third was by Walter Gropius, the leader of the Bauhaus. Both photographers went up close and stayed near to the ground, feeling the weight of the stones rising above them. Barbara Hepworth, designing the layout

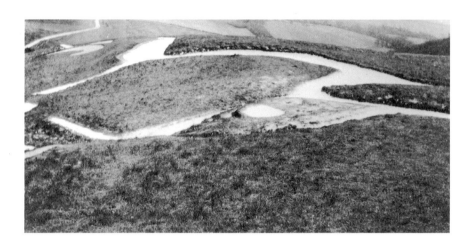

Paul Nash *The White Horse at Uffington, Berkshire*, c. 1936

for *Circle*, placed these pictures after her own essay on sculpture, which took the understanding of form and gravity to be the primary work of the sculptor. Neolithic man, it seemed, had been an unrivalled master of form, and his influence can be clearly felt in Hepworth's work from this time. Though they were only a metre high, she saw her *Forms in Echelon* (1938) as monuments in the landscape: 'the sculpture has an upward growth but the two monoliths make a closed composition,' she said, which creates a space of 'quietness' out in the open. Here were monoliths you could live with. Hepworth imagined the sculpture in a garden setting, domesticating the sarsens while preserving their power.[18]

Henry Moore, too, wanted the monoliths in his garden. When he bought an area of land large enough to position his sculptures out of doors he rejoiced that they looked 'like a bit of Stonehenge'. He had first seen Stonehenge by night in 1921, in the days when one could wander alone through the stones and watch the moon. The experience stayed with him all his life (he recalled as an elderly man the 'mysterious depths' of those moonlit stones), and the magnetic equilibrium of his large sculptures in landscape were part of his life-long tribute to the ancient builders.[19] Moore, Betjeman, Piper, Hepworth, Gropius: prehistory had an impressive list of modern advocates appropriating its monuments for their various visions of England.

In the chalk downland of the south, men had quite literally drawn on the earth, cutting away the turf to make vast hillside engravings. The white chalk figures fascinated 1930s artists and tourists, and their mysterious origins prompted multiple narratives. John Betjeman's wife Penelope stood on the eye of the Uffington White Horse praying for fertility. Paul Nash went up near to the eye to photograph the rhythmic, wandering chalk shapes, which from this angle are abstract patterns, a network of paths without destinations, guarding the secret of what they might depict as if it were an occult code. F. J. Harvey Darton stood on the Cerne Abbas Giant's torso and beheld him grandly as 'an archive, an oracle, a herald of the very land he scars'. But what was the oracle saying?[20]

Massingham was convinced that the significance of the Cerne Giant was uncertain only because twentieth-century society was so alienated from the fertile life of the land. If only the true principles of agriculture could again be practised and understood, the Giant's occluded message from another age would become legible:

> In the principle of husbandry that returns to earth what is taken from the
> earth and feeds new life with old death, chalk Helith comes to mean
> something again. He sleeps and is not dead, as Wessex sleeps.[21]

The giant became, then, a symbol of a lost vegetative cycle, and if Penelope Betjeman prayed at Uffington for her own fertility, Massingham prayed at Cerne for the fertility of a whole nation. At Wilmington in Sussex, near Rodmell and Firle, another

puzzle and further clues were waiting. In his woodcut *The Long Man of the Downs* (*c.* 1930) the Bournemouth artist Leslie Moffat Ward made the contoured prospector look like an Egyptian hieroglyph. His bent arms and wrists and angled feet are unmistakably Eastern, while the tiny figures below him are like explorers weaving their way through some desert valley. An artistic whim? Ward was too immersed in downland history for that. The Egyptian note in his design seems less bizarre if we see it alongside Massingham's work on Diffusionist theories which posited Egypt as the single birthplace of man. This notion of an Eastern heritage was one of the most distinctive narratives offered for the downland, and a corrective to the ubiquitous odes to pure Englishness. As Massingham acknowledged, it is hard to believe that a landscape 'English to the tip of every grass-blade, bears the water-mark of Egypt'. This was, however, exactly what he claimed for Avebury, casting Silbury Hill as 'our native pyramid'.[22]

The wonders of the world had arrived in England – and people wanted to see them. So the Ramblers adopted the Westbury Horse as an emblem in their campaign for rights of way, and Shell-Mex promised to take the driver safely to Cerne Abbas, which Frank Dobson made as bright and cheery as a children's picture book (its suitability for children increased by the discretion of a passing cloud). When war came, the chalk figures were turfed over to prevent them from siding with enemy pilots. But their enduring status as national icons was suggested by the fact that the War Artists Advisory Committee asked Ravilious to paint them in the process of being camouflaged. In the event, Ravilious was too late on the scene, but he had already painted many of the figures for a proposed (but unpublished) Puffin book with text by Massingham.[23] While Massingham traced their history back several hundred thousand years, Ravilious tamed them for modern living. His Westbury Horse is seen from the window of a railway carriage, static and framed, easy to enjoy from the padded, patterned train seats. His Long Man of Wilmington, criss-crossed by the ad hoc barbed wire of wartime, keeps his place obediently within the little picket fence that hems him in. The staffs he holds are cleaner, but not much more mystic, than the saggy metal posts in the foreground with which they rhyme.

The discrepancy between Ravilious's tidy giant and Massingham's emphasis on the overpowering fertility of the land points up the range of different Englands on offer. The countryside was the bright visitor attraction of Dobson's poster, and the democratic common land of the Ramblers. It was also a site of folklore and ritual, and even an outpost of ancient Egypt. Some thought the chalk figures pointed the way to a new age of agriculture, others saw them as signs that the land had always been a canvas for drawing, and should be enjoyed at leisure. These were some of the rival mythologies of the countryside of which artists and writers were intensely aware.[24]

Clive Bell stated his own preferences in 1934 when he went to see an exhibition of art produced for Shell-Mex, which had commissioned contemporary artists

Frank Dobson *The Giant, Cerne Abbas*, 1931

Eric Ravilious *The Wilmington Giant*, 1939

to design posters and lorry bills to advertise their petrol. Most of these posters featured views of the English countryside through which Shell hoped the new car-owning tourists would drive (thereby polluting that countryside, though this side-effect was not much mentioned). Country views in advertising are common enough but rarely do they define a whole new kind of England. These posters, however, had a distinctive and coherent modern look. Vanessa Bell's scene at Alfriston was bright and lucid, emptied of quaintness; even the dusty art of the antiquary was made colourful and family-friendly in Rosemary and Clifford Ellis's 'Antiquaries Prefer Shell' poster. Clive Bell noticed how far they had come from earlier ideas of textured rustic charm, and he argued that if artists were going to be popular again it was more likely to be through this modern advertising than (and here there is a sideways stab at Leavis) through a revived organic community:

This is the nearest we have yet come in the modern world to popular art.
If that marriage between art and humanity is to be consummated, it
will be by means such as this and not by academics and 'arts and crafts',
old-world pageants, semi-detached Tudor mansions, extension lectures
and dancing round the maypole.[25]

Cyril Connolly went to the same exhibition and was equally impressed. He titled his exhibition review 'The New Medici', as if a new age of artistic patronage, and something comparable with the Italian Renaissance, were about to arrive. Like Bell he saw the significance of these posters for the fast-changing concept of rural England.

The moral of the landscapes here shown is that it is not the awe-inspiring
or exceptional which now seems important, but what is most cheerful and
genuine in our countryside – England is merry again – farewell romantic
caves and peaks, welcome the bracing glories of our clouds, the cirrus
and the cumulus, the cold pastoral of the chalk.[26]

The country he greeted was bare and bright, merry in a way that was quite remote from Lymington's merriness. There was no soil under the nails in this fresh, clean land. It is striking how geology gets bound up in his aesthetics so that chalk (as white as Nicholson's white reliefs) is inherently more modern than granite or sandstone. This goes some way to explaining why the south so insistently dominates 1930s landscape art.

The most inspired twist in Shell's advertising was its use of English place-names in its punning poster slogans. It was a high-risk strategy because place names had already become a literary cliché. There had been Grantchester; there had been Adlestrop. Orwell, rather savagely, imagined Rupert Brooke with an upset

stomach from which he vomited place-names, having feasted too luxuriously on village idylls.[27] Shell had to mark its distance from this tradition. John Betjeman was in charge of the verbal acrobatics and struck a note of brisk, knowing humour. He had a crafty way of making industrial towns sound as charming as out-of-the-way villages, so 'Chorlton-cum-Hardy but Winter SHELL come Monday' was joined by 'Newcastle-on-Tyne but SHELL on the Road'.

This was England for the Bright Young generation escaping ye olde tastes of their fathers; it was England for the readers of Evelyn Waugh, who proudly announced his secession from the faith: 'whenever I see Gothic lettering on the Ordnance Survey map I set my steps in a contrary direction'.[28] The achievement of Shell was to write even the sanctified name of Stonehenge in a big modern sans-serif. 'Stonehenge Wilts, but Shell goes on forever' was a gift for Edward Bawden who drew a suitably droopy monolith. Two years later Shell straightened the stones out again. Edward McKnight Kauffer produced a poster showing them at night looking invincible in a cartoon moon-landscape. Amiably teased like this, antique England became a familiar possession. Stonehenge was colossal and enigmatic, but it was also the easily accessible destination for a good day out.

Shell's irrepressible advertising director, Jack Beddington, was keen on Betjeman's idea that the company might sponsor a series of guidebooks to help the new motorists find their way around. Betjeman duly became the editor of Shell County Guides. The list of authors he managed to recruit for the pleasant but excessively time-consuming job of guide-writing indicates the topographical predilections of the period's cultural personalities. By the mid-1930s it seemed that everyone was out gazeteering: Betjeman in Cornwall and Devon, Paul Nash in Dorset, John Nash in Buckinghamshire, John Piper in Oxfordshire, Robert Byron in Wiltshire (though the excellent Wiltshire gazetteer was provided by Edith Olivier and became a model for all the others).

Betjeman had grown up with Victorian guides of the 'Highways and Byways' variety which were intent on taking the reader on a quest for authentic England. Authentic, in this case, meant medieval and vernacular; anything later tended to be treated as a violation of the old country. These guides from a previous generation were now the subject of much fondness and hilarity. After dinner at Fawley Bottom the Betjemans and Pipers sometimes played a game at their expense. Each player would produce guidebook entries in parody 'Byways' style and, predictably, England's oldeness took on some fantastical proportions. Friends reported that Myfanwy Piper was especially good at inventing ethnographies and dark, terrifying customs for medieval villages.[29]

The Shell Guides had fun with mysticism (pixies, cuckoos and witches populate every mile of Betjeman's Cornwall; Nash's Dorset is stalked by dinosaurs) but they also tried to get away from fairyland. Piper's *Oxon* is an essay in the pleasures of

Vanessa Bell *Alfriston*, 1931

Lord Berners *Faringdon Folly*, 1936

ordinariness. He was glad to find a sane, unselfconscious county where 'the fields are flat and have the usual number of cows'.[30] Turning his back on the venerable spires and deciding not to include Oxford city, he went off to find unsung outposts, the bits of countryside *between* places. Piper's Oxfordshire is not a land of touristic sensation. Old England is allowed to be also a modern lived-in country. A photograph of clustered advertisements which would have troubled purist preservationists is fondly captioned 'a tree of knowledge', and an oval photograph with faded edges evokes nostalgia only to affront it with a big sign advertising a 'super cinema'.

Betjeman gave his writers special instructions to look at places not previously thought worthy of mention, particularly 'the fast disappearing Georgian landscape of England'. He wanted the Shell Guides to include 'churches with box pews and West galleries; handsome provincial streets of the late Georgian era; impressive mills in industrial towns; horrifying villas in overrated resorts'.[31] Seeing Britain with Shell meant looking beyond authentic windy villages to enjoy fakes and masquerades; it meant adopting a Georgian taste for classical architecture and antiquarian eccentricities. A whole series of Shell posters was devoted to follies, including Ralph Allen's sham castle near Bath, the fake ruins at Virginia Water, and Chanter's Folly in Appledore, eccentric, aristocratic sites now advertised as part of a public countryside open for business.

Lord Berners made his own folly at Faringdon one of the sights to see, painting a view of it for a Shell poster in 1936. It is a folly with much to say about 1930s taste. Designed by Gerald Wellesley in 1935, it was one hundred and forty feet high, mostly classical with a gothic top. It was plainer than Berners had intended: he got back from holiday only just in time to request a few token pinnacles. As if to compensate for disappointment, Nancy Mitford ensured that Lord Merlin's folly in *The Pursuit of Love* was properly decorated. In fiction, Berners's standard brick-work became marble inlaid with semi-precious stones, and the turret acquired a gold angel trumpeting daily the hour of Lord Merlin's birth as if he were newly born each day.[32] Berners did not anticipate when he built this folly on the site of a Norman castle that it would once again become a strategic defence position, employed as a wartime look-out. The point in 1935 was that the tower had no purpose whatever except to provide a view – 'the very view', enthused Betjeman, 'described by the laureate Pye in his poem "Faringdon Hill"'. Pye had seen England as a garden in the eighteenth century: the spire of Witney church, visible from Faringdon, looked to him like a Picturesque ornament that 'diversifies the lawn'.[33] The local council had at first refused permission for Berners's folly, and Betjeman took this to be illustrative of the miserable modern attitude to landscape. But it was an attitude being vigorously challenged. In defiance of county councils, Berners's building work went ahead, and in November 1936 a party gathered at Faringdon to enjoy the most Georgian of spectacles, a grand firework display around the new tower.[34]

In 1938 Betjeman suggested to the readers of *Country Life* (preaching to the converted, perhaps) that 'there was once a time when England was a huge landscape garden'. The eighteenth century's grandeur of vision had dwindled, he thought, into a withered and feeble sideways glance: the twentieth century sees England 'not as landscape but as material for drainage systems, slum clearance, rating, road improvements [...] Today, landscape for most of us has shrunk into a back garden'.[35] Shell, and the artists who worked for it, had a part in expanding this withered country, though the kind of view they restored was always controversial.

In fact Faringdon Hill proved a test-case for different versions of England when a minor skirmish arose in 1942. There was a question mark over who would be chosen to illustrate Betjeman's 1944 anthology *Landscape Verse*, with its celebration of 'peers in their libraries looking across the park'.[36] It was initially to be Graham Sutherland, but Piper intervened, complaining to Betjeman that 'Sutherland would miss the point of Faringdon Hill and Grongar Hill and everything else'.[37] These two fathers of Neo-Romanticism are often cited in the same breath today, but Piper's impatient letter summed up the fundamental differences between them and between views of landscape in the 1940s. Where Sutherland gave full rein to the elemental, Piper observed how nature had been poeticized and built on by man. Piper is attracted to aristocratic vantage points so it suits him to survey the scene from a height, standing on hills, or looking down from an aeroplane. Suspicious of these elevations, Sutherland burrows down into the earth, examining root forms. Both were at their happiest in the remoteness of the Welsh mountains, but Piper's best work came from his sense of what places had meant to people before him. His *Gordale Scar* (1943) is an encounter with nature at its most dramatic, but it is also an encounter with James Ward's nineteenth-century ideas of the sublime. Sutherland, by contrast, is alone in his remote landscapes; he is seeing them first and last, and the consciousness he projects onto them is his own.

Christening Betjeman a 'topophil' in 1947, Auden was careful to distinguish topophilia from other kinds of landscape appreciation: 'it has little in common with nature love. Wild or unhumanized nature holds no charms for the average topophil because it is lacking in history'.[38] Betjeman's *Landscape Verse* was an exercise in topophilia, reading places through poems, asking how the land has been seen through many eyes. Sutherland's journeys, on the other hand, take him in search of something much older than the Picturesque. He digs down into the *Origins of the Land* (1951), making the canvas a stratified, fossil-studded cliff face. His tin mines turn into fleshy pulsating blood vessels because the earth itself is a body to be erotically entered.

The mystic vitalism of D. H. Lawrence pulses through these pictures where the landscape folds itself into incantatory rhythms and performs a kind of hallucination. Objects cling to one another until they grow together, as in the gnarled

arboreal courtship of *Association of Oaks* (1940). The blood-shot Pembrokeshire of *Red Landscape* (1942) burns feverishly against a crimson sky. One cannot imagine coming here with a guidebook at the weekend: it is a country of extremes that demands submission. In his 'Welsh Sketch Book', an open letter published in *Horizon* in 1942, Sutherland evoked his relationship with this part of Wales. His language is bodily ('arms of land' embrace the bay) and human beings themselves are small, dependent creatures in this mother earth. His people are like Thomas Hardy's characters crossing the giant forehead of the heath, but they are protected rather than exposed: 'To see a solitary human figure descending such a road at the solemn moment of sunset is to realise the enveloping quality of the earth'.[39]

Sutherland's green lanes are protective cavities. Tunnelling into the country at Sandy Haven in Pembrokeshire, he painted his *Entrance to a Lane* in 1939. It is a fantasy about going back to the beginning. The earth is maternal, offering uterine shelter; the viewer is passive, wanting to be enveloped. It is a primal version of homeliness and, as befits such an image, Sutherland could not leave it. He returned, year after year, in 1943, 1944 and 1945, to paint variations on this lane. Some are so abstract that all sense of a through road disappears, leaving concentric forms that both embrace and repulse. He was painting icons of deep country, but Sutherland never wanted the lane to be shut off from outside influences. His places are formed from converging traditions: the fertile, effulgent, threatened Kent of Samuel Palmer is revived in him by the frisson of seeing recent work by Picasso. The biomorphic growths of Surrealism graft themselves onto the landscape. Sutherland reacted with anger to the suggestion that he had turned his back on Paris: 'Surely if English painting is to gain strength', he wrote, 'it will do so in the open [....] and not behind the sheltered wall'.[40] This was his assurance, both to the public and to himself, that England did not need to be defined in insular terms. It would have no vital future if it remained simply, in Morton's phrase, 'true to type'. The disagreements over the view from Faringdon started to look like a sign of health.

The best of the Neo-Romantics knew the dangers of a too singular creed and were always on their guard against it. The extravagance of Piper's ruins and dark skies was tempered by his willingness to study pavements for days on end; Sutherland rankled at any accusation of insularity and leapt to demonstrate the eclectic sources in which he found inspiration. Powell and Pressburger, too, the Romantics of the silver screen, had this capacity for critical self-knowledge, and it is part of what makes their work so enduringly appealing. In *A Canterbury Tale* particularly, their 1944 sequel to Chaucer's epic anthology, they indulge all their inclinations to hymn sunken lanes while at the same time launching a fulsome attack on the mystical dog-matism to which Neo-Romanticism can lead.[41]

Graham Sutherland *Entrance to a Lane*, 1939

The villain of the film is a gentleman farmer, Thomas Colpeper, Esquire, (played by Eric Portman), whose desk is strewn with titles like *Soil and Sense* that might have been on Eliot's organicist list at Faber. When his village becomes host to wartime newcomers – an army regiment posted nearby and a group of land girls learning the ropes – he begins a project to indoctrinate the visitors with mystical country lore. A dark, impish evangelist, his angular figure silhouetted against lantern-slides of rural relics, he is consumed by his task of initiation. In the village hall he lectures the politely gathered soldiers about the ancient road of the pilgrims. He holds up an archaeological relic that is for him the philosopher's stone, humming with voices. He has strange ways of imposing discipline on his pupils: by night he is the weird 'phantom glue man' who pours glue onto women's heads in an attempt to keep them from associating with soldiers who should be concentrating on his history lectures. In this gentle English detective story, which knowingly defines itself against the sensations of Hollywood, Colpeper is the 'gum man' ready to shoot. He is also, in Ian Christie's phrase, 'a perverse Puck of Pook's Hill', a representative of neo-paganism turned neurotic and malign.[42]

Powell and Pressburger use their own Puckish humour against him, exposing the constraints and perversities of this vision of insular old England. *A Canterbury Tale* is their assurance that England yields different secrets to everyone who looks for them, and allows every motley pilgrim to finish his own particular pilgrimage. This is partly the story of The Archers themselves, a union between Kent-born Michael Powell, son of a hop-farmer, and the Hungarian Emeric Pressburger, who had come to England in 1935 and was adopting it as his own. Both wanted to make a seductive film about a place worth fighting for, but they also wanted to ask how such places are best discovered and passed down.

Chaucer is their guide. 'Whan that Aprill whith his shoures soote / The droghte of March hath perced to the roote ...' So begins *A Canterbury Tale*, as the Cathedral bells peal ecstatically to invite us onwards, and a map of the Pilgrims' Way unfolds to show the route. Chaucer's pilgrims, forever delayed and distracted, more interested in their roadside stories than their ultimate goal, never made it to their shrine. And because no English pilgrimage should get too efficiently to its goal, Powell's film begins with a mistake. A young American sergeant called Bob, on his way by train to Canterbury having promised his mother he will see the Cathedral, gets off at the wrong station, unable to read the signs in the black-out. This is Chillingbourne, a village out of George Sturt's recollection, so busy is its wheel-wright, and plagued by the gum man, whom Bob heroically determines to unmask.

Chaucer represents what the alienated writers of the 1930s have dreamt of: his is the 'organic community' zestily performing its unlimited fund of tales. Michael Powell has a raucous group of pilgrims come chattering along the road in the opening sequence of the film before they metamorphose into contemporary soldiers.

Chaucer's pilgrims were from all sorts of different backgrounds and with various degrees of shady past. Powell's have the same comical, uncomprehending experiences of culture shock, and the same realizations of what they have in common. Lying on the site of the old Canterbury road, the land girl Alison (who shares a name with the Wife of Bath) hears the long grass whispering with voices, the anarchic energies of Chaucer having been transferred to the land itself. She may work in a department store, but she can inherit the ancient land along with the garden furniture she normally sells. Bucolic nature – it is springtime, of course and the laughter of children floats idyllically from the willow-bordered pools – is more in sympathy with her youthful romances than with any history lesson. Powell uses the art of cinema, which demands eternal youth, to make a modern idol of the English landscape. Hollywood produces flawless film stars whose charismatic beauty transcends their circumstances, but in The Archers' cinema the landscape plays the lead. Projected onto the screen it is re-mythologized, made magically greener and more fertile by the hallowed flickering of black and white. Powell makes a celebrity of his countryside while at the same time (because it is not to be unthinkingly worshipped) he shrewdly analyses the constituents of its star quality.[43]

Arriving, at last, in Canterbury, Powell's inadvertent pilgrims get their rewards, which are sacred revelations on a personal scale. Alison gets news that her boyfriend, thought dead, is alive in Gibraltar. Peter, the English sergeant who played the cinema organ in peacetime, gets to play Bach in the Cathedral. Bob, a lumberman from Oregon, gazes up at the vaulting and realizes that the same woodworking techniques have been used here as were used by his forefathers in the church back home. This is Canterbury after the Baedeker Raids, a bombed, wounded city, which Powell anaesthetizes by making it a picturesque haven with sheep straggling through the ruins. It is still a place where small miracles of continuity and survival can take place for those ready to listen to each other's stories of pilgrimage. *A Canterbury Tale*, however, provides no happy resolution for the self-appointed *genius loci*, the glue man. This is his punishment for claiming spiritual ownership of a country that does not have a sole proprietor.

An HOURS
in the GARDEN

Modernism had declared its allegiance to the waste land, not to the herbaceous border, and to confirm this Eliot began *The Waste Land* with a nightmare inversion of gardening: 'April is the cruellest month, breeding / Lilacs out of the dead land'.[1] Nature's insistent rebirth is imagined here as a perversion, insensitively oblivious to ruination. To come to life in this barren country is not springtime joy but an agonized awakening. In the search for more fitting places, where the lilacs would not try to flower, Auden followed Eliot to landscapes of 'gasworks and dried tubers'.[2] This was no time for pretty gardens, so poetry concerned itself with inorganic places, preferring the austerity of arterial roads and the decaying industrial heartlands of the north.

By the mid-1930s, however, Eliot himself was returning to more verdant territory. He did so ambivalently at first, tentatively imagining in 'Burnt Norton' what it would be like to walk 'down the passage which we did not take / Towards the door we never opened / Into the rose garden.' The garden he enters is a version of Eden, 'our first world', but it is a ghostly and decaying one, humming with invisible presences. And it has elements of the waste land: 'dry the pool, dry concrete, brown edged'.[3] A great inheritance of garden and nature poetry is gathered and revised in this strange patch of bare concrete. There is a recollection of the 'pond edged with greyish leaves' in Thomas Hardy's desolate 'Neutral Tones', a lifeless but haunted place suitable for the death of love. But Eliot hints, too, at the kinder 'fringed pool' of Thomas Edward Brown's garden, where God's presence seemed proved beyond question by the tranquillity which reigned in this 'veriest school / Of peace'.[4] The pool at Burnt Norton invokes a history of doubt and apocalypse, but there is also the possibility that it may become an oasis. In answer, it is suddenly filled with water, offering – but only for a moment – a vision of redemption, replacing the concrete of a barren period with a new poetry of life.

And the pool was filled with water out of sunlight,

And the lotos rose, quietly, quietly,
The surface glittered out of heart of light.[5]

Other writers and artists undertook, in their different ways, the journey from the literary desert into the garden. For Powell and Pressburger the willow-fringed pools of Kent offer baptism for the children who play there, though their games are miniature simulations of war. Organic Chaucer, having undergone Eliot's 'burial of the dead', is very much alive again on the grassy old road through the garden of England. Evelyn Waugh opened *Brideshead Revisited* with the first leaves of a wartime spring unfolding in a mutilated orchard. But he quickly turned away in horror to feast instead on the scent of meadowsweet in happier times. He had Anthony Blanche declaim *The Waste Land* from an Oxford balcony because the poem had become the anthem of his milieu's fetishized melancholy, but Blanche has little time for stony rubbish. Delivering his words to the hearty rowers and fertile grasses of Christ Church Meadow, he makes sure Eliot is suitably re-pastoralized.[6] Osbert Sitwell entitled the first book of his autobiography 'The Cruel Month', referring to the conditions of war in which he was writing. But it was not a painful April that he chose to describe; it was the glorious gardens at Renishaw:

Here in spring, when the trees are burgeoning, the ground is covered for three weeks at a time with the azure snow of bluebells, and later, in the summer, you find the tall, over-weighted spires of wild Canterbury bells, no doubt descended from flowers escaped long ago from older enclosed gardens of the monasteries and manors.[7]

Eliot's 'forgetful snow' has been replaced by a snow of bluebells, and *The Waste Land's* painful alienation from Chaucer's hopeful April pilgrimage is healed in Sitwell's imagination by the Canterbury bells, which are emblems of fertile continuity with the past, connecting his garden back to the Middle Ages.

For all their growing status as a subject of study, twentieth-century gardens get short shrift in histories of the arts, and rarely are the names of the major modern gardeners heard in relation to the names of Eliot or Woolf or Piper. But flower beds were debated as fiercely as paintings. And because the 1930s cultural renaissance took so much of its energy from the desire to put down roots and create a sense of belonging, gardens became small theatres in which to act out the homecoming of a nation's arts.

The decades up to the First World War had been a golden age of British gardening, the heyday of Gertrude Jekyll's bright swathes of perennials and William

Robinson's wild gardens, celebrating in all their carefully planned spontaneity the abundance of nature. Jekyll's herbaceous borders at Munstead Wood were inspired by the English cottage garden, but no cottage garden had ever been so grand. This was the work of a supreme aesthete whose distinctive planting patterns (blue thistles set against silver leaves; lupin spires next to bushy roses) were subtle orchestrations of colour and form. She had expansive tendencies (the main border at Munstead was two hundred feet long), but she also knew the benefits of smallness and became famous for her sequences of seductive, intimate garden 'rooms'.

The billowing perennials would never lose their popularity. But to many horticultural thinkers after the war these profusions looked wrong: they seemed to belong to an older, perhaps more innocent world, a world in which huge teams of gardeners might be employed to tend these old English idylls, and in which long skirts might brush against the straggling lavender, sending up an accidental waft of summer fragrance. Jekyll's flower beds often had petticoats of their own: underskirts of white-grey planting at the edges, formal and flirtatious at once. But now hemlines had risen and the huge team of gardeners, once standard on an estate of any size, had departed. What kind of modern garden might now emerge?

The call for functionalism and rationality was heard clearly in garden design circles, and the person who did something about it was a young Canadian living in England: Christopher Tunnard. As a junior colleague at Percy Cane's Arts and Crafts design firm, doomed to the daily planning of arbours, he was desperate for escape. He travelled in Europe, he looked at abstract art, he visited (or at least he talked about visiting) some of the new functional gardens in France, Belgium and Sweden, and he made up his mind: garden-makers must forge a way ahead alongside Mondrian and the constructivists. Gardening had fallen into a conservative stupor, oblivious to progress in all the other arts; 'Clearly it is in need of the invigorating modern spirit.' In 1938, still only twenty-eight years old, he published his *Gardens in the Modern Landscape*. Here was horticultural modernism: an audacious vision of ordered plots and rationally corresponding spaces all thoughtfully integrated with the landscape. Everything was to be clear and open, from the overall plan to the details of garden furniture. Paying homage to Adolf Loos, Tunnard suggested that we remove the knobs and finials from our garden benches. There was no need, he said, for decoration in a garden. In its plainness and practicality, the new 'functional' garden 'avoids the extremes of both the sentimental expression of the wild garden and the intellectual classicism of the "formal" garden; it embodies rather a spirit of rationalism'.[8]

If Le Corbusier's houses were machines for living in, Tunnard's gardens were machines for relaxing in, efficient settings for the kinds of recreation (swimming, sunbathing, outdoor games) deemed so beneficial in the 1930s. The recreation would not involve much actual gardening, however. Tunnard's low-maintenance schemes

Serge Chermayeff and Christopher Tunnard The garden at Bentley Wood, Halland, Sussex, 1938

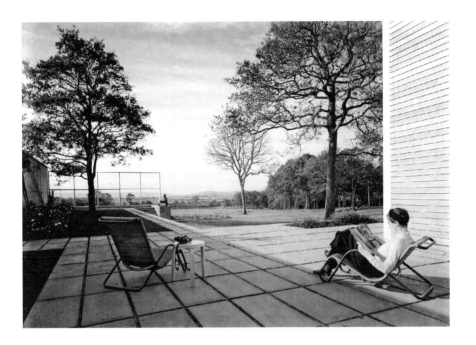

Serge Chermayeff and Christopher Tunnard Bentley Wood terrace with Henry Moore sculpture, 1938

relied on gorses, brooms and other hardy shrubs that would look after themselves. It was a rejection of Robinson and Jekyll. Tunnard thought that even Le Corbusier did not go far enough in the quest for rationalism since his placing of trees and wild grasses showed him to be too much distracted by 'nature worship'.[9] Romantic unruliness was no longer something to admire. Tunnard loathed the nostalgic escapism of gardens which dreamily pretended to be the cottage plots of a pre-industrial age. This was a deceit, he thought, and an abrogation of responsibility to the present.

Rationalism, for Tunnard, meant openness. Hidden dells must be replaced with clear vistas. Like the open-plan modern house that rejected interior walls in favour of inter-communicating spaces, the new garden would not aspire to be a series of private rooms but a dynamic public whole. Above all, Tunnard wanted to incorporate the garden into the surrounding environment. He took his inspiration from the eighteenth-century aristocrats whose vision was one of expansive ownership. They wanted to look out from their houses across their acres of land – hence their invention of ha-has to avoid petty barriers like fences. Tunnard borrowed their techniques for more democratic purposes, arguing that ordinary home-owners could take visual possession of the wider landscape rather than locking themselves away behind the leylandii: 'The garden of tomorrow will not be the hedged, personal, half-acre of today', he said, 'but a unit of the broad green landscape itself, controlled for the benefit of all'.[10] He had plans for how the great estates, many of which were now being sold off, might be carefully redeveloped to house thousands of people in terraced houses, each with a small private garden giving on to a communal area of parkland.

For the moment, however, he tested his theories on private commissions. Tunnard put his major precepts to work at Chermayeff's Sussex home, Bentley Wood, in close collaboration with Chermayeff himself.[11] Geometric paving (sane not crazy) formed an orderly apron around the house and stretches of open grass allowed the eye to travel freely from the garden to the South Downs. Tunnard saw it as a work of art ('to be a garden in the true sense of the word it must first be an aesthetic composition') and Bentley Wood was certainly a contemporary one.[12] At the far end of the paving was a panelled screen giving architectural structure to the view. It was related to Mondrian's grids, and it resembled the panels that Paul Nash frequently incorporated into his landscape paintings.[13] While it turned itself into an abstract painting, the garden was also a platform for sculpture. Henry Moore made a voluptuous recumbent woman to lie on a plinth beside the grid. He liked to think of her enjoying this spectacular place: 'my figure looked out across a great sweep of the Downs, and her gaze gathered in the horizon. [...] It became a mediator between modern house and ageless land.'[14]

Mediation was Tunnard's project. For all his fierce functionalist decrees he cared passionately about the spirit of place. At Bentley Wood, the bright white paving

of the sun terrace was calculated to echo the chalk downland paths in the distance. The slender piloti of the house itself rhymed with the supple trunks of silver birch trees; the kempt lawns anticipated the hummocky, rabbit-shaven turf of the hills.

Tunnard's gardens were distinguished by their mediation between international modernism and English garden history. At his own home, St Ann's Hill, Chertsey, he designed a neo-Georgian park stretching out around Raymond McGrath's circular concrete house. A series of terraces, 'part axial, part asymmetrical', provided a sheltered area where exotics and palms could grow, and from which one could look out through open screens (like the grid frame at Bentley Wood) onto the parkland beyond.[15] A landscape garden already existed, and the Cedars of Lebanon, against whose dark spreading branches the house shines white, gave St Ann's Hill a rangey maturity. Tunnard integrated the old and the new, mixing abstract sculptures with old stone pavilions, thinning and moulding the established trees into an eloquent pattern of masses and voids.

Calling his gardens 'landscapes' and looking to his eighteenth-century forebears, Tunnard was one of a group of thinkers active in the new Institute of Landscape Architects. It would prove influential, and after the war designers like Brenda Colvin and Sylvia Crowe would use the aristocratic landscape tradition as a basis for the development of communal green spaces. But Tunnard's ideas for rationalized living did not claim the hearts of ordinary gardening Britons. For every open functional new garden, several thousand enclosed domestic havens appeared, in suburbia and across the country, packed with shrubberies, sheds, idiosyncratically cut flower beds bordered by windy paths. The modernist garden was a professional affair, exquisitely designed from the start and intended to stay looking much the same. But English gardening is the joy of amateurs who want to tinker and change things and make their closely nurtured space different from the one next door.

Jane Brown, the best historian of modern horticulture, points to the paradox in trying to create gardens in the style of the International Modern Movement: 'Gardens are connected to soil and climate; how can they be international?' Plus they don't move: 'Gardens are the opposite of movement: they stay still and need to be looked after'.[16] Tunnard departed for America in 1939 to work with Walter Gropius at Harvard, and no one took his place. Even on the roof the English opted for a period feel. For the European modernists roof gardens meant advanced city living. Le Corbusier's roof terraces (at the Villa Savoie for example) showed how white rails and concrete frames might give the feel of a cruiser deck and bring the geometries of Mondrian into aerial reality. English designers were not convinced. The half-forgotten career of Ralph Hancock demonstrates that in the end the period's most ambitious aerial gardening was carried out in a style of exuberant historical pastiche.

Commissioned to make a roof garden for Rockefeller Center in New York between 1933 and 1935, Hancock constructed not one but six, each representing a

The English garden at Rockefeller Center, New York, designed by Ralph Hancock, 1934

different nation. The English garden was a Tudor world where sunken grassy paths led through mullion arches, past topiary yews, to a stone sundial closing the vista. The turf was brought from England, the honeyed stone was from the Cotswolds, and the rocks in the rockery (so the guidebook proudly announced) had come all the way from Lake Windemere. It was just what Tunnard most detested: a fake, a fraud, completely and comically at odds with its surroundings, as the skyscrapers of Manhattan loomed up on every side. With New Yorkers, however, it proved extremely popular.[17] In 1936 Hancock returned to England and started work on the Kensington roof garden that survives today. A woodland with a river and flamingos leads into a Spanish garden with Moorish arches, which leads into another Tudor fantasy, where old roses climb across herringbone brick walls. Soaring hundreds of feet above two of the most advanced cities in the world, Hancock's aerial gardening dramatized the meeting of urban progress and horticultural history. He used the most radical new technology to keep old England flowering in soil only thirty-six inches deep.

As Hancock devised his reconstructions, a more original designer, Geoffrey Jellicoe, the twentieth century's most ingenious interpreter of garden tradition, set out on his long career. He had already written about Italian gardens, touring the Continent, like the Sitwells, in search of the baroque. In 1933 he was commissioned by Ronald and Nancy Tree to redesign the gardens at Ditchley Park in Oxfordshire. Surviving plans from the 1720s showed that grand splayed avenues and a formal parterre were originally to have surrounded the house. These elaborate garden designs, however, had never been put into practice and Jellicoe was asked to 'interpret' them along lines of his own. This was an unrivalled opportunity for pageantry and Jellicoe could feel himself being lured in: 'Casting aside therefore all thoughts of twentieth-century art, of Picasso and Le Corbusier and Frank Lloyd Wright, I threw myself enthusiastically into a unique study of landscape history made real'.[18] What Jellicoe created at Ditchley was a vision of baroque Italy moulded to the English landscape. Low hedges were clipped into arabesques on the parterre, lawns scrolled, saplings paraded. Sculpture was bought *en masse* at the auction of Wrest Park in Bedfordshire and given a new and unexpected life.[19] The amenities of modern leisure were here, but in disguise: the swimming pool came in the form of a large ornamental pond, screened from the house by a row of fountains.

'This was a magnificent essay in the grand manner,' wrote Jellicoe's business partner Russell Page, 'worthy neighbour to the splendours of Blenheim and the little-known gardens of Rousham'.[20] But those splendid neighbours had once been radical themselves and, if it was to reflect their spirit, Ditchley needed to do more than quote its predecessors. This is why it is important that Jellicoe was not quite 'casting off' modern influences, but matching their ambition and structural clarity with the formalized exuberance of clipped yews and urn-lined walkways. Jellicoe wrote of the gardens at Ditchley that 'if they lack the psyche for which the mind of

modern man is searching, they can certainly remind him of some of the qualities of history he may be passing by'.[21] Jellicoe was already searching for ways of bringing history and the modern 'psyche' into alliance.

One of the reasons for the failure of rationalized landscape was that it did not allow for many flowers. Lord Berners planted a few paper ones at Faringdon to fool passers-by and to demonstrate that cottage authenticity was not at all the order of the day. Inside the properly modern building there always seemed to be a cactus on the window-sill, making a gesture towards nature and at the same time warding it off. Osbert Lancaster's wickedly observant drawings of 'Twentieth-Century Functional' houses feature cacti as essential accoutrements: 'The cactus sprouts where once flourished the aspidistra', he noted in a caption.[22] In the up-to-date garden, architectural greenery was favoured, though Amyas Connell constructed large triangular rose beds in dramatic splayed terraces to complement his Y-shaped Corbusian house.

Flowers refused to be edited from the English imagination. Sacheverell Sitwell published his *Old Fashioned Flowers* in 1939, calling for a return to the high art of flower cultivation. The architectural forms of grasses and cacti were not for him: he was in thrall to the elaborately hybridized specimens, which once performed to their admirers in the baroque parterre. He dedicated the book to his father, George Sitwell, who made the Italianate gardens at Renishaw. If the younger Sitwells rebelled against their father and complained of his tyrannies, the horticultural lineage, at least, was affectionately acknowledged. Sir George's sense of floral drama lived on in the pages of *Old Fashioned Flowers*. 'The florist's triumphs are flowers that are follies or conceits', writes Sacheverell, and he devotes a rapturous chapter to the auricula, the only species dramatic enough to have merited its own 'auricula theatre'.[23] The Sitwells, who were themselves so insistently eccentric, sympathetically championed the spectacular individuality of plants.

Examined closely, with a ripe imagination, plants could be the most surreal of subjects, as John Nash revealed in his wonderfully threatening illustrations for *Poisonous Plants* (1927) and *Plants with Personality* (1938). He favoured the deceptive and downright dangerous: 'The open innocent countenance of a Daisy or Anemone may seem easy to draw, but they too can be a snare, and sometimes I prefer the hooded labiates, helmeted monkshood and Balsam, or the leering countenance of Foxglove and Penstemon.'[24] His singling out of individual species belongs to the tradition of the botanical print, which often has its own alarming strangeness, but his is a distinctively 1930s aesthetic of the neatly contained and well-loved specimen.

When Ravilious and Bawden painted gardens – as they often did, and Bawden was himself a keen gardener who collected books of old-fashioned garden lore – they

Geoffrey Jellicoe's baroque garden at Ditchley Park, 1934–39

Pergolas and crazy paving in Beverley Nichols's garden at Thatch Cottage

saw that every lettuce was in its place, shapely and labelled, surrounded by freshly forked earth and perhaps a caterpillar on its way to add some drama.[25] Ravilious's 1939 'Garden' designs for Wedgwood crockery featured wooden barrels neatly stocked with the garden implements he loved as symbols of homely tidiness. On one side of the lemonade jug are a hoe, shears, rake, fork and broom. On the other side, in a series of tiny cameos, are scenes from the productive garden: a portable cloche, a rhubarb forcing pot, a well-stocked greenhouse, and an active hive of bees. The dinner plates show logs chopped and loaded into the wheelbarrow, and it seems that the woman who sits reading in a deckchair under the tree has deserved her rest.

While at Great Bardfield the emphasis was all on busy practicality, with some chance surrealist associations in the snake of a hose or the eruption of a cauliflower, some gardeners allowed themselves to get extremely sentimental. Beverley Nichols played the Georgian aesthete and doted on the chic domed greenhouse he fitted into his small London garden. But he wreathed this urban temple with flowers, made little rockeries around it, and embraced every form of garden prettiness. This town garden was a companion to his first love, his cottage garden. He became famous in the early 1930s for his unashamedly nostalgic accounts of 'Allways', his country 'hiding-place'. He fashioned himself as a grudging cosmopolitan who wanted only to be left alone with his hollyhocks; he would sit in London dreaming of getting back to the garden, but 'it was not to be, because always tomorrow I was lunching with a film star at the Savoy'. In one of his Allways books he cited in a tone of feigned confession his appointment diary for a stay in New York: 'Thursday. January 10th. Dine with J at Ambassador's 8 o'clock not dressed, go Harlem afterwards. Write B. to plant twelve hollies in gap between pond and road.' These were the jottings, he supposed, of a 'narrow, provincial and utterly unfashionable mind'.[26] But this provincialism, particularly when combined with urban high-living, was the height of fashion.

Partly it was made so by the society gardener Norah Lindsay, who appeared to go drifting around in a haze of chiffon and glamour, but whose legacy to English gardening was a substantial one. Inheriting both the Arts and Crafts tradition of Gertrude Jekyll and the grand Italianate style of her friend Edith Wharton, she energetically revised their pre-war aesthetics and invented sophisticated country gardening for the interwar connoisseur. She made a theatre of the flower bed, banishing Jekyll's trim 'skirts' in favour of self-seeded plants and loud clashes of floral colour. She liked a sense of spontaneity, even improvisation, but it needed a formal structure to make it work. So she contained her perennials within corridors of low box hedging, and she often clipped yew trees into conical shapes that would rise up, dark and striking, in the middle of the beds. She became a figurehead for the survival of the herbaceous border, though she gave it a new style of her own. This was a brand of high-class modernism done the vernacular way.[27]

Norah Lindsay knew that the glories of the Edwardian garden were still profoundly attractive to her clients. Other gardeners, too, were cleverly asserting continuity with pre-war days, while also being up-to-date. The florist Constance Spry made her name by going back to the 'wild gardens' of William Robinson, bringing them indoors, and arranging them spectacularly. For a party she would prepare huge vases of trailing weeds, old man's beard and cow parsley, wittily transplanting nature into the most artificial of settings. Her style was a sensation: she employed seventy assistants at the florist shop she opened in Mayfair in 1934. Crossing between Surrealism and baroque whimsy she might fill a grand vase with curly kale or a bird-cage with lilacs.[28]

Like Lindsay, who planted her garden at Sutton Courtenay with vigorous old shrub roses, Spry was a serious collector of old rose varieties and she designed arrangements to show off the individual characters of each. She was part of a distinguished rosarian community. The pioneering Lawrence Johnston had been growing old roses at Hidcote Manor for years, but it was only now, in the mid-1930s, that they really caught the imagination of English gardeners. The revival was spurred on by Edward Bunyard, epicure, pomologist, desert-specialist and one of the 1930s' great authorities on roses. His 1936 book *Old Garden Roses* brought a surge of interest in the long history and modern possibilities of England's best-loved flower and, for those who wanted to order some for the garden, Bunyard's nurseries had over 400 varieties in stock.[29] Bunyard explained that 'there are indeed some rose enthusiasts who refuse to see any beauty of form save in the long pointed bud of the Hybrid Tea Rose of today, just as the ideal of beauty for their grandparents was the Hybrid Perpetual.'[30] He knew that taste in roses, as in so many things from furniture to houses, had changed from buxom Victorian fullness to a slimline modern elegance. But, as Bunyard pointed out, it was quite possible to mix ancient and modern, and he would himself point the way.

So the story of 1930s gardening has much more to do with rose revivals than with gridded concrete paving. The old Arts and Crafts idyll stubbornly survived the decade of abstraction, and then came the war, which placed modernism at a still further remove. The garden could no longer afford to be a series of interlocking forms or a geometric sun terrace: it was fertile ground in which to grow vegetables for a family. Over three million people listened to Mr Middleton's radio programme *In Your Garden*, storing up practical advice about the cultivation of leeks and potatoes that would supplement the rations. 'The harder we dig for victory', said Mr Middleton, 'the sooner will the roses be with us again.'[31] Keeping up the Blitz spirit, he cheered people along with the reflection that at least now they did not have the trouble of mowing the lawn.

Mr Middleton (son of the bailiff at Renishaw and now Sacheverell Sitwell's gardener at Weston Hall) always acknowledged that a few luxuries should be allowed in these straitened times. There might still be a flower bed, and perhaps some edible treats like melons and pumpkins. These small gestures against utility share something of the spirit of *Brideshead*, and of the Sitwellian gardens from which they were broadcast: they are determined to prove that pleasure and imagination will not be stamped out by war. Romantics and flower-lovers went to extraordinary lengths to procure blooms in wartime. The Transport of Flowers Order (1943) banned their transit by rail and consequently, as Tim Richardson reports, 'flower smuggling broke out': 'there were tales of flower-filled suitcases brought up to Covent Garden from the West Country, of cauliflowers with their hearts scooped out and filled with anemones, and even of a flower-filled coffin sent from Cornwall to London'.[32]

Gardens have long been planted in conditions of war. Kenneth Helphand's inspiring book *Defiant Gardens* (2006) records some of the gardens made against the odds in the most difficult conditions, by prisoners of war across the world and by soldiers in the trenches during the Great War. There is the German soldier who wrote home from the trenches in winter 1916 with a plea for garden seeds: 'please send me sweet peas, convolvulus, sunflower, flax, mignonette, etc. I want to cover the unsightly earth with verdure'.[33] This letter and the many like it are testament to the symbolic power of gardening. The soldier's longing for nature in the barren landscape of the first war is similar to that of Jean Hélion in the second, dreaming not of abstract shapes but of women and trees. Honouring this principle, the Royal Horticultural Society sent out from Wisley thousands of seed packets to prisoners of war in Germany and received, in return, descriptions of gardens planted in the midst of hopelessness, carefully hoed and weeded as symbols of survival.[34]

On the Home Front, the 'Dig for Victory' campaign had as much to do with building up morale as it had to do with the growing of food. Both were essential and entwined. Vegetable digging could be boring and onerous, but few gardeners remained immune from the pleasing sense of having grown something useful. The allotments in Kensington Gardens were a very visible sign of everyone 'doing their bit', growing onions in the shadow of the Albert Memorial to keep Victoria's great nation afloat. Other sites were especially symbolic, like the grassy moat at the Tower of London which was planted with peas and beans. Once the moat had kept invaders from the Tower; now it had taken up another key defensive role supplying beans that would – more indirectly – keep the enemy from the gates.

Growing things is a counter to the destruction of things. Leonard Woolf recalled in his autobiography that when, one afternoon, Virginia called him in from the garden to listen to Hitler on the radio he decided not to go. He preferred to carry on planting his irises, which would be 'flowering long after [Hitler] is dead'.[35] This

was what Vita Sackville-West felt about her garden at Sissinghurst. To plant bulbs in the middle of a war was to assert one's firm belief in the future. She made a point of planting a slow-growing magnolia in spring 1939, wanting to believe that there would be someone there to see it in a hundred years' time.[36]

Since 1930 she and Harold Nicolson had been making the garden at Sissinghurst. It is a garden with aristocratic flair, but it affirms at every turn its sympathy with the homely cottage plot. There are ten discrete sections, each with its own atmosphere and sense of privacy, but they lead fluidly into each other, and from all directions the view is given backbone by the Elizabethan tower rising up in the midst. Anthropomorphizing her plants, Sackville-West liked them to display the qualities she admired in other people – and in herself. She had always been pleased by the gypsy strain in her blood (she wrote a biography of her gypsy grandmother Pepita) and in tribute she called her ramblers 'gypsy roses', saluting their expansive roaming spirit. Sackville-West's plants embodied the values of her gardening. However far the rambler roses roamed, they stubbornly set down their roots in a particular place. Like most other varieties of rose, they establish themselves slowly and firmly in the earth and hate to be moved. In gardens all over England roses are, for this very practical reason, symbols of continuity. They flourish when they are allowed to stay put.

The roses at Sissinghurst were very carefully chosen. Eschewing the new hybrid forms, Sackville-West insisted on the old varieties. A tea rose might grow more quickly and flower more reliably, but the exquisite ancient fragrances were lost. So Sissinghurst became famous for its collection of old roses: Madame Alfred Carrière climbing all over the South Cottage, shrub roses like the sweet-scented Madame Plantier taking over the borders. Sackville-West read Bunyard's *Old Garden Roses* at Christmas 1936, immediately invited the author for lunch, and spent 'a lovely orgiacal day' walking through the garden and 'ordering roses recklessly'.[37] In December 1939 Vita started to imagine the White Garden, and wrote ecstatically to Harold about 'white clematis, white lavender, white Agapanthus, white double primroses, white anemones, white camellias, white lilies including *giganteum* in one corner, and the pale peach-coloured *Primula pulverulenta*'.[38] The White Garden would have to wait until after the war, but just to imagine it was a kind of defiance.

Sackville-West's other defiance was to write her long poem *The Garden*. It was conceived as a companion piece for *The Land*, that passionate almanac of the Sussex Weald, which she had written in Isfahan nearly fifteen years before. Back then she had ceded the 'birthright' of the poet to roam free over all places and decided instead to tell 'calm tales of home'.[39] Now she was at home at Sissinghurst, although in 1940 all concepts of homeliness were endangered. Harold was writing to her with daily

Roses at Sissinghurst Castle, flowering in defiance of war, 1942

news bulletins from Westminster ('be ready to summon all the courage that is in you', 'I force myself to see what will happen if they land at Hastings and Faversham and make a pincer movement to cut off our forces in Kent').[40] She worked on *The Garden* intermittently through the next five years of war, returning to it after days of anxiety, building in it a poetic garden akin to the real garden that she was building outside.

The poem opens out seed catalogues for the reader, mulling over plant names, and filling stanzas like flower beds. The modest tools of the gardener's art – earthy, simple, full of purpose – become objects of devotion: terracotta pots in 'umber half-light', 'sieves that orderly against the wall' hang dangling from their nails. The same reverence is accorded to the physical tools of the writer: the 'foolscap, and the blue-black ink / Drying upon his pen'. Sackville-West incorporates into the celebration of home the desire to be elsewhere, imagining herself in Venice and in Africa, and berating the predictability of England: 'Too tame, too snug, I cry; / There's no adventure in security'.[41] But just as the poet's mind roams freely about the world and returns to the same homely point, so the garden at Sissinghurst is the end-point for the travels of many plants, exotic varieties coming from all over the globe to be planted here in Kent.

The garden is a last citadel, 'a miniature endeavour' to conserve beauty and peace. 'Is it cowardly / To draw the curtain on the misery of outward day?' she asks, and answers emphatically 'Oh no!', imagining the gardener shutting out the world with black-out curtains, and poring over seed catalogues in the safe circle of light from his lamp. Wanting to endow the daily and homely with the monumentality of epic, she reworks the close of *Paradise Lost*. Milton's Adam, starting out in the world with 'wand'ring steps and slow', becomes the gardener returning to the tool-shed with 'obedient steps and slow', going home to Eden.[42]

Sackville-West revises Milton and she revises T. S. Eliot. She quotes the first four lines of *The Waste Land* in order to dispense with them: 'Would that my pen like a blue bayonet / Might skewer all such cats'-meat of defeat'. Her poetic weaponry looks vulnerable when compared with Eliot's, but her argument is a strong one:

The land and not the waste land celebrate,
The rich and hopeful land, the solvent land,
Not some poor desert strewn with nibbled bones,
A land of death, sterility and stones [43]

Contrasting this desert with her own fertile garden, she advocates the role of literature as a form of replenishment. In the eyes of many contemporaries, she succeeded. The *TLS* reviewer compared her with Jane Austen carrying on while Napoleon waged war.[44] Richard Church (who had already, perhaps too generously, named her

as one of eight living poets destined for immortality) admired the 'patient courage which lifts up the poem and its author to heroic proportions'.[45] Sackville-West was awarded the Heinemann Award for the poem in 1946 and received £100. Characteristically she spent it in one go, on a mass of azaleas for the garden.

11

DREAMING *of* MANDERLEY

Exiles have, since Virgil, been the most committed poets of home. It is not surprising that years characterized by dislocation and dispossession produced a body of art that is haunted by remembered houses and homes left behind. To acknowledge this preoccupation with home is not at all to underestimate the extent of the period's cultural travelling. Literary critics have long remarked on the obsessive mobility of interwar writers: Paul Fussell's *Abroad: British Literary Travelling Between the Wars* diagnosed the 'hotel-consciousness' of a whole society, and his addictive lists of nomadic writers accumulate to form a portrait of a literary establishment on the move.[1] Valentine Cunningham constructed what he called a 'typology' of 1930s travelling, and the word is an apt one because travel was indeed a religion among writers.[2] Its gospels were packed with symbols to be explicated: ports and islands, transformative crossroads, heady escapes, foreign confrontations.

Travel was the orthodox response to modern times. Futurist paintings glinted with the metallic curves of cars and locomotives; inanimate canvases, ashamed of stillness, tried to look like they were on the move. Modernist writing, it often seemed, was best done while on the way to somewhere else. Joyce's signature to *Ulysses* – 'Trieste-Zurich-Paris' – gave a representative address for the modern author: a hyphenated place between places. Yet Joyce, of course, had spent his time in exile recreating the city of his childhood, assembling in words a picture of Dublin so complete, he said, that if the city were ever to disappear it could be reconstructed from his book.[3]

All through the 1930s English writers set out on their own projects of home building. Evelyn Waugh was seduced by the idea of eccentric happenings in distant places and he devoted much of his life to travel-writing. But he was rarely very happy when on the move. He was bored in Djibouti and bored in Addis Ababa. Brazil was monotonous and his hammock was uncomfortable.[4] The travellers in Waugh's novels are, likewise, perennially miserable: poor Tony Last in *A Handful of Dust* (1934), sweating feverishly in the jungle, hallucinates about the draughty

Victorian rooms of his beloved Hetton Abbey; the county gentleman William Boot in *Scoop* (1938) is cruelly extracted from his comfortable West Country house and deposited in Africa as a foreign correspondent. Finding themselves in distant lands, people settled down to write about England. Osbert Sitwell delighted in his travels, but it is not unusual to find him in the Gobi Desert brushing sand from the manuscript of a book on Brighton.[5] The cottage-loving aesthete Beverley Nichols explored central Europe and the Middle East, but he decided to call the resulting travel book *No Place Like Home* (1936).[6]

Even those who fashioned themselves as roaming documentary reporters looked with fascination into well-lit drawing rooms. Bill Brandt allowed his eye to linger. In his 1936 book *The English at Home*, he juxtaposed images of fur-clad Mayfair gentry with those of the servants downstairs. It was a pictorial essay on the gap between rich and poor, but it was also a fond study of the ways people take possession of their environments, presented by a German exile with a faked English identity and an obsession with what people look like at home. Next, in 1938, Brandt went on a nocturnal walk through the capital, taking pictures for his book *A Night in London*. He recorded the life of the streets, but mostly he peered through windows into people's lamplit parlours and drawing rooms. A family huddles around the table in a cluttered dining room, tucking into their meat and potatoes, close-knit with their backs to the camera, excluding strangers, intent on their food; through a bay window in the suburbs, the net curtains drawn back, we see a woman playing patience while a man reads the paper – so ordinary, so private, and completely compelling. Brandt is the shadowy figure who does not belong to these scenes, setting up his camera in the glinting puddles of a wet pavement and looking through the darkness up to the bright rectangle of a bedroom window before the last light goes out.

In the 1940s Brandt made a long series of portraits of writers and artists, posing each against a backdrop which represented his or her natural home. He sat Elizabeth Bowen in the large sash-window of her London house, and E. M. Forster in a rather dingy armchair. John Piper stood at the gate of Fawley Bottom, his much-loved house standing firm behind him, his sharp features associating him with the flints in his garden wall. Brandt's people come complete with an environment which, by some magic process, has become a part of them.[7]

W. H. Auden was the most influential of those writers who said they were leaving home behind. He set his poetry in the shelterless landscapes of the northern mining country, using an elusive, transitional language of cruxes and watersheds. Again and again he pictured himself as an exile. In a 1933 poem he described himself dosing in a deckchair on a sunny day in an Oxford garden. But because this is too comfortable and complacent a way to spend the afternoon, the guilty poet dreams that he is in fact a roaming seagull wheeling around a lost ship.

Auden is hopelessly 'looking for land', as he put it in this dream-poem, and yet his 'looking' is never a committed search: it would be inappropriate and complacent to put down roots.[8]

No one felt more sharply than Auden the dangers of continual movement and the sadness of feeling unattached. If only there were some tangible force binding him to his country, he thinks, wryly envying Newton whose discovery of gravity tied him not just to the earth in general but to England in particular:

> Make us as Newton was, who in his garden watching
> The apple falling towards England, became aware
> Between himself and her of an eternal tie.[9]

Had gravity gone wrong in Auden's case? He felt no inevitable attachment to English soil. He respected, within limits, the seemingly unproblematic odes to England that he found in the work of his contemporaries G. K. Chesterton and John Betjeman, both of whom he included in his anthology of light verse. He could not, like them, subscribe to England, 'this country of ours where nobody is well'; but where else was he to go?[10]

He would leave, of course, for America; much later he would buy his first home in Austria and only then, in his fifties, would he be able to offer 'Thanksgiving for a habitat'. In January 1938, however, haunted by thoughts of war, no longer very sure what he was looking for and now certain that it did not exist, Auden wrote a desolate poem called 'The Voyage'. 'Does the traveller find [...] Proofs that there exists somewhere, really, the Good Place', he asked. The answer he had to give was 'no':

> No, he discovers nothing: he does not want to arrive.
> The journey is false; the false journey really an illness [11]

The great modern journey fails, and there is nothing secure to come back to.

There are two near-contemporary novels that brilliantly expose this failure: Evelyn Waugh's *Vile Bodies* (1930) and Elizabeth Bowen's *To the North* (1932). They are both fascinated by strangeness and speed, but they are also painful diagnoses of what it might mean to have lost a sense of home, by people who would later write celebrations of the houses from which they felt themselves exiled. *Vile Bodies* begins with a journey back to England. 'Home, sweet home' says someone in the slightly queasy party playing bridge on the ferry, but when they arrive no one is very much at home in England.[12] The empty-headed hero Adam lives at Shepheard's Hotel, ancient seat of deposed kings and nameless red-faced majors; his friends spend their time

drunkenly commuting between parties, losing track of where they are. The novel's token country house is Doubting Hall, whose very name undermines all notions of certainty that might reasonably be expected of a colonel's home in rural Buckinghamshire.

Waugh describes a society sentenced to constant movement in the direction of nothing in particular. He takes his epigraph from *Through the Looking-Glass*, in which the Red Queen warns Alice that it takes all the running you can do to stay in the same place. Waugh's characters are stuck on this surreal treadmill behind the looking-glass, going ever faster. At a motor race, the excitable Agatha Runcible leaps into a car and makes a crazed circuit of the track before losing control and veering off across the fields. The life-enhancing rhetoric of speed and travel is inverted and made deadly. Far from 'finding herself', Agatha loses everything. Rescued from her smashed car and asked her name, she can only point to the band around her arm as a clue to her identity – 'spare driver'. And as the 'stab of a hypodermic needle' releases Agatha from herself and her hallucinations, she says – to no one – 'There's nothing to worry about, dear ... *nothing at all ... nothing*'. She is haunted by a nauseating dream. 'I thought we were all driving round and round in a motor race and none of us could stop [...] and car after car kept crashing until I was left all alone driving and driving –' She is describing the nightmarish demise of a whole milieu: Adam, standing beside Agatha's bed, reports that he is 'thinking of committing suicide, like Simon'.[13]

Vile Bodies is a nihilistic, impotently raging book. Waugh's marriage was breaking down, his wife was with another man, he was left in 'a nightmare of very terrible suffering'.[14] He had been set adrift and the loneliness was intense. The futile, floating Adam is his nightmare of homelessness. Like his namesake in Genesis, Adam appears to have no relations at all, and the past – in the form of his autobiography – is confiscated by a customs officer at the outset of the story. This situation turns out to be far from paradisal, since, without any history to weigh him down, Adam must wander about aimlessly in search of something to do. Bowen's *To the North* is similarly populated by unattached people: the unaccountable Markie lives 'completely cut off' from his sister, communicating from his eyrie by means of codified whistlings; Emmeline is not even the daughter of her century, only its 'step-child', born (like Bowen) to the nineteenth century and adopted by modern times.[15]

Commandeering the established modernist imagery of interwar locomotion (platforms and trains, road-signs, speedometers and aerial views), Bowen empties it of holiday cheer. She allows her characters, and her reader, to feel the excitement and liberation of travel, but to feel its poison working too. *To the North* 'hums' (as Hugh Haughton puts it) with modern transport systems. It describes a culture in which the question 'Do you read Shakespeare much?' yields the impeccably mobile answer 'I carry him in my car'.[16] The country vicar in this novel has a passion for motoring

and is a recognizable 1930s figure, not quite so progressive as the pilot-turned-clergyman whom John Betjeman described in his 1932 poem 'Our Padre', but close behind.[17] Bowen's heroine, Emmeline, runs a travel agency and spends her days in an office which seems to 'radiate speed'. With the map of Europe never far from her mind, her imagination is consumed with 'crowds rushing from platform to platform'; waiting at Hendon airport she is enthralled by 'an exalting idea of speed', and, airborne, she rejoices in 'a pleasure-cruise through the archipelago of the cloud-line'.[18] Yet such pleasures are short-lived. The novel starts with a purgatorial train journey; it ends with a terrifying and fatal drive.

Bowen rivals Auden in her use of roads and thresholds. Finding himself captive in Emmeline's speeding car, Markie looks out of the window 'trying to fix himself with an idea of fixity'. But with grim irony the 'idea of fixity' that Bowen provides for him is the image of 'three cars, standing empty, nosed into the jaded glare of an all-night café': one of her 'places for the dispossessed'. Walking with Markie through the Parc de Saint-Cloud, Emmeline is gripped by a desire simply to stop. She puts her hand against a tree to steady herself, but even her perception of the tree is inflected by her traveller's consciousness of trees worldwide. She longs to be fixed, 'to watch even an hour complete round one object its little changes of light, to see out the little and greater cycles of day and season in one place, beloved, familiar'.[19] But places which are 'beloved, familiar' are also fragile: temporarily adopted or liable to fall apart.

These novels are about dizziness, and they induce vertigo. In *Party Going* (begun in 1931, the same year as *To the North*), Henry Green took the reader up high to look down on the crowds gathered at a London railway station. A fog has set in, bringing the trains to a halt and leaving Green's disorientating prose dense with confusion. Nobody can go anywhere, but nobody can return home. While frustrated travellers grow impatient on the concourse, a group of socialites gathers in the station hotel and peers out nervously from the window, terrified by the sight of thousands of people all wanting to get somewhere, and all trapped in the unknowable world of the station. Green's title says it all: here is a society perpetually 'going' but never reaching its destination. For Bowen, too, arrivals and departures are abortive; her people get trapped in that state of 'going'. Emmeline and Markie in *To the North* drive to a country cottage for a rest, but they are soon off again. '"Here we are," she had thought, coming in: but she had been wrong, they were not' and they have to get on the move.[20]

Bowen reproduces the giddiness she describes. Her skewed symmetries invoke formal stability and dislodge it. Whole passages of *To the North* threaten to break loose and become autonomous. The most dramatic secession of the part from the whole is an extraordinary extended simile, in which Cecilia's widowhood is linked with the loss of a great house. The 'meaner living, gaudy, necessitous' of those

Menabilly in Fowey, Cornwall, the house that fascinated Daphne du Maurier

who have been bereaved is compared with the 'livable, kindly and sometimes gay' existence in small houses, among 'brave little shops, radiant picture palaces' that replaces the noble life of the big house. 'Lovers' lanes in asphalt replace the lonely green rides; the obelisk having no approaches is taken away.'[21] It is the kind of post-lapsarian society that Lady Chatterley inhabits: 'we are among the ruins, we start to build up new little habitats, to have new little hopes'.[22] This vision of a courageous but diminished kind of life asserting itself in the place of grandeur is intensely emotive, but the simile dwarfs the personal grief it sets out to describe. The analogy is bigger than, and overshadows, Cecilia. It might have come, intact, from somewhere else. It is a compressed epic involving a complete shift in scale, and bringing with it all of Bowen's earlier big house novel *The Last September* (1929). Even the novel's sad, beautiful metaphors for uprootedness seem not quite to belong.

For both Waugh and Bowen, the idealized antithesis of compulsory movement is the settled life of the country house. And for both writers its dissolution is a dire symbol of a modern world which offers no shelter or continuity. There are few other periods in which country houses feature so prominently on the literary horizon, and for good reason. In Ireland civil war had left a landscape pitted with the remains of Ascendancy houses burned by the IRA. In England inheritors faced ruinous taxation, agriculture was in decline, and heritage tourism was still a small, uncertain business.[23]

The old country homes to be found still standing in 1930s literature are reduced to dust-sheets and packing-cases. Bowen is one of the period's best writers about these strange, misunderstood places – both English and Irish. In her short story 'The Disinherited', two bored young women attend a party at an anonymous mansion belonging to an absent Lord Thingummy, who occasionally thinks of visiting his house but is put off by the thought of the damp. The building is masterless and under wraps, a place of 'glacial sheeted outlines' which turn into 'icebergs' when the lights come on. It is here that the wayward Oliver, who is supposed to be cataloguing the unknown treasures of the library, assembles a group of disaffected people with uncertain pasts. Familiarity breeds contempt: 'It's a nice house', Oliver admits, 'till you get used to it'. Even Miriam, who owns a teashop specializing in olde worlde homey comforts, has a horror of being settled. She echoes Oliver precisely: 'it's nice till you get used to it'.[24]

Bowen's narrative is so full of dead-ends and disjunctions that the reader is not allowed to get used to anything either. The short story form itself breaks apart in the effort to contain nebulous lives, and the strange incidents that bubble up out of unaccountable pasts. 'The Disinherited' has a gash through the middle: the extended interruption of a long confessional letter, harbouring a murder and a

stolen identity, written to a woman who is dead, by a man living an adopted life in a room so bare of belongings that it seems to be 'to let'. The big house has failed, and has been failed: this party puts it to shame, and it wears 'an air of outrage'.[25] Only a housing estate without a pulse has come to fill the gap, leaving a generation semi-detached like the buildings it half-inhabits. Davina's aunt promises to leave her own house to Davina, but such gestures towards continuity seem meaningless. The story ends with surveyors coming to peg out the new road – just as fatal, and as quietly mundane, as the fall of an axe or the arrival of the speculators in Chekhov. Like the houses of Chekhov's fin-de-siècle, these are condemned places waiting for the worst to happen. They are about to be auctioned, or burned, or (like Forster's *Howards End* and by extension England herself) branded with the letting agent's sign.

Those who move in are well aware that they cannot fully take possession. Daphne du Maurier described in *Rebecca* (1938) the doomed attempts of an innocent young woman to make herself at home in an old English house. Manderley is like one of Bowen's *unheimlich* homes, full of accusing furniture and macabre secrets. Its new occupant, the second Mrs de Winter (who, like so many of Bowen's young women, has no family of her own), feels she is continually trespassing. Every room, every ornament, every menu for supper is haunted by her predecessor. Bowen might have made the house itself reject her; du Maurier invents the malign *genius loci* Mrs Danvers to do the job. At any rate, the narrator is a tenant barely tolerated by a house not hers. This ancient seat of a nobility now diseased and dying is not available to the ingénue who might want to claim it. This is a fable in which the country house would rather burn to death than fall into new hands.

Maxim de Winter has let himself be exploited by his first wife Rebecca because she has kept up the country house charade. With her hollow demonic energy she has furnished and run the house better than any other in the county, all as a cover for sexual exploits too dark for du Maurier to name. The glories of Manderley, from the azaleas to the tea tray, are a sham. The novel pretends to teach us a lesson: do not care too much for houses. Maxim delivers the sermon to himself: 'I put Manderley first, before anything else, and it does not prosper, that sort of love. They don't preach about it in the churches. Christ said nothing about stones, bricks, and walls.'[26] His young wife is not listening, being consumed instead with the real-ization that Maxim never loved Rebecca. All that matters now is that they have each other – or so a good romance should end. But it does not work like that because Manderley haunts their dreams. All the pent up, displaced eroticism of the novel is transferred to the building, which becomes itself the temptress. The good middle-class girl carries on wanting the no-good house. The reader carries on feeling *its* allure, not hers.

Why should du Maurier write such a story? Partly it grew out of her fascina-tion with Menabilly, the large empty house hidden deep in the woods near Fowey, a

Daphne du Maurier on the stairs at Menabilly, 1947

house entailed to the Rashleigh family for eight hundred years. It was once a Royalist stronghold and a family home, but it was now deserted, 'grey, still, silent'. Du Maurier had set out with her sister one day to find it, but darkness fell and the owls were calling before they found what was at the end of the twisting drive. Later she recalled how she set out again, at dawn, and pressed on through the undergrowth to the rhododendrons, the lawn and at last the house itself. 'There would come no wreath of smoke from the chimneys,' she thought, sad and fascinated, 'The shutters would not be thrown back.'[27] Du Maurier herself lived in a cheerful weather-boarded cottage on the harbour, right in the middle of the Fowey bustle. What might it be to live in that house secreted in the woods, in its own world, governed by its own rules? She wrote *Rebecca* as a possible answer. Du Maurier applied for permission to walk on the land around the house, and finally, in 1943, she was allowed to rent the house itself – and she did so with the proceeds from Hitchcock's 1940 film *Rebecca*. But Menabilly was only rented: it was not quite hers. Like the second Mrs de Winter, she was a long way from being the lady of the house (and twenty years later she would be unceremoniously evicted from the paradise she had never owned). Writing *Rebecca* in 1937 she was imaginatively claiming Menabilly, but only to the extent that her nameless, guileless heroine was allowed to claim Manderley.

The homeless Mrs de Winter narrates her story from a hotel room somewhere in Europe, having been cast out from her corrupt English Eden. And *Rebecca* is du Maurier's book about exile. She began it while feeling herself an impostor at the army camp in Egypt where she was staying with her husband. She was abroad, in the distracting heat of a desert climate, 'sitting at a desk in Alexandria and looking out upon a hard glazed sky and dusty palm trees'.[28] She imagined herself back into the cool, damp, familiar English countryside. But although *Rebecca* is a nostalgic story of home, full of lush plants and English habits, it also turns home into enemy territory. The rhododendrons are fertile and luxurious, but they are also 'monsters, rearing into the sky, massed like a battalion'.[29]

Mrs de Winter must fantasize about these monsters and tame them as she tries to get through the days of exile in an 'alien land'. She sits on impersonal hotel balconies under glittering skies, and thinks of 'half past four at Manderley'. There are 'dripping crumpets' on the table, scones, gingerbread, and Angel cake, 'bursting with peel and raisins'.[30] It is one of those desperately imagined literary teatimes – like the one which Rupert Brooke hoped might still be served, complete with honey, at home in Grantchester. Stevie Smith contributes to the tradition: from a barren military tower in *Over the Frontier* (1938), faced with a bowl of burnt porridge, Pompey thinks herself back to Piccadilly cake shops where she would talk and eat with her friend Harriet:

I can see again the little cake-shop-cum-restaurant where so often we have

lunched together, lunched, that is to say if one may use the word for so slight
a choice, upon a sandwich and a pot of English Lady's luncheon coffee.[31]

These writers test their powers to think themselves out of desolation, and they
dramatize the process by inventing characters who do the same. So Mrs de Winter
explains the mental games that are her survival tactics. She reads, obsessively, about
the English countryside she cannot inhabit:

> I know the name of every owner of every British moor, yes – and their tenants
> too. I know how many grouse are killed, how many partridge, how many head
> of deer. I know how trout are rising and where the salmon leap. I attend all
> meets, I follow every run. Even the names of those who walk hound puppies
> are familiar to me. The state of the crops, the price of fat cattle, the mysterious
> ailments of swine, I relish them all.[32]

Scouring magazines and memorizing facts, revising for the exam in country living
that she is no longer required to take, she builds her own inalienable home.

While du Maurier was negotiating her access to Menabilly, Evelyn Waugh was
beginning a search for a house of his own. Preoccupied with home thoughts from
abroad, he wrote to Laura Herbert from Addis Ababa in 1935 about the kind of place
he wanted. He was tempted by what he called 'the Berners Betjeman country'
meaning the stretch of Oxfordshire and Buckinghamshire around John Betjeman's
Uffington cottage and much grander Faringdon nearby (where the Betjemans took
their horse Moti for tea among the antiques). But on the whole he would prefer
'Dorset or Somerset near water sea or river. Long way main road but near mainline
station.'[33] When he got engaged to Laura the following year the house-hunt became
a joint one, and the budget, to Waugh's delight, significantly increased.

The house they eventually found, and which Laura's grandmother gave them
as a wedding present, was Piers Court in Stinchcombe, Gloucestershire, a sixteenth-
century building with a well-proportioned and suitably crumbling Georgian façade.
It was crumbling a bit too much to be comfortable. 'The main objection to the house
is the lack of water, light and gas and all the chief rooms face north. Also the snow
gets in through holes in the roof' Waugh wrote happily to Diana Cooper, while
keeping warm at his regular hotel in Chagford.[34] But the furnishing and improving
of 'Stinkers' was an appealing project. Waugh inserted himself, belatedly, into the
continuous life of the house, and when later he wrote his autobiographical novel
The Ordeal of Gilbert Pinfold (1962), he adopted the name of the family who had lived
at Piers Court from 1640 to the late eighteenth century, the Pynnfolds. He wanted

Evelyn Waugh at Piers Court, Stinchcombe, Gloucestershire

to play, in full costume, the role of the country gentleman, so he dressed in country tweeds, assumed a proprietorial air, and stood in the driveway to be photographed against the sash-windowed and porticoed façade.

He recorded the urgency of this quest for home in *Work Suspended* (1943), the novel he was forced to abandon when war broke out. It is not much read today, but Waugh conceived it as his major work. And he chose to put at its centre a full-scale house-hunt. John Plant (the first of Waugh's first-person narrators: he was moving towards the intimate, confidential narrative voice of *Brideshead*) is a roaming novelist who spends most of his time in Fez, having exhausted the range of possible English retreats, 'country inns, furnished cottages, seaside hotels out of season' – places where he might have found one of Bowen's displaced heroines.[35] Coming into his inheritance after the death of his father, he resolves to buy a country house and, appropriately, the hunt proceeds in parallel with a love-affair: the language he and Lucy learn together is the estate-agents' jargon.

Plant's friends rummage for eighteenth-century engravings and advance the merits of a 'Composed Hermitage in the Chinese Taste' (complete with cupola, bells, minaret). Plant himself contributes a trenchant paragraph to the history of taste when he explains the particular enthusiasm that he and his friends have for domestic architecture. It is an important statement of the dreams of a whole social group:

> In youth we had pruned our aesthetic emotions hard back so that in many
> cases they had reverted to briar stock; we none of us wrote or read poetry,
> or, if we did, it was of a kind which left unsatisfied those wistful, half-
> romantic, half-aesthetic, peculiarly British longings which, in the past, used
> to find expression in so many lambskin volumes. When the poetic mood
> was on us, we turned to buildings, and gave them the place which our fathers
> accorded to Nature – to almost any buildings, but particularly those in the
> classical tradition, and, more particularly, in its decay.[36]

Plant's friends might include Betjeman, Hussey, or James Lees-Milne (those passionate advocates of Georgian taste), and Margaret Jourdain, who could never understand why Ivy Compton-Burnett was not more specific about the architecture in her novels. When Evelyn Waugh observed that domestic architecture was for Plant's generation what nature had been for his father's, he was claiming it as the modern artist's muse.

Architecture and literature were peculiarly entwined in the 1930s and 40s. The young American-based critic Nigel Dennis made this point emphatically in the *Partisan Review*: 'In this love of house, of continuous domicile and individual roof, Waugh appears for the defence in one of the most important struggles in English poetry and letters of the last 20 years'.[37] He was identifying a fundamental difference

of vision, though it was not as cut-and-dried as perhaps he made it sound. The left-wing poets of the 1930s had seen the inherited home as a thing of the past, irrelevant to a world of urgent international crises in which so much had self-evidently gone wrong. 'It is too late to stay in great houses', wrote Stephen Spender in 1933, 'we must advance to rebuild'.[38] Spender and many others vacated their fathers' houses as a gesture of political defiance and with much slamming of doors, but it was rarely a simple denunciation. For Spender, certainly, the idea of home remained magnetic, and in 1936 he and Inez bought, with Spender's brother Humphrey and his wife, a smart house commanding the market square of Lavenham in Suffolk. It was rapidly filled with good, comfortable, antique furniture and pictures. It was not ancestral, but it was nonetheless a family home, and there were times over the next few years when Spender and Waugh sounded very much alike. Neither inherited property – but they rebuilt fast to make up for the loss, and both, when it came to it, appeared 'for the defence'.

Waugh moved to Stinchcombe with high hopes but home was not to last for very long. He always knew it was precarious – that was the characteristic of 1930s homes, as he made clear so often and so regretfully in his fiction. In 1939 just after war was announced, Piers Court was let out to Dominican nuns, who used it as a girls' school until the end of the war. John Plant had an even more fleeting glimpse of the settled life in his ideal house. He reported in the 'Postscript' to *Work Suspended* that it was requisitioned for the war effort before he had even spent a night there.[39] For better or worse, this was the fate of many large houses during the war. The house in Lavenham became an army mess, and the eviction came at a desolate time for Spender, just after the break-up of his marriage. His writing, which had once been full of movement, registered the hunger for belonging, and understood the war as, more than anything else, a physical violation of home. He published his 'September Journal' in *Horizon*, which was a suitable place:

> Above all, the world should be home, it should be somewhere where
> everyone has his place, is surrounded by the simple machinery, the task,
> the house, the furniture, the companion, the river, the trees or the streets
> which assure him that he is loved. Everyone should be rooted.[40]

When Stephen Tennant's Wiltshire house Wilsford was given over to the Red Cross as a convalescent home for the wounded, servicemen puzzled over the gilt pillars and shell-encrusted tables while Tennant made efforts to entertain them. Spender remembered Tennant assembling soldiers one day to watch the transplantation of a buddleia from one part of the garden to another.[41] It must have been a strange scene, though some of the soldiers appreciated Tennant's efforts to keep aesthetic pleasures alive however incongruous they seemed.

The decadent rites of possession which characterized the 1930s were at an end. In wartime extravagant houses belonged to the imagination, and it was in writing and in painting that they would be rebuilt. In 1946, when Cecil Beaton was forced to leave his rented Eden, he photographed Ashcombe from every angle. Taking his last look round, he started work on the book that would 'bear witness' to his life there 'in the far-off decade before the Second World War'.[42]

12

HOUSE
BUILDING

Lying awake in London one summer night in July 1940, Virginia Woolf went over, one by one, the rooms of 22 Hyde Park Gate, the house in which she had grown up. It was a soothing, systematic mental exercise, this rebuilding of a remembered home. She began in the basement and worked upwards in memory. Then, by daylight, she turned the night's explorations into notes for her memoir – a memoir she never finished but which was published long after her death as 'Sketch of the Past'. She had built *Between the Acts* as a house, room by room. The first draft was a series of scenes ('The Bedroom', 'The Library', 'The Terrace') making narrative units into inhabitable spaces, and although she changed the chapter titles, we can still feel the novel moving between rooms, taking stock of the surroundings, looking out of the window.[1] Now, in her memoir, she marshalled whole inventories of furniture from the family home: the long baize-covered table in the dining room, the carved sideboard in the alcove 'on which stood a blue china dumb-waiter; and a biscuit tin shaped like a barrel':

> It was a very Victorian dining room; with a complete set of chairs carved
> in oak; high-backed; with red plush panels. At dinner time with all its silver
> candles, silver dishes, knives and forks and napkins, the dinner table looked
> very festive. A twisting staircase led to the hall. In the hall lay a dog,
> beside him a bowl of water with a chunk of yellow sulphur in it.[2]

And so she goes on, describing a place which, with its stationary dog in the hallway, seems complete and essentially unchanging.

The meticulousness of Woolf's memorial house building ran counter to the conditions in which she was currently living, which were full of rush and uncertainty. She began the memoir in April 1939 and wrote in snatches all through that spring and summer. Outside, war looked inevitable. Germany was renouncing its non-aggression pacts and allying itself with Italy. Inside the Woolfs' house in Tavistock

Square there were anxieties about work, compounded by a lot of banging and hammering from the nearby builders. On 15 May 1939 (the memoir is structured as a diary), Woolf described herself on a damp and chilly day, surrounded by *Athenaeum* articles and Roger Fry's letters, 'all strewn with the sand that comes from the house that is being pulled down next door'.[3] The two houses at the end of the street were being demolished, leaving number 52 in the middle of a building site and newly exposed to the noise from Southampton Row beyond. A home that had felt solid for many years now seemed a thin shell providing little protection from the world. And Woolf's notes and drafts for her biography of Roger Fry lay around her – a great friend's life reduced to sheets of paper that needed somehow to be pieced together.

Sitting in this disorienting mess of 1939, she looked back to her childhood and conjured a series of bravura Victorian 'scenes': summer days at Little Holland House, strawberries and cream on the lawn. She recorded with interest this process of 'scene-making' and wanted to measure her artfully arranged scenes against the sprawling, unprocessed stuff of the present. She was often in a hurry, and was only able to inhabit the past in short, half-guilty escapades from other projects. But, for all the hastiness, she lingered over those episodes of her childhood which were most pleasurable to remember, going back and back again to the summers at St Ives: the familiar stations on the train journey down, the colour of the village houses, the shout of the fishermen when the pilchards came.

'I write this', she says on 19 July 1939, 'partly in order to recover my sense of the present by getting the past to shadow this broken surface'.[4] The surface would be shattered by war within the year, but already it seemed broken: the building site at Tavistock Square was a prelude to the unknowable landscape of wartime rubble. The straying sand that fell on Woolf's desk would find its way into other books of the 1940s: it is the grit which comes drifting, in Elizabeth Bowen's *The Heat of the Day*, onto Stella's dressing table through the window which is no longer there, becoming an ominous sign of the 'breaking down of immunity'.[5] The trespassing dust of wartime and building sites contrasts with the containment of the scenes and framed portraits that Woolf wheels out from the 'mind's picture gallery'.[6] And as she toured her controlled internal gallery, her physical pictures and possessions were being dismantled and boxed up: the Woolfs were moving house. They left Tavistock Square for Mecklenburgh Square in search of a quieter place to work, but war intervened and they never had the chance to make themselves at home there. The bundles of manuscripts stayed in piles; the old transplanted furniture seemed not quite to fit. With her world in boxes around her, Woolf's writing became more and more concerned with tracing continuous lines between past and present.

This was a long way from those cool, weightless paintings that hung, free from association, in the 'Abstract and Concrete' exhibition just a few years before. They had sought to cleanse the viewer of memory and association, abandoning time

and changefulness in favour of geometric permanence. Woolf defied chronology not by eliminating time but by repeating it. She imagined a kind of time-defying radio which would allow one to tune in to former days. 'I shall fit a plug into the wall', she said, 'and listen in to the past. I shall turn up August 1890'.[7] It was one of her brilliant visions of how the modern world might give access to the old, as if she might invent an electronic time machine. But what interested her most was the bumpy transit. She wanted to take account of the interference which might disrupt and distort the signal.

What if the interference were so extreme that it threatened to drown out all sounds from the past? What if the experiences of war rendered the peaceful past an irrelevant fantasy? These were questions that another writer, Henry Green, was asking. Convinced earlier than most that war was coming, he had volunteered for the Fire Service in 1938. During the Blitz he was based in Westminster, at a sub-station near Grosvenor Square. In the daytime, between the blazing nights, he wrote *Caught* (1943), a novel about firemen, widely admired as one of the most powerful evocations of London at war.[8]

Green interleaved description of nights at the fire-station waiting to be killed with excursions to the country house where the fire-fighter Roe spent his childhood. These excursions are sometimes literal (on rare periods of leave), but mostly they are imaginative. As Roe sits in the bleak station, tense, bored, waiting for an inferno, he conjures different surroundings for himself. There is a moat, a deer park, and crumbling, rose-covered walls. It is warm inside; the library is 'old, long and low'; there are willow-pattern cushions on the sofa. Green allows his language to meet Roe's need for sensuous fulfilment. Swelling and overripe, it is a much-needed counter to fire-station banter:

> The roses, when they came to the rose garden, were full out, climbing
> along brick walls, some, overpowered by their heavy flowers, in obeisance
> before brick paths, petals loose here and there on the earth but, on each
> bush and tree of roses, rose after rose after rose of every shade stared like
> oxen, and came forward to meet them with a sweet, heavy, luxuriant breath.[9]

In its repetitious excess, this language brings into being a pungent dream world. With hallucinatory surrealism, roses become perfumed oxen.

In writing this novel Green too was hallucinating. His feeling for his own childhood home, Forthampton, went into this desperate evocation of an old house in the Welsh foothills. Forthampton Court is on the bank of the River Severn, and across the fields one hears the bells of Tewkesbury Abbey. Green remembered those

Henry Green's home, Forthampton Court, near Tewkesbury, remembered in *Pack My Bag* and *Caught*

bells in his memoir *Pack My Bag*, savouring their sound again in 1939 when all that was beautiful looked likely to end: 'always at any time the pealing bells would throw their tumbling drifting noise under thick steaming August hours and over meadows between, laying up a nostalgia in after years for evenings at home'.[10] The house itself is one of those that has accrued through the centuries, starting as a medieval manor, and subsequently altered in the seventeenth century, straightened out in the eighteenth century, and remodelled in the nineteenth by Philip Webb and William Morris who made of it their own Arts and Crafts ideal.

The heavy roses of *Caught* are Green's dream of Manderley – or Forthampton – made all the more potent by the fact that it is circumscribed. Roe's burgeoning roses multiply while he sits 'on the back steps of a heavy unit pump, with a mangy kitten swiping at flies attracted by a cod's head in the gutter at his feet'. Memory is a means of survival during Roe's months of waiting. But the novel culminates in the struggle between past and present which comes when, after weeks of major air raids on the capital, Roe is sent home from the fire service with his whole imaginative life reoriented. He can think of nothing except the 'pandemonium of flame' he has lived through. His home and family seem less real; the gardens and familiar hills are drained of meaning, and those heavy luxurious roses offer themselves as images not of home but of the burning night skies: 'a dark mosaic aglow with rose'. Even a year after the raids, 'he could not go back to his old daydreams about this place. It had come to seem out of date'.[11] This is the failure of memory, in a wet canteen after the Blitz. War has drowned out Roe's old life, however beautiful, and it seems that his dreams of home are of little use now.

As if in tribute to Roe, and as a gesture of reparation for robbing him of day-dreams, Green set his next novel in a country house in neutral Ireland, safely removed from bombing. Full of ornament and sensuality, *Loving* (1945) is, like *Brideshead*, a butter-book, making up for what is rationed. The idea for the novel came, Green said, from the story of a butler who loved 'lying in bed on a summer morning, with the window open, listening to the churchbells, eating buttered toast with cunty fingers'.[12] This would be sexy, sated writing, throwing open a window amid the claustrophobia of air-raids and austerity, going back again and again to those pealing bells in the 'steaming August hours'. And yet the setting Green invented was not really a comfortable haven, and it has none of the ancient natural beauty of Roe's home in *Caught.* Green is self-conscious and self-critiquing about his big house fantasies, so he gives us a faux castle called Kinalty, replete with florid decoration whose richness he finds obtuse, decadent, superfluous and – ultimately – immoral. This is a place as gothically moribund, as eerie and unknowable, as Manderley. Each piece of furniture is alive with carved swans and naked cupids, a black boy in cast iron puts out his hand to help one up the stairs. Straining sashcords turn passageways into 'deathtraps'; behind fake panels there are hidden mechanisms

with mice caught between the cogs.[13] Miscellaneous body-parts appear at every turn. Symbols of innocence are carelessly decapitated: daffodils and doves lose their heads.

The peacocks which wander in, as if from Yeats's poem 'Ancestral Houses', meet a gruesome fate at Kinalty. Yeats described the elegant gardens 'where the peacock strays / With delicate feet upon old terraces'; Henry Green lets his peacocks scream in the castle grounds before being killed and strung up in the larder, 'swarming with maggots'. Like the colonial Anglo-Irish seats that Yeats both celebrates and attacks, Kinalty is exposed as a fraud, built out of bitterness and violence, breeding mice rather than heroes. It is a folly built in homage to aestheticism, and it has its complement of small follies within. There is a dovecot shaped as the Leaning Tower of Pisa (Victorian Bowen's Court made do with an alabaster model of the tower under a glass dome), and a mechanical weathervane attached to a map of the locality – a map which turns this stretch of Ireland into a series of tourist sites with dubiously erotic Celtic pasts. Green mixes up splendour with banality: the sheets in the Gold Bedroom have been damaged by sleepers with long toenails. Kinalty is the last folly in Ireland 'still to be burnt down'.[14] Its existence is temporary and accordingly Green names its owners the Tennants. The great house has sunk to kitsch decadence and it has no future.

Like so many of the country houses built imaginatively in wartime, Kinalty is a flawed place. But these houses, for all their failings, take possession of writers who record them in words before the originals are pulled down or go up in smoke. Elizabeth Bowen's family house in Cork escaped the flames only very narrowly. An IRA group met inside the house one night when Bowen was away, and took a vote on its fate. The house was given a stay of execution, but Bowen was haunted for much of her adult life by visions of it burning.[15]

In 1939 she started work on a history of the house and its family. Written mostly in London during 1940 and 1941, *Bowen's Court* took shape out of the rubble of the Blitz. It was a book about walls and rooms at a time when walls and rooms were being blown apart. By 1964, when Bowen returned to the book to revise it and write an afterword, Bowen's Court had been demolished. Burdened by debt, she had sold it to a farmer who said he would let the building stand, but in fact the house was pulled down in 1960. All that remained (and remains today) was the basement and a bit of the garden wall. The loss sharpened Bowen's sense of what she had been doing in writing that book. She knew that during those years of war, the 'attachment of people to places' was 'to be dreaded as a possible source of too much pain'. Like loved ones, places might be lost. But she wanted to confront that attachment and explore it, which is why, in *Bowen's Court*, she took 'the attachment of

people to places as being generic to human life', and why she probed the very notion of 'home'.[16]

Reflecting on the process of writing in wartime, Bowen recalled how, 'in the savage and austere light of a burning world, details leaped out with significance':

Nothing that ever happened, nothing that was ever willed, planned or envisaged, could seem irrelevant. War is not an accident: it is an outcome. One cannot look back too far to ask, of what?

Working on *Bowen's Court* she had borne witness to these details. She saw her family home as a 'miniature theatre' in which a representative fragment of European history was played out, and in which the dynamics that made the Second World War possible could be faintly but surely detected. She traced the Ascendancy history which reached its violent denouement in one war, and the wider European history which had to be held responsible for another. Bowen's history was about the individual's relationship with tradition, the nature of ownership and the dangers of possession.[17]

For successive men in Bowen's story, the urge to defend what is owned, and to own more of it, is self-destructive and all-consuming. At times these people of property allow themselves to be ruled by it; these inheritors are as flawed and as restless as the disinherited wanderers who inhabit Bowen's fiction. There is a pronounced element of farce in the story of her forebears' obsessively proprietary attitudes, and lawsuits of Dickensian longevity are continued from generation to generation. Bowen patiently refuses to elide details or skip ahead to the outcome. The experience of these wranglings, in all their compulsive precision, is integral to her story. She therefore narrates the decline of the land-owning Bowens into obsession and illness by giving measured consideration to every detail. There is no easy idealism in *Bowen's Court*, but Bowen's belief in the value of private ownership is unfailing. She stated her politics explicitly in the afterword:

Property gave my people and people like them the means to exercise power in a direct, concrete and therefore limited way [...] I submit that the power-loving temperament is more dangerous when it either prefers or is forced to operate in what is materially a void.[18]

Power without an object is uncontainable, which is why, she thinks, 'we have everything to dread from the dispossessed'.[19] This is the rational justification of that deep feeling for ownership and for continuity which runs through *Bowen's Court*, a book which starts with a map, a long topographical prelude that lays claim to a whole stretch of north Cork landscape, and a lover's description of a house which has moods and expressions:

Bowen's Court shows almost living changes of colour. In fine weather
the limestone takes on a warm whitish powdery bloom – with its parapet
cut out against a bright blue sky this might almost be a building in Italy.
After persistent rain the stone stains a dark slate and comes out in irregular
black streaks – till the house blots into its dark rainy background of trees.
In cold or warm dusks it goes either steel or lavender; in full moonlight it
glitters like silvered chalk.[20]

Bowen is not always as romantic as this (the tone of her book changes, like the colour
of her house, between lavender and steel), but she is always this closely attentive.
She uses physical things – portraits, furnishings, windows – as structuring princi-
ples in the narrative, resisting material voids. Every corner of the house has a story;
it matters that events have taken place 'here', on this spot. As at Pointz Hall, Lucy
Swithin indicates the bed in which she was born ('yes, here'), Bowen's aunt Sarah goes
to one end of the library, marks 'with absolute certainty a spot in the carpet with her
toe', and announces '*This* is where our grandmother died'.[21] The house may represent
an abstract idea of social rectitude, but abstract ideas are rooted in carpets and walls.

Elizabeth Bowen knew that she was the last Bowen of Bowen's Court. So she
made the book an archive, reproducing family portraits, collaging extracts from
letters and diaries (there are sixteen pages of quotation from the diary kept by the
children of Robert Cole Bowen). Like Virginia Woolf in 'Sketch of the Past' and in
her biography of Roger Fry (the writing of all these difficult memorials overlapped),
Bowen wanted to give a sense of the jumbled, evocative relics with which she was
working. Woolf put her reader in the place of biographer, surrounded by passports,
hotel bills and straying sand from the building site; Bowen evoked, with good
humour, the task of the family historian. In this role we find her searching for lost
architects' plans:

The ground plans, the elevations, the estimates, the builders' notes and
receipts, the records of stones quarried and trees felled, the Italians' designs
for the fireplaces and friezes, the alternative drawings, with detail, submitted
for the grand staircase are all nowhere.[22]

The sentence enacts the frenzy of searching, the anticlimax of not finding, and
(particularly in that emphatic qualification, 'with detail') it hints at the susceptibility
of this researcher to the obsessive, doomed pursuits that racked her forebears. But
this is not just a private family trait, it is modern society's need of bits and pieces
from the past.

The talismanic power of relics, granting the bearer passage back in time,
became the subject of Bowen's story 'The Happy Autumn Fields', written in summer

Elizabeth Bowen at Bowen's Court, County Cork, Ireland

1944, in her bombed but half-inhabitable London home. It is a story about the things people think about when the world is falling down around them. Mary is the last remaining occupant of a bombed terrace. Everything is covered in dust and plaster; the house is unsafe and Mary's lover Travis is trying to get her to leave. But Mary is in the midst of a dream that cannot be interrupted. Among the ruins she has found an old box of letters, diaries and photographs, which take her back in imagination into the full, glowing, highly wrought family life of a Victorian big house.

The story opens with her vision of a family group out walking, in a procession of twos and threes, all bound together by complicated feelings of love and loss. They process though golden cornfields, lyrically evoked: 'There was no end to the afternoon, whose light went on ripening now that they had scythed the corn'. Mary is so involved in this bright autumn afternoon that her own body, and her own bleak present, feel alien to her. Sliding back into reverie, she brings the imagined family home from their walk, into a 'beautiful warm red room' lit up by the rays of the setting sun. It is a room that wears a profound air of permanence.[23] For all its precariously piled objects, it seems that no real catastrophe can intrude on this solid world:

> The towering vases on the consoles, the albums piled on the tables, the shells and figurines on the flights of brackets, all had, like the alabaster Leaning Tower of Pisa, an equilibrium of their own. Nothing would fall or change.[24]

This is the fantasy of Victorian stability and rich family feeling that Mary conjures as she lies alone in the rubble of her home. She knows that her Victorians were riven with pain, jealously, fear that things would not last. But the point is that they have the capacity to feel. Mary envies their emotional engagement, when all she can feel for herself is an unreal imitation of emotion: 'I cannot forget the climate of those hours. Or life at that pitch, eventful – not happy, no, but strung like a harp'. Travis confiscates the 'dangerous box' of relics because it has such a strange effect on Mary. But the story suggests quite the opposite: that, far from being dangerous, the box and the imaginative reconstruction it prompts are a kind of salvation.[25]

Falling plaster affects literature in polarized ways. When buildings fall, literary structures can, in sympathy, fall with them. They can also, in defiance, grow stronger and more watertight. Bowen responded with both kinds of writing. Looking back on wartime London, she observed that 'the violent destruction of solid things, the explosion of the illusion that prestige, power and permanence attach to bulk and weight, left all of us, equally, heady and disembodied'. Her short stories emerged as 'disembodied' fragments from among this general wreckage. They were, she said, 'flying particles', 'sparks' of a general experience which was not necessarily her own.[26] 'The Happy Autumn Fields' imagines a sunlit world of 'bulk and weight' but the story itself is torn apart by interruptions, the dull sound of a distant

explosion breaking into Mary's dream. The form of the story replicates the breaking apart of what once appeared solid. Bowen's other wartime stories narrate, in fragments, the stories of discontinuous people whose voices we hear late at night behind curtains and in the corners of cafés.

Alongside these 'flying particles' she was writing a different kind of literature. Like Woolf's memoir, *Bowen's Court* resists fragmentation and builds something solid over the 'broken surface' of the present. This is the urge, too, that underpins the paintings that Piper made of bombed churches and houses, in which he layers impasto on the surface of the canvas as if constituting a physical façade. At Coventry or in the Georgian terraces of Bath, the walls have fallen, but in Piper's pictures there is an insistence on substantiality. Stones, bricks, mortar plead against transience.

This is partly why Stonehenge, the heaviest structure of all, was so emotive an icon: those tough, inviolable bluestones, which had stood for millennia out on the exposed plain, were massive symbols of all that is heavy and permanent. In 1944 Bill Brandt photographed a group of sarsens huge and dark against the sky, a few nonchalant cows wandering below them as life unshakably carries on. The fallen bluestone in the foreground does not designate the site a ruin so much as show the stones to be part of the land itself, the foundation from which the photograph can rise. Henry Moore used this imagery to demonstrate that the people of England were themselves the bedrock. In his *Shelter Drawings* the huddled sleepers on London Underground platforms became part of the ancient rocky structure underpinning the city above. The people he actually saw when he went out at night with his sketchbook did not really look like this. There are photographs of Moore sketching in the stations and what the camera catches is the alert wide-awake eyes in the gloom and the restless, ungainly, uncomfortable bodies. Moore, in recompense, gave them weighty significance. They are prehistoric, his swaddled sleepers, going on forever.

In times that left one feeling 'heady and disembodied', the response of many artists and writers was to make a kind of art that is about *em*bodiment. The period's great literary house-builders – Woolf and Bowen, Daphne du Maurier and Henry Green – practice a form of substitution, supplying what a chaotic present denied in the way of continuity, luxury and individualism. This construction work was taken to its limits in two wartime books that Bowen particularly admired, and which looked back from a 'burning world' to an intricately and passionately recreated past. Evelyn Waugh's *Brideshead Revisited* and Osbert Sitwell's autobiography *Left Hand, Right Hand!* were campaigns waged against utility, and the most extravagant of all English tales of home.

13

Literary
ARCHITECTURE

The first print run of *Brideshead* sold out within a few days at the end of May 1945. It was three weeks since VE Day. The streets had been full of crowds and bunting, the bells had rung for the first time in five years. But long-pent tension and grief had not dissolved overnight and, in a climate of compulsory cheerfulness, Waugh's novel of extravagant melancholy tapped some of the currents of feeling that ran beneath the celebrations.

Waugh had served an inglorious year in the army, hating the discipline and the tedium, constantly rebuked for laziness and assigned the lowliest of jobs. His survival tactic was to think up a novel, and in January 1944 he was granted leave from the army to write it. This was, as he wrote to his commanding officer, his contribution to the war effort, and one for which he was better equipped than for modern warfare. Repeatedly over the next few months he was ordered to return to duty and he pleaded in panic for a week or two more. He was writing the novel in stolen time and one can feel this sense of the illicit in its language. By the time the proofs came through he had been posted abroad again and was homesick in Topusko, but he had stolen enough time to write out Charles Ryder's dreams.[1]

Waugh established a framework narrative of present day wartime routine and weariness as Charles's regiment pitch their camp in the grounds of a country house – a house that Charles knows well. As he talks to the uncomprehending subaltern Hooper on a cold morning in the grounds of Brideshead, where corrugated iron now litters the view to the Doric temple, his mind flies back to pre-war years. This is what Paul Fussell has called literary 'compensation':

> instead of the straight lines enjoined by the military – the posture of attention, the 'dressing' of ranks, bunks and tents, 'the ultimate straight line of the bullet' – the novel offers the inestimable relief of the baroque, with its benignly impertinent curves and surprises.[2]

The novel emphasizes its curves by incorporating the straight lines too, its framework scenario of army life containing the baroque reminiscence that swells out bulbously from between Ryder's two conversations with Hooper on a single morning. Waugh turned from army camps to a house of 'gilt pagodas and nodding mandarins, painted paper and Chippendale fretwork', all presided over by a 'high and insolent dome'.[3]

The baroque house at the centre of *Brideshead* lends its architecture to the novel itself. Waugh's narrative eschews linearity in favour of curves and domes: a graph of its chronological progress would look like the straying graphs in *Tristram Shandy*. Tristram mapped his leisurely digressions from the mechanical straight line (the line of exacting cabbage planters and printing presses), and Waugh's reader might, similarly, map Ryder's journeys back from the straitened wartime present into the more accommodating past. He takes us first to Oxford in the 1920s, roaming back and forth over the chronology of those hallowed few terms, and then on to Venice, and back into Julia's history.

These narrative arabesques stand against wartime utility, but the novel is concerned with a 'conversion to the baroque' that takes place long before the outbreak of war: one of the stories it tells is about the transition from modernism to romance. Ryder arrives in Oxford in 1923 as a good formalist and follower of Fry. He decorates his room with a screen from the Omega Workshops and puts a reproduction Van Gogh over the mantelpiece. But this is not to last. The first stage of his aesthetic conversion occurs when Sebastian opens a copy of Clive Bell's *Art* and effortlessly throws into doubt its whole premise. 'Does anyone feel the same kind of emotion for a butterfly or a flower that he feels for a cathedral or a picture?' asks Bell, meaning it as a rhetorical question to which the answer must be 'no' since art is separate from the world, commanding feelings of its own. But Sebastian answers differently: 'Yes. *I* do,' he says, reclaiming 'aesthetic emotion' for life itself. The world is, for him, a work of art long before it is painted, so there need be no distinction between art and life. Both are subjects for sensuous contemplation. This is a decadent version of the widespread reaction against monastic 'immunity'. Pitted against Sebastian's joyous, uncritical ways of seeing, Bloomsbury comes to stand in the novel for a kind of ascetic earnestness. 'The puritanism of Roger Fry' is, according to Waugh, an unfulfilling, life-denying thing. Charles exchanges the 'winter garments' of Bloomsbury for a 'richer wardrobe' and at Brideshead the conversion is completed, 'a whole new system of nerves' is awoken.[4]

This aesthetic conversion is also a social conversion: Charles becomes an apologist for the religion of aristocracy, and religion is not too strong a word since Waugh's troubling implication is that sanctity resides in the exquisite taste of a leisured few. The war in *Brideshead* is therefore not between nations but between classes. Waugh sees the exquisite sensibility of Flytes and Marchmains besieged

by the philistinism of Hoopers; he sees a barbaric process of levelling down to the same common mean. Waugh's snobbery was virulent and embattled because he anticipated the 'massacre' of the upper class. In his 'Modest Proposal' of 1946, a satiric essay of Swiftian fierceness, he foresaw 'judicial murder' and 'mass deportations' as the only means of achieving a classless society.[5] He felt himself, and his values, under violent attack, and was as offensive as possible towards those he perceived as aggressors. Accused of snobbery by his reviewers, he agreed wholeheartedly. It was, he said, an affront to class-prudery at a time when 'to mention a nobleman [was] like mentioning a prostitute sixty years ago'; this was his perverse liberation of the oppressed.[6] The recruitment of Charles Ryder to the aristocratic cause (as the middle-class admirer able to appreciate but not inherit Brideshead) was part of a campaign for the interim preservation of a moribund tribe. And, far from addressing itself to an elite few, Waugh's novel aimed at the conversion of the public he despised.

The baroque fountain at Brideshead became an index for these social and aesthetic battles. The Quartering Commandant explains that young officers used to lark about in it, so the water has been turned off. Charles does not notice much improvement: now the 'dry basin' contains only 'cigarette-ends and the remains of sandwiches'. Waugh's literary war-work was to imagine the fountain flowing again. He made it a symbol of England's aesthetic sympathy with nations now her enemies, the fountain having been imported from an Italian piazza by Sebastian's ancestors and 're-erected in an alien but welcoming climate'. And with this fountain as his emblem Waugh entered into dialogue with his literary contemporaries. When T. S. Eliot looked down into the concrete pool at Burnt Norton, 'The surface glittered out of heart of light'. Eliot's earthly desert is filled by faith. Waugh's faith is offended by such asceticism and depends instead on richness. Waugh also answers Yeats by reviving the dizzy fountain of 'Ancestral Houses' and the basin spilling over with life. These are not, he insists, outmoded images, long since proved false. These are images with the power to keep changing: 'clustering feats of daring and invention'. Watching the fountain at Brideshead, Charles Ryder feels as if 'the water that spurted and bubbled among its stones was indeed a life-giving spring'.[7]

In narrating the story of Brideshead and ornamenting it with his language as the baroque painters once ornamented the dome, Ryder is celebrating a home which was never his. He can only say to Hooper 'It belongs to friends of mine'. He is himself 'homeless, childless, middle-aged, loveless', turning from rootlessness to a fantasy of belonging. Charles claims Brideshead as the second Mrs de Winter claims Manderley, in the conditional tense of fiction, 'as it might have been'.[8]

How does the wandering writer make a home? It was the question Auden would raise when at last he found somewhere to settle. 'City-planners are mistaken', he reflected:

The fountain at Castle Howard, Yorkshire, one of the inspirations for *Brideshead Revisited*

a pen
for a rational animal
is no fitting habitat for Adam's
sovereign clone.[9]

He was denouncing the failures of functionalism, but querying, too, with a pun as paltry as the planners' apartments, the fitness of the habitats built by a writer's pen. Are the habitats of literature more worthy of Adam's clone? In the fiction of wartime, houses are made watertight by obsessive research and recall; the details that the abstract artists could afford to edit out are rendered sacred, even redemptive. So Mrs de Winter thumbs through tattered pages of the *The Field*, administering descriptions of the English countryside as she would take a medicine: 'A poor pastime, perhaps, and not a very intellectual one, but I breathe the air of England as I read, and can face this glittering sky with greater courage.'[10] In the same spirit, Charles Ryder remembers Oxford and Venice and Brideshead, breathing pre-war air. He opens the third book of his narration in grand Miltonic fashion: 'My theme is memory', he declares, 'that winged host which soared about me one grey morning in war-time'. But the metaphor for memory slips from the Eucharist to the strutting pigeons of Venice, 'a tumult of fowl'.[11]

Waugh's confidence in compensatory memory survived the violence; it was peace which made it seem out of date. In 1946 Waugh considered *Brideshead* to be his best work. By 1959 he felt that its very existence needed justification. It had to be excused on account of the climate in which it was written. When preparing the new edition he cut some particularly gluttonous passages that he could not bear to read again.[12] He abbreviated, for example, an expansive overture to a particular bottle of Burgundy. The style was intrinsic to the book, however, and could not be retracted.

Parodying the novel and its reception in *Sword of Honour* (1965), Waugh had one reader observe that it was 'hardly what we expected from the author of the aphorisms', but then, 'few of the great masters of trash aimed low to start with'. Looking back on *Brideshead* after fifteen years and imagining this fictional version of it by the dreadful Ludovic, Waugh considered that it was not only 'trash' but, much worse, it had been part of a 'movement'. The novel caught exactly the contemporary spirit of nostalgia and found itself one of many:

half a dozen other English writers, averting themselves sickly from privations
of war and apprehensions of the social consequences of the peace, were even
then severally and secretly, unknown to one another [...] composing books
which would turn from the drab alleys of the thirties into the odorous
gardens of a recent past transformed and illuminated by disordered memory
and imagination. Ludovic in the solitude of his post was in the movement.[13]

Waugh writing *Brideshead*, Woolf, in *Between the Acts*, imagining a festive day in the gardens of an old English house, Eliot going through 'the door we never opened', Bowen looking back on Bowen's Court, Henry Green observing in *Caught* the very process by which the mind turns from 'drab alleys' to 'odorous gardens'. From their scattered wartime posts, these writers were collectively building the imaginary architecture of home.

For Waugh the 'odorous gardens of the recent past' were all the more appealing when already decaying and near-deserted. In *Brideshead* he looked back to a time when the great house, though not yet under threat from bombing or requisitioning, was already shuttered and dying. When Charles first sees Sebastian's home it is already a vision of injured, condemned grandeur where 'gilt mirrors and scagliola pilasters' glint among the 'islands of dust-sheeted furniture'.[14] The aesthetic appeal comes from the sense of an ending.

While worshipping Brideshead and other fallen houses, Charles builds his reputation on their decline, making 'portraits of houses that were soon to be deserted or debased'. He is therefore a haunter of moribund places, taking the death mask and performing last rites. His arrival seems often to be 'only a few paces ahead of the auctioneer's, a presage of doom'. Ryder knows that he is making an art of compensation. 'When the water holes were dry', he explains, 'people sought to drink at the mirage'. Conjuring these mirages in the desert, Ryder is in league with Waugh himself, understanding it as the duty of the artist to offer an illusion of nourishment.

Waugh's description of Ryder as antiquarian and painter owes much to the model of John Piper. At times the connection is unmistakeable, as when Ryder recalls his days as a schoolboy bicycling round the neighbouring parishes, 'rubbing brasses and photographing fonts'. Rather later than Ryder, Piper began in wartime to make 'portraits of houses', which answered exactly to Ryder's love of 'buildings that grew silently with the centuries, catching and keeping the best of each generation'.[15]

One of the first houses that Piper was commissioned to paint was a royal one: Windsor Castle. The idea was that he should make a record in case the castle was damaged by bombing, and Piper had to reconcile his task as a topographical draughtsman with the need to make the castle an emotive national symbol. The commission stipulated the use of watercolour, envisaging an echo, almost three centuries on, of Paul Sandby's drawings of the castle. The Librarian at Windsor, O. F. Morshead, warily advised Piper to avoid anything too abstract, and to look on Sandby as a model. The vast series of watercolours by his predecessor prompted some anxiety in Piper ('I follow unworthily in the footsteps of Paul Sandby who did 200 watercolours for George III', he told Betjeman) but he was not put off by nervous warnings.[16] He drew on the wide vistas and expanses of sky loved by

Paul Sandby *Windsor Castle, The Round Tower,* 1756

Sandby, but where the eighteenth-century views are built on carefully balanced horizontals and verticals, finely delineated in pencil and washed over with pale clear colour, Piper's Windsor has not so much the pared-down elegance of a stately home as the castellated staginess of a medieval fortress, re-militarized in paint. Further commissions followed. Edward Sackville-West invited Piper to paint Knole, and when Osbert Sitwell asked him to make a series of views of his Derbyshire home, Renishaw Hall, a monumental project began.

Ever since the Munich crisis Sitwell had felt himself on the brink of apocalypse. He had fought at Ypres in the last war, and knew what another war might mean. In autumn 1938 he tormented his guests with continual warnings that everything was happening 'for the last time', and earned himself comparison with the raven in Poe's poem, hypnotically croaking 'nevermore'.[17] While Piper's work at Windsor had been prompted by the threat of bombing, and Knole, being in Southern England, was similarly vulnerable (it did in fact sustain minor damage), at Renishaw the motivation had less to do with bombs than with the passing of an age. Renishaw was not about to be demolished, but the ruin of other great houses in the area, reflecting the dereliction or institutionalization of houses across England, made it seem a lone and vulnerable survivor. Sitwell's impulse to record its history and appearance was akin to Bowen's wish to record the life of Bowen's Court, which still stood strong, but (for other reasons) inhabited a country of ruins.

Sitwell realized when war broke out that a large house standing empty was likely to be requisitioned. He saw it as his duty to house-sit for the duration, standing guard over the priceless furniture and keeping the estate in order. So, not long after the declaration of war, he went up to Renishaw, tried to block out the drafts, and settled down to write an autobiography that took eight years and filled five volumes. He wanted a pictorial counterpart: 'In that book I was trying to record a way of life, as well as my own adventures, in my own medium; and I asked Mr Piper to record, in his, the setting'.[18]

Sitwell had greatly admired *Brighton Aquatints*, and when he broached with Piper the subject of Renishaw the response was whole-hearted: 'Thank goodness opportunities like this can still occur for painters', wrote Piper, 'this is the sort of thing one lives and works for'.[19] The project evolved over several years, with Piper paying regular visits to Renishaw and, later, travelling to the Sitwells' Italian castle Montegufoni. Osbert Sitwell became Piper's patron, fashioning their relationship on that between Lord Egremont and Turner at Petworth in the 1820s and 1830s. Turner had become an honorary member of the Egremont family, going well beyond his initial commission and looking out from his studio to paint the deer appearing through the mists or heat hazes of Petworth Park. Piper, likewise, was adopted and was able to watch the house in many moods. In their excited, affectionate correspondence (which grew voluminous – 'I seem to write to you, dear John, every day'

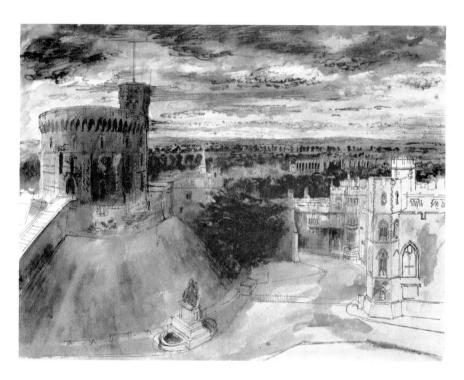

John Piper *Windsor Castle, Berkshire*, 1942

observed Sitwell without much exaggeration), Piper and Sitwell wondered who was getting more pleasure from the relationship, artist or patron.[20] 'You seem to be part of the life of the house', wrote Edith, while knitting Piper a jumper to fend off the Renishaw chill. Osbert's appetite for the paintings was insatiable: 'I want another *huge* picture', he demanded, again and again. In return, the Sitwells answered Piper's need for 'sophistication, for lively conversation, for some constructive and slightly abrasive experience of literature and painting and music and indeed life'.[21]

All these art forms came together when preparation began in 1942 for a revival staging at the Aeolian Hall of Edith Sitwell's poetic entertainment *Façade*. The curtain that Piper designed for the occasion was an apt symbol of the changes that had occurred in English aesthetics since the first performance in 1922. Back then Frank Dobson had produced a cheerfully modern curtain, with a primitivist mask and a small pot plant. Piper seized the various elements of Dobson's design and showed what happened when the baroque imagination took charge. The pot plant flourished and became an enormous floating poinsettia, the African mask became an eighteenth-century stone water feature, and the colonnade became an ethereal palace reflected in a lake by moonlight, inspired by the Italianate gazebos and gothic archways of the Renishaw gardens.

The house itself was equally ethereal in some of Piper's drawings for Sitwell. Windows are blind eyes, walls are blank faces turning a peaky yellow-green. This gothic world alternates with a more substantial and earthy vision, a montage of scored, scarred, floodlit walls, deep shadows, and thick tangled grass. Some of the pen and wash sketches creep up on their subjects from unexpected angles, but the major oils, like *The North Front*, announce their presence and confront the façade head-on. The building glows and smokes as if it were burning; the weathervane struggles for survival in a violent sky.

Piper's feel for 'pleasing decay' made him appreciative of buildings as they stand, with all their flaws. He subscribed to Ruskin's religion of the time-honoured house as a sacred record of people's lives. Ruskin advised that since a building does not reach its prime until 'four or five centuries have passed over it' (not just passed, but tangibly passed over it, leaving their mark) the designers should plan ahead to take weather-staining into account.[22] Piper paid tribute to their foresight. One of his best essays about houses and their evolution was a piece about Vanbrugh's theatrical mansion Seaton Delaval. 'This vast old war-horse of a house was built with a splen-did sense of drama, and acts up', he wrote in 1945, attributing to brick and stucco a mischievous quick-wittedness. The house knew how to amuse its eighteenth-century occupants with tricks and spectacles; it then caught fire in 1822 and pleased the Victorians by looking romantically ruined. In the twentieth century it knew how to 'toe the line' by helping out in wartime as a barrack and storehouse. Seaton Delaval, like all the houses Piper painted during the war, is 'somehow alive', not in

need of an elegy because it is still able to stand up for itself. What might finally break it, suggests Piper, is not fires or bombs but over-careful preservation. Consigned to the National Trust, this spirited veteran might 'split its sides with disastrous laughter' at the orderly tourists putting their litter tidily in the litter-basket. Noisy bank holiday crowds would be better, thought Piper, and plenty of fireworks, but 'may its surrounding grass never be mowed by the smooth Atco'.[23] Such tame, lawn-mowerly prettification would insult the tough grandeur of this place.

Renishaw was another old war-horse and many of the Sitwells' visitors in the 1930s and 1940s were dismayed by its stern, fortress-like appearance. Piper's use of inky blacks overlaid with flashes of colour answered the unforgiving topography of the area. Christopher Hussey (quoting Sitwell) called it a '"chiaroscuro world" where the very lanes are laid with clinker, a vitreous substance turquoise blue, marine blue and sea green'.[24] Piper was at his most receptive in this exposed, scarred countryside. 'I got home after, with my head full of black-trunked trees', he wrote after an early visit, 'scythed grass, the tumbled beauty of Renishaw Park, Bolsover in the mist, Sutton Scarsdale in drizzle & Barlborough in fitful sun'.[25] He was painting the aristocratic outcrops in a fallen industrial landscape, but his was not only a project about endings. He was working towards a revived Romanticism and a new energy in English art. Looking across that panorama of Derbyshire houses, each coloured by its own weather and telling its own story, he felt all the excitement of starting out.

'There is an extremely charming artist staying here and making drawings of the house' observed Evelyn Waugh in a letter home from Renishaw in the summer of 1942.[26] He would give Charles Ryder the same occupation as this intriguing guest. And Piper was not the only personality at Renishaw who provided inspiration for *Brideshead.* Osbert Sitwell was trying out his ancestral anecdotes on anybody who would listen, getting them into shape for his autobiography, and there are numerous echoes in Waugh's novel of the fraught Sitwell ménage. Waugh imagined Lord Marchmain returning from Italy to play out a grand Victorian death while, much to Sitwell's relief, *his* father remained at Montegufoni, and eventually died in Switzerland. Sitwell professed to find *Brideshead* 'overwhelmingly, *amazingly* bad', but, reading the novel just when he was preparing for the exhibition in London of Piper's Renishaw views, he responded wholeheartedly to Waugh's sentiments on the lamentable decline of houses – and their aesthetic possibilities for the painter.[27] His preface to the exhibition catalogue echoed Waugh to the letter, even in the addition of decadent, decaying Venice to the melancholic brew:

At the very moment when the great English houses, the chief architectural expression of their country, are passing, being wrecked by happy and eager planners, or becoming the sterilized and scionless possessions of the National

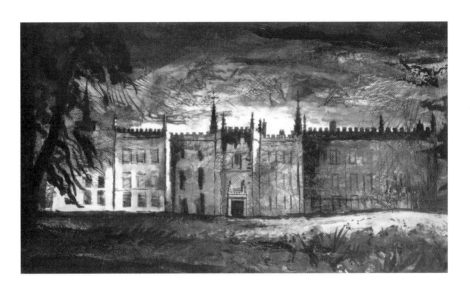

John Piper *Renishaw, The North Front*, 1942–43

Bill Brandt *Edith and Osbert Sitwell*, 1945

Trust, a painter has appeared to hand them on to future ages, as Canaletto or Guardi handed on the dying Venice of their day, and with an equally inimitable art.[28]

Renishaw in wartime was not the luxurious setting Sitwell conjured for the story of his childhood. He had customarily spent only the summer there, but now he had to stay on beyond the August sunshine, without heat or electric light. The house was largely empty, and it seemed to Sitwell like a last outpost, remote from London and society. His sister came to live there too, and they spent the days working in opposite wings, feeling very much like exiles. 'A sort of Robinson Crusoe existence', Edith called it.[29] Bill Brandt photographed them on their island looking distant and dour. He brought out the contrast between their way of life and their surroundings: chiffoniers and porcelain and the grand family portrait by Sargent make up the backdrop, but Osbert's crumpled appearance and Edith's overcoat worn indoors tell another story.

This emptiness and coldness went into Sitwell's writing, which thronged with people and was mesmerized by sunlight. From the start, his work was to be 'old-fashioned and extravagant', 'crowded with people of every sort'. He imagined it as a castle or cathedral: 'I *want* this to be gothic, complicated in surface and crowned with turrets and with pinnacles, for that is its nature.'[30] It was to tell a personal story against a panoramic social background so that, as John Pearson observes, 'the rise and the disaster of the family mirrored the rise and fall of the society [Sitwell] knew'. 'I had the fortune to be born toward the sunset hour of one of the great periodic calms of history', Sitwell wrote in his introduction, 'everything was calm and still and kindly'.[31] He was going to look back over that period of calm in such a way that the reader should experience it for himself, and he was going to trace the downfall of the Edwardian world.

Like Bowen, he was turning over details from the past as a kind of evidence, looking under stones for the small, accruing actions of which war was an outcome. But he was a less wary historian. He made no critique of the 'power-loving temperament', and he aestheticized without a flinch the industrial landscape around Renishaw. Clinker becomes a 'precious stone', miners tramp past in 'a costume which set off the black of their faces'.[32] Even these workers look to Sitwell like the fancy-dressed players in a pageant. Nevertheless, his was an ambitious attempt to retrieve what he felt to be good and preserve it. So he immersed himself without censure in his own privileged 'sunset hour'.

The autobiography is structured around an oddly mystic anatomy of the body. The title *Left Hand, Right Hand!* gives the impression of hale and hearty

marching. Its symbolic import, however, was of a different nature. 'According to palmists', Sitwell explained, 'the lines of the left hand are incised inalterably at birth, while those of the right hand are modified by our actions and environment, the life we lead'.[33] This was his subject: the interaction of the inherited past and the self-made present. Although he denied any faith in the palmist, he was attracted to the idea of these physical texts, and the flyleaves of all five volumes carried imprints of Sitwell's hands.

Sitwell envisaged his writing as corporeal, which is why when he gave a short manifesto on syntax he imagined each sentence as a body: 'it did not matter if the flesh clothed bones in a Rubens-like abundance, so long as the skeleton was there to support it'. His sentences have ample flesh and, like Rubens's pictures, are not to everyone's taste. 'I don't care for Osberts prose [*sic*]', wrote Virginia Woolf in response to *Two Generations*, the family journals which Sitwell had edited, 'the rhododendrons grow to such a height in it'.[34] The rhododendrons grew yet higher in wartime, and this linguistic profusion was a way of facilitating vicarious experience. Writing and reliving were very closely related for Sitwell, so that, for example, when he came to his hated schooldays he made 'the fullest use of every exeat or afternoon off, in the account of it that follows no less than in real life'.[35] This was one of those books that sought to make the past inhabitable again, and he described familiar places, now changed or lost to him, as if rebuilding them in words.

In order to make the structure sturdy, Sitwell composed scenes and tableaux, which (like Beaton's photographs) pause chronological progress, denying any short-age of time. Sitwell's first volume culminates in a forensically detailed account of the family sitting for a portrait by Sargent. It is a tour behind-the-scenes of the inscrutable painting, measuring the distance between the staged family on the canvas and the real family whose aspirations and tensions were played out in the studio. Sitwell recounts everything, from the logistic feat of transporting suitable props from Renishaw to Sargent's studio, to the struggles between painter and patron over the subject of Edith's nose. The portrait 'cut across our lives' he writes, and he uses it, superbly, as a cross-section. In these wartime years of emergency and moment-to-moment living, Sitwell was determined that his writing, at least, would not be trammelled by any sense of urgency. His sentences are self-perpetuating, defi-antly taking their time. The fatal moment of ending is to be avoided at all costs: life continues for just as long as one can keep producing words and scenes.

The numerous scenes are amply populated. Great processions of characters come forward, as in Edith Sitwell's history books. Dickensian urchins roam pic-turesquely between illustrious ancestors of Plantagenet lineage, and the unmarried sister of a grandmother wields an 'elaborate ear-trumpet flounced and pleated like an early lampshade'. It is a relief when Sitwell decides not to 'unleash' the whole 'ancient pack' of his great-aunts, but every new figure is made to yield something

either touching or comic. The butler's brother brings his pet seal on the train from Whitby. A grandmother's pet monkey interrupts Aunt Florence's stories of the Garden of Eden, 'vulgarly demonstrating, by his almost human outcry, the obvious falsity of so pretentious a family tree'.[36]

Early in the first volume, establishing the values with which he sets out to write, Sitwell reports a conversation with Lady Diana Cooper, whose brother owned nearby Haddon Hall. Asked if she felt attachment to this beautiful house, she replied 'Yes.' 'But roots are out of fashion now.' 'So they were', concludes Sitwell, 'and so, more than ever, they are'. A commonly felt desire for rootedness and fullness, which had so long been out of fashion, must have been responsible for the public success of Sitwell's autobiography. John Pearson observes that 'readers longing to return to the remembered happiness of peace responded to his own gargantuan nostalgia, the sheer excess and splendour of his sense of loss'. 'With this one book', writes Pearson, 'Osbert had become a sort of national remembrancer'.[37] Sitwell had always planned it as a masterpiece, and was in no doubt about his status as an artist. He referred several times in the books to Cellini and to Proust, reminding the reader of his illustrious lineage in the art of autobiography. Today, when little is heard of this English quest for *temps perdu*, we have to read the first reviews to get a sense of its reception.

Discussing the first volume in *Tatler*, Elizabeth Bowen was pleased to find Sitwell supplying English art with 'gusto, stylishness and the expectation of what in these monosyllabic days is called a good time'. It was just what was needed in 1945, but Bowen thought that its appeal would be enduring. She predicted that it would occupy a 'permanent [place] in the literature of this country'. Sitwell's sense of place appealed to Bowen ('his places, one might say, breathe') and she was fascinated by the way he registered the 'psychic weather' at Renishaw. The second volume only increased her sense that she was reading a major work. 'In England we have, as compared to France, almost no great writer about Society – its historic and monumental aspects, its rich and authoritative unconsciousness, its shifting values'. So the importance of Sitwell, she thought, could not be overrated: 'he anatomises not a single life but an age'.[38]

Thirty years earlier, the polemical statements that have come to define modernism had been couched in terms of a departure from the building site. Writers who persisted in allying themselves to the construction industry were denigrated. Henry James scathingly imagined Arnold Bennett's novel *Clayhanger* (1910) as a kind of builders' skip. It was not, he said, a monument '*to* anything',

> but just simply a monument *of* the quarried and gathered materials it happens to contain, the stones and bricks and rubble and cement and promiscuous constituents of every sort that have been heaped in it.[39]

Woolf, more generously, allowed that Bennett had succeeded in building a house, a very solid one, with 'not so much as a draft between the frames of the windows, or a crack in the boards'.[40] The wind would not get in, but life itself might get out, refusing to live there. In pursuit of elusive impressions, the modern novel turned from solid to liquid and then evaporated completely, agile, shape-shifting, always on the move. By the 1940s, however, it had again become possible to write admiringly about sturdy literary houses. Life was evanescent and extremely temporary: that was clearer than ever. But rather than aspire to life's ethereality, art could weight itself down. It could become a store of detail, its imaginary walls and furnishings safe from attack.

Not many people, of course, were able to spend the war writing books on a monumental scale, but the spirit of creative compensation expressed itself in smaller and no less powerful ways. Osbert Sitwell's friend Rex Whistler joined up at the beginning of the war and fought with the Welsh Guards for four years before being killed by a mortar bomb in Normandy in 1944. During his wartime service he made drawings in his sketchbooks which are an eloquent, comical kind of war art. Responding to the austere regimentation of army life he drew the 'Correct Layout of Kit for Barrack Room Inspection' showing how shirts had to be folded and belts and bayonets arrayed just so. But he did it all in the style of an eighteenth-century engraving, labelling each item in copperplate and framing his title with a cartouche of banners and flourishes. He also drew a *Baroque Tank*. It is done in pencil in the margin of a notebook and is not meant to be much more than a doodle. It shows a heavy army tank trundling across a bridge – but the tank has become a mobile baroque pavilion with a balustrade terrace at the back and decorative swags around the wheels. A river flows under the bridge, overseen by Neptune, and a gondolier steers his reclining passengers along. In the fields above, a little pastoral scene is played out as a shepherd pipes to his resting sheep. The tank is firing its big gun at something, but the clouds of smoke made by the shots are already beginning to dissolve into puffy little clouds.

Rex Whistler *Baroque Tank*, c. 1940 (detail)

AFTERWORD:
New MAPS

In 2006 the Victoria and Albert Museum mounted a landmark exhibition called 'Modernism: Designing a New World, 1914–1939'. I remember walking through the domed museum entrance hall, under Dale Chihuly's extravagantly sprouting chandelier, past cabinets full of competitively patterned tributes to man's ornamenting instinct, and then – silence. A heavy mahogany door swung shut and I was in an immaculate world of suspended spirals, steel tubes, and slick, shiny architectural models. Manifestos, neatly typed, occupied the walls in orderly agreement about the aims of design in the twentieth century: 'espousal of the new', 'rejection of history and tradition', 'embrace of abstraction', the desire to 'invent the world from scratch'.[1]

The V&A paid tribute to the spirit of progressive idealism which made these slogans sound tenable in the first decades of the century. Here were paintings that aspired to be engines, and homes that had become machines for living in. But the image of Woolf watching *Gammer Gurton's Needle* at Pulborough kept coming to mind, and Frederick Etchells conserving country churches. Did these, too, belong to the story of 'modernism'? Certainly they belonged to the stories of people we recognize as 'modernists'. I thought of J. M. Richards, that great friend and advocate of many of the architects represented in these glistening galleries. Richards pointed out in his memoir that it was these 'modernists' rather than the staunch traditionalists who 'took the initiative in safe-guarding the architecture of the past'. Was that not part of the work that now deserved celebration? One of Richards's anecdotes was particularly suggestive: he remembered Le Corbusier at dinner in the Reform Club 'fingering with a sensuous appreciation of their smoothness and precision the mouldings at the base of the marble columns surrounding Barry's *cortile*'.[2] Clearly to Richards it seemed symbolic – the fingers of the great modernizer feeling their way around a tradition – but the symbolism is obscured for us today.

Interviewing Christopher Wilk, the curator of 'Modernism', Andrew Marr wondered why there were so few English contributions on display. The answer was that Englishness and modernism were antithetical. 'Modernism was cosmopolitan',

explained Wilk, and English art was pastoral.[3] The gap was apparently unbridge-able, although for the purposes of radio the matter was genially resolved with the observation that there was, at least, one major English contribution: the map of the London Underground. It is easy to see why this particular bit of design fitted with the exhibition's ethos: Harry Beck's stylish rationalization of the chaotic city was in fact the negation of English geography, rearranging London to look like an electric circuit.

One of the most interesting things about the 'Modernism' exhibition was the national quarrel which sprang up around it. Wilk made the case for abstraction; a succession of journalists, and a very vocal public, responded with outrage. The structure of the debate was close to that which dominated English art in the inter-war period. John Piper recalled the 'belligerence and antagonism between abstract painters and the rest' that reigned in the 1930s and which he was committed to over-coming.[4] In 2006 that belligerence broke out again and the same arguments resurfaced. Simon Jenkins pronounced the exhibition a 'terrifying' warning against the tyranny of authoritarian aesthetics. Thankfully, he concluded, people 'turned their back on "less is more" in favour of a humane environment and courtesy towards the past'. In predictable reaction, Terence Conran advocated the continuing potential of modernist living spaces.[5] The idealists of the early twentieth century were admired for their tremendous hopefulness, and disparaged for their lack of realism; they were lauded for their impersonality, and loathed for not being personal enough. They were rising above tyranny, and letting it in.

This was a variation on a controversy which emerges periodically and takes, each time, very similar form. It erupted over Prince Charles's rhetorically laden denunciation of modern architecture in *A Vision of Britain* (1989) and his plans for Poundbury, the vernacular town built from scratch on the outskirts of Dorchester. Rehearsing the Poundbury quarrel in *A Journey through Ruins* (1991), Patrick Wright attacked the 'simple-minded polemicism' that characterized arguments for and against the project. Conservatism and modernism had become antithetical. In search of thinkers able to get beyond the polemic, Wright looked back to 1930s artists including Paul Nash and John Piper. Their work, he said, 'ridicules the idea that there could be any simple polarisation of tradition against modernism'.[6]

The role of heritage and place-conscious culture in contemporary Britain is still extremely uncertain, but there are many imaginative projects afoot which promote local knowledge as a source of cohesion for diverse communities. The researching of family histories has become a national pastime, part of a quest to know where we have come from (though it is sometimes dismissed, in the same way as Piper's old walls, as the nostalgia of the middle classes with too much time to spare). Our passion for digging up history close to home can be inferred from the television schedules alone: *Restoration, The House Detectives, Coast.*

Contemporary art, which for a while seemed wedded to the rarefied white gallery space, is again setting down vital roots in the landscape – or at least those roots are now winning more acclaim. Tate Britain, as I write, is an indoor landscape of flint circles and cut-out maps, souvenirs of the ritualized journeys made by Richard Long in the forty years since he first walked across a field and photographed the line of his footsteps in the dew. Out in the open, Antony Gormley's *Angel of the North* spreads its rusting metal wings across Tyneside, a giant archaeological relic dug out from deep below ground and looking, from an exhilarating height, into the future. Soon, an 'Angel of the South' will appear in Kent, a giant white horse cast by Mark Wallinger, a new English icon that can count the chalk figures of Uffington and Cerne Abbas among its ancestors. Gormley's angel watches over the M1, and this horse, too, will be stationed at the roadside. Wallinger was thinking about the well-worn route of pilgrims:

> The A2, from Dover to London, is the route in and out of the country and
> has been for millennia. They call it the Gateway now. It was the Pilgrim's
> Way, it was Watling Street. It was the route followed by everyone who landed
> in England, from Hengest and Horsa and St Augustine.[7]

From pre-history to modern transport: in the spirit of Eric Ravilious's 1939 *Train Landscape* (a painting he loves), Wallinger wanted Eurostar passengers to look out and see the horse from the window of a standard-class carriage.

The topographical vein in English literature has always been extremely rich. In the late twentieth century writers such as Graham Swift and Adam Thorpe performed lyrical excavations, finding submerged stories woven across stretches of land. Over the last decade Iain Sinclair has sorted through our cultural archaeology while following the road from London to Hastings or walking in the footsteps of John Clare. He has been going 'on pilgrimage in England' in ways that open up local history for a younger generation of writers. Many of today's literary geographers have contributed to *Memory Maps*, an evolving project devised by Marina Warner in collaboration with the University of Essex and the V&A. It uses the internet, a phenomenon which has in some ways disconnected us from the physical world, and explores its capacity to bring us back down to earth. Participants respond imaginatively to particular items – paintings, textiles, photographs – piecing together the changing identity of places, starting from Essex and spreading a web outwards, inspiring a kind of writing which is about individual response but also collective memory. As Warner says, there is a political purpose here, in a project which promotes active public engagement with issues of identity, ecology and stewardship.[8]

Perhaps as a corollary of these developments, art from the 1930s and 1940s begins to be more widely admired for its subtle responsiveness to places and to pasts.

It was interesting, for example, to see Paul Nash making an appearance in the 2008 Turner Prize exhibition. The Polish-born artist Goshka Macuga had been studying Nash's landscape photographs, collaging them with surreal images by Eileen Agar, and arriving at modern statements about her own relation to the English archives.[9] Work by Bawden and Ravilious is now much loved and much collected; in the past few years there have been superb exhibitions celebrating the English eye of John Piper, William Orpen, Graham Sutherland, Osbert Lancaster, Cecil Beaton and Angus McBean.

University courses on 'Modernist Literature' are now frequently elastic enough to include Elizabeth Bowen and Evelyn Waugh, while recent critical writing on canonical modernists like Eliot and Woolf has turned our attention to their investment in ideas of national tradition and local culture. I am much indebted to Jed Esty's *A Shrinking Island: Modernism and National Culture in Modern England*, which described a late modernist turn away from 'metropolitan perception' towards 'insular landscapes' as writers sought to shape a post-imperial identity for England.[10] Equally inspiring was Kitty Hauser's poetically conceived book *Shadow Sites: Photography, Archaeology and the British Landscape 1927–55*, which defined a distinctive sensibility concerned not so much with reconstructing a past that is lost, as with exploring the palimpsest which remains. She is concerned primarily with photography, and the images she discusses become penetrating records of an ancient land, evoking 'the material immanence of the past in the present'. Her book marks a refreshing change from the tendency to inwardness and insularity in accounts of Neo-Romanticism, and it points the way to new work on the modern Romantic sensibility.[11]

It is the kind of sensibility that leads us on journeys. Most people in search of modernist places go straight to the city. They watch, like Eliot, the crowds flowing over a bridge, or they walk through Dublin on Bloomsday. In his giant *British Writers of the Thirties*, twenty years ago now, Valentine Cunningham took his reader to Madrid, to the industrial towns of Northern England and to all sorts of 'seedy margins'. Looking back from the turn of the Millennium on an extraordinary century of change, Peter Conrad in *Modern Times, Modern Places* toured the urban 'citadels' of modern society – Vienna, Moscow, Paris, Berlin – in search of places where the 'fresh tenants' of a new-born universe were given life.[12] My own work has taken me to places where human beings retrieved older ways of living, where slowness, familiarity and a sense of history could be cultivated. Faringdon and Fowey, the churchyard at East Coker, the Downs between Wilmington and Firle: these places, too, have a claim on our modern memories. Hafod House in Cardiganshire has been demolished (a few stone steps lead up to an empty grass plateau), but the estate still offers glimpses of the beautiful and the sublime on 'The Gentleman's Walk'. In Dorset the carved font at Toller Fratrum felt like a breath-taking discovery, even though, thanks to Piper, I knew it was there.

Renishaw Hall – where Edith and Osbert Sitwell stood guard during the war, where Rex Whistler made a drawing of the castellated frontage (still used to embellish Sitwell notepaper), where Bill Brandt photographed garden statuary, and where Evelyn Waugh watched Piper at work – is still very much alive, though it is not quite the place that Piper painted. I took a bus from Sheffield that seemed to be going in the right direction. There was some dispute among the other passengers as to where would be the best place for me to get off, after which the harried driver made a detour from his route and dropped me at the entrance. Setting off up the long drive, I thought that Osbert Sitwell might not have approved of this pedestrian arrival, but walking gave me time to look around. The avenue had been newly planted with sunny little acacia trees, and genial voices floated across from the golf-course constructed by golfing Sitwells back in 1911. There was not much of the old fierceness: the stone of the house itself had been cleaned, and there was little to connect these walls with an industrial age of coal and clinker. The gardens designed by Sir George Sitwell in the early 1900s opened out on the far side of the house, sloping down from the south front which had always been brighter than the ominous north. Triumphant statues flanked the broad steps from terrace to terrace, huge rose bushes climbed around benches and into alcoves, while a fountain played grandly in the middle of the lawn. It was a place you could see through both Beaton's eye and Bawden's. The yew hedges were being cut; the gardener's ladder and wheelbarrow caught the sun against the dark foliage.

Like all lasting places, this one has evolved and adapted itself. The house is still a Sitwell home, but the gardens are open to all, with their bluebells in spring and Canterbury bells in summer, evoking (Osbert Sitwell thought, looking at them in 1942, wanting them to symbolize continuity) the peaceful, productive gardens of the old monasteries. One of the stables has been converted into a good museum and a series of Piper's drawings was on display. People were buying postcard reproductions, having their tea, and making their way home again. A kind volunteer from the gallery drove me back to the station, and we talked, as we went back down the long drive to the road, about the changes she had seen at Renishaw. It made me think of Piper's observation in 1937 that 'the tradition, once more, has to stretch'.[13]

NOTES

Bibliographical references given in abbreviated form in the notes are given in full in the bibliography.

PROLOGUE IN ENGLAND

1 He writes about the Toller Fratrum font, and others, in 'England's Early Sculptors', *Architectural Review* 80 (1936), 157–60 (158).
2 Piper uses the story as an epigraph to 'England's Early Sculptors', 157.
3 Virginia Woolf to Julian Bell, 2 May 1936, *Letters*, VI, 33; Richard Overy, *The Morbid Age: Britain Between the Wars* (London: Allen Lane, 2009).
4 Green, *Pack My Bag*, 120, 1.
5 Woolf, 'Anon', 373, 376.
6 Piper, *British Romantic Artists*, 7.
7 Woolf, *Between the Acts*, 13.
8 Auden, 'September 1939', *English Auden*, 245.
9 Candida Lycett Green, 'Mr Piper', in *John Piper: Early Oils and Watercolours* (London: Spink, 1996), 4.
10 W. H. Auden to John Betjeman, 2 January 1947, University of Victoria Library, quoted in William S. Peterson, *John Betjeman: A Bibliography* (Oxford: Clarendon Press, 2006), 52. Auden was editing *Slick but Not Streamlined: Poems and Short Pieces* (Garden City, NY: Doubleday, 1947).
11 For many years literary surveys of the 1930s focused on a very distinct milieu. Julian Symons acknowledged that, for him, 'Auden's devices of style and habits of feeling *are* the Thirties, or a large part of the Thirties': *The Thirties: A Dream Revolved* (London: Faber, 1975), 142. Critics of the 1970s and 1980s largely followed this lead, most notably Samuel Hynes in *The Auden Generation: Literature and Politics in England in the 1930s* (London: Bodley Head, 1976), and Bernard Bergonzi in *Reading the Thirties* (London: Macmillan, 1978). Valentine Cunningham addressed an enormous number of writers, both major and minor, in his *British Writers of the Thirties*, but even here, notions of tradition, conservatism and Englishness come low on the agenda. The uneven weighting of his book in terms of gender (male) and politics (left) provoked two intersecting critical campaigns: for greater recognition of women's writing in the period, and for the appreciation of art that is broadly conservative rather than radical. See especially, Light, *Forever England*.
12 Piper, *British Romantic Artists*, 7. There is another book to be written about the reception in the twentieth century of those more formally known as 'The Romantics', though I make a few contributions to that study here (see particularly chapter 6, The Canon Revised). For a superb account of the literary battle between Classic and Romantic in the 1920s (setting the pattern for the 1930s and beyond), see David Goldie,

A Critical Difference: T. S. Eliot and John Middleton Murry in English Literary Criticism, 1919–1928 (Oxford: Clarendon, 1998). On the Neo-Romantic engagement with Blake and Palmer, see Button, 'The Aesthetic of Decline', and Hauser, *Shadow Sites*.
13 Edmund Blunden, 'On Pilgrimage in England: Voyages of Discovery', *Times Literary Supplement*, 28 March 1942, 156, 161 (156).

1 ANCIENT AND MODERN

1 Myfanwy Evans, 'Order! Order!', *Axis* 6 (1936), 4–8 (5).
2 Le Corbusier, *Decorative Art of Today*, 188.
3 On Mondrian's white tulip, see Frances Spalding, 'Matisse's Armchair and Mondrian's Grocer', in Sally Bayley and William May, eds, *From Self to Shelf: The Artist Under Construction* (Newcastle: Cambridge Scholars Publishing, 2007), 98–110.
4 John Piper to Myfanwy Evans, 26 July 1934, Tate Archive, 200410.
5 Frances Spalding gives vivid descriptions of the early years at Fawley Bottom in *John Piper, Myfanwy Piper*, 65–66 and 162–73.
6 Fry, 'The French Post-Impressionists' (1912), in *Vision and Design*, 166–170 (169).
7 Private memoranda quoted in Khoroche, *Ivon Hitchens*, 17.
8 Myfanwy Piper, 'Back in the Thirties', *Art and Literature* 7 (1965), 136–50 (136).
9 Alan Powers gives a detailed account of the magazine's shifting aesthetics: 'The Reluctant Romantics: *Axis* Magazine 1935–7', in Corbett et al., eds, *Geographies of Englishness*, 248–74.
10 Myfanwy Evans, 'Dead or Alive', *Axis* 1 (1935), 3–4 (3).
11 Paul Nash, 'For, but Not With', *Axis* 1 (1935), 24–26 (26).
12 Paul Nash, 'Going Modern and Being British', *Weekend Review*, 12 March 1932, 322–23.
13 Geoffrey Grigson, 'Comment on England', *Axis* 1 (1935), 8–10 (8).
14 Grigson, *Crest on the Silver*, 183.
15 Hitchens's drawings are in *Axis* 7 (1936), 22.
16 For the return to national tradition in France, and the complex debates over national identity that this involved, see particularly Green, *Art in France*.
17 Jean Hélion, 'From Reduction to Growth', *Axis* 2 (1935), 19–24 (22); Jean Hélion, comment in a 1948 notebook recalling the years 1938–39, cited by René Micha, *Hélion* (Naefels, Switzerland: Bonfini Press, 1979), 22.
18 Hugh Gordon Porteus, 'Piper and Abstract Possibilities', *Axis*, 4 (1935), 15–16.
19 Porteus, 'Piper and Abstract Possibilities', 16.
20 John Piper, 'Pre-history from the Air', *Axis* 8 (1937), 4–8.
21 Varnedoe, *Fine Disregard*, 220–21.
22 Gertrude Stein, *Picasso* (1938; London: Batsford, 1946), 50.

23 Paul Nash, 'Aerial Flowers' (1945), in *Paul Nash: Writings on Art*, 155–61 (158).

24 See Hauser, *Shadow Sites*, '"Revenants in the Landscape": The Discoveries of Aerial Photography', 151–99.

25 Piper, 'Pre-history from the Air', 5, commenting on Crawford and Keiller, *Wessex From the Air*. Crawford's remarkable life and work is the subject of Kitty Hauser's biographical study *Bloody Old Britain: O. G. S Crawford and the Archaeology of Modern Life* (London: Granta, 2008).

26 Auden, 'Consider this and in our time' (1930), *English Auden*, 46.

27 Grigson, 'A White Lupin', *Several Observations*, 54.

28 Grigson, *Recollections*, 157.

29 John Piper and Geoffrey Grigson, 'England's Climate', *Axis* 7 (1936), 5–12 (5).

30 William Blake, *Blake: Complete Writings*, ed. Geoffrey Keynes (Oxford: Oxford University Press, 1972), 557.

31 Piper and Grigson, 'England's Climate', 5–6.

32 Paul Nash, 'John Piper' (1938), *London Bulletin* (1938–9; repr. New York: Arno, 1969), Vol. I, 10.

33 Paul Nash, contribution to Herbert Read, ed., *Unit One* (London: Cassell, 1934), 79–81 (80).

34 John Piper, 'The Nautical Style', *Architectural Review* 83 (1938), 1–14 (1).

35 John Piper, 'Abstraction on the Beach', *XXe Siècle* 1 (1938), 41.

36 Ibid.

37 Ibid.

38 John Piper, 'Lost, A Valuable Object' (1937), in Evans, ed., *Painter's Object*, 69–73 (73).

2 CONCRETE AND CURLICUES

1 Jean Hélion, 'Jean Hélion at 81', *Art and Artists* (1985), 19–22 (20). *Circle* was intended as an on-going periodical but in the end there was only one issue, a substantial book of 300 pages.

2 Wells Coates, 'The Conditions for an Architecture of Today', *Architectural Association Journal* 53 (1938) 447–57 (447).

3 Herbert Read, 'A Nest of Gentle Artists', *Apollo* 67 (1962), 536–38.

4 Christie's comment about the funnels quoted in Sherban Cantacuzino, *Wells Coates: A Monograph* (London: Gordon Fraser, 1978), 62.

5 Adolf Loos, 'Ornament and Crime' (lecture 1908; published 1929) in Loos, *Ornament and Crime*, 167–76.

6 Roger Fry, 'The Artist in the Great State' (1912), revised as 'Art and Socialism' for *Vision and Design*, 39–54 (47).

7 Fry, 'Art and Socialism', 48.

8 Sitwell, *Southern Baroque Art*, 9.

9 John Betjeman, '1830–1930, Still Going Strong', *Architectural Review* 67 (1930), 230–40; 'There and Back, 1851–1933: A History of the Revival of Good Craftsmanship', *Architectural Review* 74 (1933), 4–8.

10 John Betjeman, 'The Death of Modernism', *Architectural Review* 70 (1931), 161.

11 Mowl, *Stylistic Cold Wars*, 46.

12 John Betjeman, 'Charles Francis Annesley Voysey: The Architect of Individualism', *Architectural Review* 70 (1931), 93–96.

13 Nicolete Gray, 'The Nineteenth-Century Chromo-Lithograph, *Architectural Review* 84 (1938), 177–78.

14 Richards, *Memoirs of an Unjust Fella*, 118.

15 These are some of the people who appear in Peggy Angus's photographs, now in East Sussex Record Office. See also Trant, *Art for Life*.

16 Eric Ravilious to Diana Tuely, 16 November 1939, East Sussex Record Office. Thanks to Christopher Whittick for guiding me through the archive.

17 Powers, *Serge Chermayeff*, 120.

18 Kingsley Martin, *Editor: A Second Volume of Autobiography* (London: Hutchinson, 1968), 209.

19 For further discussion, see Mark Crinson 'Architecture and "National Projection" between the Wars', in Dana Arnold, ed., *Cultural Identities and the Politics of Britishness* (Manchester: Manchester University Press, 2004), 182–97.

20 Moholy-Nagy's photographs appear in Mary Benedetta, *The Street Markets of London* (London: John Miles, 1936) and Bernard Fergusson, *Eton Portrait* (London: John Miles, 1937); *Lobsters*. Dir. László Moholy-Nagy. Bury Productions, 1936.

21 John Betjeman, 'A Hungarian at Eton and Oxford', *Times (Saturday Review)*, 6 August 1977, 5.

22 Piper, *Brighton Aquatints*, facing plate 12.

23 Richards, *Castles on the Ground*, 9.

24 Richards, *Memoirs of an Unjust Fella*, 188; Richards, *Castles on the Ground*, 82.

25 See Jenkins, *John Piper: The Forties*, 23; John Piper, 'London to Bath', *Architectural Review* 85 (1939), 229–46.

26 See Angus Calder and Dorothy Sheridan, eds, *Speak for Yourself: A Mass-Observation Anthology* (Oxford: Oxford University Press, 1985), 1.

27 John Piper, 'Fully Licensed', *Architectural Review* 87 (1940), 87–100 (87, 99). Mass-Observation had made a special survey of pubs in 'Worktown' in Bolton between 1937 and 1939, but Piper was the first to consider the pubs' aesthetic value.

28 Forster, *Howards End*, 154.

29 Forster, 'Mrs Miniver' (1939), in *Two Cheers for Democracy*, 301–4 (303).

30 Woolf, 'Modern Fiction' (1925), *Collected Essays*, II, 103–10 (104).

31 Virginia Woolf, 'Solid Objects' (1920), in *A Haunted House: The Complete Shorter Fiction*, ed. Susan Dick (London: Vintage, 2003), 96–101.

32 Elizabeth Bowen, *The Last September* (1929; London: Vintage, 1998), 29; Elizabeth Bowen, *Friends and Relations* (1931; Harmondsworth: Penguin, 1959), 50.

33 Bowen, *The Death of the Heart*, 81.

34 Ruskin, 'The Lamp of Memory', *Seven Lamps*, 186.

35 Virginia Woolf to Vanessa Bell, 3 May 1934, *Letters*, V, 229.

36 Bowen, 'Pictures and Conversations' (1975) in *Mulberry Tree*, 265–98 (279).

37 Elizabeth Bowen, 'Ivy Gripped the Steps' (1945), in *Collected Short Stories*, 686–711 (690–91); Bowen, *Bowen's Court*, 22.

38 Bowen, 'Pictures and Conversations' (1975) *Mulberry Tree*, 279. Also see 'The Big House' (1940), *Mulberry Tree*, 25–29.

39 Bowen, *Bowen's Court*, 26.

40 Adolf Loos, 'Interiors in the Rotunda' (1898) in *Spoken into the Void: Collected Essays 1897–1900*, trans. Jane O. Newman and John H. Smith (Cambridge, MA: MIT Press, 1982), 24.

3 A GEORGIAN REVIVAL

1 Powers, *Serge Chermayeff*, 121.

2 See e.g. 'The Death of Modernism', *Architectural Review* 70 (1931), 161.

3 Strachey, 'The Eighteenth Century' (1926), in *Characters*, 297–302 (299, 300).

4 Strachey, 'Pope, Addison, Steele and Swift' (1905), in *Characters*, 11–22 (11).

5 Strachey, 'Hume', in *Portraits in Miniature*, 141–53 (141).

6 Strachey, 'Horace Walpole' (1904), in *Characters*, 87–92 (90).

7 Aldous Huxley, quoted in Michael Holroyd, *Lytton Strachey* (Harmondsworth: Penguin, 1971), 601.

8 See Holroyd, *Lytton Strachey*, 910.

9 Strachey, 'Pope', The Leslie Stephen Lecture 1925, in *Characters*, 279–96 (294).

10 Woolf, 'Horace Walpole' (1919) in *Collected Essays*, III, 105–9 (109).

11 Woolf, *Orlando*, 215.

12 Strachey, 'Gibbon', in *Portraits in Miniature*, 154–68 (162).

13 Woolf, *Orlando*, 299: 'There flies the wild goose. It flies past the window out to sea'.

14 Elizabeth Bowen, '*Orlando* by Virginia Woolf' (1960), in *Mulberry Tree*, 131–36 (131–32).

15 Sitwell, *Bath*, 279–81.

16 Glendinning, *Edith Sitwell*, 194.

17 Sitwell, *Bath*, 60.

18 Ibid., 267.

19 Sitwell, *English Eccentrics*, 17.

20 Ibid., 27, 68.

21 Sitwell, *Alexander Pope*, 2.

22 Glendinning, *Edith Sitwell*, 146, quotes Sitwell's letter to Allen Tanner, 23 January 1931: 'I'm convinced Baudelaire *would* have written that particular thing if he'd got it into his head, because the effect is very subtle and beautiful.'

23 Edith Sitwell to John Piper, n.d. [1943], Tate Archive, 200410/1.

24 Edith Sitwell to Myfanwy Piper, 10 December 1943, Tate Archive, 200410/1.

25 Edith Sitwell to John Piper, 12 January 1944, Tate Archive, 200410/1.

26 James Edward Smith, *A Tour of Hafod in Cardiganshire* (London: White, 1810) with etchings by J. C. Stadler after the watercolours by John 'Warwick' Smith.

27 Spalding gives a detailed account of this trip in *John Piper, Myfanwy Piper*, 142–47.

28 John Piper, 'Decrepit Glory: A Tour of Hafod', *Architectural Review* 87 (1940), 207–10.

29 Hussey, *The Picturesque*, 79.

30 Piper, 'Decrepit Glory', 208.

31 Grigson, 'The Tune' in *Under the Cliff*, 11.

32 Grigson, *Recollections*, 159.

33 Ibid., 161.

34 James Lees-Milne, 'Margaret Jourdain', *Dictionary of National Biography*, Vol 11 (Oxford: Oxford University Press, 1950), 366.

35 Quoted in Hilary Spurling, *Secrets of a Woman's Heart: The Later Life of I. Compton-Burnett* (London: Hodder & Stoughton, 1984), 95. Dorothy Stroud was a secretary at *Country Life* in the 1930s, but she became an expert on Georgian culture, both as a curator at the Sir John Soane Museum and as the author of the first study of Capability Brown.

36 In his essay on responses to the RA exhibition of British Art in 1934, Andrew Causey notes the 'general acceptance that the baroque was antithetical to a true British culture': 'English Art and the "National Character" 1933–4', in Corbett, et al., eds, *Geographies of Englishness*, 275–302 (282).

37 Steegman, *Rule of Taste*, 22.

38 Sitwell, *British Architects*, 129, 92.

39 Alexander Pope, 'An Epistle to Richard Boyle, Earl of Burlington' (1731), in *The Major Works*, ed. Pat Rogers (Oxford: Oxford University Press, 2006), 244.

40 Nikolaus Pevsner, 'The English Eccentrics', *Times Literary Supplement*, 7 April 1945, 325.

41 Sitwell, *British Architects*, 137.

42 James Lees-Milne, *The Age of Adam* (London: Batsford, 1947), v.

43 Lees-Milne, *Another Self*, 107.

44 Ibid., 108.

45 The Country Houses Scheme, and the rise of interest in Georgian architecture more generally, is described in Mandler, *Fall and Rise of the Stately Home*, 265–308.

46 Douglas Goldring, *Facing the Odds* (London: Cassell, 1940), 44–92.

47 Goldring, *Facing the Odds*, 72. See also Patrick Wright, 'Little England', *London Review of Books*, 17 September 2006, 19–22.

48 Richards, *Memoirs of an Unjust Fella*, 127.

49 Christopher Isherwood, *Goodbye to Berlin* (1939; London: Vintage, 1998), 9.

50 Olivier, *In Pursuit of Rare Meats*, 8.

51 Olivier, *Without Knowing Mr Walkley*, 270–72.

52 Rudyard Kipling, 'They', in *Traffics and Discoveries* (1904), ed. Hermione Lee (Harmondsworth: Penguin, 1987), 243–65.

53 Beaton, *Ashcombe*, 4.

54 Ibid.

55 See Beaton, 'Ashcombe', *Vogue*, 16 March 1932, 58–61.

56 Hamish Bowles, 'Like a Duchess', *Vogue*, August 2005, 230–40. Madonna's stay was shorter than Beaton's, curtailed by her divorce in 2008. Her ex-husband Guy Ritchie has stayed on at Ashcombe.

57 Waugh, *Labels*, 46.

58 Amory, *Lord Berners*, 137. See also Peter Dickinson, *Lord Berners: Composer, Writer, Painter* (Woodbridge: Boydell Press, 2008).

59 Mitford, *Pursuit of Love*, 40.

60 Mandler, *Fall and Rise of the Stately Home*, 279.

61 Douglas Percy Bliss, *Edward Bawden* (Toronto: Pendomer Press, 1979, 153.

4 VICTORIANA

1 Woolf, *Orlando*, 218.

2 Ibid.

3 Fry, 'The Ottoman and the Whatnot' (1919), in *Vision and Design*, 28–32.

4 J. M. Richards, *Edward Bawden*, Penguin Modern Painters (Harmondsworth: Penguin, 1946), 7.

5 Trant, *Art for Life*, 62.

6 Strachey, 'The Eighteenth Century', in *Characters*, 300.

7 Clark, *Another Part of the Wood*, 105.

8 Clark, *Gothic Revival*, vii.

9 Clark, *Gothic Revival*, ix, 247, and see Strachey, *Queen Victoria*, 190–92.

10 Clark, *Gothic Revival*, xi.

11 Waugh, *Rossetti*, 12, 14.

12 Waugh, *Rossetti*, 227.

13 Roy Campbell, 'Rossetti', *Nation and Athenaeum*, 19 May 1928, reprinted in Martin Stannard, ed., *Evelyn Waugh: The Critical Heritage* (London: Routledge, 1984), 71–74.

14 Clark, *Another Part of the Wood*, 174.

15 Martin Stannard, *Evelyn Waugh: The Early Years* (London: Dent, 1986), 140.

16 Waugh, *Rossetti*, 11.

17 Waugh, *Rossetti*, 225–26.

18 Kenneth Clark, 'English Painting' (1934), in Lambert, ed., *Art in England*, 15–23 (23).

19 Sitwell, *Narrative Pictures*, 3, 83, 69.

20 Read, *Surrealism*, 59, 79.

21 Strachey emphasizes this in *Queen Victoria*, 232: 'the tenacious woman, hoarding her valuables, decreed their immortality with all the resolution of her soul. She would not lose one memory or one pin.'

22 Paul Nash, 'Swanage, or Seaside Surrealism', *Architectural Review* 79 (1936), 151–54; and see Denton, *Seaside Surrealism*.

23 Hauser, *Shadow Sites*, 15.

24 [Lionel Cuffe], 'William Morris', *Architectural Review* 69, (1931), 151.

25 Waugh, *A Handful of Dust*, 14–15.

26 Geoffrey Grigson to John Murray, 21 February 1940, quoted in Hillier, *Betjeman*, 182.

27 Hillier, *Betjeman*, 115.

28 John Betjeman to Edward James, 1 January 1937, in *Letters 1926–1951*, 164.

29 Waugh, *Decline and Fall*, 120.

30 Waugh, *Work Suspended*, 114–15.

31 For the letters of criticism, see Adrian Woodhouse, *Angus McBean: Facemaker* (London: Alma, 2006), 176.

32 Waugh, 'Victorian Taste', *Times*, 3 March 1942, reprinted in *Essays*, 268–9 (269).

33 'Taste in Transition', *Times*, 3 March 1942, 5.

34 Hélion, 'Jean Hélion at 81', *Art and Artists* (1985), 19–22 (21).

35 Stephen Spender, *Journals 1939–83*, ed. John Goldsmith (London: Faber, 1985), 51; Jeremy Lewis, *Cyril Connolly: A Life* (London: Pimlico, 1998), 338.

36 Cyril Connolly, 'Comment', *Horizon* 1 (1940), 69–71 (71).

37 Connolly, 'Comment', 71.

38 Cyril Connolly, 'Comment', *Horizon* 1 (1940), 5–6 (5).

39 Geoffrey Grigson, 'Samuel Palmer: The Politics of an Artist', *Horizon* 4 (1941), 314–28.

40 John Steegman, *The Consort of Taste 1830–1870* (London: Sidgwick & Jackson, 1950); Nikolaus Pevsner, *High Victorian Design: A Study of the Exhibits of 1851* (London: Architectural Press, 1951).

41 Christopher Wood, 'A Victorian Quest: My Forty Years in the Art World', in *Christopher Wood: A Very Victorian Eye* (London: Christie's, 2007), 6–9 (7); see also John Christian's account of the revival, in *Christopher Wood*, 10–13. In literary criticism, only the tendency to 'neo-Victorianism' in the last decades of the twentieth century has received attention. Cora Kaplan's recent study *Victoriana: Histories, Fictions, Criticism* (Edinburgh: Edinburgh University Press, 2007) is an excellent guide to the politics of Victoriana from the 1970s onward, but does not go further back.

5 FROM PURITY TO A PAGEANT

1 Kenneth Clark, introduction to Fry, *Last Lectures*, v.

2 Frank Swinnerton, *The Georgian Literary Scene: A Panorama* (London: Heinemann, 1935), 361.

3 Benedict Nicolson looking back on the 1920s and 1930s in 'Round the Exhibitions', *New Statesman and Nation* 21 (1946), 461–62.

4 John Piper to Anthony West, quoted in West, *John Piper*, 56.

5 Clive Bell, 'What Next in Art?', *Studio* 109 (1935), 176–85 (185).

6 Virginia Woolf to Vanessa Bell, 8 October 1938, *Letters*, VI, 285.

7 Virginia Woolf to Vanessa Bell, 24 October 1938, *Letters*, VI, 294.

8 Fry's thinking about aesthetic emotion was never stable or easily summarized. On the development of his philosophy see Spalding, *Roger Fry*, 253–54, and Fry's 1933 lecture 'The Double Nature of Painting', in *A Roger Fry Reader*, 380–92.

9 Woolf, *The Waves*, 134.

10 Woolf, *Fry*, 213.

11 Virginia Woolf to Vita Sackville-West, 3
December 1939, *Letters*, VI, 374.

12 Woolf, *Fry*, 116.

13 Woolf described the book to Ethel Smyth as 'an
amalgamation of all [Fry's] letters': 1 February
1940, *Letters*, VI, 381.

14 Arthur Waley, 'Roger Fry', *Listener*, 24 (1940), 243.

15 Woolf, *Fry*, 161, 172, 164.

16 Woolf, *Fry*, 170, 228.

17 Woolf, *Fry*, 215.

18 Woolf, *Diary*, 14 July 1932, IV, 116; Woolf, *Fry*,
214. Hermione Lee, *Virginia Woolf*, 635, 745–67,
shows immunity and anonymity to be important
and closely related concepts for Woolf from
1932 right through to her writing of 'Anon',
her passionate responses to the engulfing floods
of winter 1940–41, and her suicide that spring.

19 Spender, *The Destructive Element*, 157, 161.

20 Virginia Woolf, 'The Artist and Politics' (1936),
in *The Moment and Other Essays* (London: Hogarth
Press, 1947), 180–82 (182). She was persuaded
to write for the *Daily Worker* by Quentin Bell's
friend, the painter Elizabeth Watson.

21 Evans, introduction to *The Painter's Object*, 5.

22 Eric Ravilious to Helen Binyon, 16 June 1936,
East Sussex Record Office.

23 Julian Bell, 'The Proletariat and Poetry: An Open
Letter to C. Day Lewis', in Bell, *Essays*, 306–92
(324). Quentin Bell, too, felt allegiance to the old
liberal values of Bloomsbury while acknowledging
their limitations. He addressed the problem
explicitly in *Virginia Woolf: A Biography* (London:
Hogarth Press, 1972), I, 185–86.

24 Bell, *Essays*, 326.

25 Roger Fry, 'Retrospect' (1920), in *Vision and
Design*, 199–211 (204).

26 Julian Bell, 'On Roger Fry', in Bell, *Essays*,
258–305 (289).

27 Bell, 'On Roger Fry', 288, 292.

28 Benedict Nicolson to Virginia Woolf, 6 August
1940, Monk's House Papers, Sussex.

29 Herbert Read, 'Books of the Day: Roger Fry',
Spectator 165 (1940), 124.

30 Clark, in Fry, *Last Lectures*, ix.

31 Ibid., xv, xxvi.

32 Ibid., v, vi.

33 Clark, *Another Part of the Wood*, 255.

34 Kenneth Clark, preface to *Catalogue of New
Drawings by Duncan Grant* (London: Alex Reid
and Lefevre, 1934).

35 Roger Fry, introduction to *Duncan Grant*, Hogarth
Living Painters (London: Hogarth Press, 1924;
2nd edn 1930), vi.

36 Woolf, *Diary*, 26 April 1938, V, 135.

37 Strachey, 'Gibbon', in *Portraits in Miniature*,
154–68 (162).

38 Woolf, *Diary*, 26 April 1938, V, 135.

39 Woolf, 'Craftsmanship' (1937), in *Collected Essays*,
II, 245–51 (250).

40 Woolf, 'Craftsmanship', 250.

41 Woolf, *Between the Acts*, 23.

42 Woolf, *Between the Acts*, 111, alluding
(fragmentarily) to Shakespeare,
Troilus and Cressida, V. 2.

43 Woolf, *Between the Acts*, 53.

44 Woolf, *Fry*, 164.

45 Woolf, *Between the Acts*, 107.

46 Woolf, *Fry*, 215.

47 Woolf, *Between the Acts*, 116, 40.

48 Auden 'Manifesto on the Theatre',
English Auden, 273.

49 Woolf, *Pointz Hall*, 33.

50 Woolf, *Between the Acts*, 69.

51 Ibid., 62.

52 Ibid., 57.

53 Virginia Woolf, *Roger Fry: A Series of Impressions*,
ed. Diane Gillespie (London: Cecil Woolf, 1994),
11; Woolf, *Between the Acts*, 94.

A BREAK FOR REFRESHMENTS

1 See West, *John Piper*, 56.

2 Virginia Woolf, *To the Lighthouse* (1927), ed.
Hermione Lee (London: Penguin, 1992), 109.

3 Loos, *Ornament and Crime*, 169.

4 Ibid., 170.

5 'Hygiene' is in the Futurist Manifesto of 1909.

6 The restaurant was La Taverna del Santapalato
and had an aluminium interior; Filippo Tommaso
Marinetti, *The Futurist Cookbook* (1932),
trans. Suzanne Brill (London: Trefoil, 1989).

7 Marinetti, *The Futurist Cookbook*, 37, 73, 105,
and see P. A. Saldin, 'Cubist Vegetable Patch',
The Futurist Cookbook, 155–56.

8 Auguste Escoffier, Introduction to the second
edition of *Le Guide Culinaire*, 1907, reprinted
in Mark Kurlansky, ed., *Choice Cuts* (London:
Cape, 2002), 26.

9 'Hélion at 81', *Art and Artists* (1985), 19–22 (21).

10 Jessie Conrad, *Home Cookery* (London: Jarrolds,
1936), v.

11 Conrad, *Home Cookery*, v, vi.

12 Adolf Loos, 'Plumbers' (1898) in *Ornament
and Crime*, 82–88 (86).

13 *A Gardener's Book*, 1699, quoted by Dorothy
Hartley in *Food in England* (1954; London:
Futura, 1985), 380; Laurence Sterne,
*The Life and Opinions of Tristram Shandy,
Gentleman* (1759–67), ed. Tim Parnell
(London: Dent, 2000), 453.

14 Mrs Philip Martineau, *Cantaloup to Cabbage*
(London: Cobden-Sanderson, 1929), 36.

15 E. M. Forster, 'Porridge or Prunes, Sir?', in Louis
Golding and André L. Simon, eds, *We Shall Eat
and Drink Again* (London: Hutchinson, 1944), 57.

16 Virginia Woolf, *A Room of One's Own and Three
Guineas*, ed. Morag Shiach (Oxford: Oxford
University Press, 1998) 22.

17 Woolf, *The Years*, appendix, 396.

18 Virginia Woolf to Vita Sackville-West, 20
September 1929, *Letters*, IV, 93.

19 Virginia Woolf to Ethel Smyth, 21 November 1931, *Letters*, IV, 407.

20 Quoted by Bee Wilson, *New Statesman*, 26 August 2002.

21 Angelica Garnett, 'The French Connection – 3', *Charleston Magazine* 8 (1993), 5.

22 Ambrose Heath, *Good Food* (London: Faber, 1932), 184.

23 Woolf, *To the Lighthouse*, 109.

24 White, *Good Things*, 278.

25 Ibid., 87.

26 Ibid., 12.

27 E.g. Edith Martin, ed., *Cornish Recipes: Ancient and Modern* (Truro: A.W. Jordan, 1929).

28 Lowinsky, *Lovely Food*, 7. On the vogue for light, elegant cooking in the 1930s, see Arabella Boxer, who argues that in the interwar years 'English food underwent a brief flowering that seems to have gone almost unremarked at the time and later passes into oblivion', *Arabella Boxer's Book of English Food*, 1.

29 Alice B. Toklas, *The Alice B. Toklas Cookbook* (London: Serif, 1994), 257.

30 For Bawden's work with Fortnum's, see *Entertaining à la carte: Edward Bawden and Fortnum and Mason* (Norwich: Mainstone Press, 2007).

31 Virginia Woolf to Vita Sackville-West, 29 November 1940, *Letters*, VI, 448. Hermione Lee notes that despite these effusions Woolf was in fact eating very little during this tense autumn and winter: Lee, *Virginia Woolf*, 753.

32 Waugh, 1959 preface to *Brideshead* (1962 edn), 7.

33 Waugh, *Brideshead*, 81, 167.

34 Constance Spry, *Come into the Garden, Cook* (London: Dent, 1942), 230, 1.

35 John Hampson, *The English at Table*, Britain in Pictures (London: Collins, 1946), 48.

36 See for example Boxer, *Arabella Boxer's Book of English Food*.

37 Hartley, *Food in England*, v, 380.

38 Grigson, *English Food*, 246.

39 Ibid., vi.

6 THE CANON REVISED

1 Geoffrey Grigson, 'Samuel Palmer: The Politics of an Artist', *Horizon* 4 (1941), 314–28 (314).

2 John Piper, 'Pleasing Decay', *Architectural Review* 102 (1947), 85–94 (93–94).

3 Fry, *Reflections*, 21.

4 Ibid., 22–23.

5 Ibid., 27.

6 Ibid., 37, 42.

7 Constable, *Exhibition of British Art*, xiv.

8 Nash, *Outline*, 123. On the debates surrounding the 1934 exhibition, see Andrew Causey, 'English Art and the "National Character" 1933–4', in Corbett et al., ed., *The Geographies of Englishness*, 275–302.

9 Adrian Bury, 'Water-colour: The English Medium', *Apollo* 19 (1934), 85–89 (85).

10 Priestley, *English Journey*, 82.

11 H. J. Paris, *English Watercolour Painters*, Britain in Pictures (London: Collins, 1945), 10.

12 Laurence Binyon, *English Water-Colours* (London: A & C Black, 1933), 61.

13 The connection here is intense and personal: Binyon's daughter Helen had a long affair with Ravilious from the early 1930s.

14 Binyon, *English Water-Colours*, 191.

15 A. P. Oppé, *The Water-Colour Drawings of John Sell Cotman* (London: The Studio, 1923), xv.

16 Richards, *Memoirs of an Unjust Fella*, 93.

17 Paul Nash, 'A Characteristic', *Architectural Record* 7 (1937), 39–44 (40).

18 Sydney D. Kitson, *The Life of John Sell Cotman* (London: Faber, 1937), 76, 78.

19 Laurence Binyon, 'The Art of John Sell Cotman', *Burlington Magazine* 81 (1942), 159–63 (159).

20 Martin Hardie, 'Cotman's Water-colours: The Technical Aspect', *Burlington Magazine* 81 (1942), 171–76 (172).

21 Woolf, *Roger Fry*, 164.

22 John Piper, 'John Sell Cotman, 1782–1842', *Architectural Review* 92 (1942), 9–11 (11).

23 Fry, *Reflections*, 119.

24 Piper, 'John Sell Cotman', 9.

25 Ibid., 11.

26 See Mowl, *Stylistic Cold Wars*, 76.

27 See Pevsner, *Englishness*, 9, recalling that all the material he collected during the 1930s took shape as the lectures at Birkbeck.

28 The difference is Timothy Mowl's subject in *Stylistic Cold Wars*, and is sensitively treated in Spalding, *John Piper, Myfanwy Piper*.

29 Pevsner, *Englishness*, 18, 117, 119.

30 Ibid., 19, 181, 61.

31 Edmund Blunden, 'On Pilgrimage in England: Voyages of Discovery', *Times Literary Supplement*, 28 March 1942, 156.

32 Myra Hess, quoted in Suzanne Bosman, *The National Gallery in Wartime* (London: National Gallery, 2008), 32.

33 [Tancred Borenius], 'The Picture of the Month', *Burlington Magazine* 82 (1943), 55.

34 Fussell, *Wartime*, has a chapter on reading, 228–50; Foss, *War Paint*, 178.

35 For listening statistics see Asa Briggs, *A History of Broadcasting in the United Kingdom*, III (Oxford: Oxford University Press, 1970); on the Reithian influence see Todd Avery, *Radio Modernism: Literature, Ethics and the BBC 1922–1938* (Aldershot: Ashgate, 2006).

36 Quoted in Michael Carney, *Britain in Pictures: A History and Bibliography* (London: Werner Shaw, 1995), 31.

37 Sackville-West, *English Country Houses*, 39.

38 Bowen, *English Novelists*, 7, 8.

39 Cecil, *English Poets*, 9, 26, 20.

40 Greene, *British Dramatists*, 7–8, 39, 10.

41 Eliot, 'The Metaphysical Poets' (1921) in *Selected Prose*, 111–21 (117).

42 Leavis, *Revaluation*, 12.
43 Leavis, *Revaluation*, 114, 175, 263. The aestheticist readings of Keats with which Leavis has his quarrel, are those of Arthur Symons and John Middleton Murry.
44 Leavis, *Revaluation*, 60, 49.
45 Eliot, 'Metaphysical Poets', in *Selected Prose*, 120.
46 Leavis, *Revaluation*, 43, 60.
47 Auden and Garrett, *Poet's Tongue*, viii.
48 Massingham, *Remembrance*, 79; Edith Olivier, *Country Moods and Tenses* (London: Batsford, 1941), 89.
49 White, *Good Things*.
50 Waugh, *Labels*, 46.
51 See Simon Heffer, *Vaughan Williams* (London: Phoenix, 2001), 98–99.
52 The most helpful survey is still Peter J. Pirie, *The English Musical Renaissance* (London: Gollancz, 1979).
53 Benjamin Britten, 'The Folk-Art Problem', *Modern Music* 18 (1941), 71–75 (71). Robert Stradling and Meirion Hughes make a series of cynical attacks on the revival in *The English Musical Renaissance* 1840–1940 (Manchester: Manchester University Press, 2001), but also offer valuable re-assessment of the extent to which a politically dubious tradition was being constructed.
54 The Schoenberg article had appeared in *Musical Standard*, 21 September 1912, and Warlock's interest remained strong; Peter Warlock, *The English Ayre* (London: Oxford University Press, 1926).
55 Auden, 'Introduction to *Slick but not Streamlined*' (1947), in Auden, *Prose*, II, 303–7 (303).
56 Auden, ed., *Oxford Book of Light Verse*, x, xiv.
57 Ibid., ix, xvi.
58 Smith, *Novel on Yellow Paper*, 231.
59 Virginia Woolf, 'The Man at the Gate' (1940), in *Collected Essays*, III, 217–21 (219).
60 Green, *Pack My Bag*, 5.
61 Grigson, *Romantics*, viii. John Livingston Lowes, *The Road to Xanadu: A Study in the Ways of the Imagination* (Boston: Houghton Mifflin, 1927).
62 Grigson, *Romantics*, 334n.
63 Grigson, *Blessings*, 106.
64 Grigson, *Romantics*, vii.
65 Ibid., 350n, 342n, 337n.
66 Read, *Knapsack*, 273.
67 Wavell, *Other Men's Flowers*, 13.
68 Wavell, *Other Men's Flowers*, 21, 26.
69 Wavell, Preface, April 1947, *Other Men's Flowers*, 19.

7 THE WEATHER FORECAST

1 Smith, *Novel on Yellow Paper*, 13.
2 Stevie Smith, 'Book of Verse: Thomas Hood', radio broadcast 8 June 1946, quoted in Spalding, *Stevie Smith*, 13.
3 Smith, *Novel on Yellow Paper*, 14.
4 Ibid., 29.
5 Smith, '...and the clouds return after the rain' and 'Brickenden, Hertfordshire', in *Collected Poems*, 146 and 114–15, both first published in *Tender Only to One* (London: Cape, 1938).
6 Smith, *Over the Frontier*, 66.
7 Smith, *Over the Frontier*, 66, quoting 'The Progress of Error' by William Cowper.
8 For Piper's parable see my Prologue.
9 Roger Fry to G. L. Dickinson, 31 May 1913, Fry, *Letters*, I, 370.
10 *A Matter of Life and Death*. Dir. Michael Powell and Emeric Pressburger. Universal. 1946.
11 Thomas Hennell, 'In Praise of Water-Colour', *The Old Water-Colour Society's Club* 21 (1943), 53–56, repr. in MacLeod, *Thomas Hennell*, 122–24 (124).
12 Nash, *Outline*, 123.
13 Richards, *Memoirs of an Unjust Fella*, 103.
14 Eric Ravilious to Tirzah Ravilious, 3 February 1938 and 3 March 1938, East Sussex Record Office.
15 Reported in Lees-Milne, *Prophesying Peace*, 211–12.
16 Fuseli's response is variously recorded in Allan Cunningham, *The Lives of the Most Eminent British Painters, Sculptors and Architects*, II (London: John Murray, 1830), 326, and C. R. Leslie, *Memoirs of the Life of John Constable* (Green & Longmans, 1845), 109. Piper mentions the incident in *British Romantic Artists*, 44.
17 On the cultural history of clouds, see Kurt Badt, *John Constable's Clouds* (London: Routledge, 1950).
18 John Ruskin, 'Of Truth of Skies' (1843), in *Selected Writings*, 12.
19 Piper, *British Romantic Artists*, 7.
20 Ibid.
21 Ibid., 36.
22 Ibid., 48.
23 John Piper to Paul Nash, 12 January 1943, Tate Archive, 7050/1076.381.
24 Woolf, *Diary*, 12 September 1940, V, 318.
25 Woolf, 'Anon', 373–74.
26 Ibid., 382.
27 Woolf, *Between the Acts*, 14.
28 Woolf, *Diary*, V, 24 July 1940, 304.
29 Woolf, 'Anon', 383.
30 Ibid., 395.
31 Ibid., 373.
32 Ibid., 397.
33 William Hazlitt, 'On My First Acquaintance with Poets' (1823) in *The Fight and Other Writings*, Tom Paulin and David Chandler, eds (London: Penguin, 2000), 246–64 (260).
34 Woolf, *Between the Acts*, 13.
35 Eliot, 'Yeats' (1940), in *Selected Prose*, 248–57 (252).
36 Vaughan Williams, *National Music*, 11.
37 Read, *English Vision*, vii, 353.
38 Herbert Read, *Annals of Innocence and Experience* (London: Faber, 1940), 26, 19.
39 Herbert Read, *Poetry and Anarchism* (London: Faber, 1938), 16–17; for Read's thinking about

industry see *Art and Industry: The Principles of Industrial Design* (London: Faber, 1934).

40 E. M. W. Tillyard, *Shakespeare's History Plays* (London: Chatto & Windus, 1944; repr. 1961), 302, 14.

41 *Words for Battle*. Dir. Humphrey Jennings. Crown Film Unit. 1941.

42 Myfanwy Piper, ed., *Sea Poems*, vi.

43 Edith Sitwell to Myfanwy Piper, 9 March 1945, Tate Archive, 200410/1.

44 Betjeman and Taylor, eds, *English, Scottish and Welsh Landscape Verse*, vi.

45 Brandt, *Literary Britain*, plate 43.

46 See, for example, David Hockney's vehement comments about Brandt's deceptions in *Hockney on Photography: Conversations with Paul Joyce* (London: Cape, 1988), 45.

47 Bill Brandt, 'A Statement' (1970) in *Bill Brandt: Selected Texts and Bibliography*, ed. Nigel Warburton (Oxford: Clio Press, 1993), 29–32 (31).

48 Brandt, *Literary Britain*, plate 10.

49 E. M. Forster, 'George Crabbe: The Poet and the Man' (1941), reprinted in Philip Brett, ed., *Peter Grimes*, Cambridge Opera Handbooks (Cambridge: Cambridge University Press, 1983), 3–7 (5).

50 Forster, 'George Crabbe', 4.

51 Benjamin Britten, *Peter Grimes*, 1945, libretto by Montagu Slater, Act II.

52 *Peter Grimes*, Act II.

53 Ibid., Act III.

54 Ibid., Act I.

55 Quoted in Matthew Boyden, Nick Kimberley and Joe Staines, eds, *The Rough Guide to Opera* (London: Rough Guides, 2002), 590.

56 *Peter Grimes*, Act III.

57 I am grateful to Alan Powers for telling me about this. He describes the memorial in 'The Dance of Life: Order and disorder in the architecture of H. T. Cadbury-Brown', *Arq* 10 (2006), 13–24 (19).

58 Maggi Hambling, quoted in Andrew Gimson, 'Victory for Shell-shocked Aldeburgh', *Telegraph*, 24 January 2004; *Peter Grimes*, Act II.

59 Benjamin Britten, introduction to the programme for the Sadler's Wells *Peter Grimes* (1945), in *Britten on Music*, 49.

60 Benjamin Britten, speech on being made a Freeman of Lowestoft (1951), in *Britten on Music*, 108–10.

8 VILLAGE LIFE

1 Blunden, *English Villages*, 32.

2 Paddy Scannell and David Cardiff, *A Social History of British Broadcasting*, I (Oxford: Blackwell, 1991), 278.

3 Walter Johnson, ed., *The Journals of Gilbert White* (London: Routledge, 1931).

4 William Condry, ed., *Wood-Engravings by Gertrude Hermes being Illustrations to 'Selborne' with Extracts from Gilbert White* (Newtown, Wales: Gwasg Gregynog, 1988).

5 W. T. Williams and G. H. Vallins, eds, *White's Natural History of Selborne* (London: Methuen, 1935), v, 8.

6 The courtship present is mentioned in Spalding, *John Piper, Myfanwy Piper*, 125; [Iolo Williams], 'The Discoverer of England', *Times Literary Supplement*, 30 April 1938, 291.

7 H. J. Massingham, intro. to *Writings of Gilbert White*, Vol. 1, xxi, xxiv.

8 Eric Ravilious to Helen Binyon, 30 January 1936, East Sussex Record Office.

9 Piper, *British Romantic Artists*, 7. For Bewick's influence on later artists, see Jenny Uglow, *Nature's Engraver: A Life of Thomas Bewick* (London: Faber, 2006), 401.

10 Woolf, 'White's Selborne' (1939), in *Collected Essays*, III, 122–25 (122).

11 Woolf, 'Anon', 376.

12 Woolf, 'White's Selborne', 125.

13 Clough Williams-Ellis, *England and the Octopus* (London: G. Bles, 1928).

14 Baldwin, 'On England' (1926), in *On England and Other Addresses*, 5.

15 Baldwin, 'The Love of Country Things' (1931), in *This Torch of Freedom*, 120.

16 Orwell, *Coming Up for Air*, 211, 198, 73.

17 Ibid., 198, 73.

18 Ibid., 230.

19 Waugh, *Vile Bodies*, 168.

20 Greene, *Brighton Rock*, 93.

21 Warner, *Aerodrome*, 178.

22 Ibid., 260.

23 Stanley Spencer, *Sermons by Artists* (London: Golden Cockerel Press, 1934), quoted in MacCarthy, *Stanley Spencer*, opp. plate 28.

24 Smith, *Novel on Yellow Paper*, 41.

25 Leavis, 'Mass Civilisation and Minority Culture' (1930), in *For Continuity*, 13–45 (29).

26 Leavis and Thompson, *Culture and Environment*, 87.

27 George Bourne, *Change in the Village* (1912; Harmondsworth: Penguin, 1984), 75.

28 Leavis and Thompson, *Culture and Environment*, 85.

29 Bourne, *Change in the Village*, 176. Iain Wright argues that, wilfully neglecting to do any historical research, 'Leavis and his collaborators never showed the least interest in establishing whether [the organic community] had actually existed'. 'F. R. Leavis, the *Scrutiny* Movement, and the Crisis', in Jon Clark et al., eds, *Culture and Crisis in Britain in the Thirties* (London: Lawrence and Wishart, 1979), 37–66 (52).

30 Leavis, *For Continuity*, 38.

31 See David Lewis, 'Scratching the Surface', *Tate Etc.* 13 (2008) 102–5, and Ben Nicholson to Herbert Read [1944], quoted by Chris Stephens, 'Ben Nicholson: Modernism, Craft and The English Vernacular' in Corbett et al., eds, *Geographies of Englishness* 225–47 (242).

32 Nicolson, 'Round the Exhibitions', *New Statesman and Nation* 21 (1946), 461; Hennell, *British Craftsmen*, 44–46.

33 Palmer, *Recording Britain*, I, 204.
34 Edward Bawden, quoted in MacLeod, *Thomas Hennell*, 110.
35 Eliot, 'Commentary', *Criterion* 18 (1938), 58–62 (60).
36 T. S. Eliot to Viscount Lymington, 7 June 1938, Hampshire Record Office, 15M84/F147/134.
37 Lymington makes several appearances in Richard Griffiths's *Fellow Travellers of the Right: British Enthusiasts for Nazi Germany 1933–39* (Oxford: Oxford University Press, 1983), a study which tracks the frightening pervasiveness of fascist sympathies among British intellectuals and politicians.
38 See Stephen Knight, *Robin Hood: A Complete Study of the English Outlaw* (Oxford: Blackwell, 1994), 211–14.
39 Georgina Boyes, *Imagined Village*, 155–62 discusses Gardiner's reaction against the prevailing ethos of folk revivalism.
40 Patrick Wright, *The Village that Died for England*, 176–202, gives a careful account of Gardiner's aims and, while acknowledging his political naivety, presents a figure struggling to honour the ideals of pre-Nazi Germany and advocating a form of 'Regional Socialism' against mass extremism.
41 Massingham, *Remembrance*, 142.
42 Lymington, *Alternative to Death*, 131, 140.
43 T. S. Eliot to Viscount Lymington, 24 December 1941, Hampshire Record Office, 15M84/F150.
44 Eliot, 'East Coker', i, *Complete Poems*, 177.
45 Ibid., 178.
46 Leavis, *The Living Principle*, 195–96. Leavis's response to 'East Coker', and the opposing rural ideologies it designates, is examined in Gervais, *Literary Englands*, 136–43.
47 Eliot, 'East Coker', i, *Complete Poems*, 178.
48 Eliot, 'Dry Salvages', v, *Complete Poems*, 190.
49 Richard Mabey, 'Diary of a Country Woman', *Guardian*, 13 December 2008.
50 Thompson, *Lark Rise to Candleford*, 56.
51 Massingham, introduction to Thompson, *Lark Rise to Candleford*, 14.
52 The 1973 Penguin edition, reprinted over many years, carried on its cover a 'Country Scene' by Allingham, blossoming with sunflowers and a prosperous garden ornamented with topiary. The BBC's *Lark Rise to Candleford* was first screened in 2008.
53 Bourne, *Change in the Village*, 176.
54 Thompson, *Lark Rise to Candleford*, 75.
55 See Martin Pugh, *'We Danced All Night': A Social History of Britain between the Wars* (London: Bodley Head, 2008), 270.
56 Woolf, 'Anon', 382.
57 Reproduced in Maire McQueeney, ed., *Virginia Woolf's Rodmell: An Illustrated Guide to a Sussex Village* (Rodmell: Rodmell Village Press, 1991), 15.
58 Woolf, *Pointz Hall*, 36–37.
59 Woolf, *Between the Acts*, 47, 6.
60 Woolf, *Between the Acts*, 119.
61 Woolf, 'Anon', 384.
62 Woolf, *Between the Acts*, 119, 125.
63 Esty, *Shrinking Island*, 56–60.
64 Woolf, *Three Guineas*, 321.
65 Esty, *Shrinking Island*, 90.
66 Una Ellis-Fermor, 'Village Drama [1350]–1937' in *English* 1 (1937), 558–61 (558).
67 Forster, *England's Pleasant Land*, 353–443.
68 Ibid., 357.
69 Noel Carrington, *Life in an English Village*. King Penguin Books (Harmondsworth: Penguin, 1949), 7.
70 Ibid., 22, 31, 18.
71 Richards, *Memoirs of an Unjust Fella*, 105.

9 PARISH NEWS

1 Eliot, *The Idea of a Christian Society*, 31.
2 Ibid.
3 John Betjeman, 'How to Look at a Church' (1938) in *Coming Home*, 76–80 (76, 80).
4 Greene, *British Dramatists*, 7–8.
5 On Bell and his circle, see Paul Foster, ed., *Bell of Chichester: A Prophetic Bishop*, Otter Memorial Papers 17 (Chichester: Chichester University College, 2004).
6 George Bell, sermon 13 December 1953, quoted in Kenneth W. Pickering, *Drama in the Cathedral: The Canterbury Festival Plays 1928–1948* (Worthing: Churchman, 1985), 135. On the revival of religious drama, see John R. Elliot, *Playing God: Medieval Mysteries on the Modern Stage* (Toronto: University of Toronto Press, 1989).
7 See E. Martin Browne, *The Making of T. S. Eliot's Plays* (London: Cambridge University Press, 1969), 55ff.
8 Eliot, 'Murder in the Cathedral', *Complete Poems*, 237–82 (239, 244).
9 Ibid.
10 Overy, *The Morbid Age*.
11 Eliot, 'Murder in the Cathedral', 281–82.
12 Vanessa Bell to Jane Bussy, 13 June 1941, *The Selected Letters of Vanessa Bell*, ed. Regina Marler (London: Pantheon, 1993), 472.
13 Wyndham Lewis, 'round robin' to Omega clients, 1913, quoted in Spalding, *Roger Fry*, 174.
14 Betjeman, *Ghastly Good Taste*, 51–52.
15 See e.g. John Betjeman to Wilhelmine Cresswell, 14 August 1935, in *John Betjeman: Letters*, 150.
16 Vanessa Bell to Angelica Bell, 24 November 1941, in *The Selected Letters of Vanessa Bell*, ed. Regina Marler (London: Bloomsbury, 1993), 472.
17 Henry Moore, *Writings and Conversations*, ed. Alan Wilkinson (Berkeley: University of California Press, 2002), 267; details about the commission from the chapter 'Madonna and Child 1943–4', 267–69.
18 The sequence appeared in America in 1943.
19 Eliot, 'Burnt Norton', i, *Complete Poems*, 172.
20 Eliot, 'Little Gidding', v, 197; 'Little Gidding', ii, 192.

21 Eliot, 'The Social Function of Poetry' (1943),
 On Poetry and Poets, 3–8 (8).
22 Eliot, 'East Coker', v, 182.
23 Eliot, 'Burnt Norton', i, 'Little Gidding', i,
 Complete Poems, 172, 191.
24 Eliot, 'Little Gidding', i, 191–92.
25 Eliot, *Idea of a Christian Society*, 31.
26 Eliot, 'Little Gidding', ii, 195.
27 Churchill, for example, often quoted Kipling in
 his speeches.
28 Eliot, introduction to *A Choice of Kipling's Verse*, 33.
29 On Piper's Christian faith, see Spalding, *John
 Piper, Myfanwy Piper*, 158.
30 Eliot, 'Burnt Norton', ii, 173.
31 Spender, *The Thirties and After: Poetry, Politics,
 People* (London: Macmillan, 1978), 96. The
 changing aesthetics of Piper and Eliot are closely
 comparable. Steve Ellis, in *English Eliot*, reads
 Four Quartets in terms of a dialogue with
 constructivism and a move towards more
 accommodating forms.

10 VARIATIONS ON A VIEW

1 The Pilgrim Trust was founded in 1930 by the
 philanthropist and Anglophile Edward Stephen
 Harkness. It was intended to promote the 'future
 well-being of Britain'. See www.the
 pilgrimtrust.org.uk.
2 Lord Macmillan, Introduction to Palmer,
 Recording Britain, I, v.
3 John Piper, 'Towers in the Fens', *Architectural
 Review* 88 (1940), 131–34 (131); and for pigments,
 see Ravilious, *Ravilious at War*, 182.
4 'A Scheme for Recording Changing Aspects
 of England', papers of the Committee for the
 Employment of Artists in Wartime, quoted
 in Foss, *War Paint*, 89.
5 Herbert Read, 'English Watercolours and
 Continental Oils', *Listener* 26 (1941), 121–22 (122).
6 Palmer, *Recording Britain*, IV, 202.
7 Green, *Pack my Bag*, 1.
8 H. V. Morton, *In Search of England* (1927; London:
 Folio, 2002), 174.
9 Priestley, *English Journey*, 65.
10 S. P. B. Mais, *This Unknown Island* (London:
 Putnam, 1932), vii. For Churchill's comment on
 Mais's excursions, see Alexander Waugh on Mais
 at www.themotiongroup.org.
11 Frank Trentmann persuasively links rambling
 and the quest for wildness with the aesthetics
 of Neo-Romanticism: 'Civilization and its
 Discontents: English Neo-Romanticism and
 the Transformation of Anti-Modernism in
 Twentieth-Century Western Culture', *Journal
 of Contemporary History* 29 (1994), 583–625.
12 Alfred Watkins, *The Old Straight Track: Its Mounds,
 Beacons, Moats, Sites and Mark Stones* (London:
 Methuen, 1925).
13 Graves and Hodge, *Long Week-End*, 275.
14 Massingham, *Genius of England*, 34.

15 W. G. Hoskins, *The Making of the English Landscape*
 (London: Hodder & Stoughton, 1955), 13.
16 Letter to the *Times*, 5 August 1927, 7.
17 For the influence on architects see Rosemary Hill,
 Stonehenge (Cambridge, MA: Harvard University
 Press, 2008), 59–85.
18 Quoted in Matthew Gale and Chris Stephens,
 Barbara Hepworth (London: Tate, 1999), 71.
 Modern artists' engagement with prehistoric
 landmarks is explored in Sam Smiles, 'Equivalents
 for the Megaliths: Prehistory and English
 Culture, 1920–50', in Corbett et al., eds,
 Geographies of Englishness, 199–223.
19 On Moore and Stonehenge see Christa
 Lichtenstern, *Henry Moore: Work, Theory, Impact*
 (London: Royal Academy, 2008), 207–12.
20 Harvey Darton, *English Fabric*, 36. Nash was
 staying with the Betjemans when he took a series
 of photographs of the horse, one of which
 appeared in his article 'Unseen Landscapes',
 Country Life, 21 May 1938, 526–27.
21 Massingham, *Remembrance*, 96.
22 Massingham, *Downland Man*, 42, 108.
23 For camouflage, see Ravilious, *Ravilious at War*,
 243, 247, 252; for the book proposal see *Ravilious
 at War*, 144–45.
24 On the modernist aesthetics of the countryside,
 and particularly the various kinds of preservation
 movement, see David Matless's revealing account
 in *Landscape and Englishness*.
25 Clive Bell, 'Shell-Mex and the Painters',
 New Statesman and Nation 17 (1934), 946.
26 Cyril Connolly, 'The New Medici', *Architectural
 Review* 71 (1934), 2–4 (2).
27 Orwell, 'Inside the Whale' (1940), in *Collected
 Essays*, I, 540–78 (552).
28 Waugh, *Labels*, 87.
29 The guidebook game is described by the Pipers'
 archaeologist friend Stuart Piggott in 'A Disciple
 of Leland', Elborn, ed., *To John Piper*, 33–35 (34).
30 Piper, *Oxon*, 7.
31 John Betjeman, 'A Shell Guide to Typography',
 Typography 2 (1937), 2–3.
32 Mitford, *Pursuit of Love*, 40.
33 John Betjeman, 'Gentlemen's Follies' (1938)
 in *Coming Home*, 81–84; Henry James Pye,
 Faringdon Hill: A poem. In two books (Oxford:
 Daniel Prince, 1774), I, 7:
 'Emerging from the thicket's bosom, there
 See BAMPTON's pointed steeple rise in air,
 To farther distance now the prospect drawn
 Lo! WITNEY's spire diversifies the lawn!'
34 Reported in the *Oxford Mail*, 5 November 1936.
 Thanks to Mary Gifford for this information.
35 Betjeman, 'Gentlemen's Follies', 81.
36 Betjeman and Taylor, eds, *Landscape Verse*, vi.
37 John Piper to John Betjeman, 5 November 1942,
 quoted in William S. Peterson, *John Betjeman:
 A Bibliography* (Oxford: Clarendon Press, 2006), 46.
38 Auden, Introduction to *Slick but not Streamlined*
 (1947), in Auden, *Prose*, 304. Beginning her book

by introducing 'A Topophiliac Generation', Kitty Hauser uses Auden's definition of topophilia as a springboard for her discussion of archaeological imagination: Hauser, *Shadow Sites*, 1–5.

39 Sutherland, 'Welsh Sketch Book' (1942) reprinted in Hammer, *Graham Sutherland*, 68–70 (68).

40 Sutherland, letter to the *New Statesman and Nation*, 25 January 1947, reprinted in Hammer, *Graham Sutherland*, 161.

41 *A Canterbury Tale*. Dir. Michael Powell and Emeric Pressburger. Granada International. 1944.

42 Christie, *Arrows of Desire*, 50.

43 On the film's revision of Chaucer, and on Powell's reinvention of the image of cinema itself, see Conrad, *To Be Continued*, 23–31.

AN HOUR IN THE GARDEN

1 Eliot, *The Waste Land*, 'The Burial of the Dead', i, *Complete Poems*, 61.

2 Auden, 'Letter to Lord Byron' (1937), *English Auden*, 199.

3 Eliot, 'Burnt Norton' i, 172.

4 Thomas Hardy, 'Neutral Tones' (1867), in *Selected Poems*, ed. Robert Mezey (London: Penguin, 1998), 6; Thomas Edward Brown, 'My Garden' (1893), in *Poems of T. E. Brown* (London: Macmillan, 1922), 135.

5 Eliot, 'Burnt Norton', i, 172.

6 Waugh, *Brideshead* (1962 edn), 34.

7 Sitwell, *Left Hand*, I, 1.

8 Tunnard, *Gardens in the Modern Landscape*, 74, 80.

9 Ibid., 79.

10 Ibid., 137.

11 Tunnard publicly associated himself with Bentley Wood, and promoted it as a highly successful realization of his rationalist theories. His role in designing the garden, however, appears to have been fairly minimal. See Powers, *Serge Chermayeff*, 132–36.

12 Tunnard, *Gardens in the Modern Landscape*, 9.

13 See for example Nash's *Equivalents for the Megaliths* (1935) and *Landscape from a Dream* (1936–8). Nash's work may well have influenced Tunnard and Chermayeff – it was certainly well known to them.

14 Moore described this project in a 1955 talk called 'Sculpture for the Open Air', quoted in Roger Berthould, *The Life of Henry Moore* (London: Faber, 1987), 156. Moore's *Recumbent Figure* is now at Tate Britain.

15 Tunnard, *Gardens in the Modern Landscape*, 74.

16 Brown, *The Modern Garden*, 8. See also Brown's other invaluable studies, *The Pursuit of Paradise: A Social History of Gardens and Gardening* (London: HarperCollins, 1999), and particularly *The English Garden through the Twentieth Century* (Woodbridge: Antique Collectors' Club, 1986).

17 See *The Gardens of the Nations*, a guidebook to the Rockefeller gardens, available – with other resources – at www.ralphhancock.com.

18 Geoffrey Jellicoe, 'Ronald Tree and the Gardens of Ditchley Park', *Garden History* 10 (1982), 80–91, 83.

19 In another strange turn, the sculpture and the parterre were later returned to Wrest Park, which is now owned by English Heritage and open to the public.

20 Russell Page, *The Education of a Gardener* (1962; London: Collins, 1983), 31.

21 Jellicoe, 'Gardens of Ditchley Park', 90.

22 Osbert Lancaster in *Homes Sweet Homes* (1939), reproduced in Knox, *Cartoons and Coronets*, 129.

23 Sacheverell Sitwell, *Old Fashioned Flowers* (London: Country Life, 1939), 3.

24 John Nash commenting on *Plants with Personality*, in 'The Artist Plantsman' (1976), reprinted in Allen Freer, *John Nash: The Delighted Eye* (Aldershot: Scolar, 1993), 33.

25 See the chapter 'Advanced Gardeners' in Yorke, *Edward Bawden*, 103–15.

26 Nichols, *Unforgiving Minute*, 218; Nichols, *A Village in a Valley*, 262. Nichols describes his small temple in *Green Grows the City: The Story of a London Garden* (London: Cape, 1939).

27 See Allyson Hayward, *Norah Lindsay: The Life and Art of a Garden Designer* (London: Frances Lincoln, 2007).

28 See Elizabeth Coxhead, *Constance Spry: A Biography* (London: Luscombe, 1975).

29 See Edward Wilson, ed., *The Downright Epicure: Essays on Edward Ashdown Bunyard* (Totnes: Prospect, 2007).

30 Edward Bunyard, *Old Roses* (London: Country Life, 1936), 230.

31 C. H. Middleton, *Digging for Victory* (1942; London: Aurum, 2008), 5.

32 'Luxuries' in Middleton, *Digging for Victory*, 188–95; Tim Richardson, *English Gardens in the Twentieth Century* (London: Aurum, 2005), 144–45. Thanks to Clare Hickman for telling me about Mr Middleton's connection with the Sitwells.

33 Helphand, *Defiant Gardens*, 41.

34 Barbara Haynes, 'The Society at War', *The Garden: The Journal of the Royal Horticultural Society*, 129 (2004), 886.

35 Leonard Woolf, *Downhill All the Way: An Autobiography of the Years 1919–1939* (London: Hogarth Press, 1967), 254.

36 Glendinning, *Vita*, 300–1.

37 Vita Sackville-West to Harold Nicolson, 20 January 1937, Lilly Library, quoted in Bunyard, *Downright Epicure*, 51. On her planting at Sissinghurst, see Jane Brown, *Vita's other World: A Gardening Biography of Vita Sackville-West* (1985; London: Penguin, 1987).

38 Vita Sackville-West to Harold Nicolson, 12 December 1939, *Vita and Harold: The Letters of Vita Sackville-West and Harold Nicolson 1910–1962*, ed. Nigel Nicolson (London: Weidenfeld & Nicolson, 1992), 318.

39 Vita Sackville-West, *The Land* (London: Heinemann, 1926; repr. 1941), 96.

40 Harold Nicolson to Vita Sackville-West, 27 May and 4 June 1940, *Vita and Harold*, 322–23.

41 Sackville-West, *The Garden*, 118, 67, 88.

42 Ibid., 93, 25, 90; John Milton *Paradise Lost* (1674), bk. XII, line 648.

43 Sackville-West, *The Garden*, 63.

44 Anon. *Times Literary Supplement*, 15 June 1946, 285.

45 Quoted in the second impression of *The Garden*. See also Church's *Eight for Immortality* (London: Dent, 1941).

11 DREAMING OF MANDERLEY

1 Fussell, *Abroad*, 53.

2 Cunningham, *British Writers of the Thirties*, 'Somewhere the Good Place?', 367–418.

3 Frank Budgen, *James Joyce and the Making of 'Ulysses'* (1934; Bloomington: Indiana University Press, 1960), 67–68.

4 Hastings, *Waugh*: Djibouti, 241, Addis, 339, hammock 272–73.

5 See Pearson, *Façades*, 292.

6 Beverley Nichols, *No Place Like Home* (London: Cape, 1936).

7 'An Odd Lot: A Gallery of Literary Portraits', *Lilliput*, November 1949, 49–56.

8 Auden, 'The month was April' (1933), *English Auden*, 131.

9 Auden, 'O Love' (1932), *English Auden*, 119.

10 Auden, 'The Orators: An English Study' (1932), *English Auden*, 62.

11 Auden, 'The Voyage' (1938), *English Auden*, 231.

12 Waugh, *Vile Bodies*, 15.

13 Ibid., 153, 169, 158.

14 Evelyn Waugh to Tom Balston [July 1929], private collection, quoted Hastings, *Waugh*, 195.

15 Bowen, *To the North*, 66, 63.

16 Ibid., vii, 131.

17 Betjeman, 'Our Padre', *Continual Dew*, 14:
'Our padre is an old sky pilot,
Severely now they've clipped his wings,
But still the flagstaff in the Rect'ry garden
Points to Higher Things.'

18 Bowen, *To the North*, 26, 135, 138.

19 Bowen, *To the North*, 243, 144; places for the dispossessed: Lee, *Elizabeth Bowen*, 73.

20 Bowen, *To the North*, 202.

21 Ibid., 99–100.

22 Lawrence, *Lady Chatterley's Lover*, 5.

23 See Mandler, *Fall and Rise of the Stately Home*, 215–310.

24 Bowen, 'The Disinherited' (1934) in *Collected Stories*, 375–407 (386, 400, 387, 399).

25 Bowen, 'Disinherited', 391, 386.

26 du Maurier, *Rebecca*, 306.

27 du Maurier, 'The House of Secrets' (1946), in *The Rebecca Notebook and other Memories* (Garden City, NY: Doubleday 1980), 36.

28 du Maurier, 'House of Secrets', 34.

29 du Maurier, *Rebecca*, 72.

30 Ibid., 8.

31 Smith, *Over the Frontier*, 241.

32 du Maurier, *Rebecca*, 7–8.

33 Evelyn Waugh to Laura Herbert, October 1935, Waugh, *Letters*, 100.

34 Evelyn Waugh to Diana Cooper, [Feb/March 1937], *Mr Wu and Mrs Stich: The Letters of Evelyn Waugh and Diana Cooper* (London: Sceptre, 1992), 91.

35 Waugh, *Work Suspended*, 108.

36 Ibid., 144–45.

37 Nigel Dennis, 'Evelyn Waugh: The Pillar of Anchorage House', *Partisan Review*, July-August 1943, 350–61 (352).

38 Spender, 'Oh young men' (1933), *New Collected Poems*, 16.

39 Waugh, *Work Suspended*, 194.

40 Stephen Spender, *Journals 1939–1983*, ed. John Goldsmith (London: Random House, 1986), 43.

41 Hoare, *Tennant*, 255.

42 Beaton, *Ashcombe*, preface [n.p.].

12 HOUSE BUILDING

1 Woolf, *Pointz Hall*, 46, 48.

2 Woolf, 'Sketch of the Past' in *Moments of Being*, 124.

3 Woolf, *Moments*, 96.

4 Ibid., 108.

5 Elizabeth Bowen, *The Heat of the Day* (1948; London: Vintage, 1998), 93.

6 Woolf, *Moments*, 110.

7 Ibid., 81.

8 Details from Jeremy Treglown, *Romancing: The Life and Work of Henry Green* (London: Faber, 2000), 124.

9 Green, *Caught*, 26, 67, 62.

10 Green, *Pack My Bag*, 2.

11 Green, *Caught*, 178, 181, 62, 179.

12 Green in 'The Art of Fiction XXII – Henry Green', *Paris Review* 19 (1958), 61–77 (70).

13 Green, *Loving*, 39.

14 Green, *Loving*, 105; Yeats, 'Ancestral Houses' (1922), in *Collected Poems*, 225–26.

15 Neil Corcoran was told about this meeting by local people in 1998, see his *Elizabeth Bowen: The Enforced Return* (Oxford: Oxford University Press, 2004), 25n.

16 Bowen, *Bowen's Court* (1964 afterword), 454.

17 Ibid., 454–55.

18 Ibid., 455.

19 Ibid., 455.

20 Bowen, *Bowen's Court*, 22.

21 Ibid., 343.

22 Ibid., 167.

23 Elizabeth Bowen, 'The Happy Autumn Fields' (1944), in *Collected Stories*, 671–85 (673).

24 Bowen, 'The Happy Autumn Fields', 680.

25 Bowen, 'The Happy Autumn Fields', 684. The bundle of old letters would itself become the protagonist in *A World Of Love* (1955).

26 Elizabeth Bowen, preface to *The Demon Lover* (1945), reprinted in *Mulberry Tree*, 94–99 (95).

13 LITERARY ARCHITECTURE

1 Hastings, *Waugh*, 456ff.
2 Fussell, *Wartime*, 223.
3 Waugh, *Brideshead* (1945 edn), 73.
4 Ibid., 26, 73.
5 Waugh, 'What to do with the Upper Classes: A Modest Proposal' (1946), in *Essays*, 312–16 (313).
6 Waugh, 'Fan-Fare' (1946), in *Essays*, 300–4 (304).
7 Waugh, *Brideshead* (1945 edn), 300; Eliot, 'Burnt Norton', i, 172; Yeats, 'Ancestral Houses' (1922), in *Collected Poems*, 225–26; Waugh, *Brideshead* (1945 edn), 73.
8 Waugh, *Brideshead* (1945 edn), 303; du Maurier, *Rebecca*, 4.
9 Auden, 'Thanksgiving for a Habitat' (1962) in W. H. Auden, *Collected Poems* (London: Faber, 1991), 688.
10 du Maurier, *Rebecca*, 8.
11 Waugh, *Brideshead* (1945 edn), 197.
12 Detailed in Robert Murray Davis, *Evelyn Waugh, Writer* (Norman, OK: Pilgrim, 1981), 179–85.
13 Evelyn Waugh, *Sword of Honour* (1965; London: Penguin, 2001), 628, 613.
14 Waugh, *Brideshead* (1945 edn), 35.
15 Ibid., 199, 73, 198.
16 John Piper to John Betjeman, 23 August 1941, quoted in Jenkins, *John Piper* (1983), 99.
17 Reported in Nichols, *Unforgiving Minute*, 270.
18 Osbert Sitwell, preface to *The Sitwell Country*.
19 John Piper to Osbert Sitwell, 17 April 1940, Osbert Sitwell Papers, Renishaw.
20 Frequency of letters: Osbert Sitwell to John Piper, 3 November 1943, Tate Archive, 200410/1; mutual pleasure: John Piper to Osbert Sitwell, 19 August 1943, Renishaw.
21 Edith Sitwell to John Piper, 18 June 1943, Tate Archive, 200410/1; Osbert Sitwell to John Piper, 24 January 1945, Tate Archive, 200410/1; John Piper, 'Notes on Life at Renishaw', quoted in Ziegler, *Osbert Sitwell*, 259.
22 John Ruskin, 'The Lamp of Memory', in *Seven Lamps*, 193.
23 John Piper, 'Seaton Delaval', *Orion: A Miscellany* 1 (1945), 43–47 (44, 47).
24 C. H. [Christopher Hussey], 'The Twilight of the Great House', *Country Life* 97 (1945), 153.
25 John Piper to Osbert Sitwell, 20 June 1942, Renishaw.
26 Evelyn Waugh to Laura Waugh, 20 June 1942, in Waugh, *Letters*, 163.
27 Osbert Sitwell to David Horner, 29 January 1945, and to William Plomer, 27 January 1945, both quoted in Ziegler, *Osbert Sitwell*, 295.
28 Sitwell, preface to *The Sitwell Country*.
29 Edith Sitwell to Ree Gorer, 21 June 1943, Sitwell, *Selected Letters*, 101.
30 Sitwell, *Left Hand*, I, x.
31 Pearson, *Façades*, 350; Sitwell, *Left Hand*, I, v–vi.
32 Sitwell, *Left Hand*, I, 108–9.
33 Ibid., xiv.
34 Sitwell, *Left Hand*, II, 32; Virginia Woolf to Ethel Smyth, 1 February 1941, Woolf, *Letters*, VI, 466.
35 Sitwell, *Left Hand*, II, 119–20.
36 Sitwell, *Left Hand*, I, 233, 169; Sitwell, *Left Hand*, II, 104.
37 Sitwell, *Left Hand*, I, 8; Pearson, *Façades*, 381–82.
38 Elizabeth Bowen, 'With Silent Friends', *Tatler and Bystander*, 11 April 1945, 54, 56 (56); and *Tatler and Bystander*, 11 September 1946, 342.
39 Henry James, 'The New Novel' (1914), in *Selected Literary Criticism*, ed. Morris Schapira (London: Heinemann, 1963), 311–42 (322).
40 Woolf, 'Modern Fiction' (1925), *Collected Essays*, II, 103–10 (104).

AFTERWORD NEW MAPS

1 'Modernism: Designing a New World 1914–1939', Victoria and Albert Museum, London, 6 April–23 July 2006; Christopher Wilk, 'Introduction: What was Modernism?' in Wilk, *Modernism*, 11–21 (14).
2 Richards, *Memoirs of an Unjust Fella*, 127.
3 'Start the Week', BBC Radio 4, 27 March 2006.
4 Piper, quoted in Rachel Billington, 'Through a Glass Colourfully', *Times*, 24 November 1983, 10.
5 Simon Jenkins 'For a real exhibition of modernism, skip the V&A and go to Manchester', *Guardian*, 7 April 2006; Terence Conran, 'Is Modernism Dangerous?', *Guardian*, 9 April 2006.
6 Wright, *A Journey through Ruins*, 246.
7 Mark Wallinger interviewed by Martin Gayford, *Telegraph*, 13 February 2009.
8 Marina Warner, 'What are Memory Maps?', www.vam.ac.uk.
9 Goshka Macuga, 'Objects in Relation', 2007, nominated for the 2008 Turner Prize.
10 Esty, *A Shrinking Island*, 8.
11 Hauser, *Shadow Sites*, 32.
12 Cunningham, *British Writers of the Thirties*, 341; Conrad, *Modern Times, Modern Places*, 9, 14.
13 Piper, 'Aspects of Modern Drawing', *Signature* 7 (1937), 33–34.

SELECT BIBLIOGRAPHY

Works quoted in the text but not appearing in the bibliography are cited with full publication details in the notes. This applies particularly to shorter articles and works fleetingly alluded to. What follows is intended as an indicative list of major sources.

I. MANUSCRIPT COLLECTIONS

East Sussex Record Office, Lewes (Papers of Eric Ravilious)

Hampshire Record Office, Winchester (Papers of Viscount Lymington)

Renishaw Hall (Correspondence of Osbert Sitwell)

Tate Archive (Collections of Paul Nash, Ben Nicholson, and John Piper)

University of Sussex (The Monk's House Papers)

II. PRIMARY SOURCES

Auden, W. H. *The English Auden: Poems, Essays and Dramatic Writings, 1927–1939*, ed. Edward Mendelson. London: Faber, 1977.

___ *Prose*, ed. Edward Mendelson. 3 vols. London: Faber, 1997–2008.

___ ed. *The Oxford Book of Light Verse*. Oxford: Clarendon Press, 1938.

___ and John Garrett, eds, *The Poet's Tongue: An Anthology*. 2 vols. London: G. Bell & Sons Ltd., 1935.

Baldwin, Stanley. *On England and Other Addresses*. London: Philip Allan & Co., 1933.

___ *This Torch of Freedom: Speeches and Addresses*. London: Hodder & Stoughton, 1935.

Beaton, Cecil. *Ashcombe: The Story of a Fifteen-year Lease*. London: Batsford, 1949.

Bell, Clive. *Art*. 1914. New edn, ed. J. B. Bullen. Oxford: Oxford Univ. Press, 1987.

Bell, Julian. *Essays, Poems and Letters*, ed. Quentin Bell. London: The Hogarth Press, 1938.

Betjeman, John. 1933. *Ghastly Good Taste, or, A Depressing Story of the Rise and Fall of English Architecture*. 1933. National Trust Classics. London: Century Hutchinson, 1986.

___ *Cornwall Illustrated in a Series of Views, of Castles, Seats of the Nobility, Mines, Picturesque Scenery, Towns, Public Buildings, Churches, Antiquities, etc.* Shell Guides. London: Architectural Press, 1934.

___ *Devon: Shell Guide Compiled, with many Illustrations and Information of Every Sort*. Shell Guides. London: Architectural Press, 1936.

___ *Continual Dew: A Little Book of Bourgeois Verse*. London: John Murray, 1937.

___ *An Oxford University Chest*. London: John Miles, 1938.

___ *John Betjeman: Letters 1926–1951*, ed. Candida Lycett Green. London: Methuen, 1994.

___ *Coming Home: An Anthology of his Prose, 1920–77*, ed. Candida Lycett Green. London: Methuen, 1997.

___ *Trains and Buttered Toast: Selected Radio Talks*, ed. Stephen Games. London: John Murray, 2006.

___ and Geoffrey Taylor, eds, *English, Scottish and Welsh Landscape Verse: 1700– c. 1860*. New Excursions into English Poetry. London: Frederick Muller, 1944.

Binyon, Laurence. *English Water-Colours*. London: A. & C. Black, 1933.

Blunden, Edmund. *English Villages*. Britain in Pictures. London: Collins, 1941.

Bowen, Elizabeth. *To the North*. 1932. London: Vintage, 1999.

___ *The Death of the Heart*. 1938. Harmondsworth: Penguin, 1962.

___ *English Novelists*. Britain in Pictures. London: Collins, 1942.

___ *Bowen's Court and Seven Winters*. Published separately 1942. London: Vintage, 1999.

___ *The Collected Short Stories of Elizabeth Bowen*, ed. Angus Wilson. 1980. London: Vintage, 1999.

___ *The Mulberry Tree: Writings of Elizabeth Bowen*, ed. Hermione Lee. 1986. London: Vintage, 1999.

Brandt, Bill. *The English at Home*. London: Batsford, 1936.

___ *A Night in London*. London: Country Life, 1938.

___ *Literary Britain*. 1951. London: Victoria and Albert Museum, 1984.

Britten, Benjamin. *Britten on Music*, ed. Paul Kildea. Oxford: Oxford Univ. Press, 2003.

Cahier Abstraction-Création Art Non-Figuratif. 1932–36. Repr. New York: Arno Press, n.d.

Cecil, David. *The English Poets*. Britain in Pictures. London: Collins, 1941.

Circle: International Survey of Constructive Art, ed. Leslie Martin, Ben Nicholson and Naum Gabo. London: Faber, 1937.

Clark, Kenneth. *The Gothic Revival: An Essay in the History of Taste*. London: Constable, 1928.

___ *Another Part of the Wood: A Self-Portrait*. London: Hamish Hamilton, 1985.

Constable, W. G. and J. G. Mann, *Exhibition of British Art, c. 1000–1860*. London: Royal Academy of Arts, 1934.

Crawford, O. G. S. and Alexander Keiller. *Wessex from the Air*. Oxford: Clarendon Press, 1928.

du Maurier, Daphne. *Rebecca*. 1938. London: Virago, 2003.

Eliot, T. S. *The Idea of a Christian Society*. 1939. London: Faber, 1962.

___ *Selected Prose*, ed. John Hayward. Harmondsworth: Penguin, 1953.

___ *On Poetry and Poets*. London: Faber, 1957.

___ *The Complete Poems and Plays*. London: Faber, 1969.

Evans, Myfanwy. [See Piper, Myfanwy]

Forster, E. M. *Howards End*. 1910. Ed. Oliver Stallybrass. London: Penguin, 2000.

___ *Two Cheers for Democracy*. 1951. Harmondsworth: Penguin, 1965.

___ *Abinger Harvest and England's Pleasant Land*, ed. Elizabeth Hine. London: André Deutsch, 1996.

Fry, Roger. *Vision and Design.* 1920. ed. J. B. Bullen. Mineola, NY: Dover, 1998.

___ *Duncan Grant.* Hogarth Living Painters. 1923. New ed. London: Hogarth Press, 1930.

___ *Reflections on British Painting.* London: Faber, 1934.

___ *Last Lectures,* ed. Kenneth Clark. Cambridge: Cambridge Univ. Press, 1939.

___ *A Roger Fry Reader,* ed. Christopher Reed. Chicago: Univ. of Chicago Press, 1996.

___ *Letters of Roger Fry,* ed. Denys Sutton. 2 vols. London: Chatto & Windus, 1972.

Graves, Robert and Alan Hodge. *The Long Week-end: A Social History of Great Britain 1918–1939.* London: Faber, 1940.

Gray, Nicolete. *XIXth Century Ornamented Types and Title Pages.* London: Faber, 1938.

Green, Henry. *Party Going.* 1939. London: Vintage, 2000.

___ *Pack My Bag: A Self-Portrait.* 1940. London: Vintage, 2001.

___ *Caught.* 1943. London: Harvill Press, 2001.

___ *Loving.* 1945. London: Vintage, 2000.

Greene, Graham. *Brighton Rock.* 1938. London: Vintage, 2004.

___ *British Dramatists.* Britain in Pictures. London: Collins, 1942.

Grigson, Geoffrey. *Several Observations: Thirty Five poems.* London: Cresset Press, 1939.

___ *Under the Cliff and Other Poems.* London: Routledge, 1943.

___ *The Crest on the Silver: An Autobiography.* London: Cresset Press, 1950.

___ *Blessings, Kicks and Curses: A Critical Collection.* London: Allison and Busby, 1982.

___ *Recollections, Mainly of Writers and Artists.* London: Chatto & Windus, 1984.

___ ed. *The Romantics: An Anthology Chosen by Geoffrey Grigson.* 1942. London: Routledge, 1943.

Grigson, Jane. *English Food.* 1974. London: Penguin, 1993.

Harvey Darton, H. J. *English Fabric: A Study of Village Life.* London: George Newnes, 1935.

Hennell, Thomas. *British Craftsmen.* Britain in Pictures. London: Collins, 1943.

The Hogarth Letters, ed. Hermione Lee. London: Chatto & Windus, 1985.

Hussey, Christopher. *The Picturesque: Studies in a Point of View.* London: Putnam, 1927.

Ironside, Robin. *Painting Since 1939.* The Arts in Britain 6. London: Longmans, Green & Co., 1947.

Kipling, Rudyard. *A Choice of Kipling's Verse,* ed. and with an essay by T. S. Eliot. 1941. Repr. London: Faber, 1963.

Kitson, Sydney D. *The Life of John Sell Cotman.* London: Faber, 1937.

Lambert, R. S., ed., *Art in England.* Harmondsworth: Penguin, 1938.

Lawrence, D. H. *Lady Chatterley's Lover.* 1928. London: Penguin, 1993.

Leavis, F. R. *For Continuity.* Cambridge: Minority Press, 1933.

___ *Revaluation: Tradition and Development in English Poetry.* London: Chatto & Windus, 1936.

___ *The Living Principle: 'English' as a Discipline of Thought.* London: Chatto & Windus, 1975.

___ and Denys Thompson. 1933. *Culture and Environment:* London: Chatto & Windus, 1942.

Le Corbusier. *Towards a New Architecture.* 1923. Trans. Frederick Etchells. London: John Rodker, 1927.

___ *The Decorative Art of Today.* 1925. Trans. James Dunnett. Cambridge, MA: MIT Press, 1987.

Lees-Milne, James. *Another Self.* 1970. London: John Murray, 1998.

___ *Prophesying Peace.* London: Faber, 1977.

Loos, Adolf. *Ornament and Crime: Selected Essays,* ed. Adolf Opel, trans. Michael Mitchell. Riverside, CA: Ariadne Press, 1998.

Lowinsky, Ruth. *Lovely Food: A Cookery Notebook.* London: The Nonesuch Press, 1931.

Lymington, Viscount. *Alternative to Death: the Relationship between Soil, Family and Community.* London: Faber, 1943.

Massingham, H. J. *Downland Man.* London: Cape, 1926.

___ *English Downland.* The Face of Britain. London: Batsford, 1936.

___ *Genius of England.* London: Chapman & Hall, 1937.

___ *Country Relics.* Cambridge: Cambridge Univ. Press, 1939.

___ *Remembrance: An Autobiography.* London: Batsford, 1941.

___ ed. *England and the Farmer.* London: Batsford, 1941.

Mitford, Nancy. *The Pursuit of Love.* 1945. Repr. Harmondsworth: Penguin, 1949.

Nash, Paul. *Dorset.* Shell Guides. London: Faber, 1936.

___ *Outline: An Autobiography, and Other Writings,* ed. Herbert Read. London: Faber, 1949.

___ *Paul Nash: Writings on Art,* ed. Andrew Causey. Oxford: Oxford Univ. Press, 2000.

Nichols, Beverley. *A Thatched Roof.* London: Cape, 1933.

___ *A Village in a Valley.* London: Cape, 1934.

___ *The Unforgiving Minute: Some Confessions from Childhood to the Outbreak of the Second World War.* London: W. H. Allen, 1978.

Olivier, Edith. *Without Knowing Mr Walkley: Personal Memories.* London: Faber, 1938.

___ *In Pursuit of Rare Meats: A Guide to the Duchy of Epicurania, with some Account of the Famous Expedition.* London: Tate, 1954.

Oppé, A. P. *The Water-Colour Drawings of John Sell Cotman.* London: The Studio, 1923.

Orwell, George. *Coming up for Air.* 1939. London: Penguin, 1990.

___ *The Collected Essays, Journalism and Letters of George Orwell,* ed. Sonia Orwell and Ian Angus. 4 vols. 1968. Harmondsworth: Penguin, 1970.

Palmer, Arnold. *Recording Britain.* 4 vols. Oxford: Oxford Univ. Press, 1946–49.

Pevsner, Nikolaus. *The Englishness of English Art.* London: Architectural Press, 1956.

Piper, John. *Oxon.* Shell Guides. London: Faber, 1938.

___ *Brighton Aquatints.* London: Duckworth, 1939.

___ *British Romantic Artists.* Britain in Pictures. London: Collins, 1942.

___ *Buildings and Prospects.* London: Architectural Press, 1948.

Piper, Myfanwy, ed. *The Painter's Object.* London: Gerald Howe, 1937.

___ ed. *Sea Poems.* New Excursions into English Poetry. London: Frederick Muller, 1944.

___ ed. *The Pavilion: A Contemporary Collection of British Art and Architecture.* London: I. T. Publications and Gerald Duckworth, 1946.

Priestley, J. B. *English Journey.* 1934. London: Folio, 1997.

Quiller-Couch, Arthur, ed. *The Oxford Book of English Verse 1250–1918.* 1900. New edn. Oxford: Clarendon Press, 1939.

Ravilious, Eric. *Ravilious at War: The Complete Work of Eric Ravilious, September 1939 – September 1942,* ed. Anne Ullmann. Huddersfield: Fleece Press, 2002.

Read, Herbert. *Annals of Innocence and Experience.* London: Faber, 1940.

___ ed. *The English Vision: An Anthology.* 1933. London: Routledge, 1939.

___ ed. *Surrealism.* London: Faber, 1936.

___ ed. *The Knapsack: A Pocket Book of Verse and Prose.* London: Routledge, 1939.

Richards, J. M. *Edward Bawden.* Penguin Modern Painters. Harmondsworth: Penguin, 1946.

___ *Memoirs of an Unjust Fella.* London: Weidenfeld & Nicolson, 1980.

Ruskin, John. *The Seven Lamps of Architecture.* 1849. New York: Dover, 1989.

___ *Selected Writings,* ed. Dinah Birch. Oxford: Oxford Univ. Press, 2004.

Sackville-West, Vita. *English Country Houses.* Britain in Pictures. London: Collins, 1941.

___ *The Garden.* London: Michael Joseph, 1946.

Sitwell, Edith. *Alexander Pope.* London: Faber, 1930.

___ *Bath.* London: Faber, 1932.

___ *The English Eccentrics.* London: Faber, 1933.

___ *Taken Care Of: An Autobiography.* London: Hutchinson, 1965.

___ *Selected Letters,* ed. John Lehmann and Derek Parker. London: Macmillan, 1970.

Sitwell, Osbert. *The Sitwell Country.* London: Leicester Galleries, 1945.

___ *Left Hand, Right Hand!* 5 vols. London: Macmillan, 1945–50.

___ , Edith Sitwell and Sacheverell Sitwell. *Trio: Dissertations on Some Aspects of the National Genius.* London: Macmillan, 1938.

Sitwell, Sacheverell. *Southern Baroque Art.* London: G. Richards, 1924.

___ *Narrative Pictures: A Survey of English Genre and its Painters.* London: Batsford, 1937.

___ *Old Fashioned Flowers.* London: Country Life, 1939.

___ *British Architects and Craftsmen: A Survey of Taste, Design and Style during Three Centuries, 1600–1830.* London: Batsford, 1945.

Smith, Stevie. *Novel on Yellow Paper.* 1936. London: Virago, 1980.

___ *Over the Frontier.* 1938. London: Virago, 1980.

___ *The Collected Poems of Stevie Smith.* London: Allen Lane, 1975.

Spender, Stephen. *The Destructive Element: A Study of Modern Writers and Beliefs.* London: Cape, 1935.

___ *New Collected Poems,* ed. Michael Brett. London: Faber, 2004.

Steegman, John. *The Rule of Taste, from George I to George IV.* London: Macmillan, 1936.

Strachey, Lytton. *Queen Victoria.* 1921. Harmondsworth: Penguin, 1971.

___ *Portraits in Miniature.* London: Chatto & Windus, 1931.

___ *Characters and Commentaries.* London: Chatto & Windus, 1933.

Thompson, Flora. *Lark Rise to Candleford.* 1945. Harmondsworth: Penguin, 1973.

Tunnard, Christopher. *Gardens in the Modern Landscape.* London: Architectural Press, 1938.

Vaughan Williams, Ralph. *National Music and Other Essays.* Oxford: Oxford Univ. Press, 1934.

Warner, Rex. *The Aerodrome: A Love Story.* 1941. New edn. London: Bodley Head, 1966.

Waugh, Evelyn. *Rossetti: His Life and Work.* London: Duckworth, 1928.

___ *Decline and Fall.* 1928. Harmondsworth: Penguin, 1937.

___ *Labels.* 1930. London: Penguin, 1985.

___ *Vile Bodies.* 1930. London: Penguin, 1996.

___ *A Handful of Dust.* 1934. Harmondsworth: Penguin, 1951.

___ *Work Suspended and Other Stories.* 1943. London: Penguin, 2000.

___ *Brideshead Revisited: The Sacred and Profane Memories of Captain Charles Ryder: A Novel.* London: Chapman & Hall, 1945.

___ *Brideshead Revisited: The Sacred and Profane Memories of Captain Charles Ryder.* Rev. edn., 1959. Harmondsworth: Penguin, 1962.

___ *The Letters of Evelyn Waugh,* ed. Mark Amory. London: Weidenfeld & Nicolson, 1980.

___ *The Essays, Articles and Reviews of Evelyn Waugh,* ed. Donat Gallagher. London: Methuen, 1983.

Wavell, Archibald Percival, ed. *Other Men's Flowers: An Anthology of Poetry.* 1944. London: Pimlico, 1992.

White, Florence. *Good Things in England.* 1932. London: Futura, 1974.

White, Gilbert. *The Writings of Gilbert White of Selborne,* ed. H. J. Massingham. 2 vols. London: The Nonesuch Press, 1938.

Williams-Ellis, Clough, ed. *Britain and the Beast.* London: Dent, 1937.

Woolf, Leonard. *Downhill all the Way: An Autobiography of the Years 1919–1939.* London: Hogarth Press, 1967.

Woolf, Virginia. *Orlando*. 1928. New edn.,
ed. Rachel Bowlby. Oxford: Oxford Univ.
Press, 1998.

___ *The Waves*. 1931. Ed. Gillian Beer. Oxford:
Oxford Univ. Press, 1992.

___ *The Years*. 1937. Ed. Jeri Johnson. London:
Penguin, 1998.

___ *Roger Fry: A Biography*. 1940. London: Vintage,
2003.

___ *Between the Acts*. 1941. Ed. Gillian Beer. London:
Penguin, 1992.

___ *Collected Essays*, ed. Leonard Woolf. 4 vols.
London: Chatto & Windus, 1966–67.
[The standard edition of the essays is now
The Essays of Virginia Woolf. Vols 1–3, ed.
Andrew McNeillie; Vols 4–5 ed. Stuart N.
Clarke. London: Hogarth Press, 1986–present.
As the final volume covering the late 1930s
has not yet been published, I have used *Collected
Essays* throughout.]

___ *The Letters of Virginia Woolf*, ed. Nigel Nicolson,
assisted by Joanne Trautmann. 6 vols. London:
Hogarth Press, 1975–80.

___ *Moments of Being*, ed. Jeanne Schulkind. 1976.
Revised by Hermione Lee. London: Pimlico,
2002.

___ '"Anon" and "The Reader": Virginia Woolf's
Last Essays', ed. Brenda Silver, *Twentieth Century
Literature*, 25 (1979), 356–441.

___ *The Diary of Virginia Woolf*, ed. Anne Olivier Bell,
assisted by Andrew McNeillie. 5 vols (1977–84).
Harmondsworth: Penguin, 1979–85.

___ *Pointz Hall: The Earlier and Later Typescripts
of 'Between the Acts'*, ed. Mitchell A. Leaska.
New York: University Publications, 1983.

Yeats, W. B. *Collected Poems*. London: Macmillan, 1995.

III. SECONDARY SOURCES

Allen, Brian. *Towards a Modern Art World*, Studies
in British Art I. London: Yale Univ. Press, 1995.

Amory, Mark. *Lord Berners: The Last Eccentric*.
London: Chatto & Windus, 1998.

Arnold, Dana. *Cultural Identities and the Aesthetics
of Britishness*. Manchester: Manchester Univ.
Press, 2004.

Bell, Quentin. *Virginia Woolf: A Biography*. 2 vols.
London: Hogarth Press, 1972.

Binyon, Helen. *Eric Ravilious: Memoir of an Artist*.
Guildford: Lutterworth Press, 1983.

Boxer, Arabella. *Arabella Boxer's Book of English Food:
A Rediscovery of British Food from Before the War*.
1991. London: Penguin, 1993.

Boyes, Georgina. *The Imagined Village: Culture,
Ideology and the English Folk Revival*. Manchester:
Manchester Univ. Press, 1993.

Bradford, Sarah, et al. *The Sitwells and the Arts of
the 1920s and 1930s*. London: National Portrait
Gallery, 1994.

Brown, Jane. *The Modern Garden*. London:
Thames & Hudson, 2000.

Button, Virginia Mary. 'The Aesthetic of Decline:
English Neo-Romanticism *c.* 1935–56'.
Unpublished Ph.D. thesis, Courtauld Institute
of Art, London, 1992.

Calder, Angus. *The Myth of the Blitz*. London:
Cape, 1991.

Calloway, Stephen. *Rex Whistler: The Triumph
of Fancy*. Brighton: Brighton Royal Pavilion,
Libraries and Museums, 2006.

Christie, Ian. *Arrows of Desire: The Films of Michael
Powell and Emeric Pressburger*. London:
Faber, 1994.

Conrad, Peter. *To Be Continued: Four Stories and their
Survival*. Oxford: Clarendon Press, 1995.

___ *Modern Times, Modern Places: Life and Art in the
20th Century*. London: Thames & Hudson, 1998.

Corbett, David Peters et al. eds, *The Geographies of
Englishness: Landscape and the National Past*.
Studies in British Art 10. London: Yale Univ.
Press, 2002.

Core, Philip. *The Original Eye: Arbiters of Twentieth-
Century Taste*. London: Quartet, 1984.

Cunningham, Valentine. *British Writers of the Thirties*.
Oxford: Oxford Univ. Press, 1988.

Delany, Paul. *Bill Brandt: A Life*. London: Cape, 2004.

Denton, Pennie. *Seaside Surrealism: Paul Nash in
Swanage*. Swanage: Peveril Press, 2002.

Elborn, Geoffrey, ed. *To John Piper on his Eightieth
Birthday*. London: Hodder & Stoughton, 1983.

Ellis, Steve. *The English Eliot: Design, Language
and Landscape in 'Four Quartets'*. London:
Routledge, 1991.

Esty, J. D. *A Shrinking Island: Modernism and National
Culture in England*. Princeton: Princeton Univ.
Press, 2004.

Foss, Brian. *War Paint: Art, War, State and Identity
in Britain, 1939–1945*. London: Yale Univ.
Press, 2007.

Fussell, Paul. *Abroad: British Literary Travelling Between
the Wars*. 1980. Oxford: Oxford Univ. Press, 1982.

___ *Wartime: Understanding and Behaviour in the Second
World War*. Oxford: Oxford Univ. Press, 1989.

Gervais, David. *Literary Englands: Versions of
'Englishness' in Modern Writing*. Cambridge:
Cambridge Univ. Press, 1993.

Glendinning, Victoria. *Elizabeth Bowen: Portrait
of a Writer*. 1977. London: Penguin, 1985.

___ *Edith Sitwell: A Unicorn Among Lions*. London:
Weidenfeld & Nicolson, 1981.

Green, Christopher. *Art in France 1900–1940*.
London: Yale Univ. Press, 2000.

Hamilton, James. *Wood Engraving and the Woodcut
in Britain c. 1890–1990*. London: Barrie &
Jenkins, 1994.

Hammer, Martin. *Graham Sutherland: Landscapes, War
Scenes, Portraits 1924–1950*. London: Scala, 2005.

Harrison, Charles. *English Art and Modernism,
1900–1939*. 1981. Second edn. London: Yale
Univ. Press, 1994.

Hastings, Selina. *Evelyn Waugh: A Biography*. 1994.
London: Vintage, 2002.

Hauser, Kitty. *Shadow Sites: Photography, Archaeology and the British Landscape 1927–1955.* Oxford: Oxford Univ. Press, 2007.

Helphand, Kenneth I. *Defiant Gardens: Making Gardens in Wartime.* San Antonio: Trinity Univ. Press, 2006.

Hewison, Robert. *Under Siege: Literary Life in London, 1939–1945.* London: Weidenfeld & Nicolson, 1977.

Hillier, Bevis. *Betjeman: New Fame, New Love.* London: John Murray, 2002.

Ingrams, Richard, and John Piper. *Piper's Places.* London: Chatto & Windus, 1983.

Jenkins, David Fraser. *John Piper.* London: Tate, 1983.

___ *John Piper: The Forties.* London: Philip Wilson and Imperial War Museum, 2000.

___ and Frances Spalding. *John Piper in the 1930s: Abstraction on the Beach.* London: Merrell, 2003.

Khoroche, Peter. *Ivon Hitchens.* London: André Deutsch, 1990.

Knox, James. *Cartoons and Coronets: The Genius of Osbert Lancaster.* London: Frances Lincoln, 2009.

Lee, Hermione. *Virginia Woolf.* London: Chatto & Windus, 1996; London: Vintage, 1997.

___ *Elizabeth Bowen.* 1981. Revised edn. London: Vintage, 1999.

Lewison, Jeremy, ed. *Circle: Constructive Art in Britain 1934–40.* Cambridge: Kettle's Yard Gallery, 1982.

Light, Alison. *Forever England: Femininity, Literature and Conservatism between the Wars.* London: Routledge, 1991.

Lubbock, Jules. *The Tyranny of Taste: The Politics of Architecture and Design in Britain 1550–1960.* London: Yale Univ. Press, 1995.

MacCarthy, Fiona. *Stanley Spencer: An English Vision.* London: Yale Univ. Press, 1997.

MacLeod, Michael. *Thomas Hennell: Countryman, Artist and Writer.* Cambridge: Cambridge Univ. Press, 1988.

Mandler, Peter. *The Fall and Rise of the Stately Home.* London: Yale Univ. Press, 1997.

___ *The English National Character.* London: Yale Univ. Press, 2006.

Matless, David. *Landscape and Englishness.* London: Reaktion, 1998.

Mellor, David. *Paradise Lost: The Neo-Romantic Imagination in Britain 1935–55.* London: Lund Humphries, 1987.

Mengham, Rod. *The Idiom of the Time: The Writings of Henry Green.* Cambridge: Cambridge Univ. Press, 1982.

Mowl, Timothy. *Stylistic Cold Wars: Betjeman versus Pevsner.* London: John Murray, 2000.

Pearson, John. *Façades: Edith, Osbert and Sacheverell Sitwell.* London: Macmillan, 1978.

Pepper, Terence, Roy Strong and Peter Conrad. *Beaton Portraits.* London: National Portrait Gallery, 2004.

Piette, Adam. *Imagination at War: British Fiction and Poetry, 1939–1945.* London: Papermac, 1995.

Powers, Alan. *Oliver Hill: Architect and Lover of Life 1887–1968.* London: Mouton, 1989.

___ *Eric Ravilious: Imagined Realities.* London: Philip Wilson, 2004.

___ *Serge Chermayeff: Designer, Architect, Teacher.* London: RIBA, 2007.

Samuel, Raphael. *Island Stories: Unravelling Britain,* ed. Alison Light with Sally Alexander and Gareth Stedman Jones. London: Verso, 1998.

The Shell Poster Book. London: Profile, 1998.

Sillars, Stuart. *British Romantic Art of the Second World War.* London: Macmillan, 1991.

Spalding, Frances. *Roger Fry: Art and Life.* 1980. New edn. Norwich: Black Dog, 1999.

___ *Stevie Smith: A Biography.* 1988. New edn. Stroud: Sutton, 2002.

___ *John Piper, Myfanwy Piper: Lives in Art.* Oxford: Oxford Univ. Press, 2009.

Stansky, Peter, and William Abrahams. *London's Burning: Life, Death and Art in the Second World War.* London: Constable, 1994.

Trant, Carolyn. *Art for Life: The Story of Peggy Angus.* Oldham: Incline Press, 2005.

Varnedoe, Kirk. *A Fine Disregard: What Makes Modern Art Modern.* London: Thames & Hudson, 1990.

West, Anthony. *John Piper.* London: Secker and Warburg, 1979.

Whistler, Laurence. *The Laughter and the Urn: The Life of Rex Whistler.* London: Weidenfeld & Nicolson, 1985.

Wilk, Christopher, ed. *Modernism: Designing a New World 1914–1939.* London: V&A Publishing, 2006.

Williamson, Philip. *Stanley Baldwin: Conservative Leadership and National Values.* Cambridge: Cambridge Univ. Press, 1999.

Wright, Patrick. *On Living in an Old Country: The National Past in Contemporary Britain.* London: Verso, 1985.

___ *A Journey through Ruins: The Last Days of London.* London: Radius, 1991.

___ *The Village that Died for England: The Strange Story of Tyneham.* London: Faber, 2002.

Yorke, Malcolm. *The Spirit of Place: Nine Neo-Romantic Artists and their Times.* London: Tauris Parke, 2001.

___ *Edward Bawden and His Circle: The Inward Laugh.* Woodbridge: Antique Collectors' Club, 2007.

Ziegler, Philip. *Osbert Sitwell: A Biography.* London: Pimlico, 1999.

ACKNOWLEDGMENTS

I am deeply grateful to Hermione Lee, who inspired me in the first place, supervised my doctorate, and who has buoyed me up ever since with her huge energy for art and life; I could not have written this without her. I would also like to thank Peter Conrad for his support and conviction, and for showing me how exhilarating reading can be. Jamie Camplin made a leap of faith in commissioning this book and it has been a privilege to work with him. My thanks to everyone at Thames & Hudson, but especially to Katie Morgan for organizing the wonderful pictures, and to my editor, Diana Bullitt Perry, for her great attentiveness, sanity and good judgment.

I have been extremely fortunate in the advice and encouragement of friends and teachers. My warm thanks to Scarlett Baron, Sally Bayley, Andrew Blades, Dinah Birch, Grace Brockington, Carolyn Burdett, Jessica Feather, Kathryn Holland, Sheila Hurley, William May, Ben Morgan, Christopher Stephens and Chris and Sue Venning. Lara Feigel piled her communist newspapers next to my books on country houses, chivvied me along, and took every opportunity to remind me how much of the 1930s I was leaving out. Steven Martin tried to tell me about church music; Felicity James helped with the food chapter and cheered me up no end. Hattie Drummond and Rosie Jarvie at Christie's gave me a wonderful introduction to watercolours, and Chloë Blackburn has continued to nurture my interest in English painting. David Bradshaw, Christopher Green and Nigel Thompson helped me gather my thoughts at an early stage in this project. Christopher Butler and Thomas Karshan read my work and vigorously held me to account. Frances Spalding examined my doctoral thesis with great insight and generosity and pointed the way towards a book. Many thanks to all.

It all took time and cost money. I am very grateful to the Arts and Humanities Research Council for funding my graduate study. My thanks also go to Christ Church, the English Faculty at Oxford, and the School of English at Liverpool for small grants and invaluable support.

I am grateful to Peter Lang for allowing me to include in chapter 4 a revised version of the essay on Victorian taste which appeared in *Strange Sisters: Literature and Aesthetics in the Nineteenth Century* (2009), and to Stuart Clarke for allowing me to include in chapter 7 some material which first appeared in the *Virginia Woolf Bulletin*, issue 31 (2009). I would like to thank the following for giving me permission to quote unpublished material and work in copyright: Faber and Faber for W. H. Auden; Faber and Faber on behalf of Mrs Valerie Eliot for T. S. Eliot; Harcourt for T. S. Eliot; David Higham Associates for Edith Sitwell, Osbert Sitwell and Geoffrey Grigson; Clarissa Lewis for John and Myfanwy Piper; Vanessa Nicolson for Ben Nicolson; Random House America for W. H. Auden; The Society of Authors for Virginia Woolf; and Anne Ullmann for Eric Ravilious.

Special thanks to Jane Lewis who first took me on a pilgrimage, and to my oldest friend Caroline Garrett, who was there at Hafod, East Coker, and Toller Fratrum. My father does not have much truck with literary excursions but he showed me how to look at things close to home and he has been the mainstay throughout. This book is for him and for my mother, who I hope would have liked it.

'Consider', copyright 1934 and renewed 1962 by W. H. Auden, 'Letter to Lord Byron', copyright 1937 by W. H. Auden, 'A Voyage', 'Thanksgiving for a Habitat', copyright © 1963 by W. H. Auden, 'September 1, 1939', copyright 1940 and renewed 1968 by W. H. Auden, from *Collected Poems of W. H. Auden*, copyright © 1976 by Edward Mendelson, William Meredith and Monroe K. Spears, Executors of the Estate of W. H. Auden. Used by permission of Random House, Inc. Excerpt from 'Burnt Norton' in *Four Quartets* by T. S. Eliot, copyright 1936 by Harcourt, Inc. and renewed 1964 by T. S. Eliot, reprinted by permission of Houghton Mifflin Harcourt Publishing Company. Excerpt from 'East Coker' in *Four Quartets*, copyright 1940 by T. S. Eliot and renewed 1968 by Esme Valerie Eliot, reprinted by permission of Houghton Mifflin Harcourt Publishing Company. Excerpt from 'The Dry Salvages' in *Four Quartets*, copyright 1941 by T. S. Eliot and renewed 1969 by Esme Valerie Eliot, reprinted by permission of Houghton Mifflin Harcourt Publishing Company. Excerpt from 'Little Gidding' in *Four Quartets*, copyright 1942 by T. S. Eliot and renewed 1970 by Esme Valerie Eliot, reprinted by permission of Houghton Mifflin Harcourt Publishing Company. Excerpts from *Murder in the Cathedral* by T. S. Eliot, copyright 1935 by Harcourt, Inc. and renewed 1963 by T. S. Eliot, reprinted by permission of Houghton Mifflin Harcourt Publishing Company. 'The Metaphysical Poets' and 'Yeats' from *Selected Prose of T. S. Eliot*, copyright © 1975 by Valerie Eliot, Introduction and notes copyright © 1975 by Frank Kermode, reprinted by permission of Houghton Mifflin Harcourt Publishing Company. Excerpt from *The Idea of a Christian Society*, copyright 1939 by T. S. Eliot and renewed 1967 by Esme Valerie Eliot, reprinted by permission of Houghton Mifflin Harcourt Publishing Company.

Lines quoted from the following works by W. H. Auden are reprinted by permission of Faber and Faber Ltd: 'Consider this and in our time', 1930, in *The English Auden*, ed. Edward Mendelson (1977), p. 46; 'The month was April', 1933, *The English Auden*, p. 131; 'O Love', 1932, *The English Auden*, p. 119; 'Letter to Lord Byron', 1937, *The English Auden*, p. 199; 'The Voyage', 1938, *The English Auden*, p. 231; 'Thanksgiving for a Habitat', 1962, in W. H. Auden, *Collected Poems* (Faber and Faber, 1976, rev. edn 1991), p. 687; 'The Orators: An English Study', 1932, *The English Auden*, p. 62; 'Manifesto on the Theatre', in *The English Auden*, p. 273; Introduction to 'Slick but not Streamlined', in *W. H. Auden: Prose*, ed. Edward Mendelson, vol. 2 (Faber and Faber, 2002), pp. 303–07; Preface to *The Oxford Book of Light Verse* (Clarendon Press, 1938). Lines quoted from the following works by T. S. Eliot are reprinted by permission of Faber and Faber Ltd: 'The Waste Land', in *T. S. Eliot: The Complete Poems and Plays* (Faber and Faber, 1969); 'Burnt Norton', in *T. S. Eliot: The Complete Poems...*; 'East Coker', in *T. S. Eliot: The Complete Poems...*; 'Dry Salvages', in *T. S. Eliot: The Complete Poems...*; 'Little Gidding', in *T. S. Eliot: The Complete Poems...*; 'The Metaphysical Poets', in *T. S. Eliot: Selected Prose* (Penguin, 1953), pp. 111–121; 'Yeats', in *T. S. Eliot: Selected Prose*, pp. 248–57; Introduction to *A Choice of Kipling's Verse*, ed. T. S. Eliot (Faber and Faber, 1941); *The Idea of a Christian Society* (Faber and Faber, 1939; repr. 1962); 'Commentary', *Criterion*, 18 (1938), 58–62; *Murder in the Cathedral*, in *T. S. Eliot: The Complete Poems and Plays*, pp. 237–82; 'The Social Function of Poetry', 1943, *On Poetry and Poets* (Faber and Faber, 1957), pp. 3–8.

SOURCES OF ILLUSTRATIONS

Measurements are given in centimetres (with inches in brackets).

Endpapers Edward Bawden, *Tree and Cow* wallpaper design, 1927. Lithograph after linocut, 87 x 54 (34 ¼ x 21 ¼). Courtesy the Trustees, Cecil Higgins Art Gallery, Bedford, England. © The Estate of Edward Bawden **Frontispiece** Edward McKnight Kauffer, *How Bravely Autumn Paints upon the Sky*, 1938. London Transport poster, 101.6 x 63.5 (40 x 25). Photo © Swim Ink 2, LLC/Corbis. © Simon Rendall **p. 8** The Church of St Basil, Toller Fratrum, Dorset. Photo © Robin Adeney **p. 9** John Piper, *The Font at Toller Fratrum*, 1936. Screenprint on paper, 50.2 x 69.8 (19 ¾ x 27 ½). Photo Tate, London 2011. © The Piper Estate **p. 13** John Piper, *Dungeness*, 1938. Collage, blotting paper, lithographs and coloured paper with black ink, 50 x 38 (19 ¹¹/₁₆ x 15). Private Collection. Photo Matthew Hollow © The Piper Estate **p. 17** Installation photograph of the *Abstract & Concrete* exhibition, Oxford 1936. Photo Nicolete Gray **p. 18** Ben Nicholson, *1934 (White Relief, Circle & Square)*, 1934. Oil on carved board, 34.9 x 61 (13 ¾ x 24). Private Collection. © Angela Verren Taunt 2011. All rights reserved, DACS **p. 23** Paul Nash, *Equivalents for the Megaliths*, 1935. Oil on canvas, 45.7 x 66 (18 x 26). © Tate, London 2011 **p. 24** Ivon Hitchens, *Triangle to Beyond*, 1936. Oil on wood and canvas, 76.2 x 50.8 (30 x 20). Photo Tate, London 2011. © The Estate of Ivon Hitchens **p. 27** Ivon Hitchens, *The Caravan, Greensleeves, c.* 1941. Oil on canvas, 46 x 51 (18 x 20). Photo courtesy Jonathan Clark Fine Art, London. © The Estate of Ivon Hitchens **p. 28** Jean Hélion, *Au cycliste*, 1939. Oil on canvas, 132 x 180.5 (52 x 71 ⅛). Photo Scala, Florence/Centre Pompidou, Musée National d'Art Moderne, Paris 2011. © ADAGP, Paris and DACS, London 2011 **p. 31** John Piper, *Painting*, 1935. Oil on canvas on board, 39.4 x 29.2 (15 ½ x 11 ½). National Museums and Galleries of Wales, Cardiff. © The Piper Estate **p. 32** John Piper, *Prehistory from the Air*, in *Axis*, Vol. 8, 1937. Photo Bodleian Library, University of Oxford (Per. 1701 d.177, pp. 7–8). Piper: © The Piper Estate. Miro: © Succession Miro/ADAGP, Paris and DACS, London 2011 **p. 34** John Piper, *Breakwaters at Seaford*, 1937. Collage, ink and gouache, 37.8 x 48.3 (14 ⅞ x 19). Calder Foundation, New York. © The Piper Estate **p. 35** John Piper, *Archaeological Wiltshire*, 1936–37. Ink, watercolour, gouache and collage with blotting paper, 41.2 x 53 (16 ½ x 21). Scottish National Gallery of Modern Art, Edinburgh. © The Piper Estate **p. 39** The Lawn Road flats, Hampstead, *c.* 1950. Photo John Maltby. © Pyroc. Courtesy the University of East Anglia, Pritchard Papers Collection **p. 40** Interior of the Lawn Road flats, Hampstead, *c.* 1950. Courtesy the University of East Anglia, Pritchard Papers Collection **p. 46** Eric Ravilious, *Tea at Furlongs*, 1939. Watercolour on paper, 45.8 x 56 (18 x 22). Private Collection. © Estate of Eric Ravilious. All Rights Reserved, DACS 2011 **p. 49** J. D. M. Harvey, *The British Pavilion in Paris*, 1937. Pencil and watercolour on paper, 57 x 76 (22 ½ x

29 ⅞). Photo RIBA Library Drawings Collection, London. By permission of Professor P. D. A. Harvey **p. 50** László Moholy-Nagy, *In Broad Street*, photograph for John Betjeman's *An Oxford University Chest*, 1937, opposite p. 80. © Hattula Moholy-Nagy/DACS 2011 **p. 51** László Moholy-Nagy, *The Ashmolean Museum & Taylorian*, photograph for John Betjeman's *An Oxford University Chest*, 1937, opposite p. 19. © Hattula Moholy-Nagy/DACS 2011 **p. 55** John Piper, *Mixed Styles: Regency – Victorian – Modern*, 1939. Aquatint for *Brighton Aquatints*, 1939 19.6 x 27.6 (10 x 15). Private Collection. Photo Matthew Hollow © The Piper Estate **p. 61** The Midland Hotel, Morecambe. Courtesy the Collection of the Friends of the Midland Hotel **p. 62** Eric and Tirzah Ravilious, *Night*, at the Midland Railway Hotel, Morecambe, 1933. Now destroyed. Photo Architectural Review 1933. © Estate of Eric and Tirzah Ravilious. All Rights Reserved, DACS 2011 **p. 67** John Piper, *Lower Pirian Falls, Hafod*, 1939. Ink, watercolour and gouache, 38.1 x 45.7 (15 x 18). Private Collection. © The Piper Estate **p. 68** Georges Braque, *Glass, Bottle and Newspaper*, 1914. Pasted paper, 62.5 x 28.5 (24 ⅝ x 11 ¼). Private Collection. © ADAGP, Paris and DACS, London 2011 **p. 74** Cecil Beaton, *On the Bridge at Wilsford*, 1927. Courtesy the Cecil Beaton Studio Archive at Sotheby's **p. 77** The Palladian Bridge at Stowe Landscape Gardens, Buckinghamshire. Photo © NTPL/Jerry Harpur **p. 78** Cecil Beaton, *Under the Ilex Trees, with his Sisters Nancy and Baba*, 1935. Courtesy the Cecil Beaton Studio Archive at Sotheby's **p. 81** Rex Whistler, *Clovelly Chintz*, 1932. Printed cotton. Courtesy Clovelly Silk, Devon. © Clovelly Estate Co. Ltd. **p. 82** Rex Whistler, Mural in the dining room at Plas Newydd, 1936–37. Photo NTPL/Andreas von Einsiedel. © Estate of Rex Whistler. All rights reserved, DACS 2011 **p. 84** Edward Bawden, *Design for a mural at the International Building Society Club, Park Lane*, 1938. Watercolour, pen and ink on paper, 26 x 121.8 (10 ¼ x 48). Courtesy the Trustees, Cecil Higgins Art Gallery, Bedford, England. © The Estate of Edward Bawden **p. 89** Edward Bawden, *Homage to Dicky Doyle*, 1931. Watercolour on paper, 17 x 22 (6 ¾ x 8 ⅝). Photo Webb & Webb Design Limited, London. © The Estate of Edward Bawden **p. 90** Paul Nash, *Bollard and Bedhead*, 1935. Photograph. © Tate, London 2011 **p. 95** John Betjeman, page layout *Dorset*, from *Continual Dew: A Little Book of Bourgeois Verse*, 1937. Published by John Murray, 1937, p.18. © John Betjeman by permission of The Estate of John Betjeman **p. 96** Cecil Beaton, *Self-Portrait*, 1935. Courtesy the Cecil Beaton Studio Archive at Sotheby's **p. 99** Angus McBean, *Beatrice Lillie 'Surrealised'*, 1940. Black and white print from glass negative 12 x 16.5 (4 ¾ x 6 ½). Angus McBean photograph, © Harvard Theatre Collection, Cambridge, Massachusetts **p. 105** Roger Fry, *Still Life: Jug and Eggs*, 1911. Oil on wood panel, 30.5 x 35.3 (12 x 13 ⅞). South Australian Government Grant 1984. Art Gallery of South Australia, Adelaide **p. 108** Duncan Grant, *A Sussex Farm*, 1936. Oil on canvas, 46 x 76.8 (25 ⅜ x 30 ¼).

Toledo Museum of Art, Toledo, Ohio. Museum purchase, 1939.87. Photo Richard Goodbody, New York. © Estate of Duncan Grant. All rights reserved, DACS 2011 **p. 111** Virginia Woolf at Knole House, Kent, in 1928, the home of the Sackville family. Photo Pictorial Press Ltd/Alamy **p. 119** Illustration from *Mrs Beeton's Every Day Cookery and Housekeeping Book*, 1890, p.525. Published by Ward, Lock & Co., Ltd, Warwick House, Salisbury Sq **p. 124** Edward Bawden, publicity material for Fortnum & Mason *For Sherry & Cocktail Parties*, May 1937. Print, 18 x 17.4 (7 ⅛ x 6 ⅞). Courtesy the Trustees, Cecil Higgins Art Gallery, Bedford, England. © The Estate of Edward Bawden and Messrs. Fortnum & Mason **p. 131** Francis Towne, *The Source of the Arveiron*, 1781. Pen and ink and watercolour on paper, 31 x 21.2 (12 ¼ x 8 ⅜). Private Collection **p. 135** John Sell Cotman, *A Sarcophagus in a Pleasure-Ground, c.* 1806. Watercolour over graphite, 33 x 21.6 (13 x 8 ½). British Museum, London **p. 138** Lady Gator's Canteen Committee outside the National Gallery. Courtesy the Trustees of the Imperial War Museum. IWM Neg. No D12967 **p. 152** Thomas Hennell, *Lime and Frost*, 1942. Watercolour and reed pen, 31 x 47 (12 ¼ x 18 ½). Private Collection. Courtesy Sim Fine Art, Chislehurst, Kent **p. 157** Paul Nash, *Spring at Fawley Bottom*, 1938. Pencil and watercolour, 38.1 x 55.9 (15 x 22). © Tate, London 2011 **p. 162** Bill Brandt, *Top Withens*, 1945. Gelatin silver print, 23 x 19.4 (9 ¹/₁₆ x 7 ⅝). © Bill Brandt Archive **p. 167** H. T. Cadbury-Brown, *Proposal for a Memorial to Benjamin Britten, c.* 1980. Pencil on paper, 21 x 30 (8 ¼ x 11 ¾). Courtesy H. T. Cadbury-Brown Collection **p. 170** Gertrude Hermes, *Stag*, 1932. Wood engraving, 22 x 14.5 (8 ⅝ x 5 ¾). From a set of six wooden engravings for *The Natural History of Selbourne*, 1932, Gwas Gregynog Press. Photo Douglas Atfield. Courtesy North House Gallery, Manningtree, Essex. © Judith Hermes Russell **p. 177** Eric Ravilious, Frontispiece from Gilbert White's *The Writings of Gilbert White of Selborne*, London, Nonesuch Press, 1938. © Estate of Eric Ravilious. All rights reserved, DACS 2011 **p. 181**t Stanley Spencer, *A Village in Heaven*, 1937. Oil on canvas, 45.7 x 182.9 (18 x 72). Manchester City Art Gallery. © The Estate of Stanley Spencer 2011. All rights reserved DACS **p. 181**b Stanley Spencer, *A Village in Heaven*, 1937 (detail). Oil on canvas, 45.7 x 182.9 (18 x 72). Manchester City Art Gallery. © The Estate of Stanley Spencer 2011. All rights reserved DACS **p. 188** Vaughan Williams rehearsing for *England's Pleasant Land*, 1938. Courtesy Ursula Vaughan Williams. Photo Lebrecht Music & Arts **p. 197** Vanessa Bell, *Nativity, c.*1941–42. Berwick Church, Sussex. Photo courtesy Berwick Church, Sussex. © The Estate of Vanessa Bell. Courtesy Henrietta Garnett **p. 198** Duncan Grant, *Christ in Glory, c.*1941–42. Berwick Church, Sussex. Photo courtesy Berwick Church, Sussex. © Estate of Duncan Grant. All Rights Reserved, DACS 2011 **p. 202** Henry Moore, *Madonna and Child*, 1943–44. Brown Hornton stone, height 149.9 (59). St Matthew's Church, Northampton. Gift of Canon J. Rowden Hussey. Reproduced by permission of the Henry Moore

Foundation **p. 210** Carola Giedion-Welcker and Walter Gropius, *Stonehenge*, in *Circle: International Survey of Constructive Art*, 1937. Photo Bodleian Library, University of Oxford (1701 d. 186, p.117). Gropius: © DACS 2011 **p. 212** Paul Nash, *The White Horse at Uffington, Berkshire, c.*1936. Photo courtesy Abbott and Holder Ltd. © Tate, London 2011 **p. 215** Frank Dobson, *The Giant, Cerne Abbas*, 1931. Shell advertising poster, 76.2 x 114.3 (30 x 45). Photo Shell Art Collection **p. 216** Eric Ravilious, *The Wilmington Giant*, 1939. Watercolour on paper, 44.7 x 53.7 (17 ⅝ x 21 ⅛). V&A, London. © Estate of Eric Ravilious. All rights reserved, DACS 2011 **p. 219** Vanessa Bell, *Alfriston*, 1931. Shell advertising poster, 76.2 x 114.3 (30 x 45). Photo Shell Art Collection. © The Estate of Vanessa Bell. Courtesy Henrietta Garnett **p. 220** Lord Berners, *Faringdon Folly*, 1936. Shell advertising poster, 76.2 x 114.3 (30 x 45). Photo Shell Art Collection **p. 224** Graham Sutherland, *Entrance to a Lane*, 1939. Oil on canvas, 61.4 x 50.7 (24 ⅛ x 20). © Tate, London 2011 **p. 230** Serge Chermayeff and Christopher Tunnard, The Garden at Bentley Wood, Halland, Sussex, 1938. Photo Dell & Wainwright/RIBA Library Photographs Collection **p. 231** Serge Chermayeff and Christopher Tunnard, The Terrace at Bentley Wood, Halland, Sussex, 1938. Photo Dell & Wainwright/RIBA Library Photographs Collection **p. 234** Ralph Hancock, The English garden at Rockefeller Center, New York, 1934. Photo © 2011 Rockefeller Group Inc/Rockefeller Center Archives **p. 237** Geoffrey Jellicoe, Ditchley Park, 1934–39. Photo Katrina Underwood/Anthurium www.anthurium-plants.co.uk **p. 238** Beverley Nichols's garden path at Thatch Cottage. Courtesy Beverley Nichols Papers, University of Delaware Library, Newark, Delaware **p. 243** Roses at Sissinghurst Castle, 1942. Photo Country Life/Bridgeman Art Library **p. 251** Menabilly, Fowey, Cornwall. Photo © The Chichester Partnership **p. 254** Daphne du Maurier on the stairs at Menabilly, 1947. Photo Popperfoto/Getty Images **p. 257** Evelyn Waugh at Piers Court. Private Collection **p. 264** Henry Green's home, Forthampton Court. Photo Bob Embleton **p. 269** Novelist Elizabeth Bowen at Bowen's Court, County Cork, Ireland, 1962. Photo Slim Aarons/Getty Images **p. 275** The fountain at Castle Howard, Yorkshire. Photo Travel and Landscape UK/Mark Sykes/Alamy **p. 278** Paul Sandby, *Windsor Castle, The Round Tower*, 1756. Pen and ink and watercolour, 30.1 x 52.7 (11 7/8 x 20 3/4). Reproduced by permission of the Provost and Fellows of Eton College, Eton **p. 280** John Piper, *Windsor Castle, Berkshire*, 1942. Ink and watercolour, 40.6 x 53.3 (16 x 21). Private Collection. © The Piper Estate **p. 283** John Piper, *Renishaw, The North Front*, 1942–43. Oil on canvas, 43.2 x 73.7 (17 x 29). Collection Sir Reresby Sitwell, Bart. © The Piper Estate **p. 284** Bill Brandt, *Edith and Osbert Sitwell*, 1945. Gelatin silver print, 23 x 19.4 (9 1/ 16 x 7 5/8). © Bill Brandt Archive **p. 289** Rex Whistler, *Baroque Tank, c.*1940 (detail). Army notebook S.O.135, pencil, 24.5 x 19.3 (9 5/8 x 7 5/8). Collection Lawrence Whistler. © Estate of Rex Whistler. All rights reserved, DACS 2011

INDEX

Page numbers in bold refer to illustrations.